LIGHTHOUSES

OF ENGLAND AND WALES

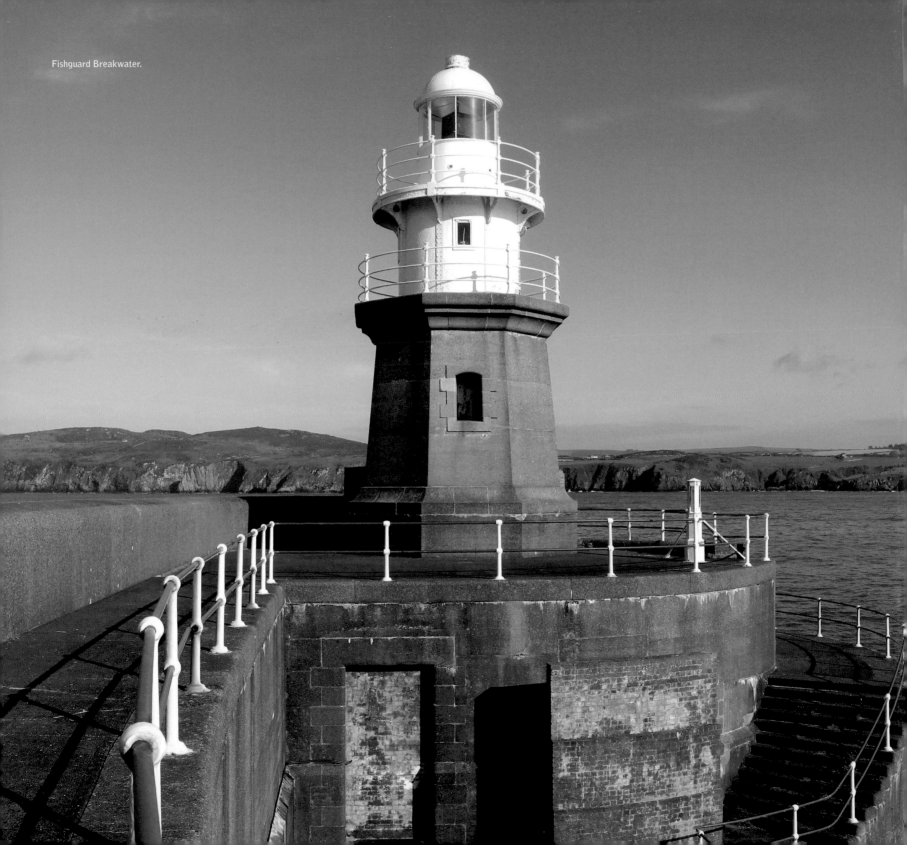

Fishguard Breakwater.

LIGHTHOUSES
OF ENGLAND AND WALES

NICHOLAS LEACH AND TONY DENTON

The History Press

First published 2018

The History Press
The Mill, Brimscombe Port
Stroud, Gloucestershire, GL5 2QG
www.thehistorypress.co.uk

British Library Cataloguing in Publication Data.
A catalogue record for this book is available from the British Library.

ISBN 978 0 7509 8697 7

Typesetting and origination by The History Press
Printed and bound in India by Thomson Press India Ltd

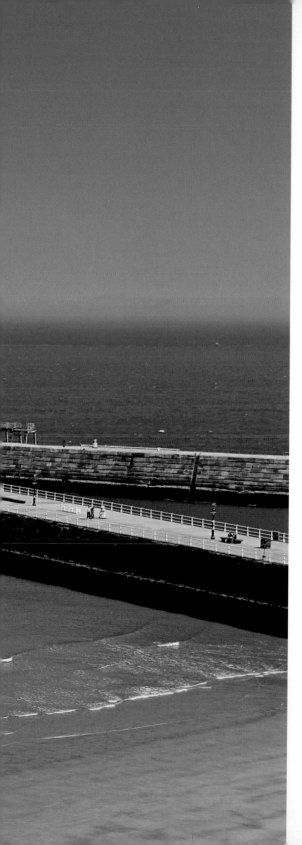

CONTENTS

Whitby Harbour in Yorkshire has no fewer than four lights at its
entrance. Although not all are operational, they are good examples
of harbour lights. Dover Harbour, one of the busiest in the country,
also has several lights marking its entrance.

ACKNOWLEDGEMENTS

For supplying photographs and images for possible inclusion, we are very grateful to:

Rob Alder	Nick Hall	Paul Russell
Trevor Boston	Dave Herbert	Hilari Seely
Andrew Cooke	Ian Lamy	Philip Simons
Jeremy D'Entremont	Maritime Photographic	Brian Slee
Michel Forand	Mike Millichamp	Tim Stevens
David Forshaw	Christopher Nicholson	Peter Webster
FotoFlite	Brian Reeds	Phil Weeks
Brian Green	Paul Richards	David Wilkinson

John Mobbs supplied numerous old postcards, for which we are very grateful; Vikki Gilson at Trinity House helped with information and images; Ken Trethewey gave the benefit of his expertise and lighthouse knowledge by checking early drafts of the original text; and Peter Bendall thoroughly proofed the text. Numerous websites and books were consulted during the preparation of the text. All photographs were taken by Nicholas Leach unless otherwise stated. Every effort has been made to correctly attribute photographs, but this may not have been possible in every instance. In the event of any omission, we request to be contacted care of the publisher, so that we might update future editions.

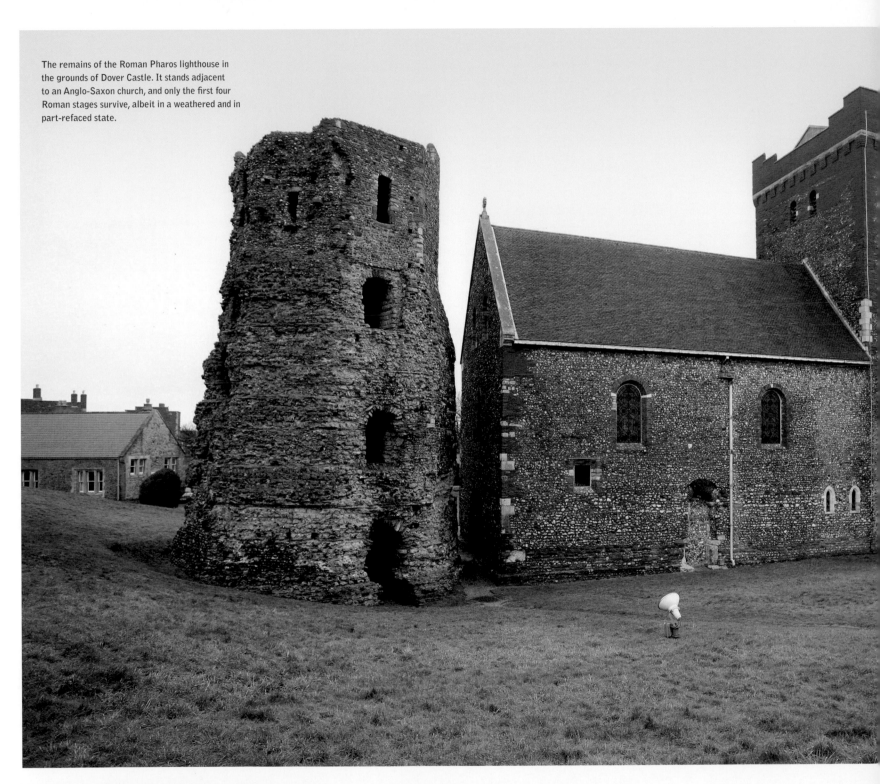

The remains of the Roman Pharos lighthouse in the grounds of Dover Castle. It stands adjacent to an Anglo-Saxon church, and only the first four Roman stages survive, albeit in a weathered and in part-refaced state.

INTRODUCTION

This book provides a comprehensive guide to the lighthouses and harbour lights around the coasts of England, Wales and the Channel Islands, the area for which the Corporation of Trinity House is responsible, although fewer than half the aids to navigation come under Trinity House's auspices. Lights on the Isle of Man, Scotland and Ireland are not included and neither are buoys, lightvessels, floating lights or small beacons. Small lights and daymarks of significance have been described.

The main body of the book contains a round-the-coast guide to the lighthouses, while this introduction provides a general overview of lighthouse development and organisation in England and Wales, focusing essentially on how Trinity House has developed and maintained its service. It also looks at how the lighthouse network has expanded, how lighthouses were funded and the methods of illumination.

The First Lighthouses

Trading by sea has been a principal activity of all civilisations, yet moving goods and cargoes by water involves facing difficulties and dangers such as storms and bad weather, avoiding reefs, headlands, sandbanks and cliffs, and making safe passage into ports and harbours. The need for aids to navigation is therefore as old as trading by sea itself and, today, modern lighthouses operated by Trinity House are supplemented by a plethora of small, locally operated lights of varying sizes and range, mainly around ports, harbours and estuaries, to make the passage of vessels safer.

The earliest aids to navigation were beacons or daymarks, sited near harbours. Seafaring families would sometimes show lights from dwellings to help guide their own boats home during darkness. Where trade was greatest, so was the concentration of lights and daymarks. The earliest lighthouses were in the Mediterranean and the oldest such structure of which written records survive was that on the island of Pharos, off Alexandra on the northern coast of Egypt. The Pharos lighthouse, 466ft in height, was the tallest stone tower in the world; built between 283 and 247 BC, it stood until 1326.

Lighthouses were quite common throughout the Mediterranean during the Roman Empire. The Romans constructed a Pharos at Dover in the late first or early second century AD which survives in the grounds of Dover Castle, albeit much altered. It formed one of a pair, with a tower across the Channel at Boulogne. Following the fall of the Roman Empire, no lighthouses were constructed until well into the medieval period and then they were established on a somewhat haphazard basis, usually through the efforts of local groups or wealthy individuals.

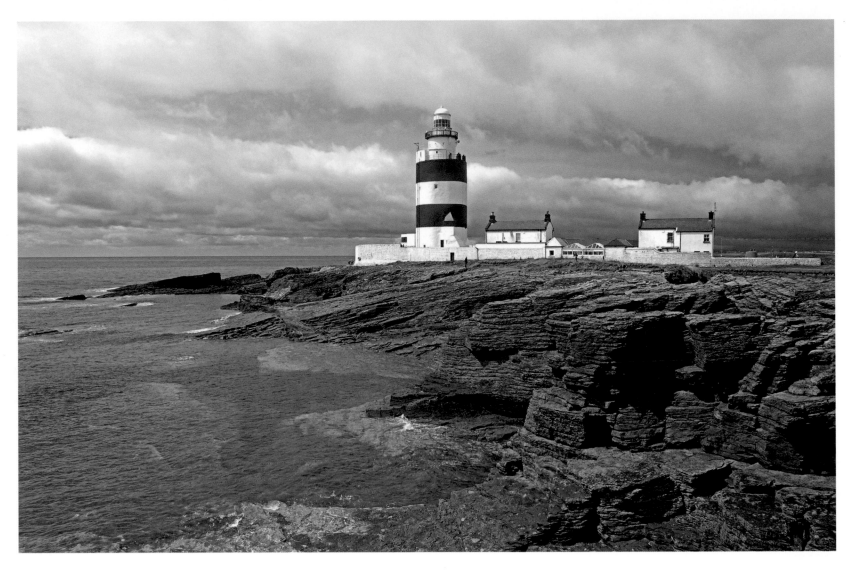

A light managed by Celtic monks at Hook Head in Waterford, on Ireland's south-east coast, was shown during the twelfth century and this was typical of early maritime lights, the majority of which were ecclesiastical in origin. In England, the earliest known light was a harbour light at Winchelsea on the Sussex coast, erected about 1261 and tended by local monks. The Royal Patent issued to the Barons of the Cinque Port of Winchelsea in 1261 entitled them to levy 'by compulsory means, two pence' from every ship that entered the port and this patent laid down the principle of ships paying light dues which operates to the present day.

Although around thirty to forty lighthouses existed in the British Isles during the medieval era, not all had religious connections. Many were on the south coast, such as that at St Catherine's oratory on the Isle of Wight which was erected by a rich merchant, Walter de Godeton. He

The light at Hook Head, now operated by the Commissioners of Irish Lights, was first established in the fifth century. The tower built in 1172 was later enclosed by a larger structure, and the present lantern dates from 1864.

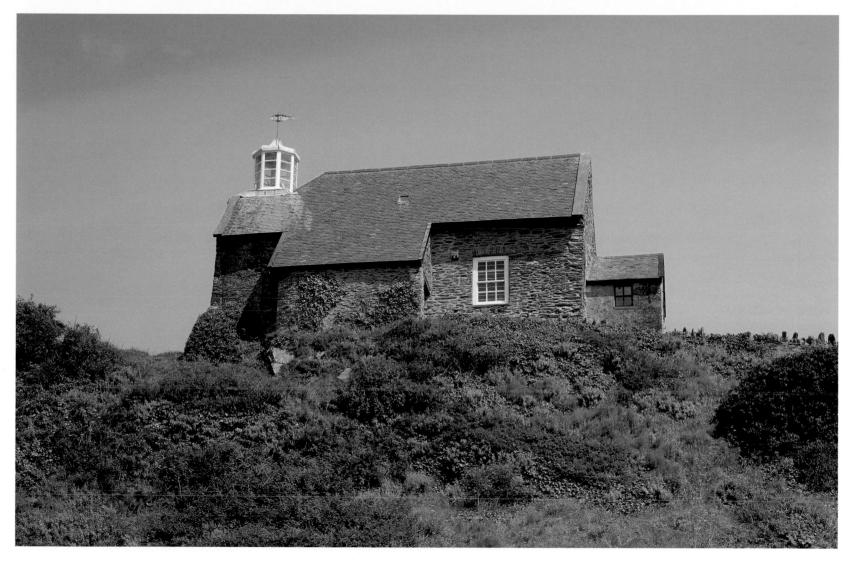

The chapel on Lantern Hill, Ilfracombe was built in 1361 and is reputed to be the oldest working lighthouse in the UK. A light or beacon has been displayed from it for over 650 years.

was threatened with ex-communication from the Catholic Church after he had purchased barrels of wine from local wreckers who had acquired them from a ship wrecked at the Point. In penance, de Godeton was instructed to build St Catherine's Oratory and establish 'a light for the benefit of mariners, to be lit every night for ever'. And from 1314 until the dissolution of the monasteries in the sixteenth century, de Godeton's family showed a light from the oratory.

Trinity House

The exact origins of the Corporation of Trinity House are obscure but probably date back to the early thirteenth century when groups of tradesmen formed guilds to protect their interests. The guilds, essentially religious in character, were made up largely of seamen, masters of merchant vessels, and pilots. Whatever its precise origins, the Deptford

Trinity House was incorporated by royal charter after its members petitioned Henry VIII to prohibit unqualified pilots on the Thames in 1513. Deptford was then a busy port and the main point of entry for the capital's trade, so pilotage duties were lucrative and Trinity House members wanted to retain their monopoly.

Henry responded by granting a royal charter on 20 May 1514 which empowered 'The Master, Wardens, and Assistants of the Guild or Fraternity of the Most Glorious and Undividable Trinity and St Clement in the Parish of Deptford Strond' to regulate pilotage of the river. Since the granting of this charter, the organisation has been managed by charters granted by successive monarchs determining the number of brethren assisting the master and wardens.

The Deptford Trinity House was one of several similar such organisations. Another, the Trinity House at Newcastle-upon-Tyne, was

The lighthouse at Lowestoft was the first to be established by Trinity House. It was originally one of a pair of lights built 'for the direction of ships which crept by night in the dangerous passage betwixt Lowestoft and Winterton'. (Courtesy of Michel Forand)

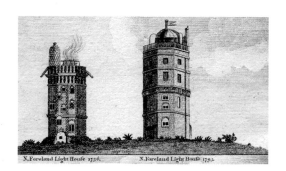

Line drawing of the North Foreland tower showing the open coal-fired light on the left, and the tower after it had been heightened by two storeys in 1793. (By courtesy of Michel Forand)

responsible for aids to navigation on the Tyne at the time of its charter in 1536. This gave it authority to erect two towers on either side of the Tyne Estuary which served as leading marks for shipping by day, while at night a coal- or wood-burning fire was maintained to mark the river entrance. The towers were completed in 1540 and 'two pence for English ships and four pence for foreign vessels' was charged for their upkeep.

Although Deptford Trinity House was not responsible for navigation marks at this time, during the mid sixteenth century, with seaborne trade on the rise, the inadequate state of coastal navigation marks gave cause for concern. The busy trade routes, such as that down the east coast, were particularly notorious and so in 1566 Parliament gave the responsibility to improve the situation to Deptford Trinity House. However, due to lack of finances, not until the early seventeenth century did the corporation erect its first lighthouse, at Lowestoft.

By this time, losses of merchant ships engaged in the coastal trade, bringing coal from the north-east to London, had become unacceptably high. The shoals and sandbanks between Haisborough and Lowestoft proved a particular hazard and the Brethren were required to build a series of lighthouses along this coast, funded by a levy of twenty pence per ton imposed on all ships leaving Newcastle, Hull, Boston and King's Lynn.

Private Lights

Despite erecting towers on the East Anglian coast, Trinity House was generally reluctant to build lighthouses and instead encouraged private entrepreneurs to build them as profit-making undertakings. As a result, private lighthouse ownership became relatively widespread during the seventeenth century. Choosing the best position for a light, with sufficiently busy ports nearby from where revenue could be collected, was a crucial decision for the light to yield a good return. As a consequence, the success of the early lights was something of a hit and miss affair.

At the Lizard headland, an area where the local population was active in smuggling and wrecking, Sir John Killigrew obtained a patent in May 1619 for a lighthouse but failed, despite quite considerable efforts, to build a light. His problems were twofold: first, the patent only allowed him to collect levies from shipping on a voluntary basis, and second, local people were openly hostile to the light, believing it would reduce their opportunities to gain by plundering shipwrecks. The light was lit in 1620 but, with no money for its upkeep, was extinguished within a year. More success was enjoyed in the 1630s by John Meldrum, a former soldier, who built lighthouses at Orfordness, North Foreland and South Foreland, and found them to be very profitable. In 1664 a Surveyor of the Navy, Sir William Batten, had two leading lights erected at Harwich, from which he also enjoyed financial gain.

Reorganisation

The number of private lighthouses gradually increased during the early nineteenth century, with Trinity House remaining reluctant to get involved. However, in 1694 the corporation did take responsibility for constructing a tower to mark the Eddystone reef, 14 miles off Plymouth, as the rocks were claiming an increasing number

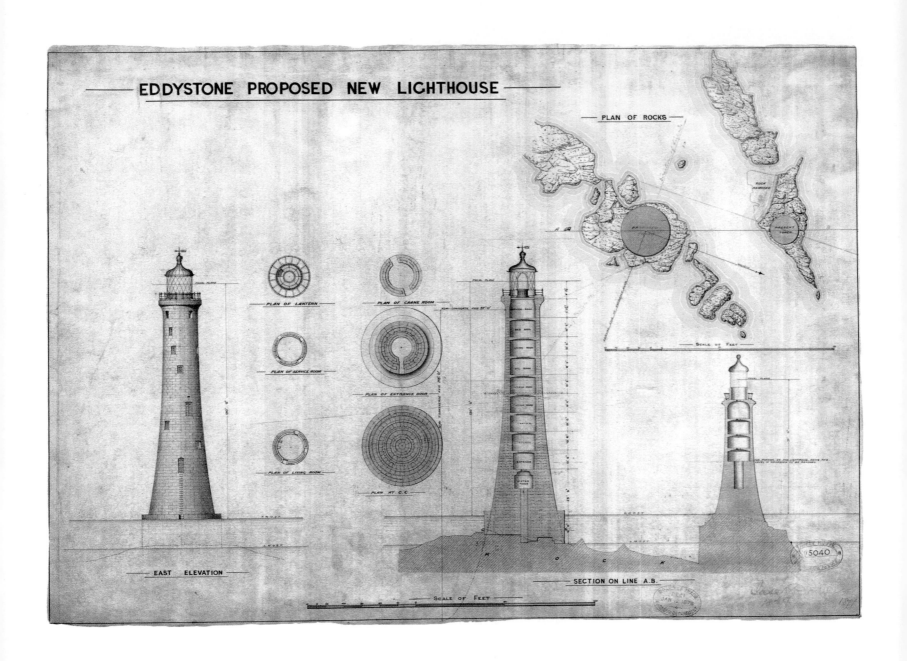

Diagram of the Eddystone Reef and the lighthouse built there by James Douglass in 1882. (Courtesy of Trinity House)

of ships. The story of the building of the Eddystone is particularly notable as it was the first true rock lighthouse and is told in the entry for that lighthouse.

Trinity House acted largely in an advisory capacity to the Crown during the seventeenth and eighteenth centuries when petitioning speculators attempted to gain patents for erecting lighthouses. Although this prevented a proliferation of unnecessary lights, private light owners gained a reputation for greed and, in many cases, inefficiency, as a lighthouse was usually only constructed when a speculator was inspired to act. As a result, large areas of the coastline remained unlit, particularly along western England and Wales. The situation soon became unacceptable and the hitherto somewhat conservative Elder Brethren were forced to act.

At the same time, change was afoot within Trinity House, with the leases on many privately owned lighthouses expiring and forcing the corporation to take over. In 1807 Trinity House assumed responsibility for the Eddystone light and the next three decades saw lighthouse organisation in England and Wales change considerably. These changes were formalised in 1836, with an Act of Parliament giving Trinity House of Deptford Strond complete authority over lighthouses and making it the body to which others, including the regional Trinity House

organisations, had to apply for sanction of the position and character of lights.

The 1836 Act not only enabled the corporation to levy dues in a consistent way but also gave it the power to use compulsory purchase orders on all privately owned lights. Although only ten lighthouses were still in private ownership, the compensation paid to their owners by the corporation was a staggering £1,182,546. The rate was calculated from the number of years left on patents or leases, multiplied by the previous year's net profit. In the case of Tynemouth, the compensation was £12,467, about £5,305 net profit per year, while the trustees at Spurn Point initially contested the compensation offered and finally agreed to £309,531.

Probably the most notorious of all the patents was that dated 13 July 1714 giving William Trench permission to build a lighthouse on the Skerries, off Anglesey, and the right to collect from passing shipping a compulsory levy for upkeep of the light of 'one penny per tun'. Skerries became the most profitable lighthouse around England and Wales and its owner in the nineteenth century, Morgan Jones II, refused to accept any offer from Trinity House until the matter was settled in court.

Between 1836 and 1841, Jones was offered £260,000, then £350,000, and finally £399,500 by Trinity House, but rejected each. Trinity House even asked Jones for his own estimate

of the compensation he believed Skerries was worth, but he refused to give a figure so the matter went to court. However, he died in March 1841 before the final negotiations were completed and the patent became the property of his descendants. A jury awarded £444,984 in compensation in July 1841, demonstrating the considerable profits that were to be made from lighthouse ownership. Even after Trinity House took over Skerries and halved its levy, the light still made a huge profit.

Trinity House Today

Trinity House gradually assumed control of lighthouse maintenance and construction during the nineteenth century. During the great period of lighthouse construction between 1870 and 1900, Victorian engineers and designers constructed and modernised at least fifty stations and built new rock towers at the Wolf Rock, Longships, Bishop Rock and Beachy Head. At the same time, Trinity House led a petition requesting clearer guidelines as to its responsibilities, which resulted in the Merchant Shipping Act of 1894. The Act made Trinity House, the Northern Lighthouse Board and the Commissioners of Irish Lights each into a General Lighthouse Authority (GLA), financed solely on the dues levied on ships entering the United Kingdom and Ireland.

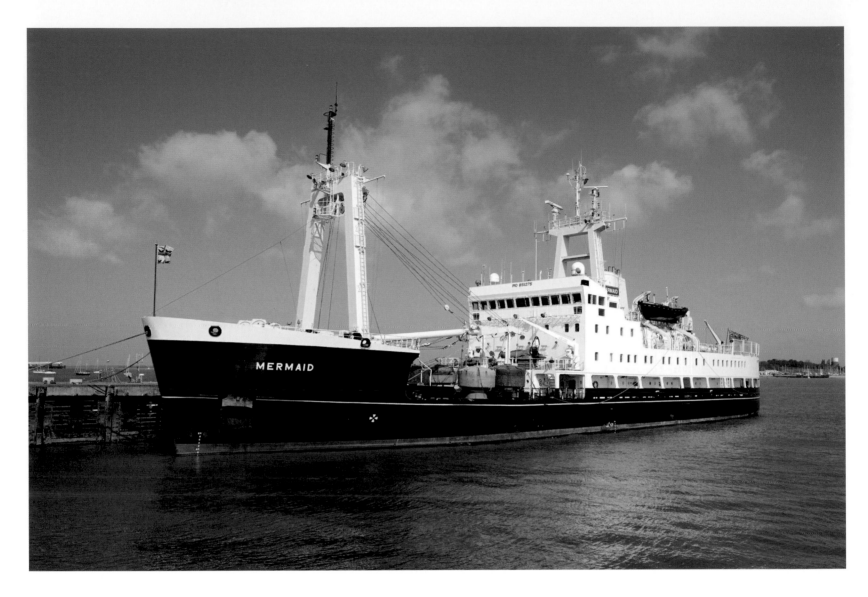

Since then, the corporation's mandate has expanded considerably, and it is now the UK's largest-endowed maritime charity, as well as being the GLA for England, Wales, the Channel Islands and Gibraltar. A long-standing familiarity with the channels, hazards, currents and markings of the UK coastline qualifies Trinity House to inspect and audit almost 11,000 local aids to navigation, license Deep Sea Pilots and provide Elder Brethren as Nautical Assessors to the Admiralty Court. Each year the charity donates around £4 million to charities, including the provision of cadet training schemes, welfare provision for retired mariners and educational programmes teaching safety at sea skills.

The duties of Trinity House include the marking of wrecks and, in some cases, their disposal. The corporation's purpose-built

THV *Mermaid*, one of Trinity House's servicing vessels, berthed at the Trinity House Depot at Harwich. Trinity House operates three purpose-built vessels, THV *Galatea*, THV *Patricia* and THV *Alert*, all of which maintain and supply the organisation's offshore aids to navigation. (Maritime Photographic)

tenders THV *Patricia*, THV *Mermaid* and THV *Alert* undertake a variety of duties including servicing lightships, navigational buoys, radio beacons and radar beacons. Marine aids to navigation in the twenty-first century consist of a mix of equipment including traditional visual aids, shipborne radar systems and satellite positioning systems.

Light Technology

Following construction of a lighthouse, the provision of adequate lighting apparatus to display a continuous uninterrupted light was the next most important consideration. As with construction techniques, light sources have advanced in line with technology. Coal, candles, wood, oil, paraffin, acetylene and electricity have all been used at one time to provide the illumination necessary to ensure a lighthouse fulfils its aim.

For centuries, coal was used, particularly in locations with a ready supply such as the north-east. However, taking coal to the lighthouse itself, and then getting it to the top of a tower, involved considerable effort by the keepers. Coal fires were refined by improving the containers so that the coal burned more efficiently, but it still presented problems: fires were enclosed inside lanterns which often became coated in soot that inevitably reduced the effectiveness of the light. Wood was also used, though less often than coal as it required more fuel and was very labour-intensive.

Although coal or wood were fairly crude forms of illumination, the only realistic alternative was candlelight. Candles were more common in the smaller lamps used as harbour marks, as the low intensity of the light precluded their use in major lighthouses. However, with the use of a reflector, candles were surprisingly effective. Smeaton used twenty-four candles in his Eddystone lighthouse, although the range was no more than 4 or 5 miles in clear weather. Despite their shortcomings, candles were used in the harbour light at Bridport in Dorset as late as 1861.

The first oil burner suitable for lighthouse purposes was invented in 1782 by Ami Argand, who discovered that illumination was increased by burning an oil wick in a glass tube with a central current of air passing through it. The burner subsequently underwent improvement at the hands of Augustin Fresnel and Douglass and Thomas Stevenson, who increased the number of wicks to as many as ten. Although never totally satisfactory despite various advances, Argand's invention was used as the principal lighthouse illuminant for more than a century.

Electric-powered lights were first used at Dungeness, South Foreland and Souter Point. An electric generator provided a high voltage that was applied to two carbon rods known as electrodes. With sufficient voltage, the air between the two electrodes created a bright spark. However, the disadvantages of electricity provided by generators were its expense and the manpower needed. So, when mains power became available, it was applied to lighthouses. South Foreland was the first station to be connected and in 1922 became the first British lighthouse to be lit by a filament lamp. Further improvements in technology resulted in the xenon discharge lamp, introduced in 1947, which gave a concentrated source of light far greater than that of any previous lighting.

Lightkeepers

A lighthouse was only of use when operated by efficient and dedicated keepers, and the lightkeeper played an essential role. However, during the latter half of the twentieth century, the era of manned lighthouses came to an end as full automation proved a cheaper and easier means of operation. Before automation every light had to be manned and the idealised view of lighthouse keepers conjures up a romantic image of men living in a tower with only the sea for company. While this was accurate for the remote rock stations, which confined their keepers in often fairly cramped quarters for

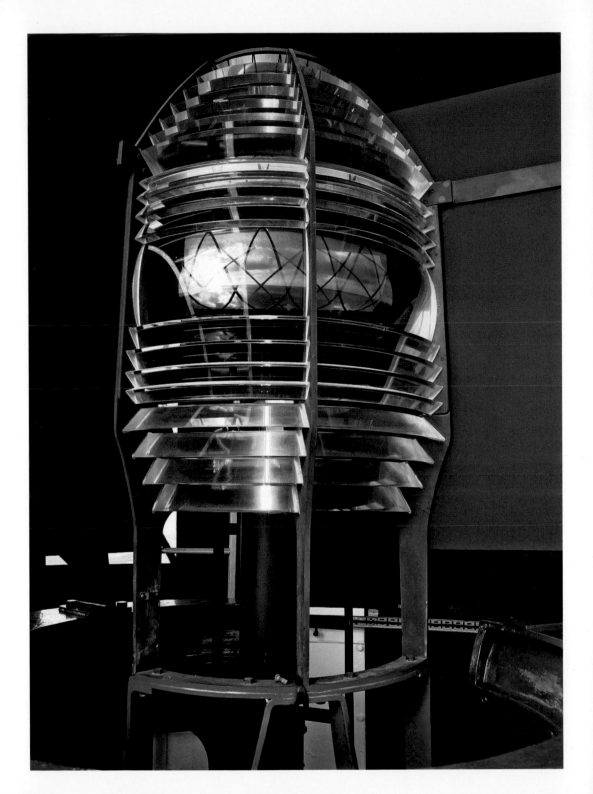

The dioptric lens used at Hurst Lighthouse in Hampshire. It is based on the ideas of the Frenchman Augustin Fresnel (1788–1827) who designed a lens, first demonstrated in 1822, which made possible the whole range of dioptric or refractory illumination. He realised that the arrangement of lenses and prisms around a light was crucial to maximising its efficiency. (David Wilkinson)

weeks at a time, the reality for most keepers was a little different. Undoubtedly, those who manned the rock stations had a difficult time, but the majority of lights were on the mainland. Here, a senior keeper would be supported by two assistant keepers, usually with families.

Following the reforms of 1836, when Trinity House assumed responsibility for all lights in England and Wales, the role of the lightkeeper became a more professional one with a career structure and level of job security hitherto unknown. The primary task of the lightkeeper was ensuring the light did not go out through lack of fuel or inefficiency, and that the equipment, including the reflectors and lenses, was maintained to the highest standards at all times. The keepers were often very busy, ensuring that there was a constant supply of fuel to the light, and leaving the lighthouse or falling asleep on duty could be punished by dismissal or demotion.

The most isolated rock towers, such as Smalls or Eddystone, required the three keepers to work and live very closely together, something

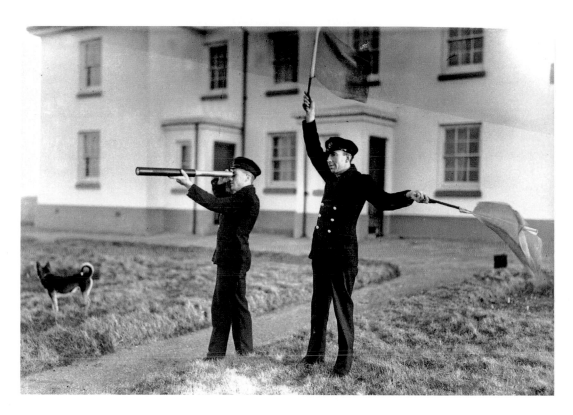

Semaphore signalling from the keepers' cottages at Sennen Cove to Longships lighthouse during the 1950s. (Courtesy of Mike Millichamp)

electronic technology, increasing reliability of diesel generators, and the ability to control and monitor lighthouses remotely spelt the end for the lighthouse keeper. In November 1998 the last manned lighthouse, at North Foreland in Kent, was automated and the six keepers left, bringing to an end a tradition that went back more than four centuries.

Harbour Lights

Much of the literature about lighthouses has concentrated on the major lights. These are often impressive structures in spectacular locations. However, no less important are the many small lights found at almost every port or harbour. Because they have developed in response to specific local circumstances, their design, construction and purpose differ markedly. The variety of such lights around England and Wales is considerable, making categorisation and generalisation difficult.

Many harbour authorities are responsible for their own aids to navigation, and this has led to a variety of lights and beacons being erected. Some ports, where vessels need to follow

that could generate comradeship but also create tensions. At stations on larger islands, such as Lundy, Bardsey or South Stack, the relative isolation was tempered by the attractions of a small resident population nearby. Those stations located in the middle of towns, such as Southwold and Lowestoft, offered the keepers and their families good employment and a comfortable living. The keeper would be part of the community, his children could go to the local

school, and his free time was not constrained as it was on the remote stations.

Advances in technology saw automation gradually being introduced before the Second World War and becoming more widespread after 1945. The introduction of helicopters to relieve the isolated rock lighthouses improved the keepers' situation, obviating the need for relief by sea, which could be delayed by bad weather for weeks at a time. Improvements in

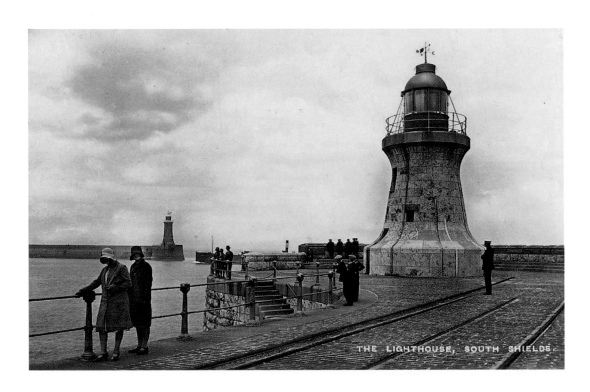

THE LIGHTHOUSE, SOUTH SHIELDS.

The entrance to the River Tyne and the busy port of Newcastle is marked by several lighthouses, including this one on the South Pier. (Courtesy of John Mobbs)

channels, have leading or range lights which, when aligned, mark a safe passage. Others have long piers or breakwaters, the limits of which need marking, and on these some of the finest light towers have been constructed, such as that at Sunderland.

In areas like the north-east, where trade between ports was competitive, new harbours were built with grand lighthouses to mark their entrances, such as at Tynemouth, Seaham and Whitby. In other areas, notably Cornwall and Wales, where the main trade

was in raw materials, more modest lights were erected at places such as Burry Port, Barry Dock, Penzance and Newlyn. Meanwhile, the growth of passenger vessels saw ferry ports such as Dover, Folkestone and Ramsgate being developed, with the new harbours being marked by lights.

Lighthouse Engineers

Constructing lighthouses was often a difficult and dangerous business. The engineers described below all made contributions to lighthouse construction, designing and building towers in some of the most inhospitable places around the English and Welsh coasts, using considerable ingenuity and skill. Their achievements represent major contributions to civil engineering.

John Smeaton (1724–92)

John Smeaton's greatest feat of civil engineering was designing and building the Eddystone lighthouse. He pioneered the use of stone in lighthouse construction when wood had been accepted as the best material. He devoted his life to writing *A Narrative of the Building and a Description of the Edystone Lighthouse with Stone*. His intention was to pass on his knowledge to benefit future civil engineers. The book took almost the rest of his life to complete and was published only a year before his death.

Sir James Nicholas Douglass, Engineer-in-Chief to Trinity House from 1863 to 1892, designed twenty-two towers and in 1864 invented the helically framed lantern.

James Nicholas Douglass (1826–98)

James Douglass served as Engineer-in-Chief to Trinity House from 1863 to 1892. He was the first man to be appointed Chief Engineer, as previous engineers had all been consultants with their own practices. Douglass was the resident engineer for the Smalls lighthouse between 1855 and 1861 and is credited with designing twenty new lighthouses including the third on Bishop Rock. He gained a knighthood in June 1882 following the successful completion of his Eddystone light. Sir James and William Douglass are credited with building two-thirds of the lighthouses around the British coast.

William Douglass (1831–1923)

The younger son of Nicholas Douglass who, when his brother James became Trinity House Engineer-in-Chief, took over as the resident engineer at Wolf Rock in 1869. William designed the second Longships lighthouse, prior to becoming Engineer-in-Chief for the Commissioners of Irish Lights in 1878. He served Trinity House for twenty-six years and then spent a further twenty years in Ireland working for the Commissioners.

William Tregarthen Douglass (1857-1913)

Son of Sir James Nicholas Douglass and nephew to William, he assisted his father during the building of the Eddystone lighthouse in 1878. On completion of this contract he was appointed by Trinity House as Resident Engineer for the rebuilding of the Bishop Rock tower, plus the establishment of a new station for the Isles of Scilly at Round Island. In 1887, he left Trinity House to set up his own Engineering Consultancy Practice.

Alexander Mitchell (1780–1868)

Living by the sea, Irish engineer Alexander Mitchell often wondered how to warn mariners of the dangers of shoals and rocky outcrops at sea and in 1828 he came up with the answer. Four years later, he became known as the inventor and patentee of the 'Mitchell Screw-pile and Mooring', a simple yet effective method of constructing durable lighthouses in deep water, on mudbanks and shifting sands, of fixing beacons, and of mooring ships. His ideas were first used for the foundations of the Maplin Sands lighthouse, at the mouth of the Thames, and at a lighthouse he supervised at the River Wyre, Fleetwood. His invention revolutionised lighthouse construction on unstable sea beds throughout the world.

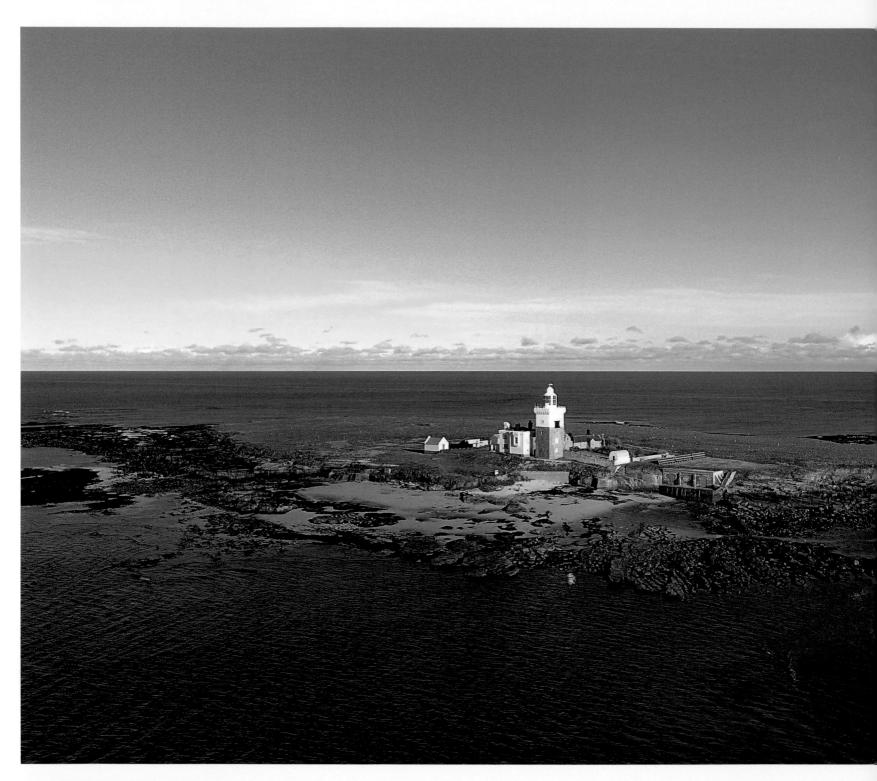

1 NORTHUMBERLAND, DURHAM AND TYNE & WEAR

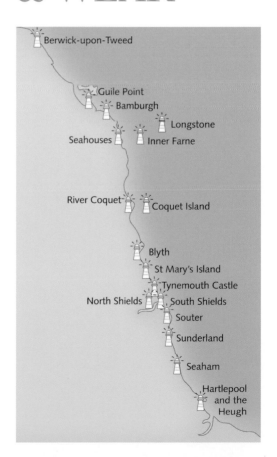

- Berwick-upon-Tweed
- Guile Point
- Bamburgh
- Longstone
- Seahouses
- Inner Farne
- River Coquet
- Coquet Island
- Blyth
- St Mary's Island
- Tynemouth Castle
- North Shields
- South Shields
- Souter
- Sunderland
- Seaham
- Hartlepool and the Heugh

Berwick-upon-Tweed

Established	1826
Current lighthouse built	1826
Operator	Berwick-upon-Tweed Harbour Trust
Access	By walking the breakwater, which is open to the public

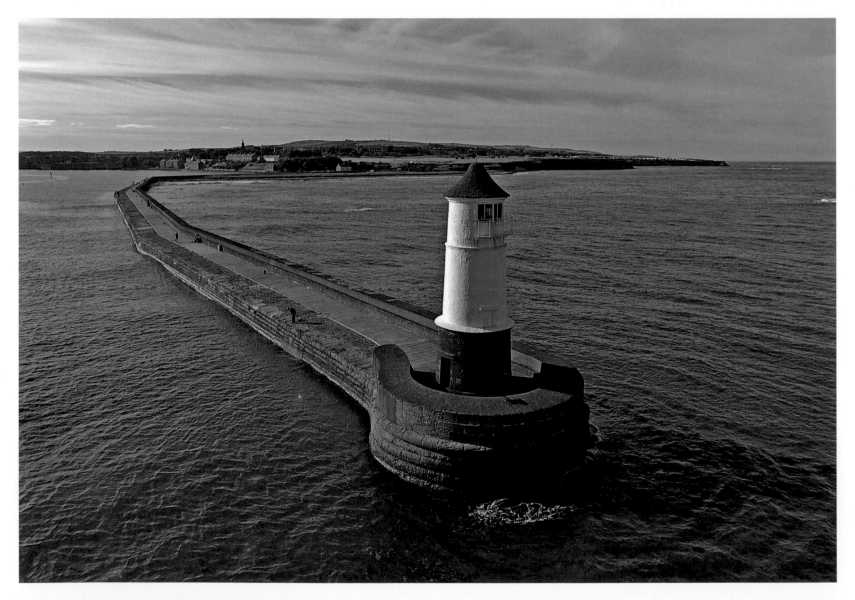

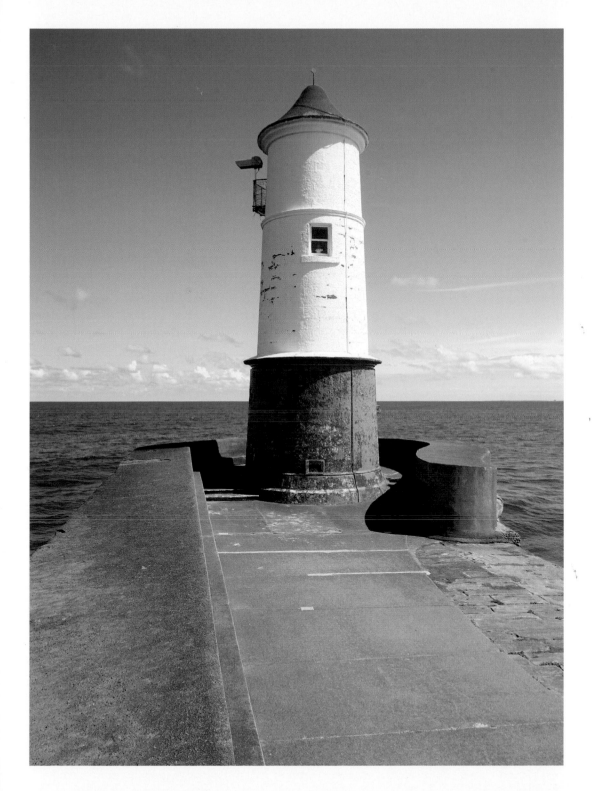

Berwick-upon-Tweed's lighthouse dates from 1826 and is situated at the end of the breakwater, which was extended between 1810 and 1811.

The town of Berwick-upon-Tweed was fought over by Scotland and England for many years before becoming part of England. During the eighteenth and nineteenth centuries the town became a prosperous port and the harbour was gradually improved. The quays were extended and protection against northerly winds was provided by a breakwater, which was built in 1810–11.

In 1826 what is now the most northerly lighthouse in England was completed at the end of the breakwater. Built to the design of Joseph Nelson, the 43ft circular stone tower with a conical top was made from one piece of stone. The flashing white light is visible for 10 miles through a seaward-facing window with a small gallery. A fixed green light visible for 1 mile is shown through a landward-facing window lower down the tower.

Lindisfarne

Established	*c.* 1820
Operator	Trinity House
Access	The Guile Point beacons can be reached via a 3-mile walk heading north from the hamlet of Ross; they can also be seen from the Heugh Hill light on Holy Island, which overlooks Lindisfarne Priory

When limestone and coal were beginning to be carried by sea during the first half of the nineteenth century, the harbour on the south side of Holy Island grew increasingly busy. However, many ships ran aground off the Island, often mistaking Emmanuel Head, on the island's north-eastern corner, for the Lindisfarne channel. To counter this, a 48ft white-painted stone pyramid was erected on the headland to guide vessels as they approached the harbour from the north.

Around the same time, two daymarks in the form of obelisks were erected at Guile Point on the mainland side of the harbour entrance, to the south of Holy Island. These beacons, topped with triangular daymarks, aided vessels involved by marking the southern approach to Lindisfarne harbour. Designed for Trinity House by John Dobson, a Newcastle architect, the beacons were built between 1820 and 1840 and, known as East and West Law, were respectively 70ft and 83ft in height, 122 yards apart. When aligned, they marked a safe southern approach into the harbour. Vessels would follow this course until reaching a point when the Heugh Beacon aligned with the belfry of St Mary's Church. At this point, course would be altered so that the narrow channel, which led to the anchorage, was safely followed.

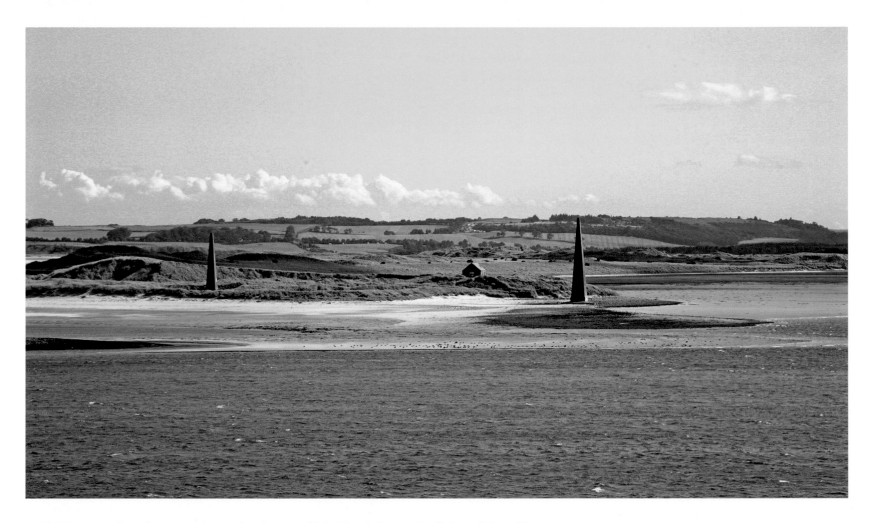

Shifting sands subsequently made the beacons inaccurate and the East Law was discontinued in 1995 when a fixed light, with a range of 4 miles, was attached a third of the way up the West Law tower. This light, under the control of Trinity House, is known as Guile Point light. It is supplemented by a new light, with a range of 5 miles, built to carry out the duties of the original East Law pyramid and sited on the opposite side of the channel on Holy Island close to Lindisfarne Priory. Known as Heugh Hill, it helps to mark the safe deepwater channel into Lindisfarne Harbour. A beacon was established on the Heugh, between the village and harbour, before 1836 and during the nineteenth century a flag was hoisted from this when ships could safely enter harbour in bad weather, even if the local pilots could not go out to them.

(Above) The two stone obelisks at Guile Point, seen from Holy Island, mark the south-eastern entrance to the island's harbour.

(Opposite) The West Law obelisk, used as a daymark, is situated over 100 yards from the east obelisk.

Bamburgh

Established	1910
Current lighthouse built	1910
Operator	Trinity House
Access	Situated at the end of The Wynding, a road out of Bamburgh village

The small lighthouse at Bamburgh on the shore edge at Black Rock Point is to the north of the town's famous castle. The Bamburgh area, and the castle in particular, has played an important role in English history since the occupation of the site by the Romans. The lighthouse, a square white-painted box-shaped tower with the light enclosed in a black cylinder on top, is rather less well known, but has guided shipping along the east coast north of the Tyne, as well as assisting vessels in the dangerous waters around the Farne Islands, for almost a century.

The lighthouse was built in 1910 and modernised in 1975. The third-order dioptric optic with a first-order catadioptric fixed lens shows an occulting white, red and green light twice every fifteen seconds. The range of the white sector is 17 miles, with the coloured sectors having a range of 13 miles. The lighthouse is now monitored and controlled from Trinity House's Planning Centre in Harwich, Essex.

Bamburgh's squat lighthouse, north of the village, is Trinity House's most northerly lighthouse.

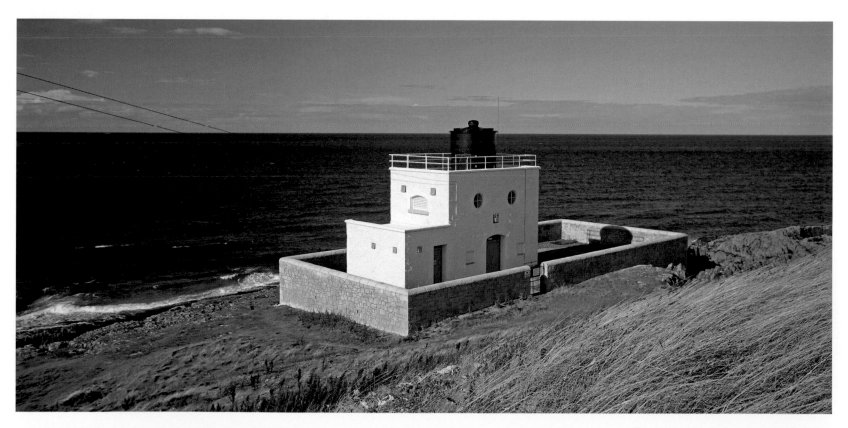

Longstone

Established	1826
Current lighthouse built	1826
Automated	1990
Operator	Trinity House
Access	Boat trips run from Seahouses, some of which enable visitors to land on the island

The Farne Islands, a small archipelago off the coast of Northumberland, consist of two distinct groups of islands separated by Staples Sound. The earliest attempt to mark the islands, a major hazard in the deepwater coastal shipping lanes, was made during the seventeenth century by Sir John Clayton, who was granted a patent to erect a light in 1669. Four years later, he had a tower erected on Inner Farne as part of his scheme for lighting the east coast but, as the Newcastle merchants refused to pay any dues for its upkeep, and Trinity House did not give it their approval, its fire was never kindled. Further applications were made during the eighteenth century for a lease to build a light on the island but not until 1776 did Trinity House agree to allow Captain J. Blackett, whose family held the lease to the islands, to build two lighthouses at his own expense.

The lights were exhibited for the first time on 1 September 1778. One tower, known as Cuthbert's Tower, was on Inner Farne while the other was at the southern end of Staples Island and consisted of a small square cottage lighthouse. The latter building was ill-sited, so was replaced in 1791 by a roughly-built coal-burning tower on nearby Brownsman's Island. In 1796 the Staples keeper, Robert Darling, moved, with his family, to the new lighthouse. This light was also deemed inadequate by local

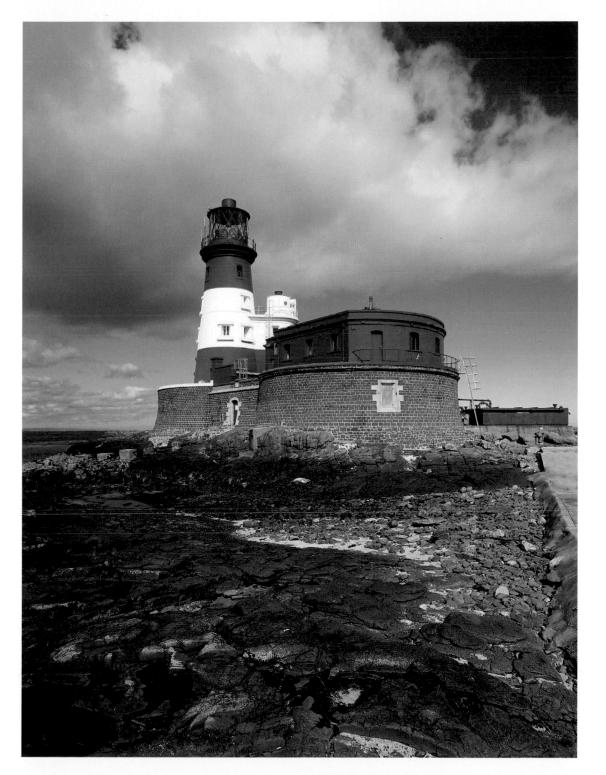

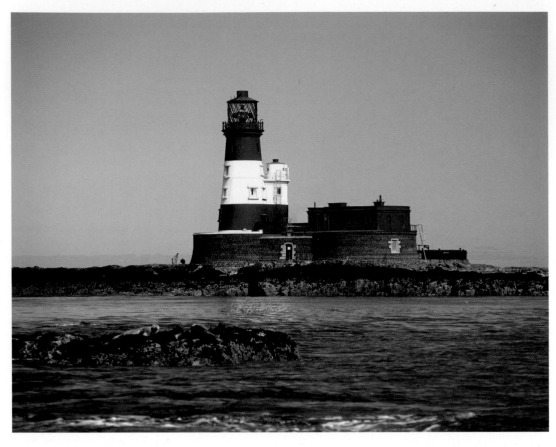

Longstone lighthouse, which has been automatic since 1990, remains one of the most iconic of any around the coasts of the UK. It can be reached via boat trips from nearby Seahouses Harbour.

shipowners, while Trinity House's instruction to improve the power of the lights by fitting Argand lamps and reflectors was ignored.

The situation was clearly unsatisfactory and by 1810 the two towers, both holding coal lights, were in a rundown state. After various discussions, the corporation took them over and decided to have two new lighthouses built, one on Inner Farne and the other on Outer Farne, otherwise known as Longstone Rock, to the western side of the island group. Daniel Alexander, the Trinity House architect who succeeded Samuel Wyatt, was paid £8,500 to organise the construction work.

The new light on Longstone bore one of the first revolving, flashing optics in the world.

By Act of Parliament in 1822, Trinity House was able to buy the site, and four years later extensive works were undertaken to Joseph Nelson's design. The result was the enlarged red and white circular tower, 86ft in height, built of rough stone with iron railings around the lantern gallery completed at a cost, with dwellings, of approximately £4,771. The lantern, which cost £1,441, consisted of twelve Argand lamps in parabolic reflectors and a catadioptric apparatus, and it was displayed for the first time in February 1826.

Longstone lighthouse is most famous as the scene of the wreck of the steamship *Forfarshire*, which was driven onto the Big Harcar Rocks on 7 September 1838. Early the following morning,

Grace Darling, daughter of principal keeper William Darling, saw the wreck about a mile from the lighthouse. She insisted on helping her father effect a rescue, and together they rowed out in a small coble to save the survivors. Of sixty people on board, forty-three were drowned immediately, but the Darlings saved four men and a woman on reaching the ship, returning with one of the survivors to save another four people. This gallant action made Grace and her father Victorian celebrities, with a gold medal voted them by the Royal Humane Society and a grant awarded by the government. But she lived only four more years, dying of tuberculosis in October 1842.

Subsequent events at Longstone have been a little more mundane, but the lighthouse remains one of the most iconic of any around the coasts of England and Wales. Major alterations were made in 1952 when electric generators were installed, the optics and fog signal apparatus were renewed and the station became home to a radio beacon. The light, which has a range of 29 miles, was automated in 1990.

Inner Farne

Established	1811
Current lighthouse built	1811
Automated	1996
Operator	Trinity House
Access	Boat trips from Seahouses are available, offering the chance to view the birds and lighthouse

The Inner Farne lighthouse is owned by the National Trust but remains fully operational, with Trinity House managing the light.

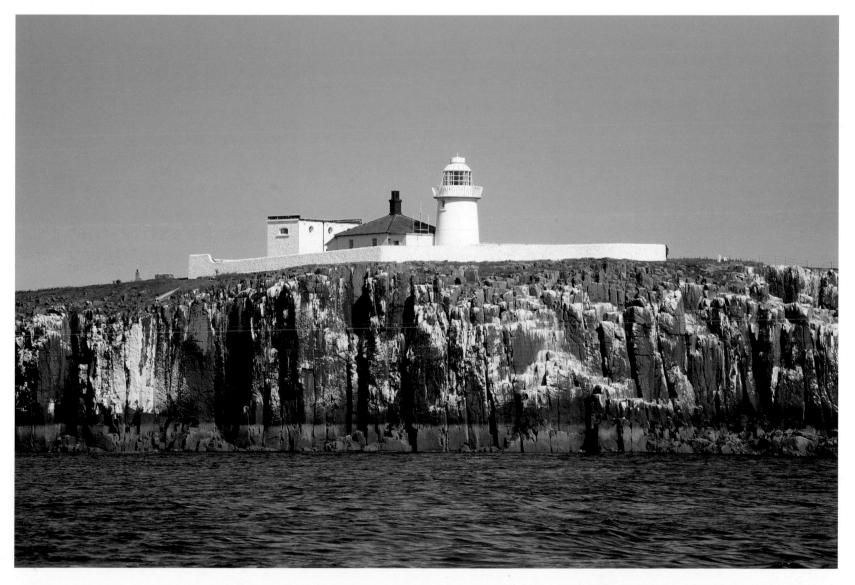

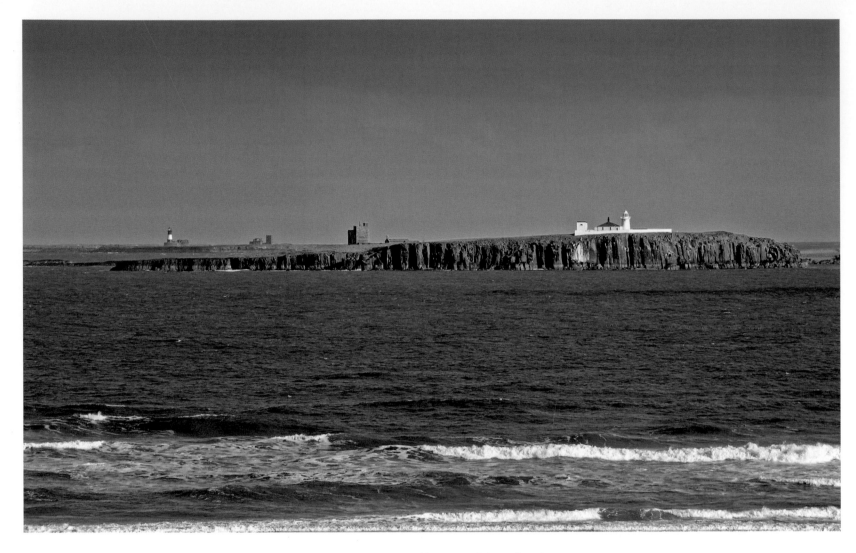

Inner Farne island is, at 16 acres, the largest of the islands that make up the Farnes, off the Northumberland coast. The lighthouse was built as part of the improvements to navigation around the Farne Islands during the early years of the nineteenth century and was one of a number of lights built in the area at the time. It was completed in 1811 to the design of Daniel Alexander and consisted of a 43ft white-painted circular tower with keepers' cottages to the rear of the tower. The lantern was installed with reflectors and Argand lamps and the gallery has closely strutted railings.

At the same time as this tower was built, a smaller tower was constructed at the north-west point of the island, about 150 yards away, and supplied with fixed white light. In 1825 Trinity House bought out the lease for the Farne lighthouse at a cost of £36,484. The light in the smaller tower was discontinued in 1910 and the present lighthouse was converted to automatic operation, with an acetylene light controlled by

The Inner Farne lighthouse can easily be seen from the mainland on a clear day, with Longstone lighthouse also visible on the left.

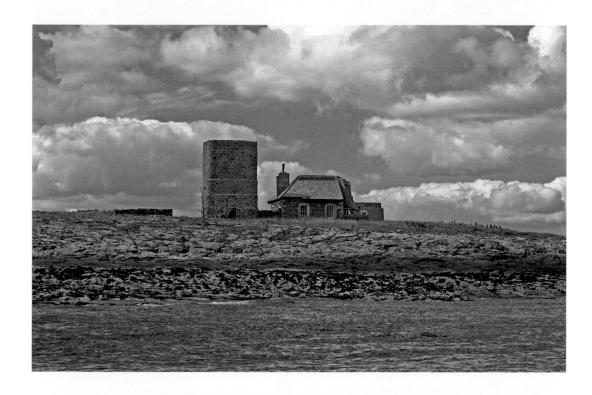

(Top) The beacon tower on Brownsman, one of the Inner Farne islands, dates from the late eighteenth century. This tower, and the fire baskets on Inner Farne, remained in use until 1810 and 1809 respectively.

(Bottom) The Inner Farne lighthouse was completed in 1811 and is now owned by the National Trust.

a sun valve. This remained in operation until the lighthouse was converted to solar power in 1996, at which point the station was also automated.

In June 2005 the National Trust bought some of the Inner Farne lighthouse buildings for £132,000 as part of an ongoing project by the trust to acquire environmentally sensitive areas of the north-east coastline. The acquisition included the keepers' cottages and a building used to house the generating plant when the light was powered by acetylene gas. One of the three rooms in the lighthouse complex was converted into office space for the wardens. The lighthouse remains an operational aid to navigation, and the first-order catadioptric fixed lens gives two white and red flashes every fifteen seconds.

Seahouses

Established	1900
Current lighthouse built	1900
Operator	North Sunderland Harbour Commissioners
Access	At the end of the north-west pier

The lighthouse built on the knuckle at the head of the north-west pier in 1900 is somewhat unique in that it consists of a 25ft white-painted dome-topped octagonal brick tower with, from the land, no apparent light. The flashing green light, which is visible for 12 miles, is in fact shown from a window in the side facing the sea. The light is adjacent to the steps used by Farne Island trip boats. There is also a fixed red light on a 20ft tripod on the breakwater head.

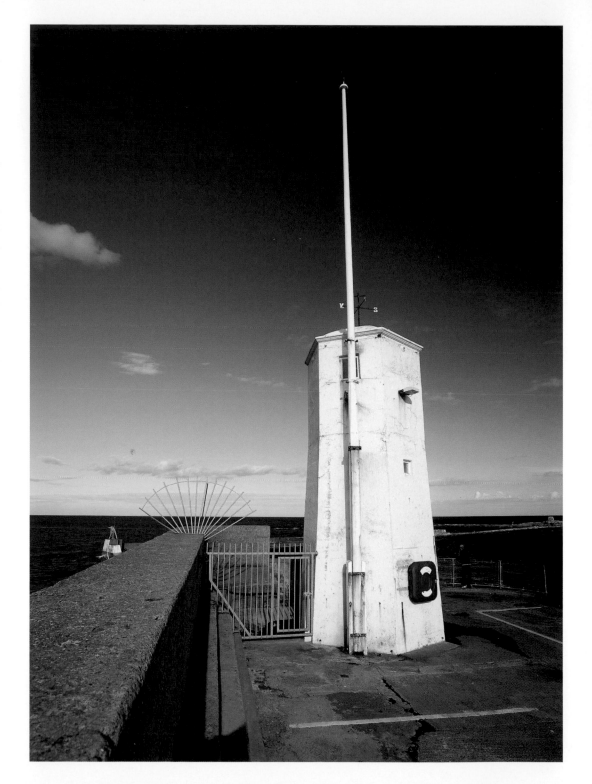

The light on the knuckle at the head of Seahouses main pier was built in 1900.

River Coquet

Established	1848
Operator	Warkworth Harbour Commissioners
Access	The south breakwater is open to the public

In 1841 a lighthouse was erected on Coquet Island to mark the channels into the river Coquet and this was supplemented in 1848 by two lights, visible for 5 miles, on the breakwaters of the river entrance to mark the approach to the ports of Amble and Warkworth, which are inaccessible at low tide. There is some confusion as to whether the lights at the harbour entrance are known as Warkworth or Amble, but for the sake of clarity the one on the south side will be referred to as Amble Breakwater Light and that on the north as Warkworth Breakwater Light.

The two lights are under the auspices of Warkworth Harbour Commissioners, operators of the harbour. Amble Breakwater Light is a fixed red light displayed from a 33ft red and white banded circular concrete tower on the south breakwater; and the other to the north, the Warkworth Breakwater Light, is a fixed green light known as Warkworth Light, mounted on a green-painted pole. In early 2000, the south pier and promenade were refurbished, funded by English Partnerships, and the area around the piers and lighthouse turned into a recreational area.

The lighthouse on Warkworth South Pier at the entrance to the River Coquet and Amble Harbour.

Coquet Island

Established	1841
Current lighthouse built	1841
Automated	1990
Operator	Trinity House
Access	Public access is not permitted, but boat trips from Amble are available to view the birds and the lighthouse

Coquet, a small island off the coast of Amble, was occupied by a small religious community as early as 684. Following the Act of 1836, Trinity House reviewed the aids to navigation in the area and in 1841 built a lighthouse on the island. This not only guided vessels up the east coast, but also marked the entry into the ports of Amble and Warkworth, although by 1848 these ports were marked by lights at the entrance to the river.

The very substantial tower is situated on the south-western shore of the island and cost £3,268 to construct. The sandstone castellated tower, 72ft in height and built to the design of James Walker, is surrounded by a turreted parapet with walls more than 3ft thick. The light is housed in a circular lantern room complete with conical roof and a domed ventilator.

The castellated two-storey dwelling houses were used by the keepers attending the light when the station was manned, but are now used by RSPB wardens in the birds' breeding season. The whole structure was erected on the ruins of the Benedictine monastery, parts of which were incorporated into the houses. The first keeper appointed to Coquet was William Darling, elder brother of Grace Darling, and the second of her brothers to become a keeper with Trinity House.

The light was initially fuelled by paraffin vapour with a first-order fixed lens, but,

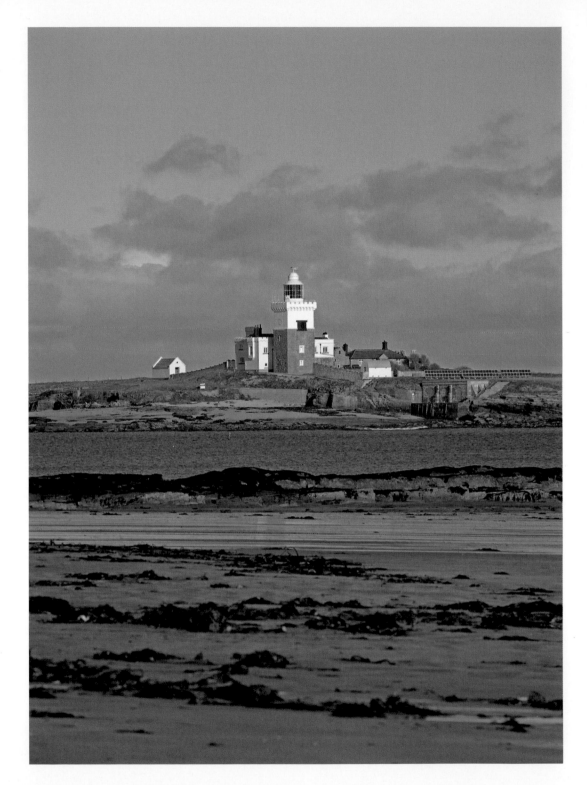

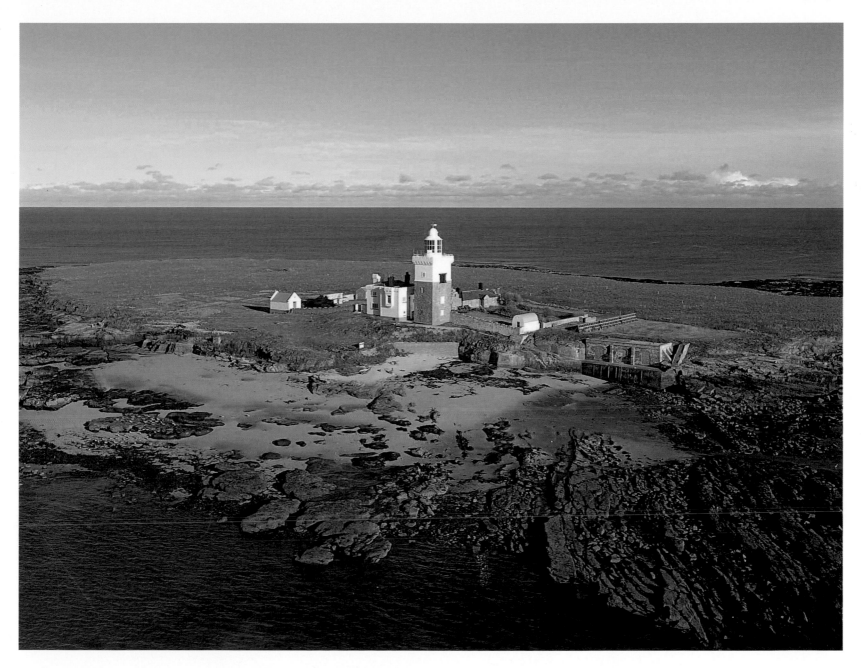

when electrified in 1976, it was changed to a catadioptric gearless pedestal rotating optic, powered by eighteen sealed-beam lamp units. Since automation in 1990, it has had an AGA PRB 21 optic with twelve 200W sealed-beam units, and shows a white light giving three flashes every thirty seconds. The white beam is visible for 21 miles, with a red sector visible for 16 miles. The fog signal, which gives a three-second blast every thirty seconds, is audible for 2 miles.

Coquet lighthouse, as seen from the village of Hauxey, has a fog signal which gives a three-second blast every thirty seconds. It is also home to ecclesiastical buildings, including a Benedictine monastery dating from the fifteenth century. A helipad has been installed in the walled area.

Blyth

Established	1788
Current lighthouse built	1884
Operator	Blyth Harbour Commission
Access	The tower in Bath Terrace can be seen from the quay and easily approached; the East Pier light can be seen from the opposite side of the river

The port of Blyth was formed around the river of the same name, and dates from the thirteenth century. It expanded and developed into a major coal exporting port during the eighteenth and nineteenth centuries, and is still a significant port. The first lighthouse, constructed in 1788 to the design of Sir Matthew White Ridley, was known as Blyth High Light. This 40ft tower lit by oil lamps was, when first built, on the seashore. However, due to land reclamation for the South Harbour, it is now about 100 yards inland at Bath Terrace. In 1858 the tower was increased in height to 54ft and raised to its present height of 58ft in 1900. The light, which had a range of 12 miles, was converted to gas in 1857 and electricity in 1932. It shone from a window just below the top and, before it was discontinued, served as the leading light for several harbour lights managed by Blyth Harbour Commission. Painted white, it now functions as a daymark.

The harbour was developed to the west by the construction of the North Pier in 1765 followed by the South Harbour in 1882. Two lights were built at this time, but the location of the second

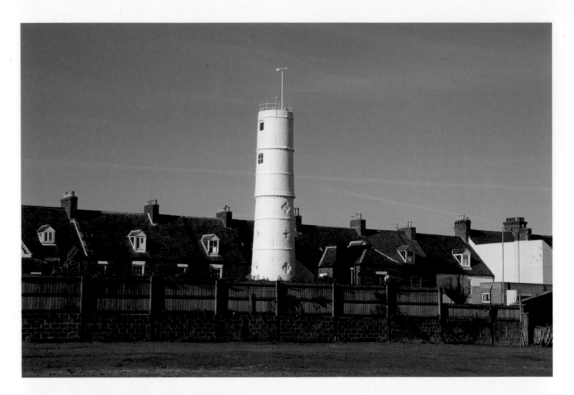

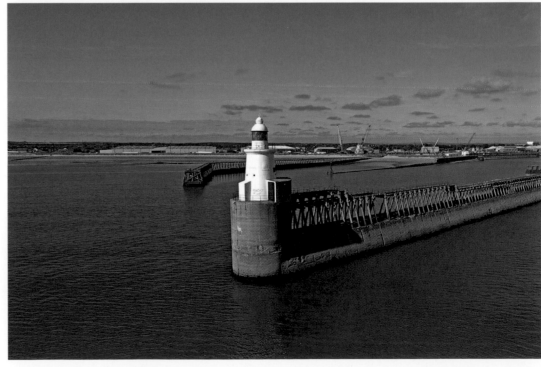

(Top) The 1788 lighthouse at Blyth, situated in Bath Terrace, was deactivated in 1985 and now functions as a daymark.

(Below) The East Pier at Blyth, with its fine lighthouse, was extended to its present length in the early twentieth century.

(Above) Blyth Snook light dates from around 1900; the hexagonal wooden tower houses a light shown through a small square opening and is on the north side of the river Blyth.

(Right) The East Pier lighthouse was officially opened by John Whitfield, a harbour commissioner, on 18 July 1907.

is unclear. The main protection for the harbour was the east breakwater on which a light was erected in 1884.

In 1906 the timber work and rubble of the breakwater were encased with concrete. By 1907 this breakwater had been extended by 900ft, and at the end the current leading light, known as Blyth East Pier Light or Harbour Light, was opened by John Whitfield, a harbour commissioner. It consists of a 46ft white tapered monolithic tower on a concrete base, with a gallery and lantern topped by a weather vane. It has a focal plane of 62ft and a range of 21 miles.

When first commissioned, the light had a third-order two-panel rotating prismatic lens driven by a clockwork mechanism and lit by a PV burner giving the upper lens a flashing white light every twenty seconds, with a range of 21 miles. A red light with a similar character had a range of 17 miles. Beneath this was a third-order drum lens powered by a PV burner with a 13-mile range. When later electrified, both lights were converted to LC lamp changers with 1,000-watt lamps.

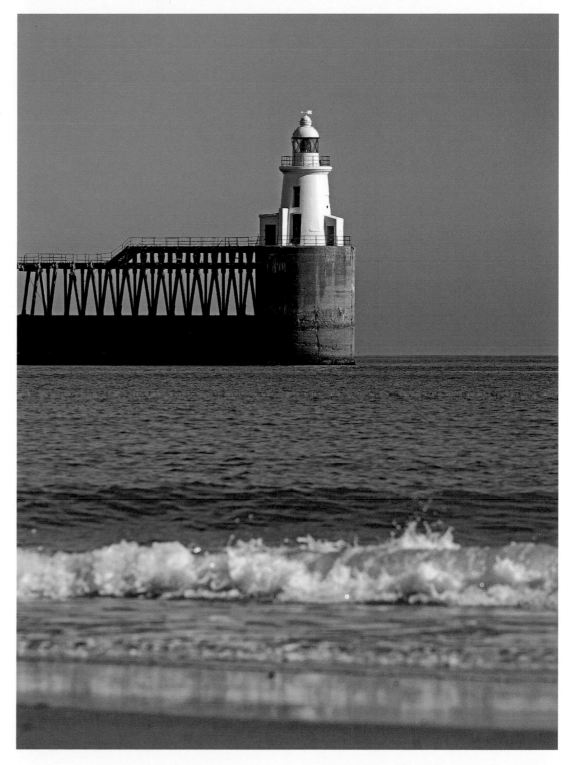

St Mary's

Established	1898
Discontinued	1984
Operator	North Tyneside Council
Access	A major landmark just north of Whitley Bay, signed from the Whitley Bay turn-off on the A19 or from the A1058 out of Newcastle, with a car park on the adjcent coast

The lighthouse on St Mary's or Bait Island was established in 1898 to replace the lighthouse on the headland at Tynemouth Priory, which had become obscured by pollution from the Tyne's industry and passing shipping. The tower, which was 120ft high, was constructed of brick by J. Livingston Miller and covered with cement render. The adjacent keepers' dwellings were constructed of stone with a covered passage connecting them to the lighthouse.

Operated by Trinity House, the light had a range of 17 miles and was powered by paraffin vapour. Although electricity was provided to the island in 1957, it was not until 1977 that the lighthouse was converted to electrical operation. Automated in 1982, it was discontinued in 1984.

Today, the island is a nature reserve and the lighthouse, now used as a visitor centre and souvenir shop, is open to the public. A climb of 139 steps gives views across North Yorkshire and the North Sea. Access to the island is possible at low tide, but this was not always so. Before the

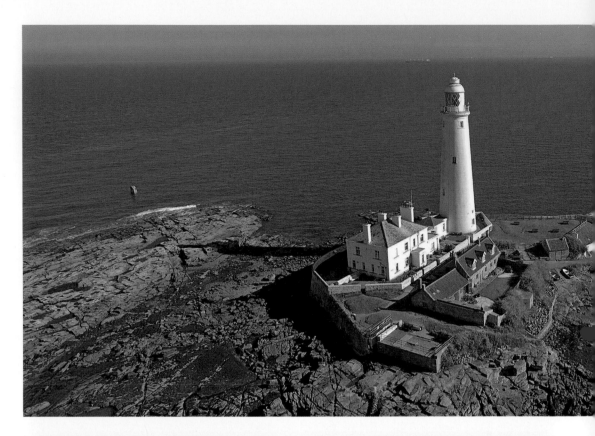

(Top) The impressive St Mary's lighthouse was established in 1898 to replace the lighthouse on the headland at Tynemouth Castle.

(Right) St Mary's lighthouse, north of the Tyne, is on an island linked at low tide by a causeway and is a popular tourist attraction.

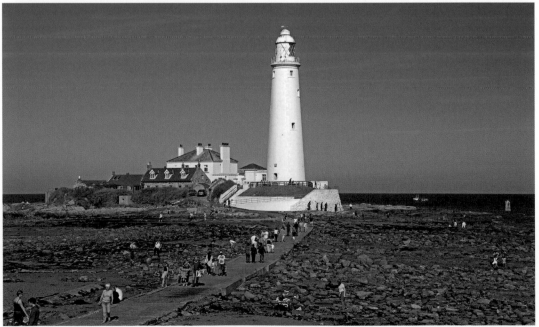

first causeway was constructed in 1929, stepping stones had to be used to cross the centre channel at low tide.

The modern causeway dates from 1966. In 2007 North Tyneside Council improved the lighthouse by renewing the electrical wiring, replacing broken lantern glazing and painting the exterior. In 2012 the lighthouse received Grade II listed status. While it is no longer an operational lighthouse, it is easily accessible when the tide is out and regularly open to visitors; in addition to the lighthouse itself, there is a small museum, a visitor's centre, and a cafe.

St Mary's lighthouse, inactive since 1984, is owned by North Tyneside Council and managed by St Mary's Lighthouse and Visitor Centre.

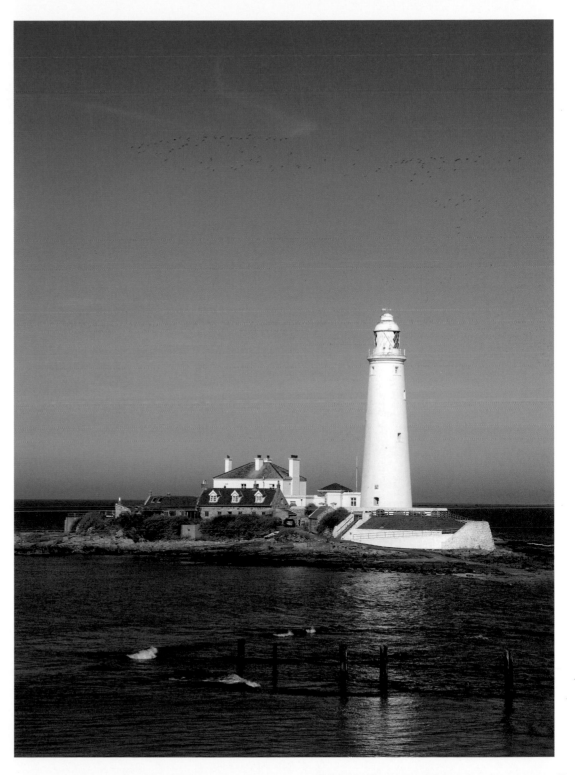

Tynemouth Castle

Established	1664
Discontinued	1898
Operator	Trinity House of Tynemouth
Access	Nothing remains of the lighthouse but the priory ruins on the headland are open to the public

Tyne North Pier

Established	1908
Current lighthouse built	1908
Operator	Port of Tyne Authority
Access	It is possible to walk the North Pier

As early as the twelfth century, monks kept a light burning in the church tower on the headland on the north side of the River Tyne, in addition to a light in their priory on St Mary's Island. In 1664, Colonel Villiers, Governor of Tynemouth Castle, replaced this light when he built a 79ft tower out of stone from the priory ruins in the north-east corner of the grounds. The coal-fired light was shown from a roofed lantern room with the keeper's dwelling in the base of the tower.

In 1775, the lighthouse was partially rebuilt before the light was changed to a revolving oil lamp with copper reflectors in 1802. Although complaints were made about the visibility of the red light which was obscured by pollution from ships' exhausts, nothing could be done until after the Act of 1836, which empowered Trinity House of Tynemouth to take over the lights in the area and allowed compensation of over £124,000 to the owners. In 1898, after the lighthouse on St Mary's Island had been built, the Tynemouth Castle light was discontinued and the tower was subsequently demolished.

In easterly gales, it proved impossible for ships to enter or leave the Tyne so, in 1852, an Act of Parliament was passed which gave the Tyne Improvement Commission permission to build

The lighthouse at the end of the North Pier marking the entrance to the River Tyne. The pier was designed by James Walker, president of the Institution of Civil Engineers, and the foundation stones were laid in 1854, but construction took the best part of half a century. The north pier is open to the public and shelters a small beach at Prior's Haven.

piers at the mouth of the river. Work started on the north pier in 1854 and should have been completed within seven years. However, a series of disasters resulted in the work lasting more than fifty years.

The pier was breached in 1867 when 1,900ft had been completed and again in 1897 after it had been completed to its 2,959ft length. It was found to be unstable and had to be rebuilt, but was eventually completed in 1910.

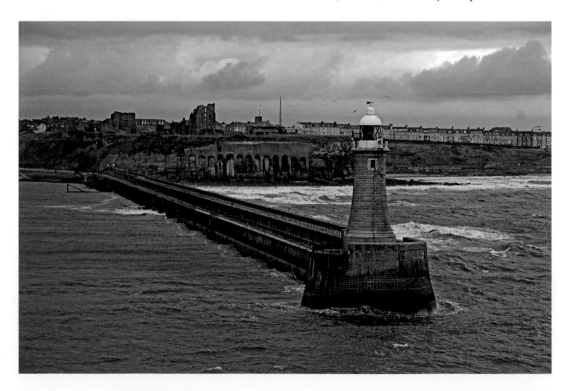

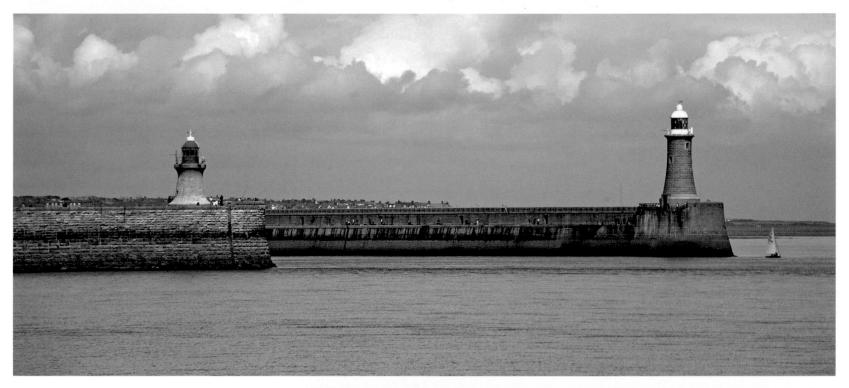

The mouth of the Tyne, with lighthouses on the South Pier (above left) and North Pier (right).

The lighthouse on the end was constructed during the original build and was first lit on 15 January 1908.

Operated by the Port of Tyne, the light was shown from a 55ft tapered circular stone tower complete with gallery and lantern, with the flashing white light visible for 26 miles. The lantern was made in Paris in 1890; the lens, one and a half tons in weight, floated in a bath of mercury. The tower also had a foghorn which gave a blast every ten seconds.

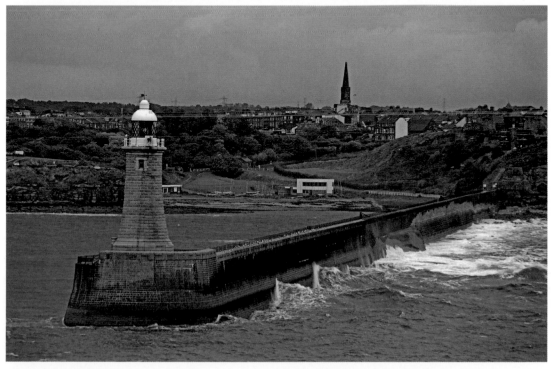

North Shields

Established	1537
Current lighthouse built	1807 and 1808
Operator	Port of Tyne Authority
Access	The lights are closed but can be viewed from the fish docks and south side of the river

The Tyne has always been a busy river and the need to mark the river channel was apparent as early as the sixteenth century. In 1537, a request was made to Trinity House for a pair of lights to be erected at North Shields. These were initially candle powered but, in 1727, Trinity House of Newcastle replaced them with a new pair of lights. The low light was situated on the fish quay, with the high light at Beacon House, Trinity Buildings, 300 yards to the north-west. This light, which still exists, was a square four-storey building with a small lantern complete with a ball finial on an ogee-hipped roof. A two-storey extension was added later. These lights were powered by three candles each, until 1736 when they were increased in intensity by installation of copper reflectors, and then in 1773 they were equipped with oil lamps.

In 1807, the lights had to be realigned, at which point the high light was discontinued. The low light was rebuilt on the same site to the design of John Stokoe, for Trinity House

(Above) The old light of 1727 is now located on Beacon Street, just above Fish Quay, and is used as an almshouse.

(Left) The high and low lights at the North Shields Fish Quay. In the middle is the old light dating from 1727.

of Newcastle. It consisted of an 85ft six-storey square brick tower with a small lantern on the roof. The fixed white light, operated by the Port of Tyne, was visible for 13 miles. In 1816 a two-storey red-brick dwelling was added; today the site is a fish curing plant.

In 1808 a new high light was erected in Dockray Square, also to the design of John Stokoe.

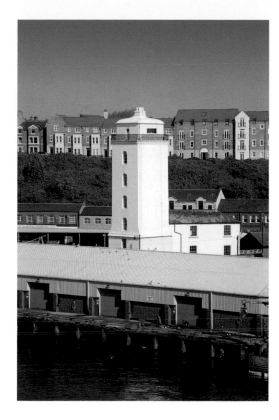

(Above) The low light as rebuilt to the design of John Stokoe, for Trinity House of Newcastle, in 1808, situated on North Shields Fish Quay.

(Right) The high light, situated above North Shields Fish Quay.

The 58ft, square, four-storey, white-painted brick tower had a wrought-iron balcony below a small lantern room on the roof. A two-storey dwelling was attached in 1860. The fixed white light was visible for 16 miles. Both these towers are now daymarks as the lights have been discontinued. All three lighthouses are listed buildings and of historical significance.

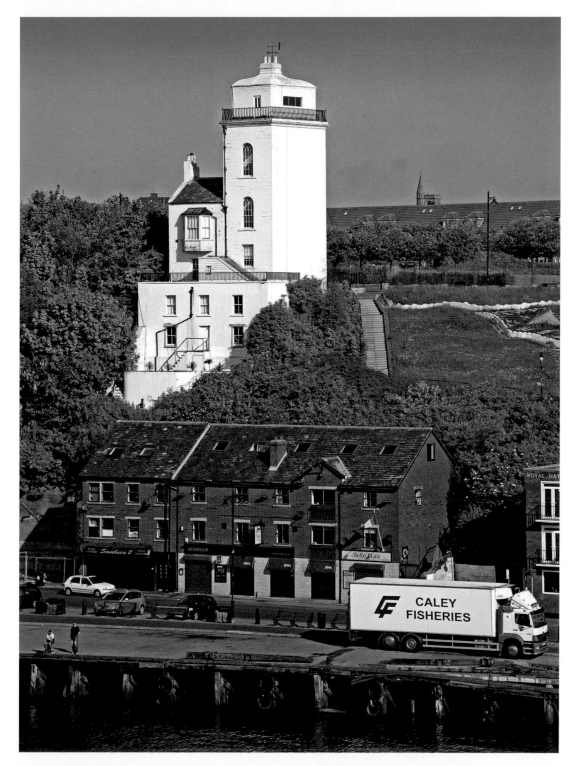

Tyne South Pier

Established	1895
Current lighthouse built	1895
Operator	Port of Tyne Authority
Access	It is possible to walk the south pier

In comparison to the North Pier, the South Pier proved somewhat easier to build, although gales during the 1860s so hampered the work that, after construction had started in 1856, the pier and its lighthouse were not completed until 1895. The light is of similar design to that on the North Pier but, at 39ft, shorter. The lantern and gallery railings are painted red, and the dome is surmounted by a weather vane. The light, visible for 13 miles, has three sectors, white, green and red, which show the safe channel into the harbour, with the green sector warning vessels of Bellhues Rocks, which lie just over a mile to the north of the river.

The South Pier lighthouse is the smaller of the two lights which make the entrance to the River Tyne.

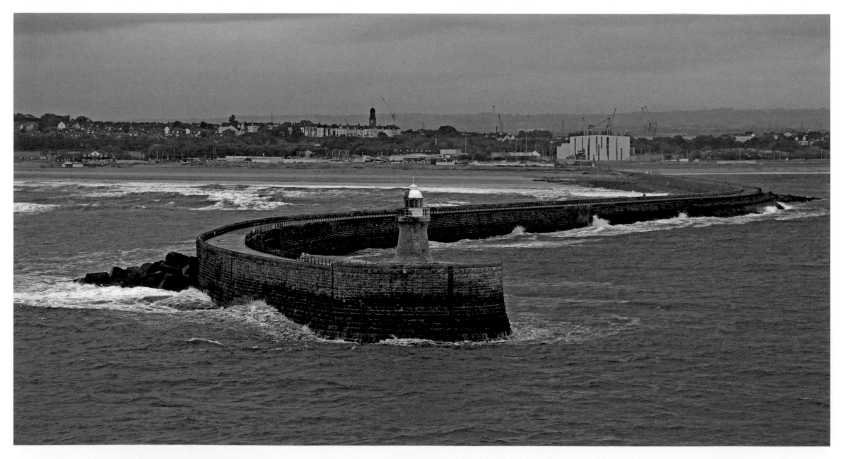

South Shields

Established	1882
Current lighthouse built	1882
Operator	Port of Tyne Authority
Access	In fair weather it is possible to walk the groyne

Although the channel into the Tyne had been marked by a pair of lights on the north side since 1537, the construction of two piers at the river mouth changed the direction of the channel into the port. To mark this, a new lighthouse was erected in 1882 at the end of Herd Groyne on the south side of the river. Situated almost opposite the North Shields lights, it marked the new channel by displaying lights which could be seen both up- and downstream.

It consists of a 48ft red-painted corrugated-iron service room on iron legs and displays the lights to seaward through a window in a domed red-and-white-striped lantern room, with the landward light shown from a separate lantern. The seaward light, visible for 13 miles, has an occulting white leading light, around a bearing of 249 degrees to mark the river entry, as well as red and green sectors. The landward light shows a fixed light for ships leaving the harbour and the tower also carries a fog bell. This light, marking the new channel, made the North Shields lights surplus to requirements and so they were discontinued.

Herd Groyne lighthouse, with its distinctive hexagonal cone roof and ball ventilator, is one of several aids to navigation marking the entrance to the River Tyne.

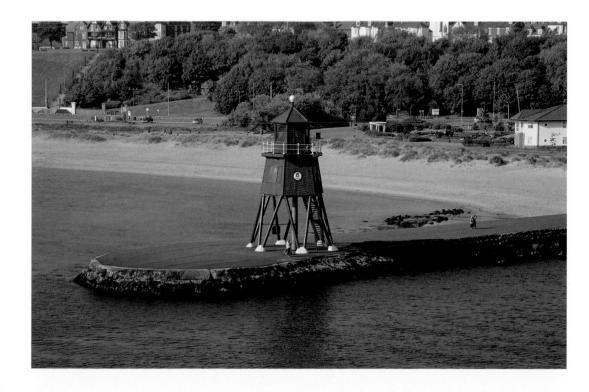

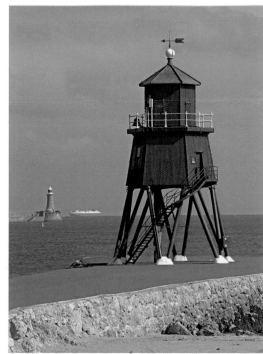

Souter

Established	1871
Current lighthouse built	1871
Decommissioned	1989
Operator	Trinity House, now run by the National Trust
Access	East of A183 main road between South Shields and Whitburn

Souter Point lighthouse was built to mark an underwater reef known as Whitburn Steel or Stile between the Tyne and the Wear. During the nineteenth century, the seas off this part of the north-east coast became increasingly busy with all kinds of vessels, ranging from coastal trading craft, carrying bulk cargoes such as coal and iron ore, to the expanding fishing fleets of the local ports. The dangers of the reef were highlighted on 16 November 1866 when the ship *Sovereign* from North Shields struck Marsden Rock. Although her eleven crew managed to scramble ashore, a series of fatal shipwrecks occurred during the next few years.

To improve navigation in the area, Trinity House decided to build a new lighthouse at Lizard Point, Marsden. It was named Souter Point after the location originally chosen but then rejected as a Lizard lighthouse already existed. The station consisted of a 76ft red-and-white-painted circular tower designed by James Douglass, Chief Engineer to the Corporation, and built by Robert Allison of Whitburn from rubble masonry covered in Portland cement to protect it from the weather. The associated buildings, to landward of the tower, were laid

The impressive tower at Souter was one of many designed by James Douglass, Chief Engineer to Trinity House.

(Above) Souter lighthouse is a well-known landmark on the north-east coast and is now in the care of the National Trust.

(Right) The Souter lighthouse at Lizard Point, Marsden, seen from the sea.

out around a square courtyard with a covered inner courtyard and included an engine and boiler house, workshop, and dwellings for the lighthouse staff and their families. At one point more than thirty people were resident at Souter including four keepers and an engineer.

Trinity House managed the station throughout its operational life. The lighthouse entered service in January 1871 with Sir Frederick Arrow, Deputy Master of Trinity House, stating at the time that 'no lighthouse in any part of the world would bear comparison with it'. Visible for 26 miles, the white light flashed for five seconds at thirty-second intervals and was notable for being the first to be powered by electrical alternators. These were the invention of Professor Holmes and proved very successful. The light they produced was magnified 230 times by a battery of lenses mounted in a rotating octagonal drum. This arrangement was used until 1914 when a

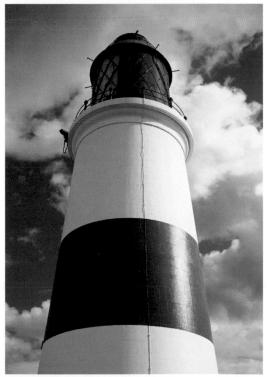

new and larger lantern was installed and the light itself was converted from electricity to oil. In 1952, it reverted to electricity again. The turntable was rotated by a simple weight-driven clockwork motor until an electrical system was installed in the 1970s.

The light was decommissioned by Trinity House in 1989 and the tower handed over to the National Trust. The trust now maintain the lighthouse, which is open to the public, while it also still serves as a radio navigation beacon. The engine room, which originally housed Holmes' magneto-electric generators and two Cornish boilers supplied by the Fairburn Engineering Co., remains just as it was when the station was handed over to the trust.

Sunderland

Established	1856
Current lighthouse built	1903 (Roker Pier)
Operator	Port of Sunderland
Access	Roker and the seafront are signed in the city centre; the 1856 lighthouse is on the east side of the coast road north of Roker

Before the New North or Roker Pier and New South Pier were constructed between 1885 and 1907, the entry into Sunderland Harbour was guarded by what are now called the Old North and Old South Piers. A lighthouse was built in 1856 on the Old South Pier, but it was deactivated in about 1903 when the new pier lights made it redundant. In 1983 this pier was shortened and the lighthouse described below removed to Roker Cliff Park. Today, a 27ft red metal framework tower, with a red flashing light visible for 2 miles with a daymark, stands on the shortened pier.

A light designed by Johnathan Pickernell was erected on the Old North Pier in 1802 and moved to the end when the pier was extended in 1841. Today, a 27ft yellow metal tower stands on the site showing a quick green light visible for 8 miles. At the end of the New South Pier is a 33ft white metal tower with a white flashing light visible for 10 miles.

The most noteworthy of the current lights is on the end of the New North Pier. Known as Roker Pier Lighthouse, the conical granite-built

The 1856-built lighthouse was built at the end of the South Pier until 1953, when it was moved to its current position to the north of Roker Beach near Roker Cliff Park.

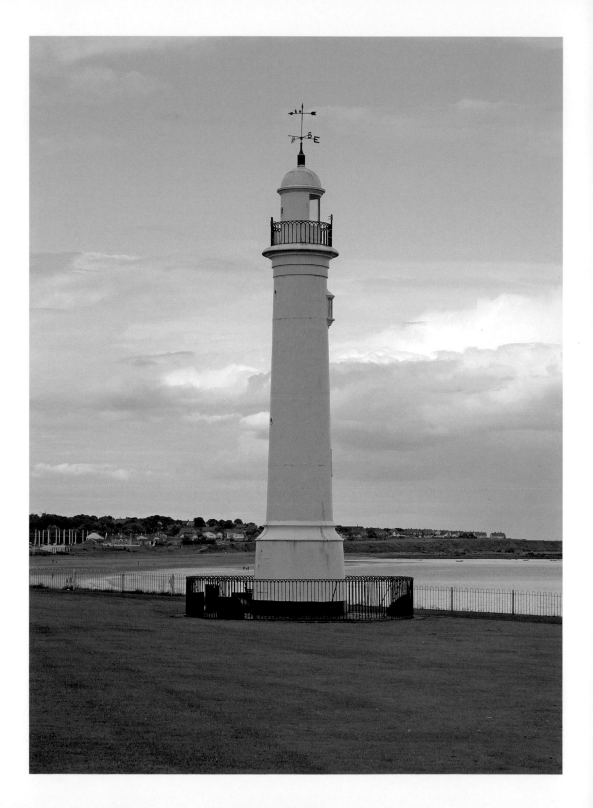

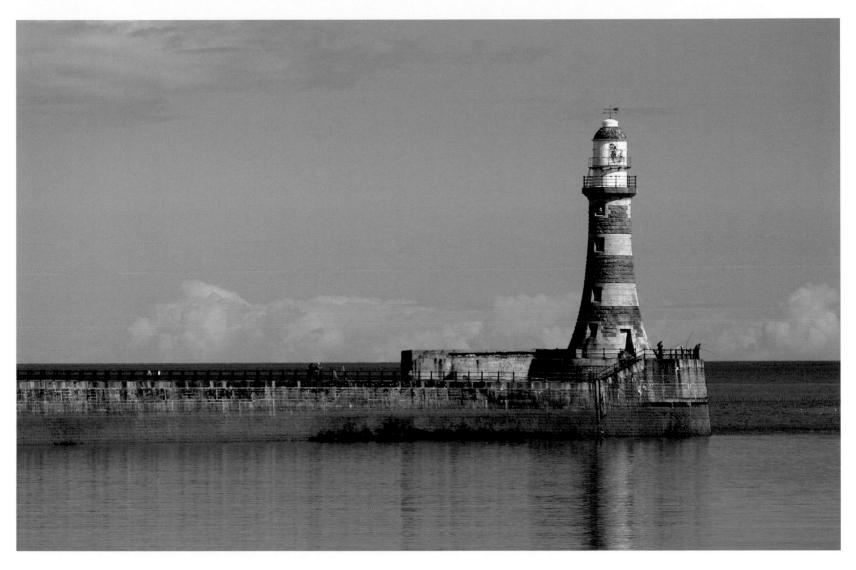

tower stands 75ft and is topped by a gallery and a tall decorative white lantern with a black domed roof. It is built of alternating bands of naturally coloured stones to give a banded red and white appearance. The flashing white light, visible for 23 miles, is, along with all the other lights, operated by Sunderland City Council, owner of the port.

As mentioned above, the lighthouse on the Old South Pier was relocated in 1983 and now stands in Roker Cliff Park approximately 800 yards north of Roker Pier. Built by Thorns Meik in 1856, the 50ft circular tower consists of white riveted wrought-iron plates around a cast-iron staircase. The tall white lantern room with its black gallery railings is surmounted by a weather vane. The lights to the south of the river are inaccessible but the Wear River Trail passes close to the Old North Pier and along Roker Pier. It also goes past Roker Cliff Park.

The elegant lighthouse at the end of Roker Pier. Over the course of three years both the pier and lighthouse have undergone an extensive restoration programme, with the council investing over £1.35 million to conserve the lantern house and repair the pier deck.

Seaham

Established	1836
Current lighthouse built	1905
Operator	Seaham Harbour Dock Company
Access	Access to the dock is restricted but the pier and light can be seen from the main road

In the 1820s coal output from the Durham coalfield was increasing, and additional export facilities were required. To meet this demand, the Marquess of Londonderry had the foundations for a new dock facility at Seaham laid in 1828, with the first coal exported from it in 1831.

To guide ships into the port, a wooden lighthouse was erected to the north of the dock entrance. In 1836 this lighthouse burned down, so later that year a new 58ft stone lighthouse was erected by William Chapman at nearby Red Acre Point. It had a revolving white light above with red light below. The first lightkeeper was William Fairless, who had fought against Napoleon.

In 1856 the interior of the tower burnt out, but it was restored a year later and the light continued to operate until 1905, when major harbour extensions made it redundant. The tower survived until 1940, when it was demolished as it was in the line of fire of Second World War defence guns.

Part of the major alterations to the harbour in 1905 involved the construction of two long breakwaters. The northern one, which started close to the old lighthouse, extended 1,383ft to

The 1905-built lighthouse with distinctive black and white bands is a notable landmark at the end of the port's north breakwater.

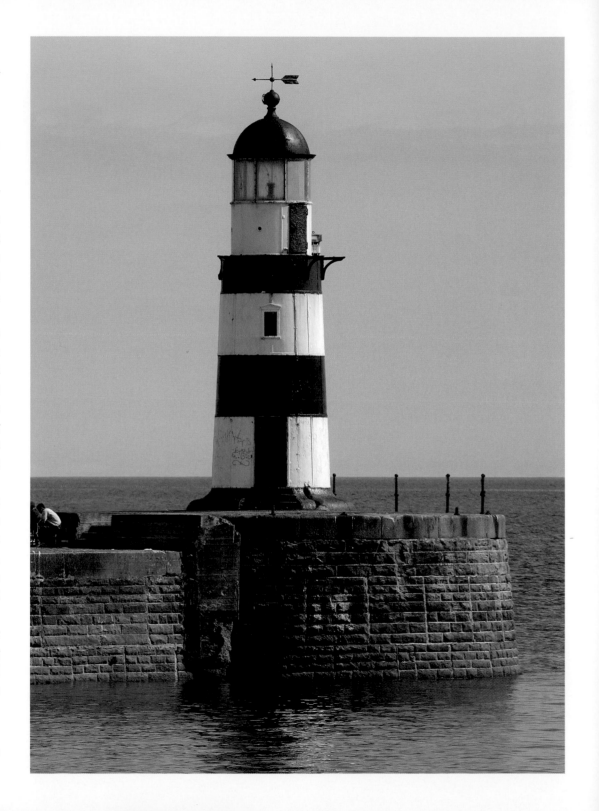

form, with the 876ft south breakwater, a new outer harbour. On the end of this breakwater a 33ft black cylindrical cast-iron lighthouse was built. It originally had a gallery below the lantern but this was removed during the 1960s. Today it shows a flashing green electric light visible for 11 miles, which is changed to fixed green in bad weather. The tower also carries a foghorn which sounds one blast every thirty seconds.

The 1905-built lighthouse with the gallery intact.

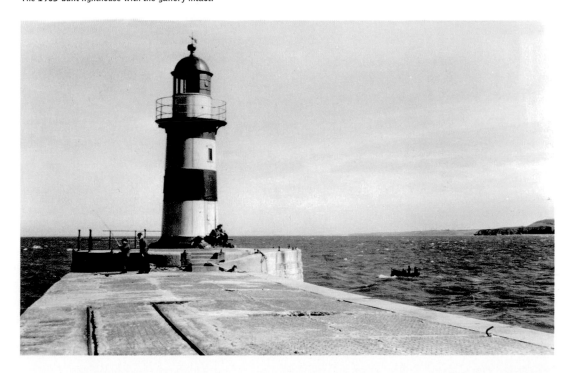

Established	1847
Current lighthouse built	1927
Operator	PD Teesport
Access	The Heugh is signed north of the town

Three lighthouses have been built on the headland known as the Heugh, to the east of Hartlepool. Hartlepool was built around a natural harbour which, during the mid nineteenth century, was developed to handle the expanding trade resulting from Britain's industrialisation. As the number of sailing ships increased, a lighthouse became necessary to warn of dangerous rocks in the locality, such as the Longscar, and notify vessels when it was safe to enter the harbour. The impetus for building a lighthouse came in the 1840s after many ships had got into difficulty and, in 1844, a public meeting was held at which demands were made for construction of an aid to navigation.

The first Heugh lighthouse was built in 1846 by Stephen Robinson and, sited on the clifftop at Hartlepool Headland, it was nearly 85ft above high tide mark. The 48ft tower was built of white sandstone and the lantern for the main light was powered by coal gas. The light was exhibited for the first time on 1 October 1847 and had a range of 18 miles.

The new lighthouse was probably the first to be lit reliably by gas. The invention of a new type of burner made it possible to regulate the amount of air mixed with the gas to give a steady beam of light. The gas lamp from this first lighthouse is on display in the Museum of Hartlepool. Below the white light was a small

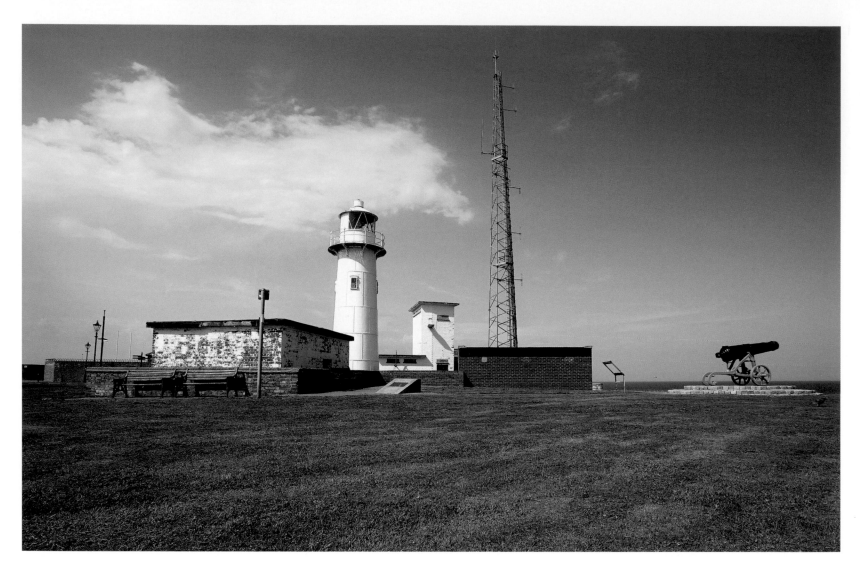

red one that showed when the tide was right for vessels to enter the harbour at night.

In 1915, the first lighthouse was taken down because it stood in the way of the guns at Heugh Battery and was replaced by a temporary wooden light on the Town Moor. This temporary light, used until 1927, was fitted with the original lamp.

The current lighthouse, built in 1926–27 to replace the temporary light, stands 42ft high,

62ft above high water, near the site of the first lighthouse. When built, it was 170ft west of the most easterly point of the cliff. Powered by electricity, it was designed to be taken down in an emergency, something that almost happened during the Second World War when the authorities were worried that the Germans could use the lighthouse as a landmark. It remained standing, although the light was not used during the conflict because of the blackout.

The lighthouse at the Heugh, a white-painted cast-iron tower, dates from 1926–27. The headland is the site of the original town.

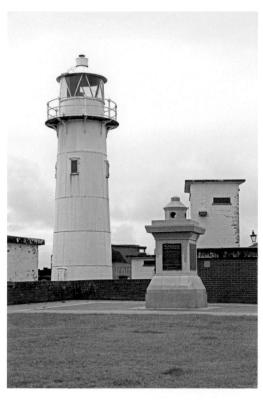

Hartlepool Harbour

Established	1836
Current lighthouse built	1836
Operator	PD Teesport
Access	The pier and breakwater are accessible from the old town

(Left) The lighthouse at the Heugh, east of Hartlepool, is situated close to the gun battery and fort. The memorial to the right marks the bombardment of the Hartlepools in December 1914 by German battleships when at least 130 local people were killed.

(Below) The first lighthouse at the Heugh, on Hartlepool Headland, was built in 1847 and used until 1915.

In the early 1800s the township of West Hartlepool was supported mainly by fishing, but during the nineteenth century the transport of coal and minerals became the port's main economic activity. By 1836 a new pier had been

(Below) The wooden square lighthouse at the end of the Old Pier was moved to its present position in 1911, when the pier was extended.

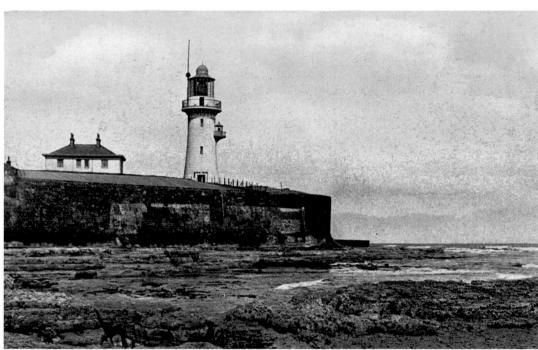

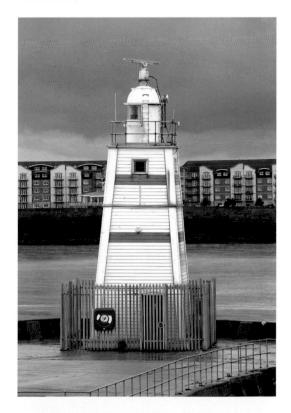

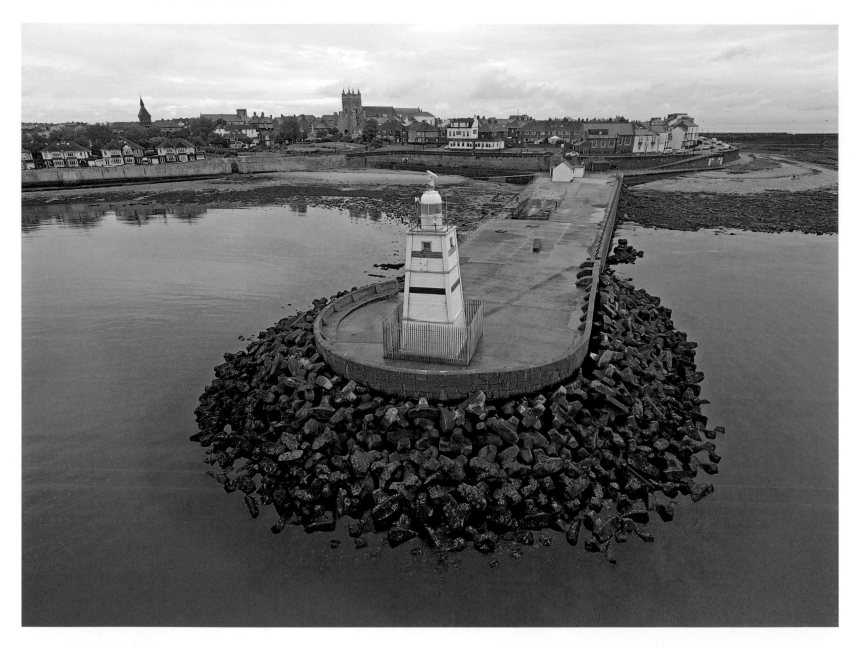

built on the west side of the entrance to the Old Dock and, to guide ships, a 38ft square-pyramid-shaped wooden tower was erected on its end.

Although the gallery on top is square, the lantern is circular with an ornate domed roof. The light, visible for 7 miles, shines through a window. It flashes white over the safe channel but green otherwise. The tower is painted white with two red horizontal bands and has a rotating radar antenna on top. It has recently been renovated, as has the old pier, which was renamed Pilots Pier.

The entrance to Hartlepool Harbour is marked by a wooden square lighthouse at the end of the Old Pier. It is open to the public and easily accessible from the surrounding roads.

Seaton High Light

Established	1838
Discontinued	unknown
Access	Via Hartlepool Marina

To assist shipping passing the Longscar Rocks, off Liverpool, a 70ft circular stone lighthouse on a square stone base was erected in 1838 at Staincliffe in Seaton, a short distance to the south of Hartlepool. Little is known about this light, also known as Seaton Tower, but in a report on a bombing raid in 1917 it was referred to as the old lighthouse. The light was probably not a success and was superseded in 1847 when the light on the Heugh was first shown.

With the increase in trade at Hartlepool, a new dock was constructed to the south of the old dock, complete with a railway terminal to export coal, hence the local name Old Coal Dock. But with the demise of the industry, the dock became derelict until the late 1990s when it was redeveloped into a marina complex with residential housing. The lighthouse was re-erected, minus its lantern, as a war memorial on the end of the southern entrance pier.

The old Seaton high light tower, discontinued around 1884, is now part of Hartlepool Marina, minus its lantern. It was rededicated as a war memorial on 11 November 1997, and has eleven marble plaques around its base.

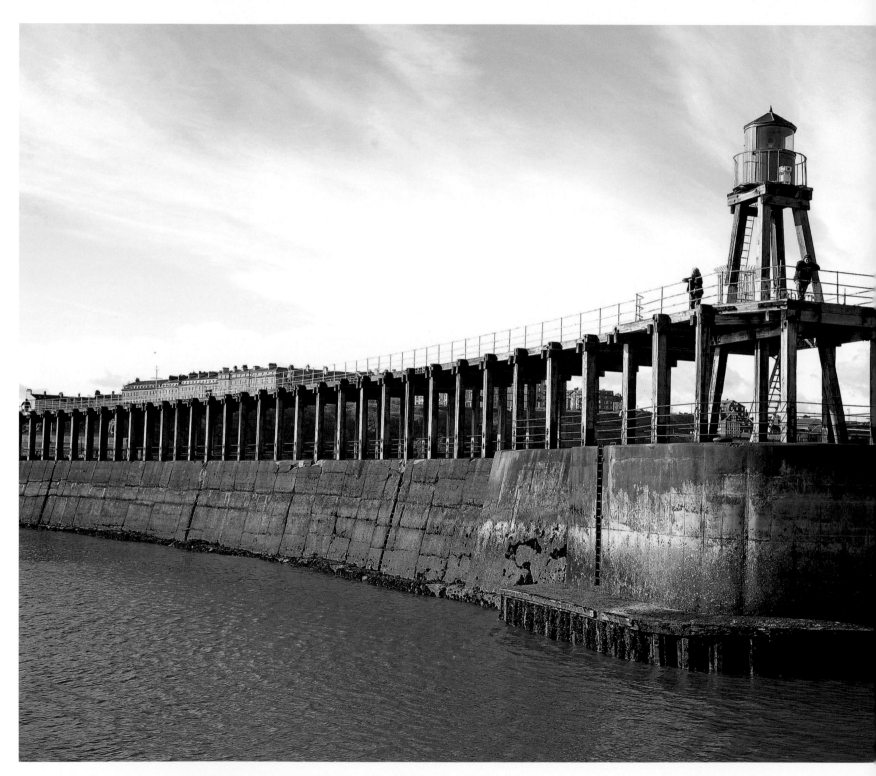

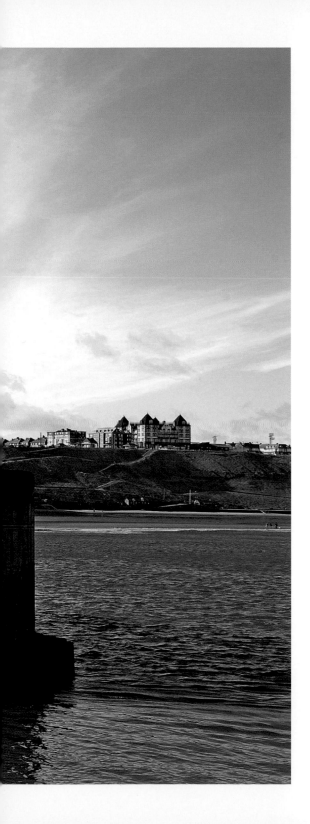

2 YORKSHIRE AND HUMBERSIDE

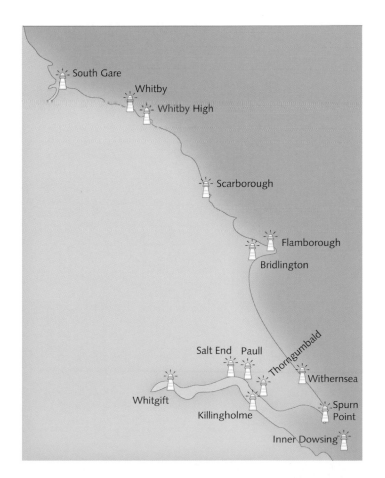

South Gare

Established	1884
Current lighthouse built	1884
Automated	1970s
Operator	Tees and Hartlepool Port Authority
Access	Via road from Redcar

The entry into the River Tees has always been tricky and so, in the 1880s as an increasing number of ships used the river, measures were taken to improve the situation. In 1884, the port authority built a 43ft cast-iron lighthouse on the eastern point of Salt Scar Rocks and in 1888, when the South Gare Breakwater was constructed to shelter the entrance to the river, a light was incorporated into the knuckle on the northern end. Lighthouse keepers' cottages were built partway on the breakwater. The light was automated in the 1960s, at which point the keepers' cottages were demolished.

Currently operated by PD Teesport, the tower is painted white and shows a white flashing light every twelve seconds, which is visible for 10 miles over the approach channel, with red sectors to each side. It is now a Grade II listed building and, in 2007, became the first lighthouse in the UK to be fuelled by a hydrogen fuel cell.

Further up the River Tees, within Teesport, are a number of small navigation lights. When the Norsea Terminal was built in 1975, a pair

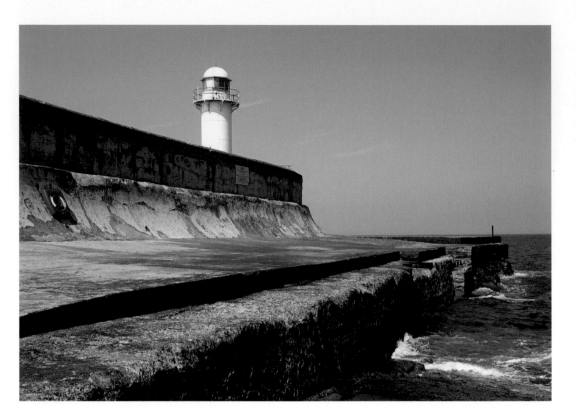

(Top) The cast-iron tower at the end of the South Gare Breakwater marks the entrance to the River Tees.

(Right) The front range light within Teesport, on the north side at the Phillips Norsea Oil Terminal.

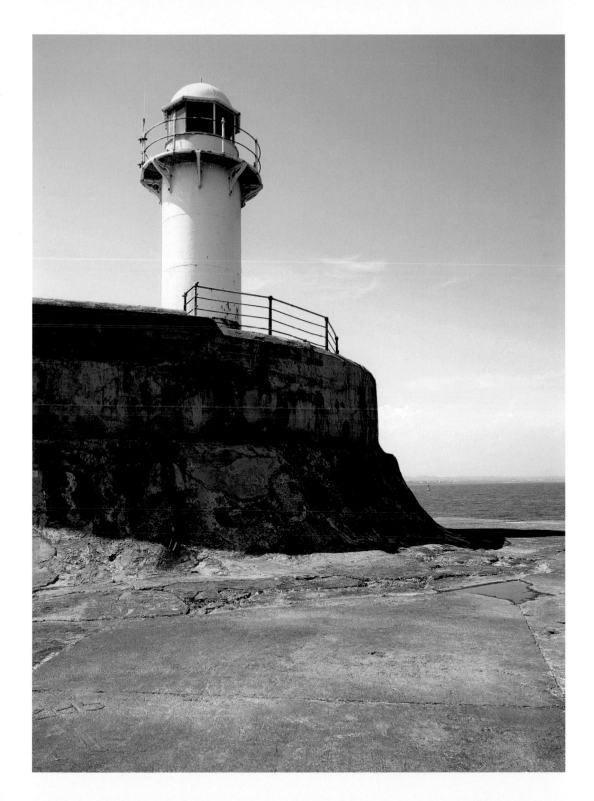

of navigation lights was erected to guide ships into the terminal. The front light consists of four high-intensity red lights in a square shown through a window at the top of a red-and-white-banded circular concrete column. The rear light, 500m behind on a lattice tower, shows six red lights in a two-wide by three-high formation.

The light at the end of the South Gare Breakwater is now a listed structure.

Whitby Harbour

Established	1831 (west), 1855 (east), 1914 (piers)
Current lighthouses built	1831 (west), 1855 (east), 1914 (piers)
Breakwater lights deactivated	1914
Operator	Scarborough Borough Council
Access	Breakwaters and west pier open to public

Whitby, on the River Esk, is the only deepwater anchorage on the North Yorkshire coast, but entry into the harbour can be difficult. To improve access, two stone piers were built in the mid 1800s with a lighthouse on the end of each. The West Pier lighthouse of 1831 was the first aid to navigation to be built and consists of an 83ft fluted yellow stone Grecian Doric column with a square base. The white hexagonal lantern is mounted on a square stone gallery with white guard rails. Originally a fixed green light visible for 10 miles, after the pier extensions were built in 1914 it was shown only when a vessel was due and entry into the harbour was safe.

The East Pier lighthouse, on the East Breakwater, was built in 1855 and consists of a smaller, at 55ft fluted yellow stone Grecian Doric column with a round base. The white hexagonal lantern was mounted on a round stone gallery with white guard rails and an ornate black roof. The light, visible for 8 miles, showed a green fixed light with a red sector to indicate the wrong channel. This light was discontinued when the pier extensions were built and the red sector is now marked by a fixed red light on the church steps.

The east breakwater lighthouse at Whitby was built in 1855.

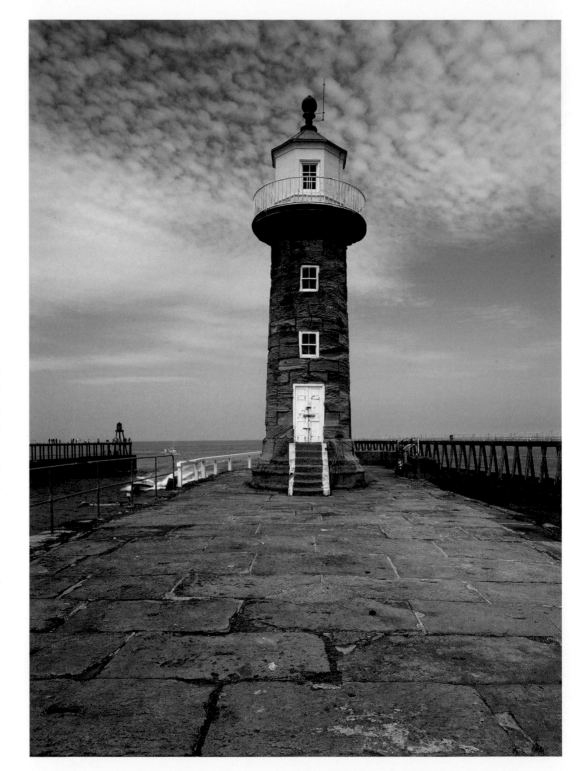

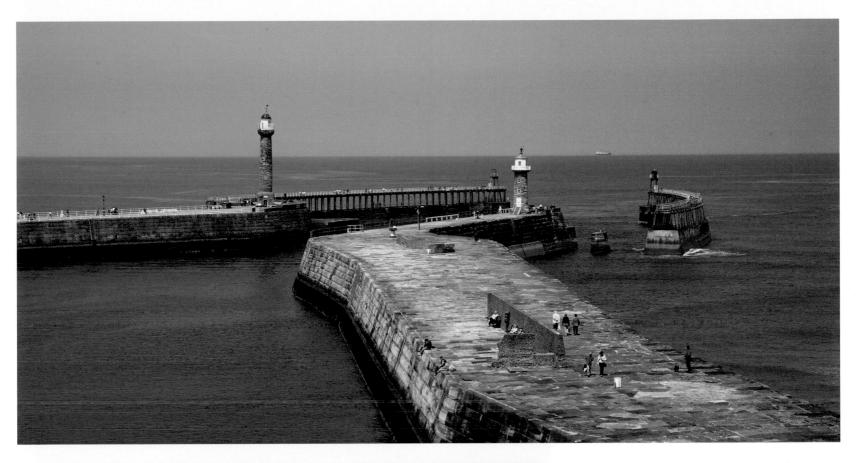

(Above) The picturesque entrance to Whitby Harbour is marked by no fewer than four lights.

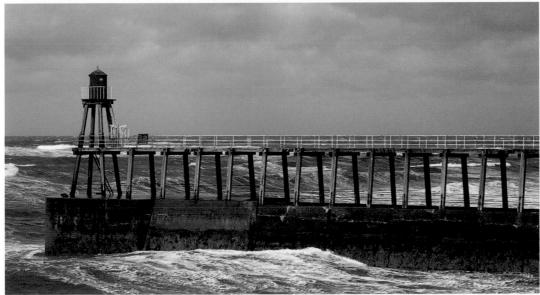

(Left) The light on the east pier extension shows a fixed red light. There is no public access to this pier extension, although the light is easily viewed from various other vantage points round the harbour. The harbour entrance can be very dangeours in bad weather, and many vessels have come to grief trying to enter the historic port.

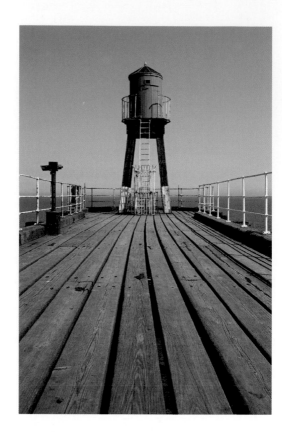

(Above) The light on Whitby's West Pier extension shows a fixed green light.

(Right) The lighthouse on Whitby's West Pier, the tallest of the harbour lights, was built in 1831 but has not been used since 1914.

In 1914 the entrance channel was improved when pier extensions were constructed. Each had a stone base with a raised wooden section and was marked at its extremity by light beacons. The West Pier light consists of a 26ft green lantern with a black top on a square wooden pyramidal support, which shows a fixed green light visible for 3 miles. The East Pier light, which displays a fixed red light visible for 3 miles, consists of a red lantern with black top, mounted on a 45ft square wooden pyramidal support.

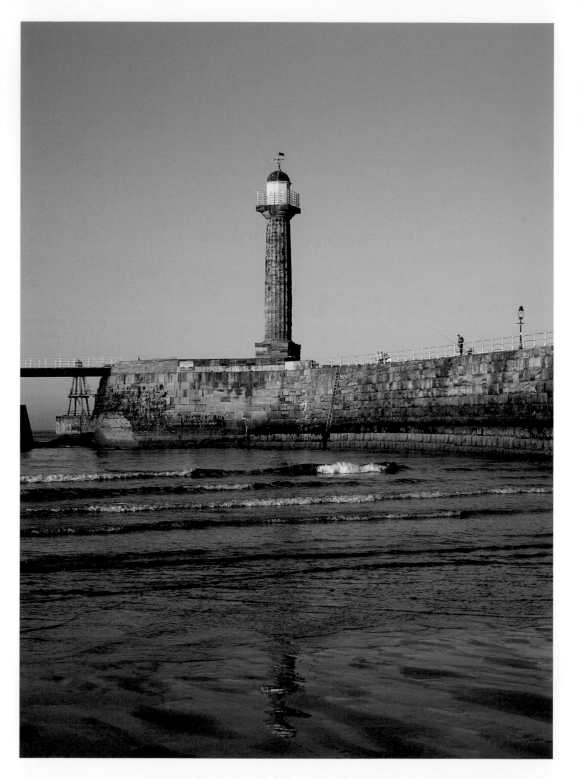

Whitby High

Established	1858
Current lighthouse built	1858
Automated	1992
Operator	Trinity House
Access	2 miles east of Whitby on Cleveland Way footpath; can also be reached by road via Hawsker Lane from Whitby

The lighthouse situated about 2 miles east of Whitby at Ling Hill is correctly named Whitby High. When constructed in 1858 by Trinity House to James Walker's design, it consisted of two towers aligned to mark Whitby Rock. The lower light, a 66ft white octagonal tower with lantern and gallery, was deactivated in 1890 and subsequently demolished.

The old keepers' cottages at Whitby High lighthouse, painted in standard Trinity House colours, are now used as holiday homes. The fog signal station can be seen to the far left.

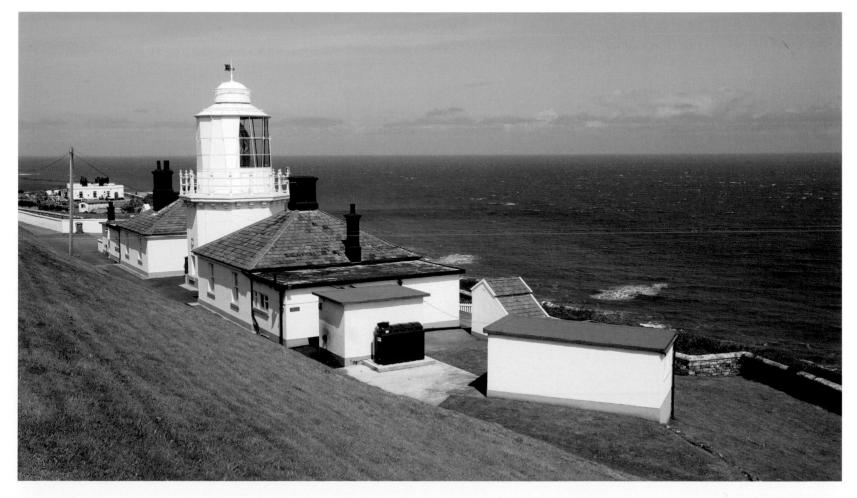

The high light was then refurbished and the 44ft white octagonal tower equipped with a more effective light mounted in an octagonal lantern. The Whitby Rock was marked by a red sector. The electrically powered isophase white and red light is visible for 18 miles. The two single-storey keepers' dwellings attached to each side of the tower were redundant with automation and are now hired out as holiday lets. There was originally a fog signal giving four blasts every ninety seconds housed in an adjacent building with two large horns on the roof, but this has been discontinued.

(Right) Whitby High lighthouse, to the south of the town, is situated on Ling Hill overlooking the North Sea.

(Below) An old postcard of Whitby High lighthouse. (Courtesy of Michel Forand)

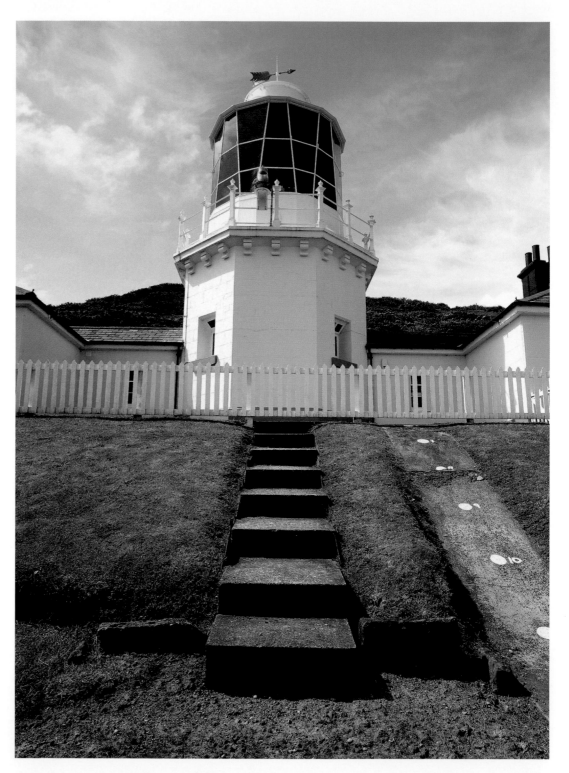

Scarborough

Established	1806
Current lighthouse	built 1931
Operator	Scarborough Borough Council
Access	The pier is open to the public but the tower is closed

Although Scarborough has had a harbour since the eleventh century, it was not until the 1730s that the present outer piers were built. The outer harbour was formed by the Vincent Pier, built by William Vincent in 1752, with the East Pier being constructed some years later. In 1804 a signal flag was displayed on the end of Vincent Pier and in 1806 a circular brick lighthouse built on the site. In 1843, it was increased in height by 17ft and a keeper's house attached to the seaward side. The light, visible for 4 miles, was displayed in a lantern room with a gallery.

On 16 December 1914 the lighthouse was severely damaged by German naval forces and had to be demolished. Not until 23 September 1931 was its replacement, the current tower, commissioned. Operated by Scarborough Borough Council, the 49ft white circular brick tower shows a white flashing light in an octagonal domed lantern room. The light, visible for 4 miles, is supplemented by both storm and tidal signals. The attached

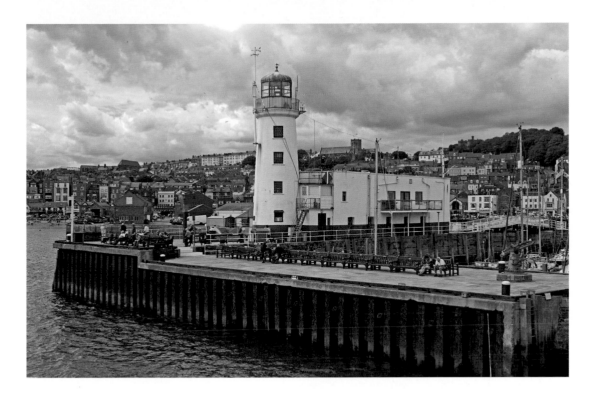

(Top) Scarborough lighthouse on Vincent Pier in the old harbour is a well-known landmark in the town. The light was manned until 1997 and the building is reputedly haunted by a former harbourmaster.

(Right) An old postcard of Scarborough lighthouse in the heyday of the paddle steamers of the Yorkshire coast.

Flamborough Chalk Tower

Established	1674 (never lit)
Current tower built	1674
Access	North of road to Flamborough Head

keeper's facilities have been occupied by Scarborough Yacht Club since 1952. Lights are also maintained at the end of both inner harbour piers. The East Pier light, visible for 3 miles, is on a 13ft mast and the West Pier light, visible for 4 miles, on a 10ft watch hut.

An octagonal cylindrical white chalk tower, 79ft in height, was erected in 1674 on high ground near the chalk headland of Flamborough Head to warn shipping of the dangers of the headland. King Charles II granted Sir John Clayton permission to build the tower for use as a beacon and, although it is said to be the oldest surviving light tower in England, it was in fact never used as a lighthouse.

Clayton's Chalk Tower did not succeed in warning vessels of the dangers of Flamborough Head at night and, between 1770 and 1806, no fewer than 170 ships were wrecked off the headland. The Collector of Customs, Benjamin A. Milne, convinced the Trinity House Brethren that such a disastrous loss of shipping could be prevented by a proper light built on the headland. The building is preserved, having served for more than a century as a daymark.

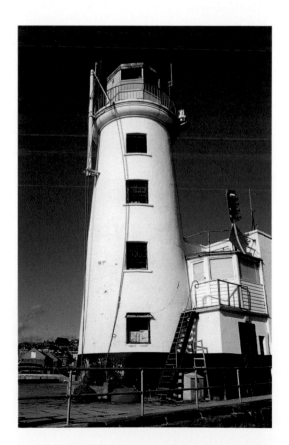

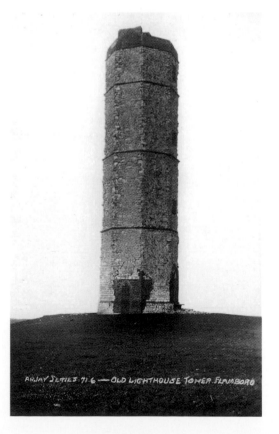

(Far left) Scarborough lighthouse is 49ft high and dominates the town's harbour.

(Left) An old postcard showing Flamborough Chalk Tower.

(Opposite) The historic seventeenth-century octagonal Chalk Tower at Flamborough Head now stands on a golf course; the site is easily accessible but the tower itself is not open.

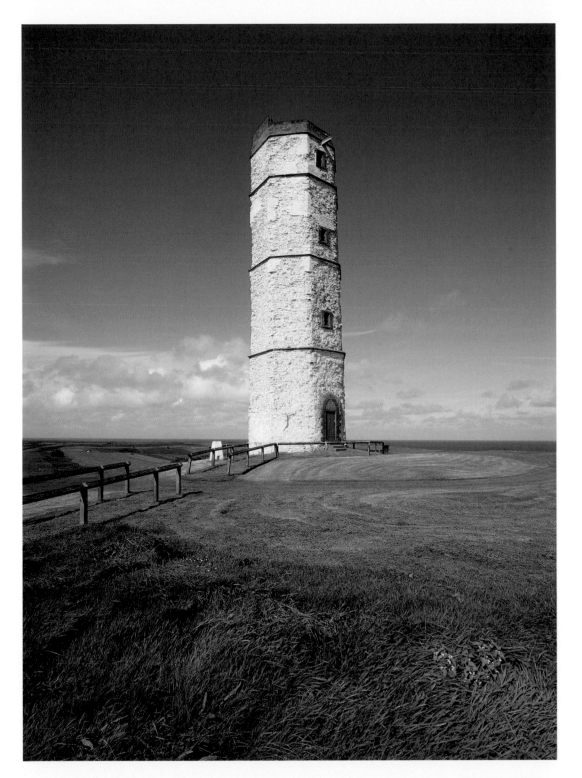

Flamborough

Established	1806
Current lighthouse built	1806
Automated	1996
Operator	Trinity House
Access	On headland at North Landing

Once Trinity House were convinced that a light was needed at Flamborough Head, and Clayton's chalk tower was not helping matters, plans for a new lighthouse were put in place. A tower, designed by Samuel Wyatt, was constructed and a light was first exhibited from it on 1 December 1806. The brick tower, 87ft in height with a lantern and double gallery, was built at a cost of £8,000 by John Matson, a builder of Prospect Street in Bridlington, who used no scaffolding and completed the work in nine months. A two-storey keepers' house was built to the east of the tower.

The original lighting apparatus was designed by George Robinson and consisted of a rotating vertical shaft to which were fixed twenty-one parabolic reflectors, seven on each of the three sides of the frame. Red glass covered reflectors on each side, giving for the first time in lighthouse characteristics two white flashes followed by one red, an innovation soon adopted elsewhere. The lighthouse was oil-burning, with an equivalent candle power of 13,860.

In 1940 the lighthouse was electrified and further modifications took place in 1974. An electric fog signal was installed in 1975 replacing diaphone apparatus. Originally a rocket was fired every five minutes during foggy weather. The lighthouse was automated in early 1996

and the keepers left on 8 May that year. The fog signal was refurbished and a standard fog detector fitted. The light, 214ft above sea level, is visible for 21 miles.

The lighthouse has served as a waypoint for deep-sea vessels and coastal traffic. It also marks the headland for vessels heading for the small ports of Scarborough and Bridlington. Flamborough Head, which is about 6 miles north-east of Bridlington, is a popular tourist spot and the headland has a large car park. Tours of the lighthouse are organised by East Riding of Yorkshire Council under licence from Trinity House.

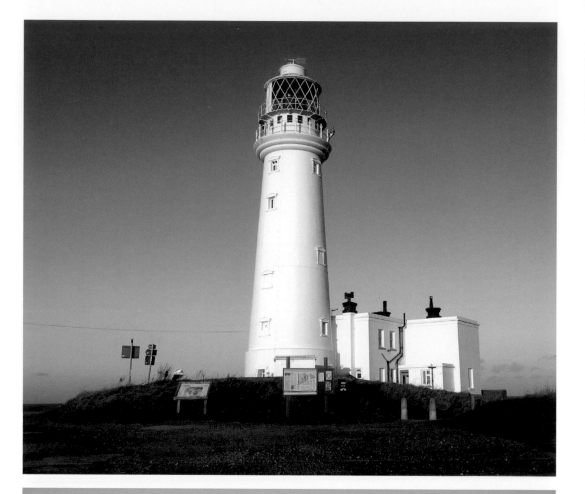

(Top) The impressive lighthouse at Flamborough is just over a mile from the village.

(Right) Flamborough Headland with the lighthouse on the left and signal station to the right.

(Opposite) Flamborough Headland is dominated by the lighthouse, with the historic Chalk Tower in the background.

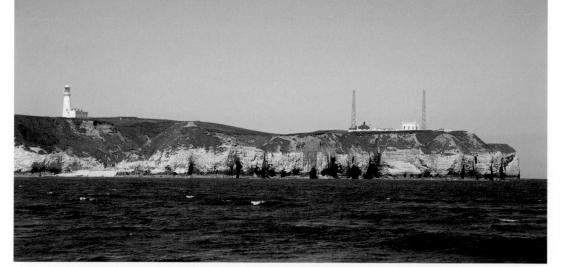

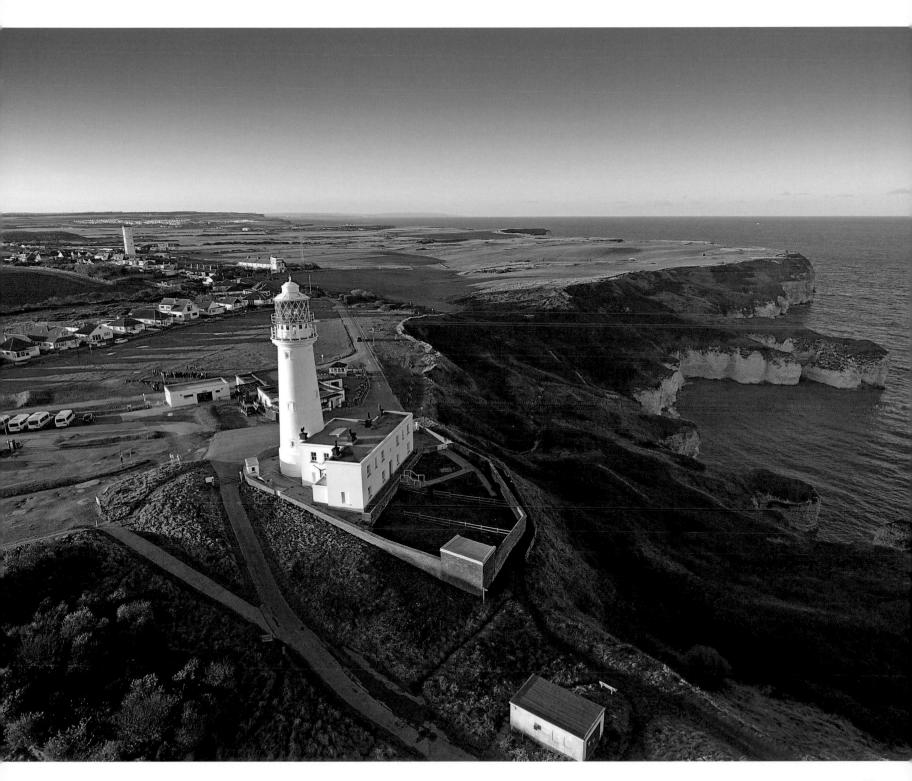

Bridlington

Established	1852
Current lighthouse built	1852
Operator	Bridlington Harbour Authority
Access	The pier is open to the public

Withernsea

Established	1894
Current lighthouse built	1894
Deactivated	1972
Operator	Withernsea Lighthouse Trust
Access	In the centre of the town, open to the public March to October, open daily in summer

The harbour in Bridlington dates from medieval times. The wooden piers that formed the harbour were damaged and altered several times until, in the mid nineteenth century, the stone piers were constructed which are in use today. The North Pier was completed in 1852 and on its end was placed a 28ft cast-iron column with a flashing white light, with a range of 9 miles, in a lantern not unlike an old street lamp. Although the column is not particularly noteworthy, it is somewhat ornate with a black trim to the white column and a red base which carries a lifebelt. The column also carries two further navigation lights operated by the Bridlington Harbour Authority. A similar cast-iron column is sited on the north harbour wall.

The ornate harbour light at Bridlington, with THV *Patricia* at anchor in the bay.

The architecturally unique 127ft tapering octagonal brick lighthouse in Withernsea is situated in Hull Road in the centre of the town. Established by Trinity House in 1894, it was designed to work in conjunction with the Humber Lightship to guide vessels into the Humber Estuary. Its rotating white light, visible for 17 miles, was deactivated in 1972.

In 1989 the lighthouse was taken over by the Withernsea Lighthouse Museum Trust and opened as a museum, largely through the efforts of the Campbell family, to house mementoes of Kay Kendall, a family member and film star of the 1950s. The base of the lighthouse houses a variety of displays relating to local interest, including the Humber and Withernsea lifeboats, as well as coastguards and shipwrecks, and there is a café in the attached keeper's cottage.

The lighthouse is no longer active but is open to visitors, who can climb the 144 steps to the top to enjoy the impressive views over Withernsea, East Yorkshire and the adjacent coastline; on a clear day it is possible to see the towers of the Humber Bridge.

(Left) Withernsea lighthouse, now a museum, is situated on Hull Road in a fairly central position in the town, and is one of only a handful of lighthouses built inland.

(Below) Withernsea lighthouse when operational. It was built over a period of eighteen months in the early 1890s because of the large number of ships being wrecked when they could not see lights at either Spurn or Flamborough.

The Light House. Hull Road. Withernsea.
The Wrench Series, No. 5176

Spurn Point

Established	1674
Current lighthouse built	1895
Deactivated	1985
Operator	Trinity House
Access	Spurn Point, a spit of land three miles long but only 150ft wide in places, is operated as a nature reserve by Yorkshire Wildlife Trust; since the spit was breached in storms, access has been limited

In 1427 a hermit named William Reedbarowe was given permission to charge dues for a light on a tower on Spurn Point. However, no records exist of lights – if indeed any were lit – on Spurn until 1674, when a pair of coal-fired lights was erected on the point, which was then 2 miles north of the current tip. These lights, known as high and low lights, were washed away several times, but the high and low light strategy was necessary to mark the treacherous Humber Estuary and so was maintained.

Both original lights were replaced in 1766 by L. Thompson. Ten years later Smeaton built a pair of coal-fired swape lights on brick towers, one 90ft and the other 50ft in height, near the tip of the then lengthened point, just north of the lifeboat station and cottages. The high light, visible for 12 miles, suffered cracks to its base and was replaced by the present 128ft high brick tower in 1895. The base of the old light, adjacent to the present tower, is still visible. The rotating light, mounted on the new tower, was visible for 17 miles.

Spurn Point high light, with its black band, dates from 1895 but has been inactive since 1985.

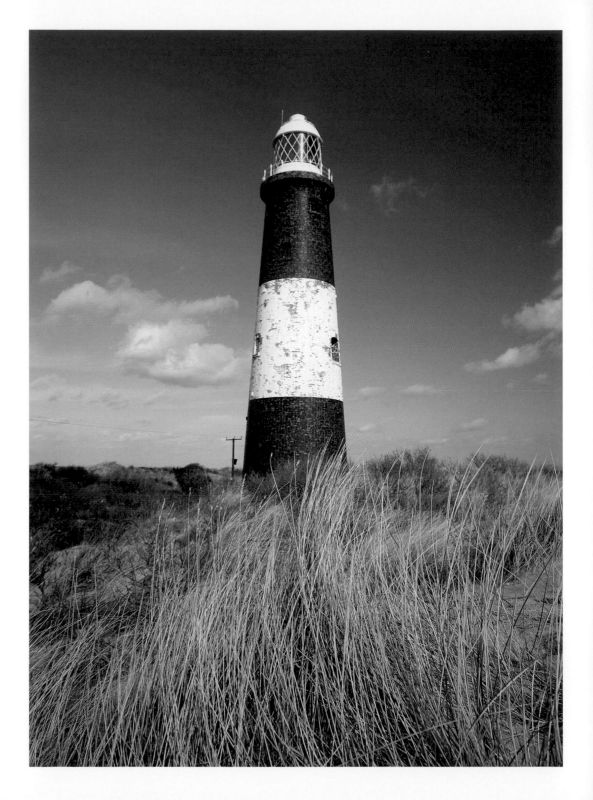

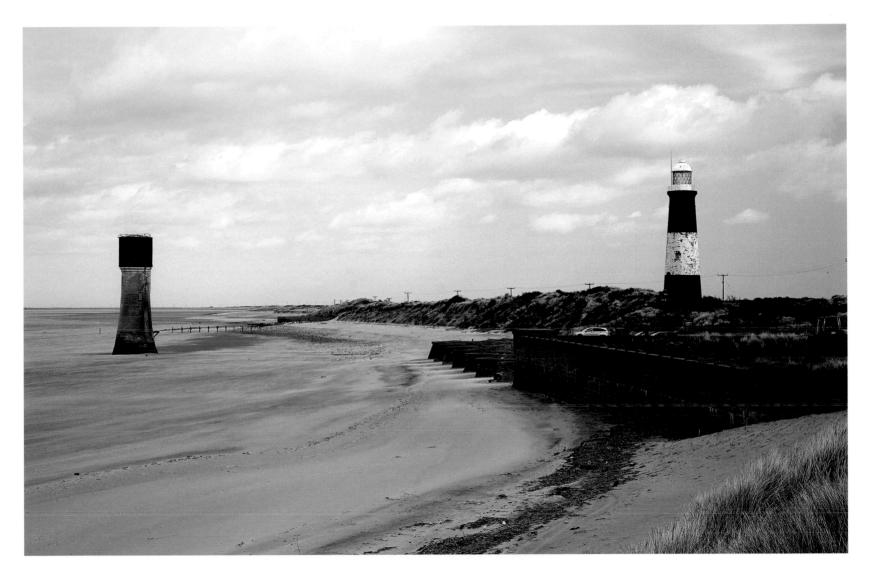

The low light built in 1776 gave good service until the 1810s, when the woodwork of the swape was found to have decayed so much that it needed to be replaced. Work on a new 50ft tower, equipped with an Argand lamp, started in July 1816. The tower, built by John Earle to the design of architect John Shaw, first exhibited a light on 25 November 1816. Another new low light had to be built in 1852 after the 1816 tower had been undermined by the sea.

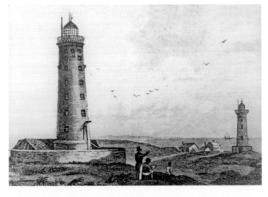

(Above) Although the two towers at Spurn are now disused, they are distinctive landmarks at the entrance to the Humber Estuary.

(Left) A print from 1820 shows the Smeaton-designed high light and Shaw's tower of 1816 at Spurn Point, overlooking the River Humber.

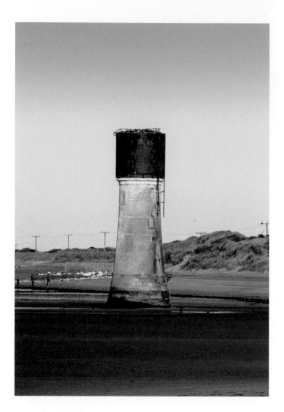

(Above) The foundations of John Smeaton's 1767 tower at Spurn Point about 50 yards west of the high light on land owned by the Yorkshire Wildlife Trust.

However, the 1895 tower made the low light redundant, as three subsidiary fixed lights were shown from lower down the tower, so the low light lantern was removed from the tower, which was subsequently used to store explosives. A water tower was later added to the top, and this structure remains standing. The high light, originally oil-fired, had a range of 17 miles, and flashed once every twenty seconds. It was converted to electricity in 1941, but was decommissioned and closed on 31 October 1985. Access to Spurn Point is restricted after the spit was breached by a severe storm in 2013.

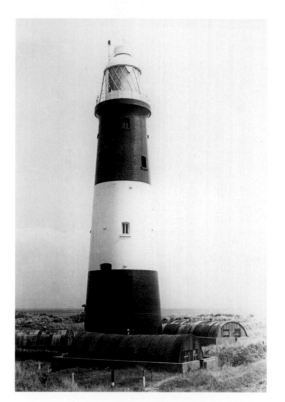

(Top) During the Second World War Spurn Point high light was surrounded by various military buildings.

(Above) Looking down from the lighthouse on the circular compound with the lightkeepers' houses surrounding the site of Smeaton's high lighthouse during the Second World War. This compound and the houses have since been demolished.

Inner Dowsing

Established	1971
Deactivated	1993
Access	No public access

South-east of the Humber Estuary is a series of sandbanks called Haile Sand and Rosse Spit, with Inner Dowsing Overfalls to the south. In 1861 Trinity House stationed a lightvessel at the northern end of the spit to mark both the Humber Estuary and the bank. On 13 September 1971 this lightvessel was replaced by a second-hand gas platform on which was mounted a 20ft red lattice tower transferred from Lightvessel No. 89. Its electrically powered multicatoptric white flashing light was visible for 24 miles. In 1993 the lightvessel returned and was used until 2003.

The Inner Dowsing light was operational from this platform between 1971 and 1993. LV-93, the last Inner Dowsing lightvessel, was withdrawn in 2003, sold in 2004 and is now at Trinity Buoy Wharf, London. (FotoFlite)

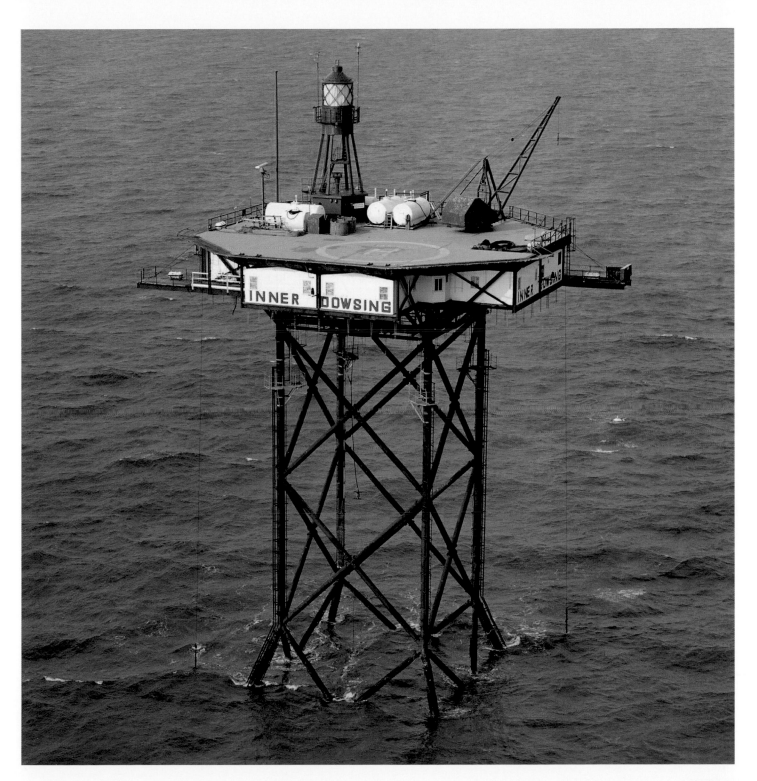

Thorngumbald Clough

Established	1870
Current lighthouses built	1870
Operator	Associated British Ports Hull
Access	Via a short walk along sea defence wall; work is continually being carried out on the sea defences in the area and access may be affected

Because of changing channels, by the 1860s the lighthouse built at Paull in 1836 no longer marked a safe passage through Paull Roads, and so in 1870 it was discontinued. In its place, a pair of lights was erected about half a mile east at Thorngumbald Clough. The high light was a 50ft red cast-iron framework structure. The lantern, showing a white occulting light visible for 8 miles, is housed in a red lantern room with a white domed top.

The low light, 300ft away, is mounted on a 30ft white circular metal tower with a white domed lantern room on top. The white occulting light, displayed through a window, is visible for 9 miles. The lights, when aligned, mark the safe channel for ships leaving the port of Hull. Vessels then realign with the lights at Killingholme on the south Humber bank to proceed to sea.

In 2003, following a breach in the sea wall between Paull and Thorngumbald, a decision was made to carry out a controlled land flooding scheme rather than repair the breach. This involved the area around the two lighthouses, and consideration was given as to whether to resite them. In the end, the sea defences on

Thorngumbald Clough high light with lantern and enclosed watchroom. The building is listed for its special architectural and historic interest.

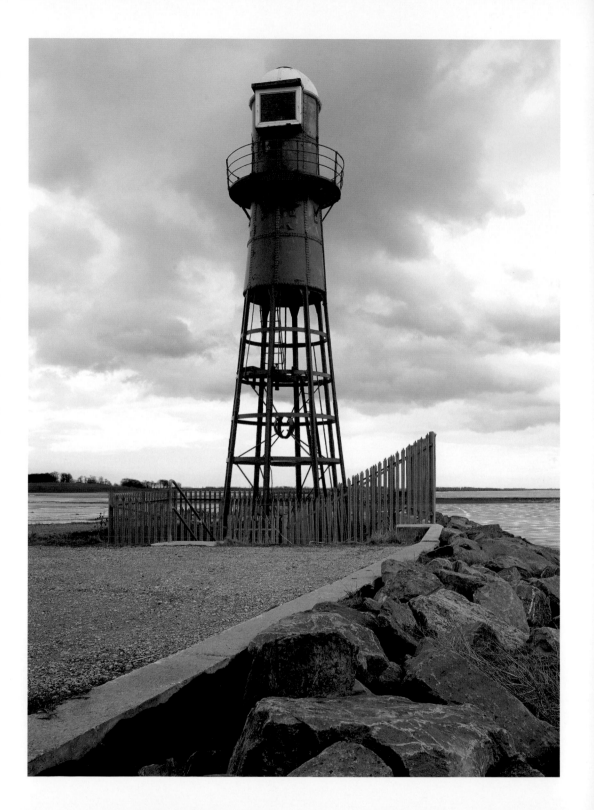

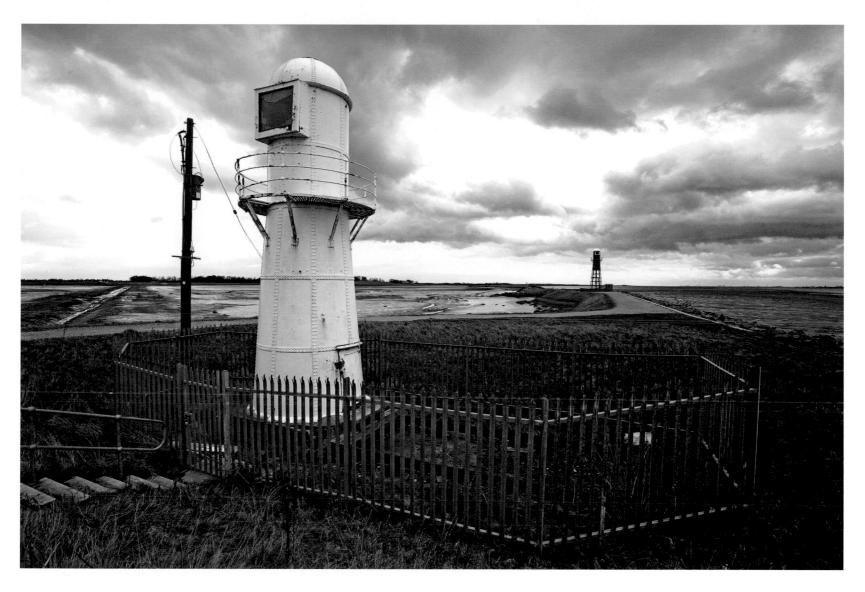

which they stand were reinforced by tons of large stones and the land behind them was sacrificed to the sea. They therefore now stand on a long stone promontory which is surrounded by sea. The keepers' cottages, which were situated between the high and the low lights, were demolished in 1998.

The white-painted Thorngumbald Clough low light on the north bank of the Humber, a short distance south of Paull. The keeper's house, once between the low and high lights, has been demolished.

Paull

Established	1836
Current lighthouse built	1836
Discontinued	1870
Access	On the main road to the seafront

The white-painted 46ft-high conical brick tower situated on the street corner at Paull was opened by Trinity House in 1836. The light, displayed in a domed lantern room, the window of which faced Hull, guided vessels as they left port past the sandbanks. The light was manned by a keeper paid £50 per annum, with an attendant paid £40. It was originally oil powered, but was later changed to gas.

At this point the river channel is narrow due to sandbanks, and vessels leaving port had to navigate towards Paull lighthouse before changing course towards Killingholme lights on the south bank. Because the sandbanks shifted, the light was deactivated in 1870 and replaced by the two lights at Thorngumbald Clough. The tower was originally freestanding in a space at the corner between the two terraces, but in 1820 a Mr Robert Thompson bought the land that the lighthouse is built on and subsequently extended the two terraces to join the tower.

After it was decommissioned, the lighthouse was handed over by Trinity House in 1909 to Humber Conservancy Board, who sold it at auction in 1947. A number of different people owned it, until in 1985 it was purchased by the present owner, who has extensively renovated it and turned it into a bed and breakfast.

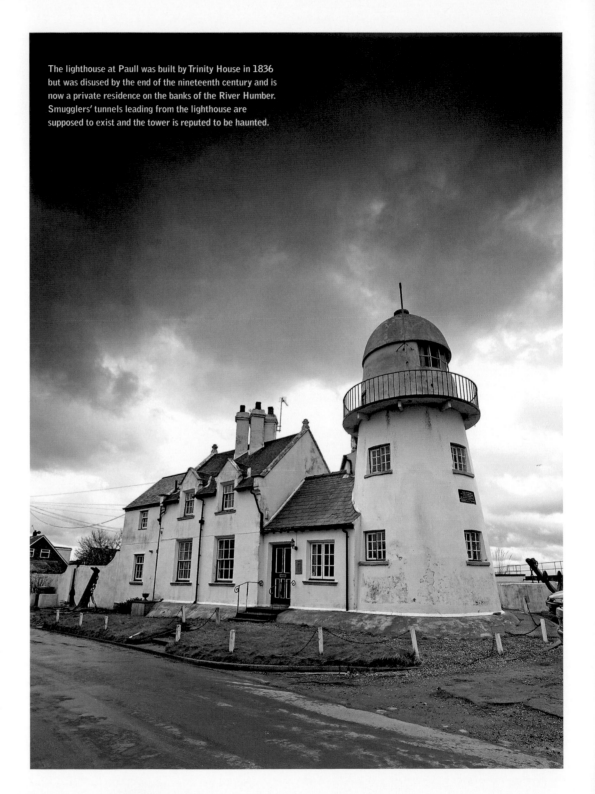

The lighthouse at Paull was built by Trinity House in 1836 but was disused by the end of the nineteenth century and is now a private residence on the banks of the River Humber. Smugglers' tunnels leading from the lighthouse are supposed to exist and the tower is reputed to be haunted.

Salt End

Established	1870
Deactivated	Prior to 1960
Access	No trace exists

The two lighthouses at Salt End on the banks of the Humber were established in July 1870. Built by Thompson & Stather, of Hull, on the foreshore on land purchased for £30 from the Humber Conservancy Commissioners, they marked the centre of the deep water channel from No.13 Hebbles Buoy to Victoria Dock.

The high light, a red-painted 54ft cylindrical tower, was of wrought-iron girders on masonry foundations with a keeper's cottage adjoining. Access to the lantern was by spiral staircase inside the open latticework to the storeroom and then by iron ladder to the lantern. The keeper appointed in 1877 was Fewson Hopper, who had been coxswain of the Spurn lifeboat and was father of James Hopper, landlord of the Lifeboat Inn at Spurn Point. The occulting white light, originally powered by oil lamps, was converted to electricity in 1926 and was visible for over 12 miles.

The movcable low light was a white wrought-iron 22ft cylindrical tower. The light was originally mounted on a trolley which ran on rails 21ft long so that it could be moved along a north–south axis in front of the high light to ensure the shifting sandbanks were accurately marked. By 1939 the lights were unattended and no keeper was employed. The lights fell into disuse with the building of the new jetties for the British Petroleum Oil Terminal in the 1960s, and were demolished.

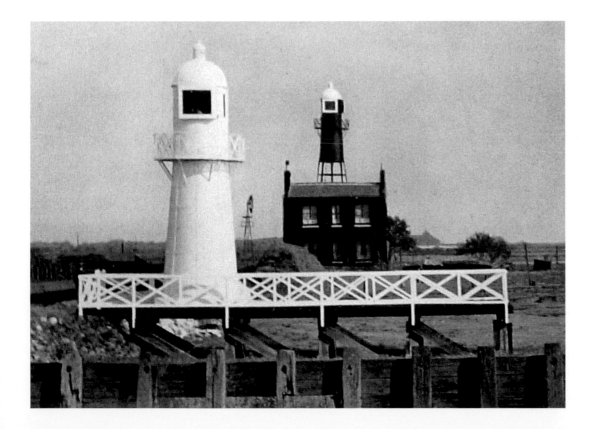

The old lights at Salt End are no longer in existence. The low light was originally mounted on a trolley which ran on rails 21ft long so that it could be moved along a north–south axis in front of the high light to ensure the shifting sandbanks were accurately marked. The light was moved slightly on its rails in 1893 and in 1897 a red sector light was added to cover the Skitter Sand Elbow. (Courtesy of Mike Millichamp)

Spurn Lightvessel

Established	1927
Last vessel	1959
Deactivated	1985
Operator	Hull City Council
Access	Original lightvessel on display at Hull Marina, Castle Street, Hull; open April to September

As well as the land-based aids to navigation on the Humber, manned lightvessels were also located along the river, from beyond Spurn Point to west of Hessle at Hebbles, as early as 1820. One position was off Spurn Point, where LV-16 initially served as Spurn Lightvessel.

Built in 1927 for the Humber Conservancy Board by the Goole Shipbuilding and Repairing Co. at a cost of £17,000, it was towed into position in the estuary on 17 November 1927 to act as the first aid to navigation at this location. The vessel is partitioned into three areas: the crew's living quarters with four sleeping berths, a wash area, and a kitchen unit. The rotating light was oil powered, with parabolic reflectors as well as a foghorn.

In 1959 a new lightvessel was under construction for Spurn so LV-16 was reallocated to become Bull Lightvessel. Before going there, she was surveyed and repainted red, having been black while at Spurn. She was decommissioned from Bull in November 1975 and sold to Hull City Council in 1983. In February 1987 she went to Hull Marina.

On 28 June 1959 the new lightvessel LV-14 was towed out to Spurn to replace LV-16. She was built at Cook, Welton and Gemmell's Yard in Beverley and had accommodation for seven crew. The rotating light, which was initially oil fuelled, had a prism lens as opposed to the usual parabolic reflectors. The light was later converted to electric operation. After being decommissioned on 11 December 1985, she was sold to Guernsey, then went to Conwy in 1988, then to Milford Haven and later Waterford, before being towed by her present owners.

Built from steel, LV-16 was restored to her original condition in the 1980s and taken to Hull Marina, where she is open to the public from March to September.

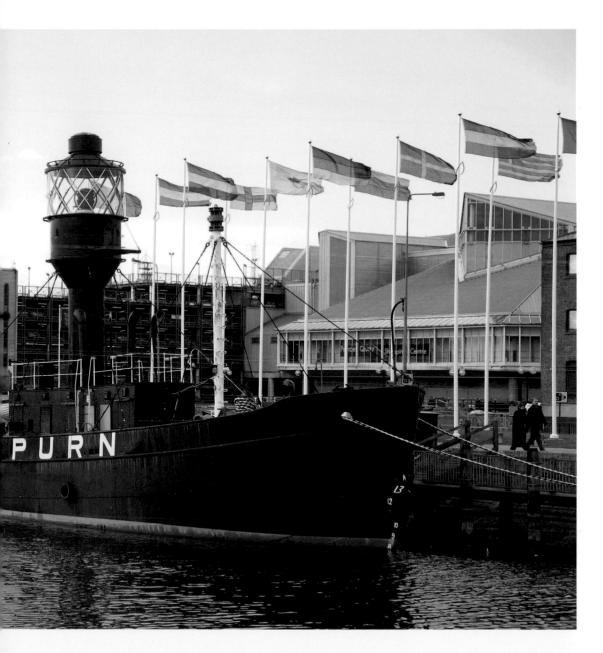

River Ouse

Apex

Established	1933
Automated	1933
Current tower	Early 2000s
Operator	ABP Port of Goole
Access	Original light is on display at Yorkshire Waterways Museum, Dutch Riverside, Goole, adjacent to No.5 Coal Hoist

Whitgift

Established	Unknown
Operator	ABP Port of Goole
Access	Through the centre of Whitgift village, reached via private garden and field with permission

Although a number of beacons and lights guide vessels on the River Ouse, only two can be described as lighthouses. One, at Whitgift, which is also known as Whitgift Bight, consists of a slightly tapering white-painted 46ft brick tower on an unpainted hexagonal brick base on the floodbank of the river. Its continuous red light shines through a window in a dome-roofed lantern complete with a gallery.

The other, Apex, is situated in the river channel 3 miles east of Whitgift, at Trent Falls, where the rivers Ouse and Trent converge to become the Humber. The first light here, on the end of the training wall, was shown from a brick lighthouse erected by the Lower Ouse Improvement Trustees in 1933, but was within the jurisdiction of the Humber Conservancy Board, and consisted of a red 40ft elaborate circular steel tower on a sturdy square wooden base. Sometimes known as Trent Falls lighthouse,

it was powered electrically from the trust's power plant on the north side of the river at Blacktoft, with an acetylene light as back-up.

The light was a fourth-order dioptric group triple flashing, showing three periods of half a second on, one second off, half a second on, one second off, half a second on, with a final six and half seven seconds off, every ten seconds. It had a white sector for entry into the Trent visible for 10 miles, and a red sector visible for 6 miles for entry to the Ouse. In addition, the lighthouse had a diaphone foghorn operated by compressed air. This gave a blast of one and three quarter seconds every twelve seconds, with an electric siren for use as a back up. The lighthouse was 40ft in height and the focal plane of the light was 30ft above high water.

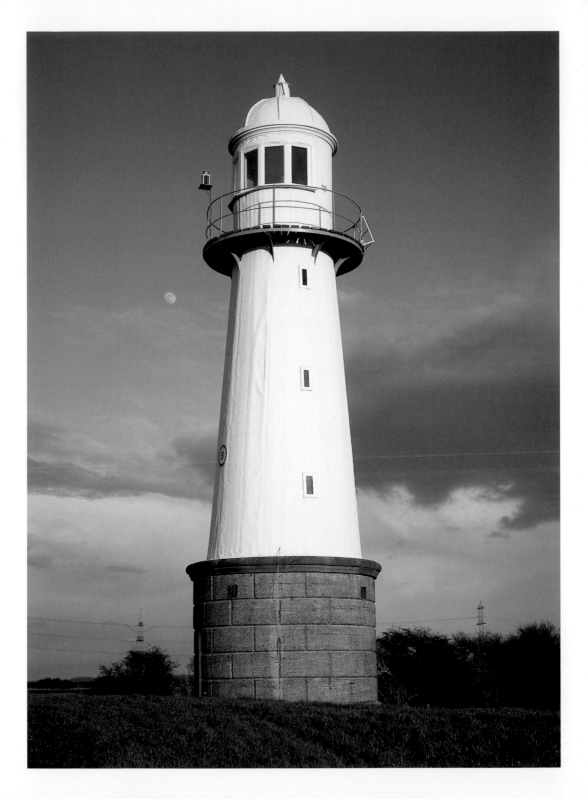

Whitgift lighthouse on the south bank of the River Ouse stands 6 miles east of the port of Goole.

This lighthouse is now preserved and on display at the Waterways Museum in Goole. The modern light consists of a steel tube which supports a simple green flashing light on the end of the training wall. The Whitgift light can be seen in the village, while the Apex light is best viewed from Flaxfleet on the north bank. Both the lights and fog signals were controlled by the pier master at Blacktoft Jetty.

Another light, No.2 beacon, is mounted on a wooden trellis with a single pole which supports a gallery and red lantern showing a flashing green light. It is situated about 50ft to the west of the Apex light.

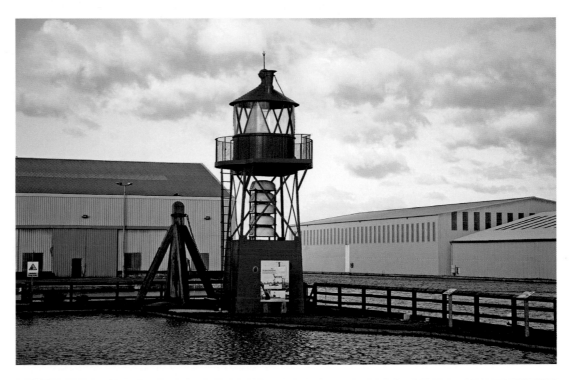

(Top) The refurbished Apex light on display next to the No.5 Coal Hoist at Goole Docks forms part of the nearby Waterways Museum. The lighthouse was dismantled when no longer required and re-erected on the Dutch Riverside at Goole.

(Right) Apex light in the River Ouse is situated at the end of the training wall at the entrance to the River Trent. Despite the training wall and the Apex Light, navigation at Trent Falls is not simple. (Tony Denton)

Killingholme

Established	1831
Current lighthouses built	1836, 1851, 1876
Operator	Grimsby & Immingham Port Partnership
Access	Via the sea wall which protects all three

To the north of Killingholme are three lighthouses, the High, North and South Low lights. The High light, a red-painted stucco-covered tapering conical 79ft tower, was commissioned in 1831 and rebuilt in 1876. The occulting red light, visible for 14 miles, is shown through a window housed in a domed lantern room, below which is a gallery. Originally operating in conjunction with both the North and South Low lights, it now marks the entry into the lower reaches of the Humber Estuary in conjunction with the South Low light.

Prior to the decommissioning of Spurn Point lighthouse, it operated in conjunction with that also. The South Low light erected in 1836 is a white-painted stucco-covered 46ft tapered conical brick tower. It shows a flashing red light, visible for 11 miles, through a window in a white-domed lantern room. Like the high light, it has a gallery below the lantern room and although neither tower has an adjoining building, each has a set of chimneys running up the tower and protruding above the dome.

The North Low light, 800 yards to the north, was built in 1851 and consisted of a 46ft white-painted stucco-covered tower and attached

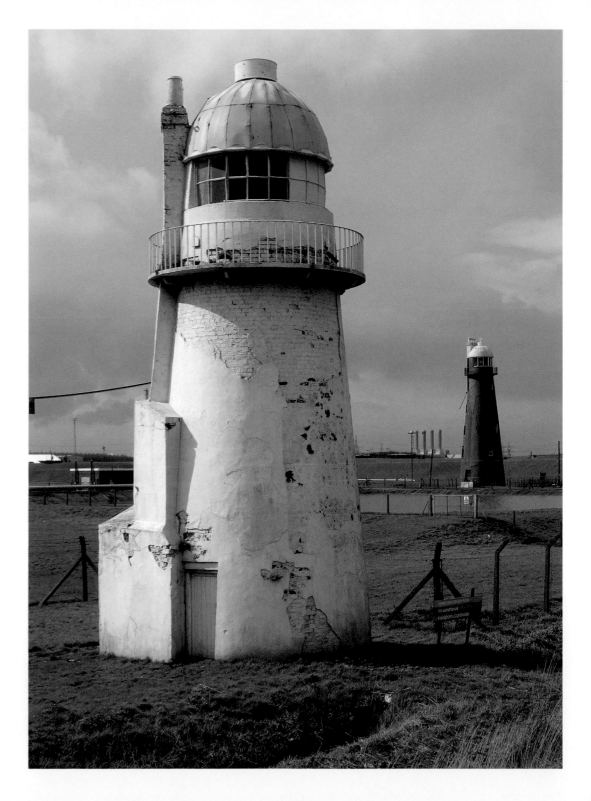

The white-painted Killingholme South Low light stands close to the red Killingholme High light on the south bank of the Humber, on either side of a sewage works lagoon.

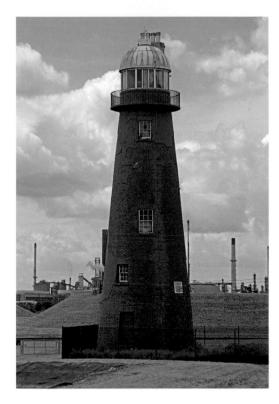

(Above) The red-painted Killingholme High light stands in the grounds of a sewage works.

(Top right) Killingholme North Low light, now inactive, has a single-storey keeper's house attached which is used as a private residence.

(Bottom right) The Killingholme lighthouses with the High and South low lights foreground left and the North Low light in the background.

dwelling house. The light, visible for 11 miles, was displayed through a window in a white lantern room with black domed top. Like the other two lights, it also has a gallery and set of chimneys. Decommissioned in 1920, the lighthouse was used as a signal station prior to the establishment of the coastguard station and is now a private dwelling. The lights once dominated the landscape but they are now dwarfed by the nearby oil refineries, power station and sewage works.

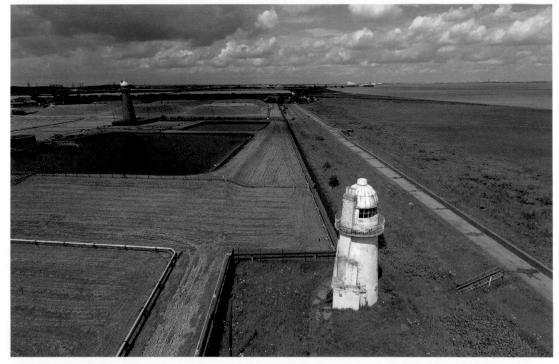

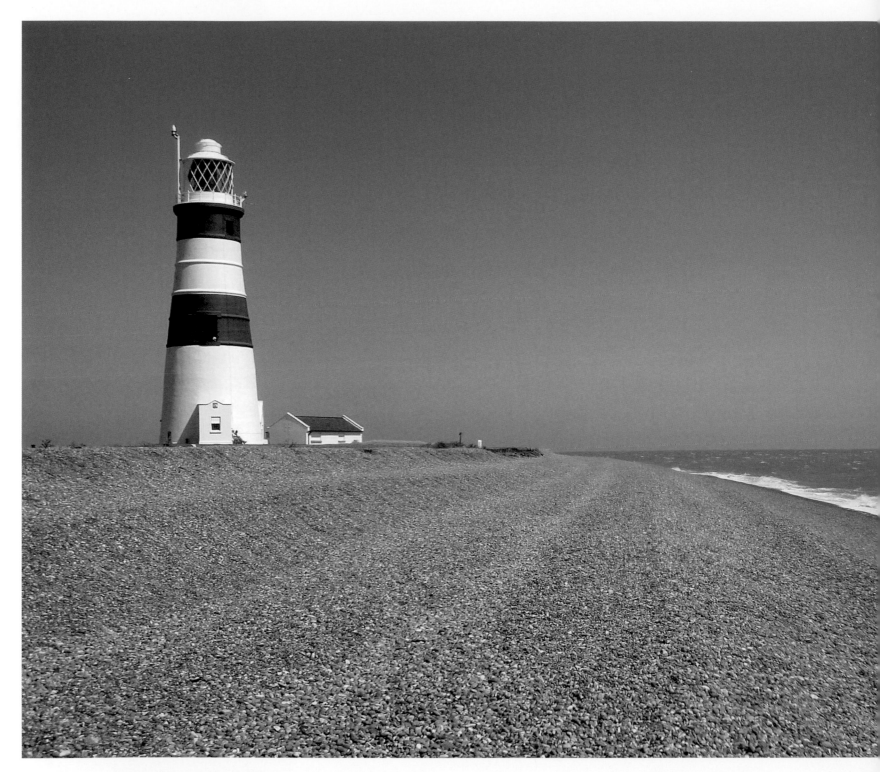

3 EAST ANGLIA

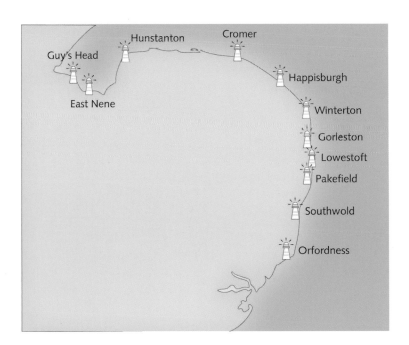

Guy's Head
East Nene
Hunstanton
Cromer
Happisburgh
Winterton
Gorleston
Lowestoft
Pakefield
Southwold
Orfordness

River Nene

Established 1826 (possibly never lit)

Access Although only 100 yards apart as the crow flies, the lights are 4 miles apart by road; the East Bank Light is at the end of a narrow road about 2 miles from Sutton Bridge; the West (Guy's Head) Light can be approached via the roundabout on the west side of Sutton Bridge into the village, then the second left down a winding road passing King John Farm and left to Guy's Head; a footpath passes close by

East End lighthouse at the mouth of the River Nene is in private hands having never operated as a light.

In 1826 the river Nene, where it emerged into the Wash, was realigned into what was then the new cut and what is now Nene Outfall. This level section from Sutton Bridge into the Wash was a fine new entrance and, to make it even more impressive, a pair of ornate lighthouses was constructed at the then headland. Since then land has been reclaimed and the towers are now a short distance inland.

These 60ft six-sided cone-shaped towers each had small light windows near the top with a conical chimney protruding above the copper-clad roof. The East Bank Light was a stand-alone tower but buildings have been added to provide accommodation. It was occupied by the naturalist Sir Peter Scott during the 1930s, and now forms part of the Snowgoose Wildlife Trust in his honour.

The West Light, also known as Guy's Head Light, had a keeper's house attached but it too has had more accommodation added subsequently. Although these lights were believed never to have been lit, in August 2005 the owner of the East Bank Light wrote, 'The lighthouses have and continue to have condensing lanterns lit automatically every night at the owners' expense.' The lighthouses at Sutton Bridge are both Grade II listed buildings.

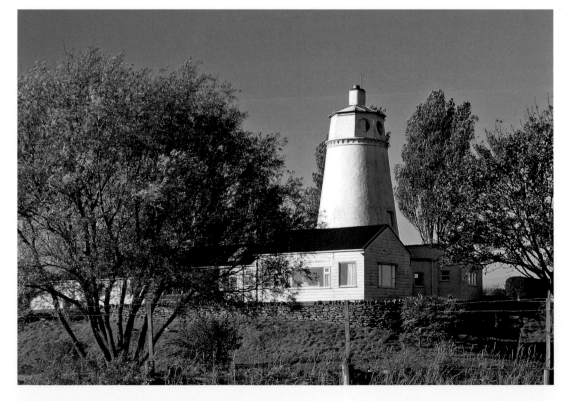

(Right) Guy's Head lighthouse on the River Nene, now restored and used as a private residence.

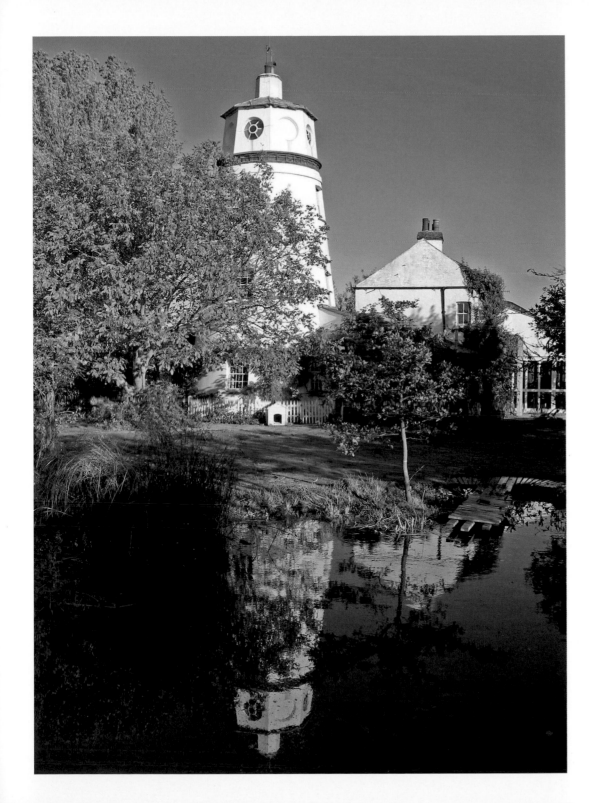

Hunstanton

Established	1665
Current lighthouse built	1838–40
Access	Near the coastguard lookout building on the cliffs above the beach, south of Old Hunstanton

In 1665 two stone lighthouses were built at a cost of £210 on Hunstanton Cliff to mark a passage through the extensive sandbanks of the Wash. The lights had been built following the petitioning of King Charles II by shipowners who believed that the Old Lynn Channel, through which vessels passed on their way to King's Lynn, needed marking to improve navigation. Shipowners paid dues of 8*d* on every 20 tons of coal or other goods and 1*d* per ton was levied on the cargo of foreign vessels to fund the light.

The inner light was coal-burning and the outer was fitted with candles. The former light had to be rebuilt after a devastating fire damaged it beyond repair towards the end of 1777. The new tower was a simple structure, 33ft in height, built of timber throughout and fitted with a reflector and oil lamps, instead of an open brazier. The arrangement of the reflectors, designed by Ezekiel Walker, was such that a single oil lamp was set precisely in the focal centre, where the light rays would be set to their maximum intensity. The new light, shown for the first time in 1778, was more advanced and brighter than any other lighthouse then in existence, this being the first time an illuminant other than coal was employed in a major light.

The tower remained in private hands until 1837, when Trinity House purchased the rights

from the then owner, Frederick Lane. Plans were made for the timber structure to be replaced and in 1838 work commenced on a new circular brick tower. The tower, 63ft high from base to gallery, was constructed by William Candler, of King's Lynn, and showed a light for the first time on 3 September 1840.

In 1861 an additional floating light was established off the Lincolnshire coast at the Inner Dowsing Shoal, and in 1878 a lightvessel was stationed at the Bar Flat, where various channels enter the Lynn Deeps. A chain of floating lights was gradually built up around the Wash, including the Dudgeon, Lynn Well and Roaring Middle lightvessels. These combined to make the light at Hunstanton superfluous and so in 1921 it was discontinued and sold in 1922, when the lantern was removed. It was used as an observation post during the Second World War but has since become a holiday house, with the lantern replaced by an extra storey.

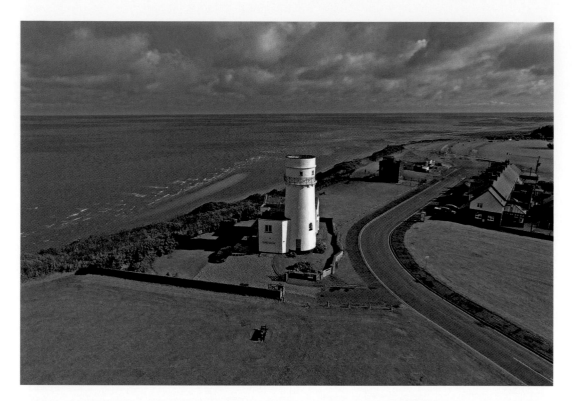

(Top) The tower, with the lantern removed, and cottages at Hunstanton are now a holiday cottage. The Trinity House coat of arms on the tower faces the road.

(Right) Hunstanton lighthouse on the cliffs overlooking the beach, depicted in an old postcard issued when it was operational. It has been inactive as an aid to navigation since 1921 but was used as an observation post during the Second World War.

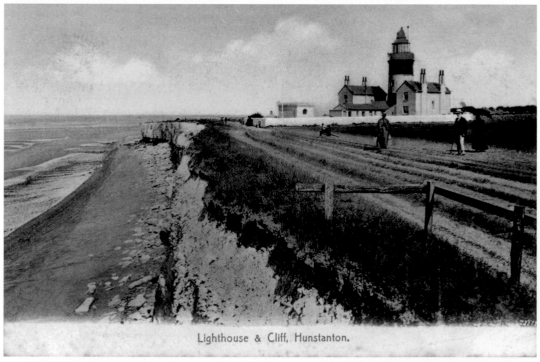

Lighthouse & Cliff, Hunstanton.

Cromer

Established	1670
Current lighthouse built	1833
Automated	1990
Operator	Trinity House
Access	On the cliffs east of the town, close to the golf course and a public footpath

Before the lighthouse was built at Cromer, lights to guide vessels were shown from the tower of the parish church, one of the tallest in Norfolk. During the twenty years following the restoration of the monarchy in 1660, many proposals were put forward for lighthouses on all parts of the coast. One of the petitioners, Sir John Clayton, suggested five lighthouses including one at Foulness, south-west of Cromer, and another at Corton near Lowestoft. Despite opposition to his schemes, Clayton, together with George Blake, obtained a comprehensive patent in 1669 and at a cost of £3,000 erected towers at four sites.

The patent was for sixty years and specified that dues be paid voluntarily by owners of passing vessels. But the cost of maintenance was high and, as many shipowners were unwilling to pay the dues, Clayton could not afford to kindle fires in the tower. However, despite being unlit, it served as a beacon and was marked on sea charts after 1680 with an explanation that it was 'a lighthouse but no fire kept in it'.

The owner of the land at Foulness, Nathaniel Life, considered that the situation required a lighthouse and took steps to light Clayton's

original tower. Assisted by Edward Bowell, a Younger Brother of Trinity House, he persuaded the Brethren to apply for a patent. They obtained it in 1719, the dues to be a quarter of a penny per ton on general cargo and half a penny per chaldron (about 25 hundredweight) of Newcastle coal. Life and Bowell jointly received a lease at a rental of £100 per annum on the undertaking that the tower with 1 acre of ground should pass to Trinity House when the patent expired after sixty-one years.

A coal-fired light enclosed in a lantern was first lit and displayed on 29 September 1719. Trinity House took possession in 1792 on expiry

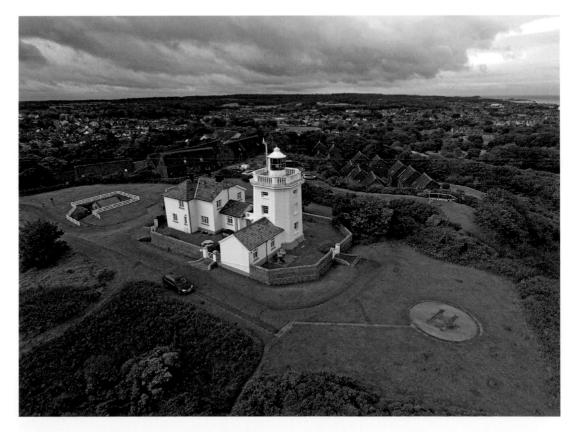

The Cromer lighthouse stands in the middle of the local golf course on a footpath to the south-east of the town. The octagonal lighthouse has the keepers' cottages attached.

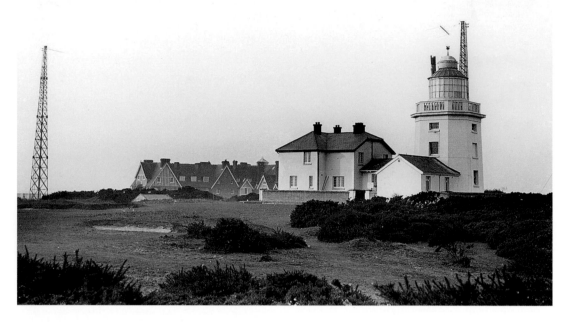

(Above) The lighthouse, built in 1833, with the lantern that was used before its conversion to electric operation in 1958.

(Below) Cromer lighthouse is situated on the town's golf course.

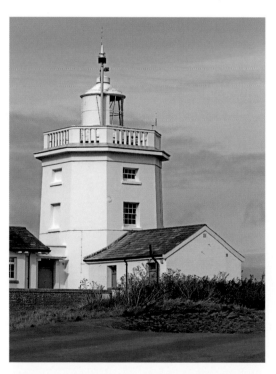

of the lease and fitted its second flashing light in the tower. This consisted of five reflectors with Argand oil lamps on each of the three faces of a revolving frame. The first keepers were two young women who together received a pound a week for wages. However, the sea encroached rapidly and threatened the tower; in 1799, 1825 and 1852 huge sections of cliff slipped into the sea and the building was finally destroyed by a landslip in 1866.

The present lighthouse, a white octagonal tower standing about half a mile from the cliff edge, was built in 1833 and converted to electric operation in 1958. The light is 275ft above high water and has a range of 23 miles. In June 1990, the station was converted to automatic operation and the keepers' cottages can be rented as holiday accommodation, although the property is still owned by Trinity House. The light is next to the Royal Cromer Golf Course. There is also a circular walk that takes in the beach, cliff and heathland on the North Norfolk Coast path, with breath-taking views.

Happisburgh

Established	1791
Current lighthouse built	1791
Operator	Happisburgh Lighthouse Trust
Access	On farmland east of the village

Happisburgh lighthouse, situated in the centre of a field about half a mile from the shore, was established following a severe winter storm in 1789, when seventy sailing ships and 600 men were lost off the coast of Norfolk. A subsequent inquiry drew attention to the lack of lights between Cromer and Winterton and resulted in Trinity House building two lighthouses at Happisburgh. A low light was erected on the clifftop, about 400 yards north of Cart Gap, and a high light, 85ft tall with the lantern 134ft above sea level, about 400 yards inland.

The two lighthouses, which replaced the old Caistor lights, formed leading lights marking safe passage around the southern end of the treacherous Haisborough Sands. They were first exhibited on 1 January 1791. By keeping the lights in line, vessels were guided around the sands and into a sheltered stretch of water. In 1863, a new lantern was installed which consisted of diagonal frames crossing each other at a constant angle, enabling shipping to see the light from all angles to seaward. It remains atop the lighthouse today.

The low light was discontinued in May 1883 after an extra lightvessel had been stationed to guard the Haisborough Sands. Threatened by coast erosion, the light was demolished soon after it had been taken out of service. With only one tower at Happisburgh, it was necessary to

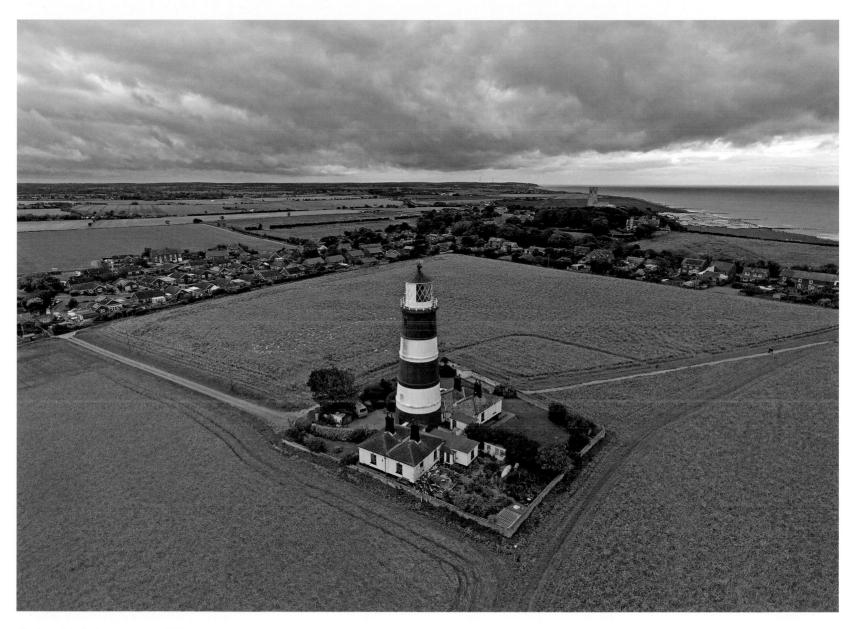

distinguish it from that at Winterton during daylight and so in 1884 the Happisburgh tower was painted with three broad red bands, which remain today. The light was also changed to an occulting character, the light shining for twenty-five seconds followed by a five-second eclipse.

In 1929, acetylene was introduced, which meant the resident keepers were no longer needed and the keepers' cottages were sold to become private dwellings. In 1947, electricity was installed and the light, with a range of 18 miles, was changed to emit a flashing sequence of three white flashes every thirty seconds. In 1988, the future of

The impressive Happisburgh lighthouse stands just outside the small village, surrounded by farmland and overlooking the crumbling cliffs of the Norfolk coast. The light it displays has a range of 18 miles.

the light came under threat when Trinity House undertook a major review of aids to navigation and included it in their list of five lighthouses and

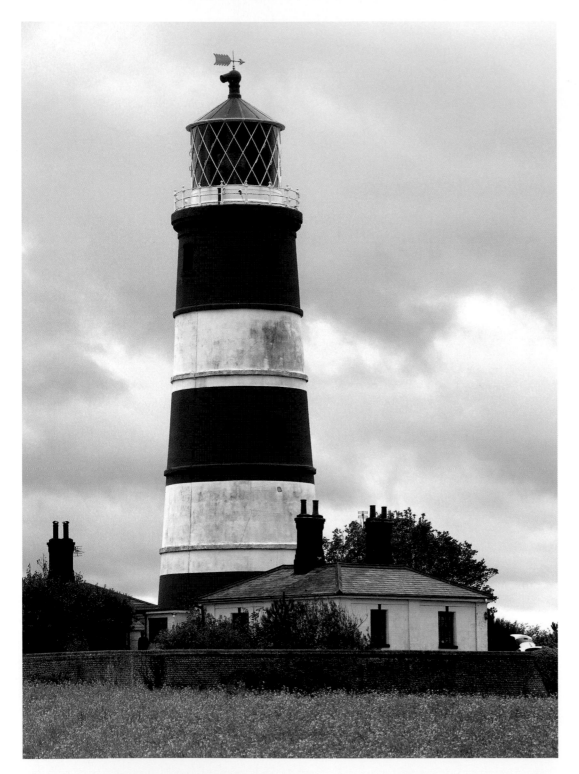

(Above) Happisburgh lighthouse in the mid twentieth century when it was operated by Trinity House.

(Left) There are ninety-six stone steps on the inside of the iconic tower's perimeter wall, which lead to the service room directly below the light.

four lightvessels to be discontinued. The date for scheduled closure and decommissioning by Trinity House was 13 June 1988.

However, a petition to oppose the closure was organised locally and the Friends of Happisburgh Lighthouse was established, funded by voluntary contributions, to promote the campaign. Trinity House agreed to postpone the closure. Following an Act of Parliament passed in April 1990, the Friends were able to take control of the lighthouse after the Happisburgh Lighthouse Trust had been formally established as a Local Light Authority.

The trust is a registered charity governed by six appointed trustees responsible for operating and maintaining the light, which became the only independently operated lighthouse in the UK. It was repainted inside and out in August 1990 for the BBC programme *Challenge Anneka*, and is now the oldest working light in East Anglia, and the only independently run lighthouse in Great Britain. The lighthouse is open to the public on occasional Sundays and bank holidays throughout the summer, with opening times listed on the website: happisburgh.org.uk/lighthouse.

Winterton

Established	1616
Current lighthouse built	1840
Discontinued	1921
Access	Via the lighthouse holiday chalet complex

Built in about 1616, the original coal-fired light at Winterton-on-Sea was, along with that at Orfordness, among the first in the British Isles but was destroyed by fire. Erected to mark the dangerous Winterton Ness, it was supplemented with a second light in about 1677. The lighthouse was rebuilt in 1687 in the form of an octagonal tower and was privately owned by the Turnour family. No trace remains of these early lights, which were sometimes known as the Thwart Lights.

In 1840 a brick-built 61ft circular tower, with a galleried window light and adjoining keepers' cottages, was erected on the edge of the dunes to the north of the village. It housed a paraffin light visible for 17 miles. The light was discontinued in the autumn of 1921 and the buildings became private dwellings, the tower being converted into a four-storey house.

During the Second World War, it was taken over by the army and the top was converted to a signal station and lookout which remains on the tower. It was rumoured that the Germans were instructed not to bomb it so that they could use it as a guide. The light itself now shines in Bombay Harbour.

(Left) The tower of the old lighthouse at Winterton, which, together with the keepers' cottages, is now part of a private residence.

(Below) The lighthouse at Winterton, seen here when its lantern and gallery were intact, has been inactive since the 1920s. (MPL)

Gorleston

Established	1878
Current lighthouse built	1878
Operator	Great Yarmouth Port Authority
Access	On Pier Road, among shops on the promenade at Bush Bend, facing the entrance to the harbour; the pier is open to the public

The 69ft circular red-brick tower in Pier Road opposite the harbour entrance at Gorleston-on-Sea was built in 1878. It has a gallery and lantern with a red conical roof. The lantern itself is now unused but the fixed red light, visible for 6 miles, is displayed from the lantern room window. At a height of 23ft is a flashing white light which is displayed through a first-floor window. This light is the rear light working in conjunction with a front light mounted on a white metal pole on the roadside 115ft away. This white occulting light is housed in a red cylindrical casing on top.

In 1852 a fixed white light was displayed on the south pier and, in 1887, a 30ft iron and wood lighthouse, complete with lantern and gallery, was erected on the end. This tower displayed a fixed white light in addition to red and green navigation lights. When the pier was demolished in 1955, the tower was replaced by a series of lights fixed on the roof of the harbour master's office, situated at the end of the new south pier. This building is a 28ft-high two-storey concrete and brick structure, and is now occupied by the National Coastwatch Institution.

Gorleston lighthouse, situated among shops on the promenade, is a distinctive landmark in the town and dates from 1878.

Lowestoft

Established	1609
Current lighthouse built	1874
Automated	1975
Operator	Trinity House
Access	On the east side of the main A12 road into the town, on a bluff behind Lowestoft Ness, about a mile north of the harbour entrance

A pair of lights was first established at Lowestoft Ness in 1609. These candlelit lights, known as Lowestoft High and Low, were designed to mark the Stamford Channel. They were rebuilt in 1628 and again in 1676, when the High Light was moved to the clifftop on the north side of the town, its current location, as the Stamford channel no longer existed. The Low Light was disconnected in 1706 but reinstated in 1730 with oil lamps.

The lighthouse at Lowestoft, built in 1874 as the town's high light, is situated above Sparrow's Nest and the local maritime museum to the north of the town.

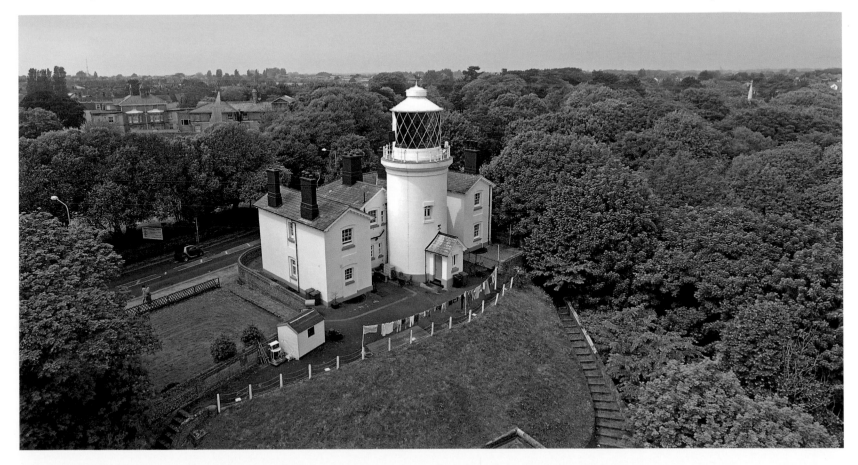

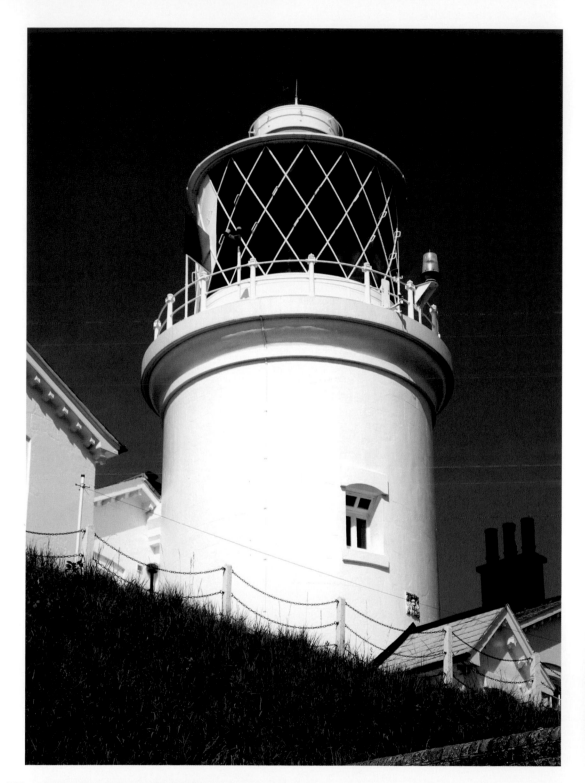

(Left) The lighthouse at Lowestoft, built in 1874 at a cost of £2,350, served initially as the town's high light.

(Below) The light on the northern side of the harbour entrance.

(Right) The two pier lights mark the entrance to Lowestoft Harbour.

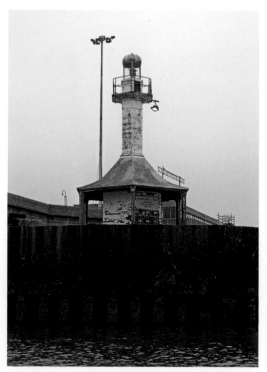

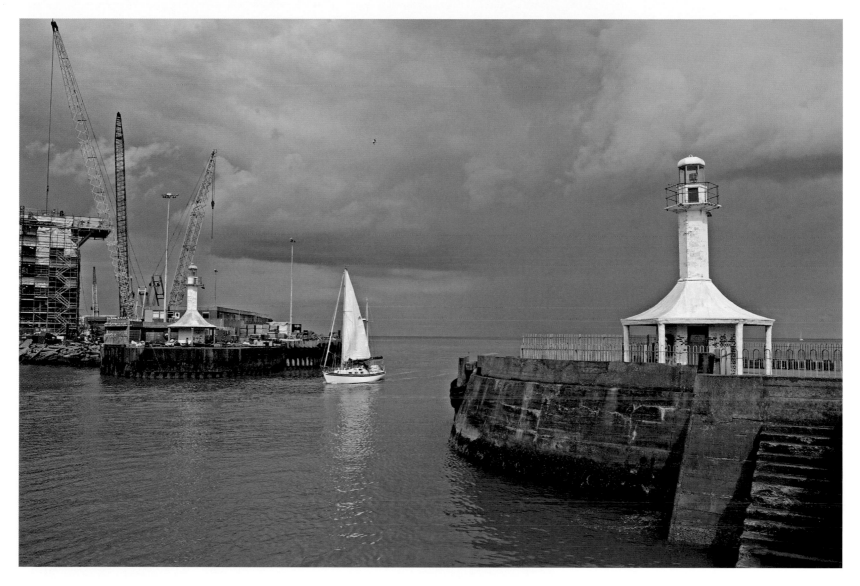

Both lights were converted to Argand lamps with parabolic reflectors in 1796. Before this, a unique experiment using a Spangle light was carried out at the high light. It consisted of a 7ft-tall, 6ft-diameter cylinder with 4,000 small mirrors and 126 oil lamps. The light was visible for 20 miles.

In 1874 the High Light was converted to electrical operation, a move that required the building of the white cylindrical 53ft tower, with accommodation adjacent that is used today. Adjacent to the tower, accommodation for the keepers was built. The construction work was carried out by Suddelay & Stanford, of Beverley. The light, which was automated in 1975, is visible for 23 miles. The Low Light was discontinued in 1923, having been moved a number of times during the nineteenth century as the foreshore shifted.

The local port authority maintains lights on each pier head. The pier lights are both white circular towers, 30ft in height, with covered aprons and seating at the base forming bandstand type structures. These lights, built in 1847 and known as Lowestoft East Pier and Lowestoft West Pier, have a range of 8 miles and can be viewed from the piers; the South Pier is open to the public.

Pakefield

Established	1832
Discontinued	1864
Access	On the cliff edge adjacent to the southern boundary of Pakefield Hall, the tower can be accessed from the beach or the land without entering the holiday park

The 30ft white lighthouse at Pakefield was first lit in 1832, when it had a range of 9 miles, but had a comparatively short life. By 1850 the channel it marked had shifted and so a light was erected 3 miles to the south at Kessingland, and in 1864 the Pakefield light was discontinued. The Kessingland light was extinguished in the early nineteenth century and no trace of it remains.

However, the Pakefield tower remained and it was sold in 1929 to the owners of Pakefield Hall. After the war, the tower was eventually purchased by Pontins, and in the 1960s was used by the camp's official photographers as a dark room. In 2000 a team of volunteers restored the tower and the lantern room was given over to the National Coastwatch for use as a Coastwatch Centre open to the public during the summer.

The lighthouse at Pakefield was built in 1832 and sold in 1929 to the owners of Pakefield Hall, which later became a holiday camp. Since 2000 it has been in use as a Coastwatch station after being renovated, and is now surrounded by chalets.

Southwold

Established	1889
Current lighthouse built	1889–90
Operator	Southwold Millennium Foundation
Access	In the centre of the town, tower open for guided tours during weekends, Wednesdays, and bank holidays from April to October

The lighthouse standing in the middle of the small town of Southwold is a landmark for passing vessels and guides craft into the town's harbour. The lighthouse is situated near the centre of the famous resort, nestling among rows of small houses in a picturesque setting. The site, beside the coastguard station, was described at the time as 'very advantageous, the smoke from the town will not obscure the light and its nearness to the cliff must make it very prominent all along the coast'.

Construction of the 101ft tower began in May 1889 under the supervision of Sir James Douglass, Engineer-in-Chief, and the light replaced three lighthouses which were under threat from erosion. While the round masonry tower was being built, a temporary light was shown from a wooden structure and this light was first displayed on 19 February 1889. It survived a fire in its original oil-fired lamp just six days after commissioning.

Once completed, the lighthouse came into operation on 3 September 1890 and was originally provided with an Argand burner. This was replaced by a Matthews incandescent oil burner in 1906. A Hood petroleum vapour burner was installed in 1923 and remained until the station was electrified in 1938 at which point it was de-manned. Two red sector lights, with a

Southwold lighthouse is now managed by Southwold Millennium Foundation who organise tours of the tower under licence from the Corporation of Trinity House.

range of 15 nautical miles, mark shoals to the north and Sizewell Bank to the south. The main navigation light has a 150-watt lamp giving a range of 24 nautical miles.

A locally based attendant visits the lighthouse regularly to carry out routine maintenance. The lighthouse was the site of charity abseil events in 2009, 2011 and 2013 to raise money for the Southwold lifeboat operated by the RNLI. The lighthouse has featured in television programmes, including an episode of *Kavanagh QC* and the children's television series *Grandpa in My Pocket*.

Southwold lighthouse, built in 1889, is one of the town's most prominent landmarks having been built as a coastal mark for passing shipping and as a guide for vessels sailing into Southwold Harbour.

Orfordness

Established	1634
Current lighthouse built	1793
Automated	1965
Decommissioned	2013
Operator	Trinity House
Access	About 3 miles south-east of Orford, reached by passenger ferry and hiking trail after the site was opened by the National Trust in 1995

Orfordness lighthouse, situated at the end of a 13-mile spit running parallel to the Suffolk coast, was formed by centuries of longshore drift. The dangers of the tides, banks and shoals in the area have claimed many ships. On one night alone in 1627, thirty-two ships were wrecked on Orfordness with few survivors.

In February 1634 John Meldrum was granted a patent, which later passed to Alderman Gore, to build two temporary lights to mark a safe passage through the gap between the Sizewell Bank and Aldeburgh Napes. Under a further patent granted during the reign of Charles II, Gore built two timber towers, the high rear light to burn coal and the lower front to exhibit a candle lantern.

Ownership passed to Sir Edward Turnour via marriage to Sarah Gore, and he secured his position by acquiring the land on which the lighthouse stood as well as a large area of Lantern Marshes to provide access to the site. But under Turnour and, after his death in 1676, his son, another Edward, the lights were badly maintained and complaints were often made by masters of passing vessels.

Orfordness lighthouse is a Grade II listed building, built in 1792. (Courtesy of Trinity House)

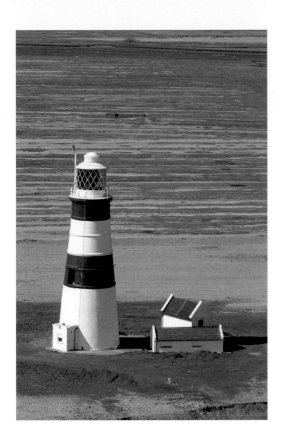

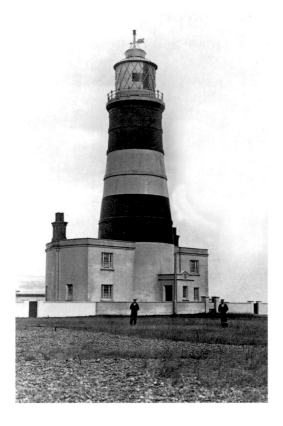

In 1691 the encroaching sea carried away the low light. It was duly replaced, only to be carried away by the sea again in 1709. In 1720 the lighthouses came into the ownership of Henry Grey, who organised the building of two new brick towers for £1,180. Four years later, the front light was destroyed by erosion, and so it was replaced by a movable structure. Between 1730 and 1790, two more towers had to be built to replace structures that had burnt down.

In 1792, a new 98ft brick tower was built by Lord Braybrooke, who had inherited ownership. Situated much further inland from the point of the headland, it became the great light and the previous great light then became the small light. This brick tower, designed by William Wilkins of Norwich and first lit on 6 May 1793, has become the operational light.

Under the Act of Parliament of 1836 which gave Trinity House compulsory powers to buy out private individuals who owned lighthouses, the corporation paid the 3rd Lord Braybrooke £13,414 for the lighthouse. In 1888, major alterations took place at the great light, or high light, which was made occulting with red and green shades fitted to form sector lights. At the same time, the lower tower was taken out of use and a new light established at Southwold.

Further alterations were made in 1914 when a new revolving lens was installed which is still in operation. It revolves around the lamp at a speed which appears as a flash every five seconds, with a range of 25 nautical miles. At the same time as this light was installed, another light was fixed halfway up the tower to act as the sector light.

In 1959 the lighthouse was converted to electric power and the keepers' dwellings, which were attached on either side of the tower, were demolished. A standby generator was then installed, along with remote control equipment. Time switches came into operation, the station became fully automatic on 6 July 1965 and on 20 September 1965 the keepers were withdrawn. The lighthouse is on land owned by the National Trust.

The lighthouse was decommissioned on 27 June 2013, because of the encroaching sea. The modern electrical equipment and hazardous materials were removed and Trinity House increased the power of Southwold lighthouse to compensate for the closure of Orfordness. Unless demolished, the Orfordness tower is expected to survive for only a few more years before falling into the North Sea as a result of erosion.

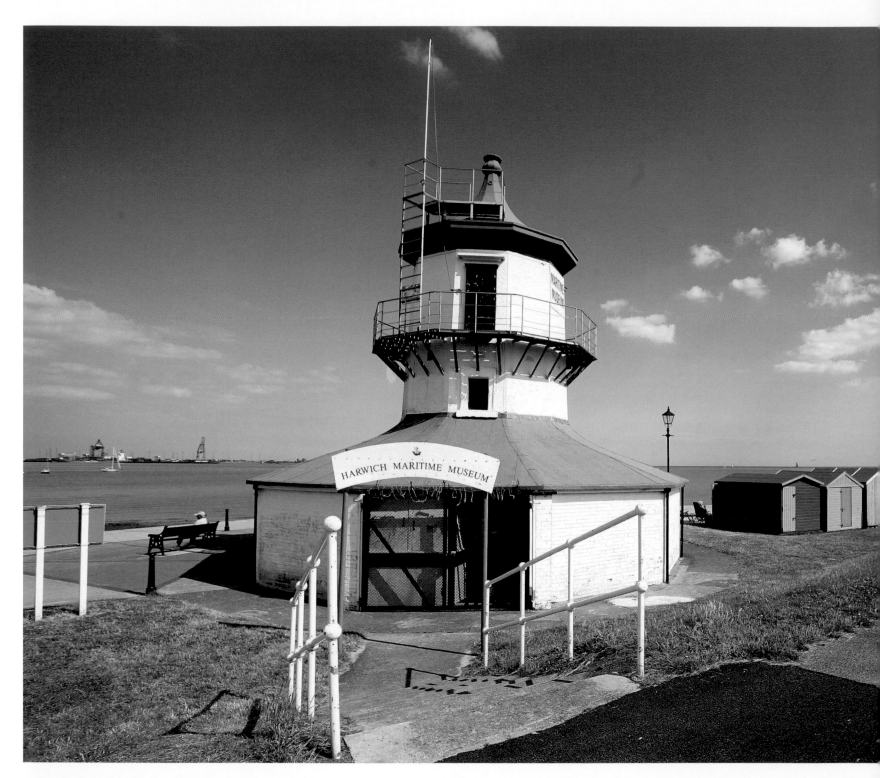

4 THAMES ESTUARY

Harwich

Established	1665
Current lighthouse built	1818
Deactivated	1863
Owner	Tendring District Council
Access	Low Light on the promenade by the Stour estuary; High Light about 200 yards away

In 1665 two lighthouses were built in Harwich to help guide ships through the entrance to the river Stour. The High Light was situated in the centre of town in what is now West Street, with the Low Light on what is now the promenade. After a succession of renewals, General Rebow was given a new grant in 1816 with the proviso that he not only improve the lights under the supervision of Trinity House, but also contribute 60 per cent of his profits to the upkeep of the church and the local street lighting. On the original sites, he built two lighthouses in 1818, both of which are still standing. He converted the High Light from coal and the Low Light from candle power to Argand lamps and reflectors.

The lights were of the same height as the old ones, but realigned by 9ft to the south-west. The High Light was a 70ft nine-sided brick tower with a pinnacle roof. A brick chimney extended above the roof on the landward side. Initially the white light was shown through a window 40ft below the top, with the upper section used

The 90ft nine-sided high light built on West Street in Harwich in 1818 was located near the site of an earlier light over the town gate. The tower is owned by Tendring District Council and leased to the National Vintage Wireless and Television Museum Trust.

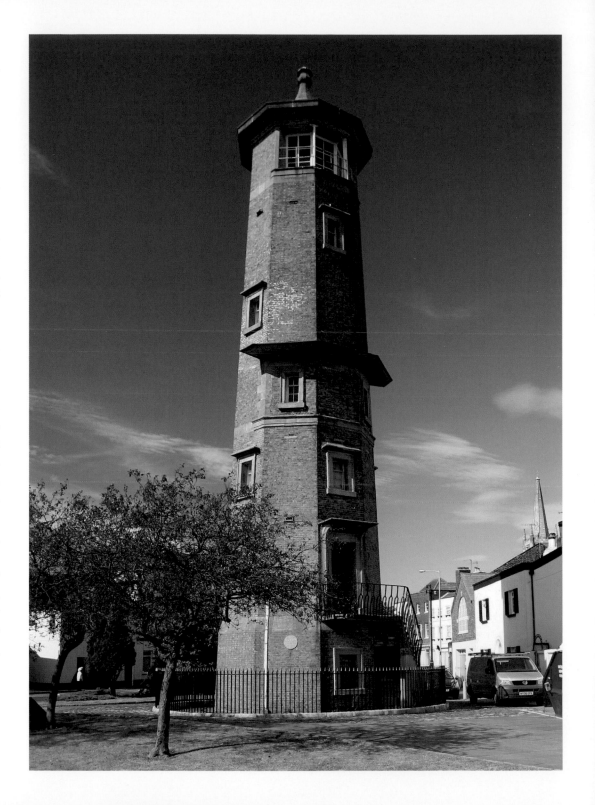

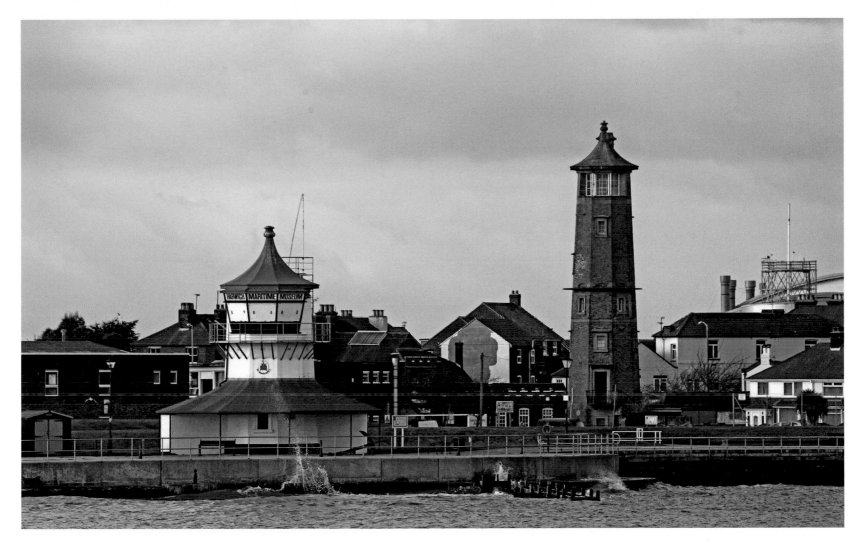

The two lighthouses at Harwich seen from the sea; despite being more than 100 yards apart, they appear close from the water.

as a landmark. However, after complaints that the lights were ineffective, the light was moved in 1822 to a window near the top.

The Low Light was an ornate octagonal tower on top of a brick shelter. Painted white, both the shelter and tower have a black roof. The light was shown through a window near the top but, after complaints, it was changed in 1819 from white to red to distinguish it from the High Light. The lights were taken over by Trinity House in 1837 but both were discontinued in 1863, when the continuing build-up of Landguard Spit rendered them ineffective.

Both were sold to Harwich Borough Council in 1909 to be kept available for possible future use as lights if necessary. The High Light was partially restored in 1974 and then, when leased to the National Vintage Wireless and Television Trust in 1991, completely restored and is open to the public, housing various exhibitions during the summer months.

The Low Light was, from 1970 to 1974, reclaimed by Trinity House as a pilot station. Now fully restored, it has been used as the Harwich Maritime Museum since 1980 and is now open daily as a museum from 1 May to 31 August, with nautical memorabilia, from photographs and paintings, on display.

Dovercourt

Established	1861
Discontinued	1917
Owner	Harwich Town Council
Access	On the seafront at Dovercourt

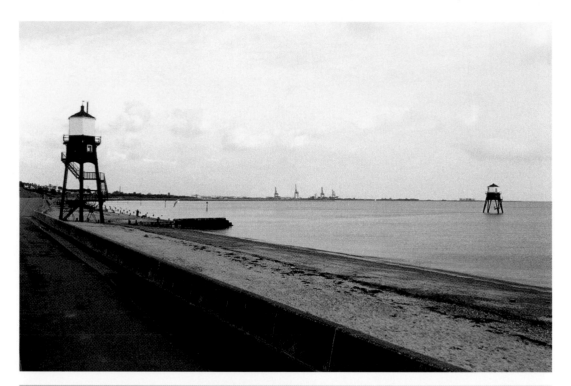

Dovercourt is essentially a southern extension of Harwich and, in 1861, a pair of lights was erected there to replace the Harwich lights which became ineffective after a changing of channels and the build-up of Landguard Spit. Both lights were erected on movable structures to enable them to be realigned if necessary.

The High Light, erected adjacent to the promenade, was a black-painted six-sided metal tower supporting a white lantern with black roof. An external ladder led to the first level with an internal stairway to the balcony and lamp room. The Low Light was a four-sided structure of similar construction, 200 yards to sea, approached by a causeway at low tide.

They were discontinued in 1917 and in 1922 sold by Trinity House to Harwich Town Council on the understanding that the lights would be demolished if they became unsafe. Two red lights were placed on the low light structure until it was dismantled. Both lights were restored between 1983 and 1988 and are now listed historic structures. In 2005, both were leased by the council to Tony O'Neil, who planned to open the High Light as a museum.

(Top) The two lighthouses at Dovercourt, inactive since 1917 and restored in the 1980s.

(Right) Dovercourt low light stands offshore from the High Light.

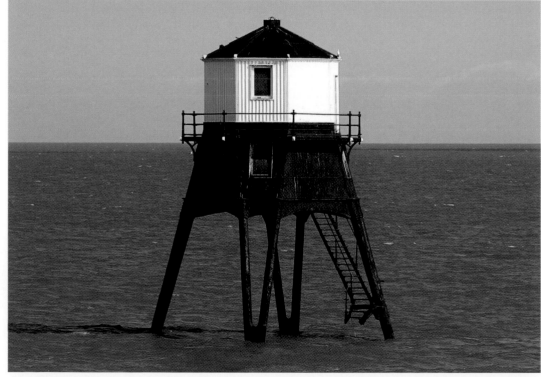

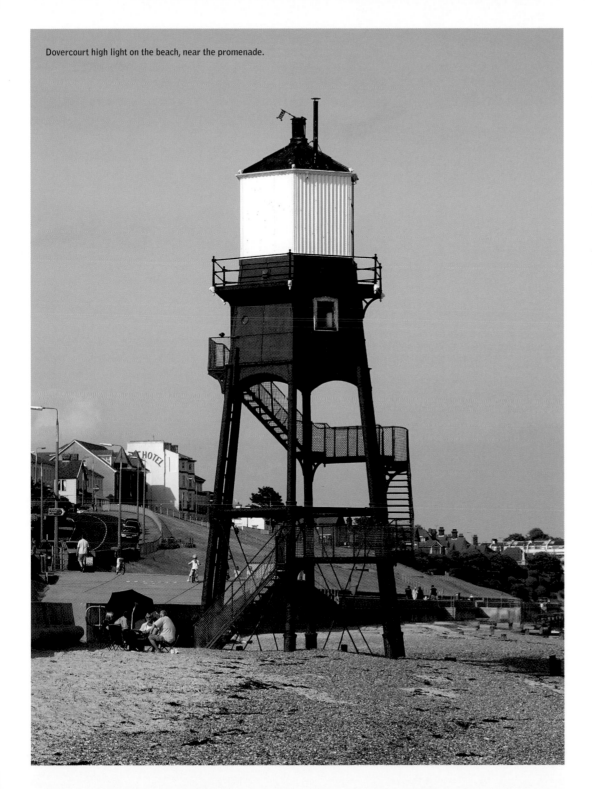
Dovercourt high light on the beach, near the promenade.

Naze Tower

Constructed	1720
Access	For a small charge the tower can be visited; it is usually open between 1 April and 1 November; for more information see: nazetower. co.uk

Naze Tower, situated to the north of Walton-on-the-Naze, near Walton Hall, was constructed in 1720 by Trinity House and, when lined up with Walton Hall, guided ships through the Goldmer Gap in the nearby shoals. However, there is some doubt whether and for how long the tower actually displayed an aid to navigation. If it was lit, a brazier on top with an open fire must have been used initially.

Information about its exact height is contradictory, with some records stating it was originally 90ft tall and others 86ft. Constructed of red brick, the tower was octagonal, in three sections, each of which was slightly narrower than the lower one. At the base it was 18ft 6in wide, and buttresses ran the full height, with the top castellated. Access was via an internal spiral staircase, which was illuminated by arched windows.

During the nineteenth century the top was rebuilt and reinforcing was added. At this time the tower was slightly reduced in height, creating doubt as to whether it is now 81ft or 86ft tall. Whichever it is, this Grade II listed building is the tallest such structure in the British Isles.

The tower has had a variety of uses. During the eighteenth century, when tea was an expensive commodity, the Rt Hon. Richard Rigby MP, owner of Walton Hall, used the tower to house exclusive tea parties. A century ago it

was used as a signal station by the Royal Navy, who adorned it with signal flags to communicate with other signal stations and ships. During the Second World War the Royal Air Force used it to house radar operators and a Chain Home Low radar dish was fitted on the roof.

Despite these activities, the tower deteriorated, until it was placed on the Buildings at Risk register. This resulted in a local family carrying out work on its full restoration in 2004, and as a result the tower was opened to the public as a tourist attraction. The highlight of the climb, via 110 steps, is the rooftop viewing gallery, which offers panoramic views over Essex and, on a clear day, as far as Kent.

Naze Tower is situated north of Walton overlooking the Essex coast. It houses a tea room, situated over eight floors up, as well as a museum, an art gallery and a shop.

Gunfleet

Established	1850
Decommissioned	1920
Owner	Gunfleet Sands Offshore Windfarm
Access	Only via boat

Gunfleet lighthouse is one of the few screw-pile structures that survive. It was erected in 1850 to mark the north entry into the Thames and the Gunfleet Sands, 6 miles off Frinton-on-Sea. The 74ft screwpile tower consisted of six outer piles and a single central screw pile driven into the unstable sand base. Designed by Trinity House, the lighthouse itself consisted of a red-painted hexagonal corrugated-iron accommodation block with, the light mounted in a small lantern room on top. The light, visible for 10 miles, was supplemented by a fog bell.

The tower was decommissioned in 1920 and replaced by a buoy. Although unoccupied since then, it was sound enough to be used by the proposed pirate radio station Radio Atlantis in 1974. The station was evicted just before Christmas that year without ever transmitting. Because it was situated just inside territorial waters, Trinity House and other authorities were able to take action against its operation. In 2002, meteorological equipment was installed in the tower as part of research into a proposed wind farm on the sands but the structure is now somewhat neglected.

The Gunfleet screw-pile lighthouse lying in the North Sea, 6 miles off the coast at Frinton-on-Sea , was constructed in 1850 and has been in existence for over 150 years. (Peter Webster)

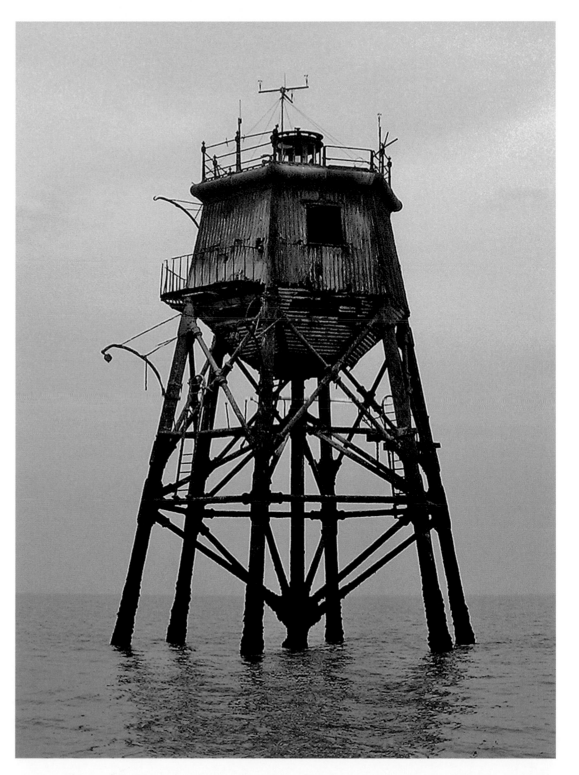

Thames Estuary

Ships approaching the lower reaches of the Thames were guided by a number of manned lighthouses, which no longer exist. Some were built on sandbanks on the Essex side of the estuary; the following were the most significant.

Maplin

The lighthouse on Maplin Sands was unique. It was built in 1838 through the efforts of a blind Irish engineer, Alexander Mitchell, who, in 1833, obtained a patent for a screw-pile lighthouse. Five years later, he constructed one on Maplin Sands, the first in the world. Designed to sit on sandy or muddy seabeds, it relied on 4ft-diameter screws on the end of 5in-diameter solid cast-iron piles to provide a firm base for the upper structure. At 69ft tall and 50ft in diameter, the Maplin light consisted of eight outer piles and a single central one to support an octagonal service area with the lantern showing a flashing white light in a circular room on top.

It is claimed that the screw-pile lighthouse in the river Wyre off Fleetwood (see p.316) was the first in the world and the first to show a light, but Maplin's screw piles were in fact in place before those at Fleetwood. When the West Swin moved its flow northwards, the lighthouse was undermined and in 1932 was swept away. In recent years, the southern edge of the sandbank has been marked by two light beacons, Blacktail

(Above) The Maplin lighthouse, a unique structure built in 1838, depicted in an old hand-coloured postcard.

(Right) The old Chapman lighthouse, situated on Chapman Sands, was demolished in 1958. (Courtesy of Michel Forand)

East and Blacktail West. Built in 1968, the 42ft towers, constructed of mild steel, show isophase green lights visible for 6 miles. Initially battery powered, they were for a time powered by experimental wind generators until they were converted to solar power in 1996. The lights are offshore and visiting them is not realistic.

Chapman

Situated on Chapman Sands near Canvey Island, Chapman lighthouse was erected in 1849. A screw-pile lighthouse designed by James Walker for Trinity House, the 74ft structure was supported on six outer piles and one central

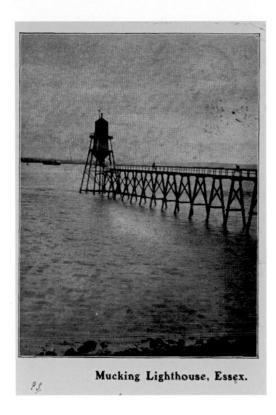

Mucking Lighthouse, Essex.

An indistinct view of the screw-pile Mucking lighthouse and the walkway which joined it to the shoreline.

PURFLEET, ESSEX.

Drawn by W Bartlett. Engraved by J Rogers.

Published by G. Virtue, 26, Ivy Lane, Jan'y 1,1832.

A line drawing of the now-demolished light at Purfleet overlooking the Thames. (Courtesy of Michel Forand)

cast-iron pile, had a red-painted accommodation block, consisting of a living room, bedroom, kitchen/washroom and storeroom with a lantern above, and displayed a fixed white light visible for 11 miles. It was later altered to an occulting light. During the two world wars, it was used as a marker for convoys leaving the Thames as they awaited an escort, but in the 1950s was undermined by the sea. In 1956 it was de-manned, and during 1957 and 1958 demolished. A single black buoy is now used, situated 800 yards offshore.

Mucking

On the eastern part of Mucking Flats, where Sea Reach gives way to the Lower Hope, a screw-pile lighthouse similar to that at Chapman was erected in 1851. Initially a 66ft black and white tower, it was raised to 70ft and painted red in 1881. Unlike Chapman, where the keepers had to row ashore, it was connected to land by a long footbridge supported on screw piles. The original coal-fuelled light showed a white occulting light with a red sector and was visible for 11 miles. It was replaced by the No.1 Mucking Buoy before the Second World War. As a result of the 1953 floods on the riverbed, and after being hit by the barge *Anglia*, the lighthouse was removed in December 1954.

Purfleet

An experimental lighthouse with a dwelling attached was built in 1829 on Beacon Hill, at Purfleet, to enable Trinity House to carry out experiments to determine the effectiveness of various lamps and reflectors. Later they tried different fuel sources and also evaluated the merits of reflectors and refractors together with different grades of glass. The lighthouse was only used infrequently and was abandoned in the late 1870s. Due to quarry working it was totally destroyed in 1925.

River Thames

Eight land-based lights are in operation on the Thames, and would be accurately described as unattended light structures rather than lighthouses. Erected and maintained originally by Trinity House, they were taken over in 1991 by the Port of London Authority (PLA), which is responsible for one of the busiest ports in the country. In all, the PLA maintains sixty-six aids to navigation and the land-based lights represent only a small percentage of the total navigation marks on the river. The following descriptions cover the lights in geographical order, starting on the Essex side, travelling west along the north bank and then east along the south bank.

Stoneness

Situated where the river bends into Long Reach, the Stoneness light was built in 1885. The 42ft square skeleton tower has a watch room just below the lantern which shows a green flashing light visible for 6 miles. The tower and lantern are red with the watch room white. A wind generator was mounted on top after it was converted from acetylene to electricity. It is possible to get reasonably close by walking the coast path across Thurrock Marshes.

Stoneness light on the south bank of the River Thames, close to the Dartford River Crossing.

Coldharbour Point

Coldharbour Point light, near Rainham Marshes, marks the bend between Erith Rands and Erith Reach. It was built to a standard design in 1885 and consists of a red 39ft lattice steel skeleton tower with a gallery and light on top. Access to the lamp, which shows a flashing white light visible for 3 miles, is via an external ladder. A footpath and track lead to this isolated light, but the whole area is essentially a landfill site.

Tripcock Ness

Outward bound on the southern side of the river, the first light is situated at the east end of Gallions Reach at Tripcock Ness. Built in 1902 to a similar red lattice steel design as Coldharbour, the 30ft tower shows a flashing white light visible for 8 miles and is surrounded by a red palisade fence and razor wire. Access is easiest by taking the coast path or the cycle track along the top of the flood defence embankment from Thamesmead Leisure Centre.

(Top) Coldharbour Point marks the bend in the Thames between Erith Rands and Erith Reach.

(Left) Tripcock Ness light is on the south side of the Thames.

Cross Ness

At the east end of Barking Reach is Cross Ness, where another standard design lattice steel light tower was built in 1895. The 41ft tower displays a flashing white light visible for 8 miles. It is surrounded by a palisade fence and situated in a housing estate. It is accessible via the estate or the embankment from the leisure centre.

Crayford Ness

At the east end of Erith Rand, where it gives way to Long Reach, is an unspectacular light at Crayford Ness. It was originally a stone-built structure erected in 1946 to the landward side of the sea defences in an industrial area. The stone tower was replaced by a standard red lattice steel tower in 1967. This tower was demolished in 1981 when the flood defences were improved and now the light is housed in a corrugated-iron shed halfway up the smaller, at 74ft, of the two Port of London radar towers on the embankment. These two towers are interconnected by a walkway from the top of the lighthouse tower. Two lights are shown

(Top) Cross Ness or Leather Bottle Point light stands in front of a housing development at Thamesmead.

(Left) The light at Crayford Ness is mounted halfway up the smaller of these two radio communication towers.

(Above) The light at Broadness, joined to the riverbank by a walkway with the container cranes at Tilbury in the background.

(Top right) The now defunct Northfleet Lower light on India Arms Wharf was built in 1883.

(Right) The operational light at Northfleet on top of a disused office block on Bevans Wharf, adjacent to the original light.

through a window, one flashing white, visible for 8 miles, and the other fixed white, visible for 3 miles. As with the other lights, this one can be approached via the coast path or the cycle track on the embankment.

Broadness

At Broadness, where the river takes a sharp bend from St Clement's Reach into Northfleet Hope, is a simple light mounted on a 43ft tripod connected to the land by a walkway. It was erected in 1975 to replace the previous standard lattice tower dating from 1885. Converted to electricity in 1981, the occulting red light is visible for 12 miles. The light is difficult to visit, as public footpaths across Swanscombe Marshes stop some distance away.

Northfleet

At the bend where Northfleet Hope gives way to Gravesend Reach, Trinity House established their first Thames light in 1859 on India Arms Wharf, at Northfleet, to guide inward-bound ships. A 53ft four-legged skeleton tower, it differs from the other lights in that it has a gallery and a lantern with the light shining through a window. The occulting light had both red and white sectors visible for 14 and 17 miles respectively. The red-painted tower has three circular equipment balconies mounted in stages up the tower. It was fuelled by acetylene, later converted to town gas, before being changed to electricity in 1975. This light was called Northfleet Lower

after a second light, Northfleet Upper, was erected in 1926 on the Associated Portland Cement Company's jetty.

The black and later white 27ft skeleton tower was demolished in 1972 and replaced by a light, still operational, on the top of an eight-storey semi-derelict office block on Bevans Wharf a few yards from the lower light. Northfleet Lower was discontinued in about 2001 and its duties passed to Northfleet Upper.

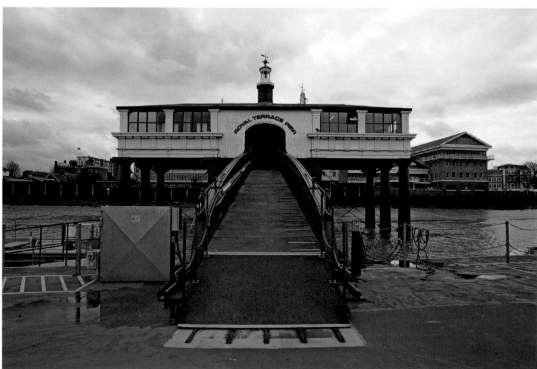

(Opposite top) The base on which the tower at Shornemead was built in 1913, with the modern Shornemead light in the background.

(Opposite bottom) The modern functional light at Shornemead dates from 2003.

(Opposite right) The Shornemead light of 1913 in store at Denton Wharf.

(Left) The light at the end of the Royal Terrace Pier at Gravesend. The pier is used by the PLA workboats and the lifeboats.

Shornemead

Situated about 2 miles east of Gravesend, on the junction between Shorne Marshes and Higham Marshes where Gravesend Reach gives way to the Lower Hope, is Shornemead light, also known as the Parson's Light The area's first light was erected in 1913 and consisted of a 48ft red cylindrical metal tower mounted on timber piles. It was connected to the land by a metal walkway, which was extended as erosion took place. By 2003, the light itself had been undermined and was leaning, and so it was replaced by a modern 50ft tower.

The new tower consists of a red and white circular tube with three galleries, each accessed via an external ladder. The flashing light is displayed from the upper one and has white, red and green sectors visible for 17, 13 and 13 miles respectively. The old light was fuelled by acetylene until converted to mains electricity. The new light, which is not connected to the land, is powered by solar panels mounted on the top gallery. The light can be seen from the Saxon Shore Way footpath. Since being replaced, the old light has been stored at Denton Wharf, which is inaccessible to the public.

Blackwall

Established	1854 as experimental lighthouse
Current	Lighthouse built 1864
Owner	Trinity Buoy Wharf
Access	The site at Orchard Place, Blackwall, is open to the public, the tower by arrangement

In 1804 Trinity House set up repair and maintenance workshops on the north side of the Thames adjacent to Bow Creek in Orchard Place, Blackwall. In 1854 they erected an experimental lighthouse to test various forms of illumination. In 1863–64, the depot was then completely rebuilt and the lighthouse was replaced by the one seen today. Designed by Sir James Douglass, it was never used as an aid to navigation but as a training and experimental facility. The discoverer Michael Faraday spent time there developing light sources.

Attached to the depot buildings, the hexagonal tower was about 35ft tall and topped by a white gallery and lantern. The top of the lantern was shaped to dispel the exhaust gases from experiments with various different fuels. The light source and optic were changed to suit the training or experimental exercises.

During the Second World War, the ship activity was transferred to Harwich but the workshops, which were damaged in bombing raids, were repaired and the repair and maintenance activities continued until 1988 when Trinity House transferred them to a state-of-the-art depot at Harwich. The Blackwall Depot site now provides artists' accommodation, having been once operated by the now-defunct Docklands Development Corporation.

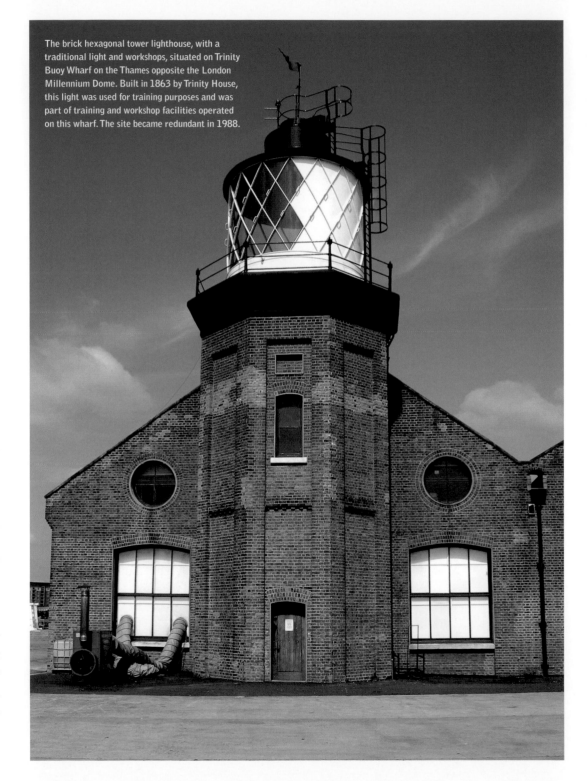

The brick hexagonal tower lighthouse, with a traditional light and workshops, situated on Trinity Buoy Wharf on the Thames opposite the London Millennium Dome. Built in 1863 by Trinity House, this light was used for training purposes and was part of training and workshop facilities operated on this wharf. The site became redundant in 1988.

Grain

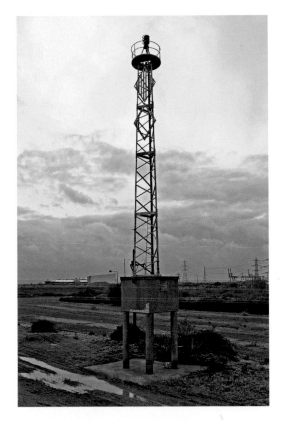

Established	unknown
Access	From the coastal path

Grain light on the Medway is a triangular 69ft lattice steel tower. Situated to the east of the power station on the riverbank, the tower has a gallery but no lantern. The quick-flashing light has white, red and green sectors visible for 13, 7 and 8 miles respectively. Although tracks lead to the rear of the station, walking from the public car park at Grain and along the coast path provides better access.

(Left) Grain light on the Medway is a triangular 69ft lattice steel tower located on the river bank east of the power station.

Whitstable

Established	1830
Discontinued	1950s

In 1830, two years before the port was officially opened, the railway line from Canterbury, known as the Crab and Winkle Line, was opened with its terminus on the East Pier. To assist boats entering the narrow harbour entrance, a pair of lights was erected on the 50ft white-painted brick chimney of the engine house. A fixed red light visible for 5 miles, which indicated when the harbour was closed, was placed in a copper lantern on a balcony at a height of 40ft. A fixed white light visible for 9 miles was mounted in another copper lantern on a 5ft-high tripod on top of the chimney. Originally oil fired, they were subsequently converted to electricity.

During the early twentieth century, the harbour fell into disrepair and in 1958 was purchased by the borough council. As part of the council's redevelopment, the buildings on the East Quay, including the chimney and its lights, were demolished. When the pier was reopened in 1965, the original lanterns were taken for display in the Whitstable Museum and Gallery. The only light now in use is a small navigational one situated on top of a metal pole on the East Quay, which helps guide ships and small vessels into the port.

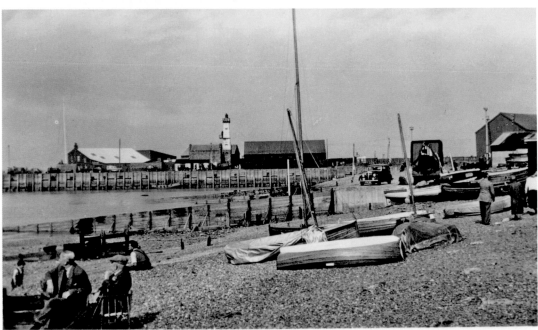

(Left) The lighthouse of 1830, among buildings on the East Quay at Whitstable, was demolished in the late 1950s. A rather insignificant pole on the East Quay displays the current light at Whitstable harbour.

5 KENT AND SUSSEX

Margate

Established	1828
Current lighthouse built	1954
Access	By walking along the pier , and also visible from the opposite side of the harbour

North Foreland

Established	1636
Current lighthouse built	1790
Operator	Trinity House
Access	Just over a mile north of Broadstairs on the B2052

The Royal Harbour of Margate was formed by the construction of an impressive 900ft-long stone pier in 1828. Near the end of the pier a 100ft Doric column supported a light in a cast-iron lantern room accessed via an internal spiral staircase. Built by Rennie and Jessop to the design of a Mr Edwards, it was topped by a weather vane, and stood as a local landmark until destoyed by the floods of 1953. The light was replaced in 1954 by a new 66ft hexagonal stone tower in the same location, designed by W.R.H. Gardner FRIBA. Built by Dorman Long & Co., it displays a continuous red light visible for 3 miles, which is housed in a lantern room and gallery. Mounted on a broad base, the light is a well-known local landmark.

The lighthouse at Margate, built in 1954, is situated at the end of the pier, which dates from the nineteenth century.

A light at North Foreland, on Kent's north-eastern point, was needed to mark the Margate Roads and the passage into the Thames. A navigation light was reputedly displayed there as early as 1499, although it was probably not lit continuously. Initially wood-fired in a swape, it was replaced by twenty-four candles in a lantern

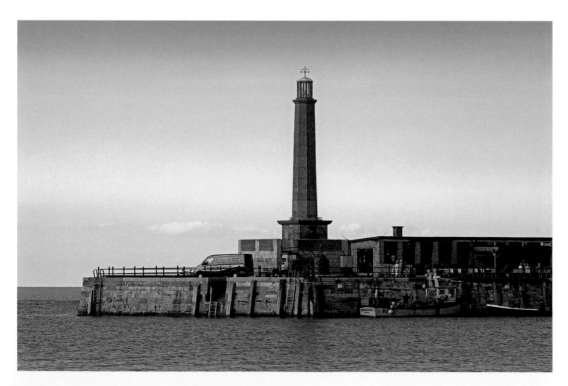

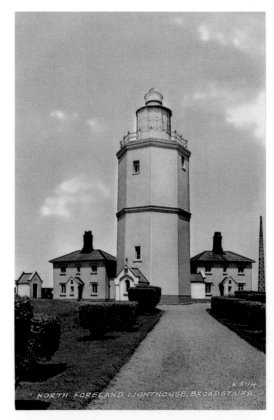

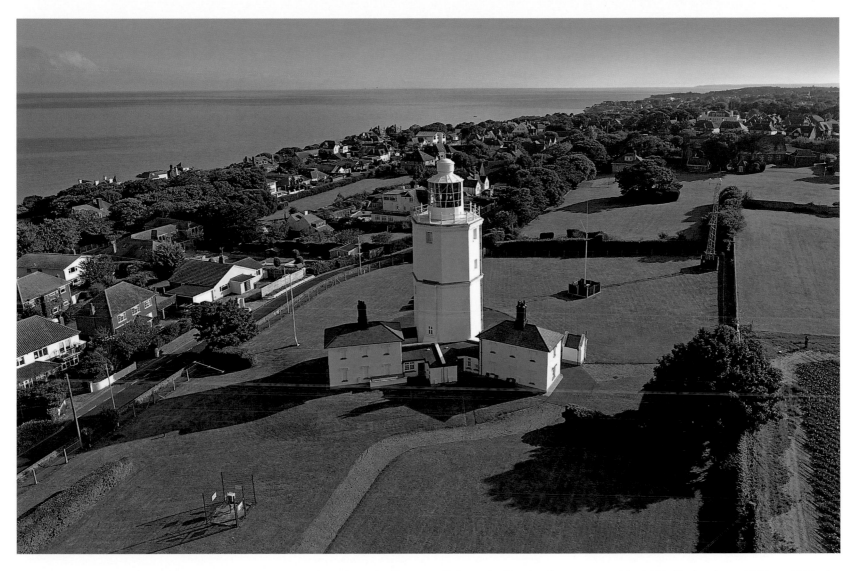

(Above) The lighthouse at North Foreland stands in immaculately kept grounds and shows a white light with a range of 19 nautical miles, along with two red sector lights of 16 and 15 nautical miles respectively.

(Left) North Foreland lighthouse in the 1960s. It had been modernised in 1866 to the design of James Walker, Engineer-in-Chief to Trinity House, and his alterations gave it the appearance that it retains today.

on top of a pole. The next light at the Foreland was built after Sir John Meldrum had obtained a patent from Charles I, opposed by Trinity House, to place lights at both North and South Foreland and charge ships passing between the two. A tower was built of wood in 1636, but it burned to the ground in 1683.

Following a period with a temporary candle-powered light, a new 39ft flint and brick octagonal tower with a coal fire basket was

erected in 1691. From about 1728 to 1730, the light was enclosed in a lantern but this proved unsuccessful and it was returned to an open fire. In 1793, the tower was increased in height by two storeys and a revolutionary new lens, designed by Thomas Rogers, installed in the lantern. Oil fired, it was not a total success and was replaced in 1834.

By then, the station had come under Trinity House control having in 1832 become one

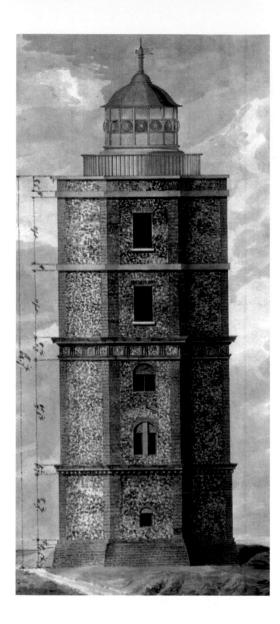

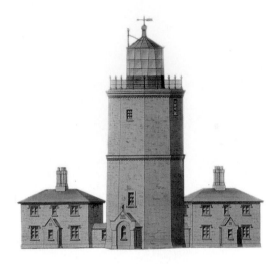

(Above) Drawing of North Foreland lighthouse prepared by Trinity House.

(Left) The tower at North Foreland as it was in the eighteenth century when owned by the Trustees of Greenwich Hospital. In 1832 it passed to Trinity House, which paid the hospital £8,366 for this and the light at South Foreland.

Established	1795
Current lighthouse built	1842
Operator	Ramsgate New Port
Access	It is possible to walk the West Pier and the East Pier has no restrictions

Although an important harbour since medieval times, not until 1779 were Ramsgate's East and West stone piers constructed to form the outer harbour. In 1783, John Smeaton drew up plans for a lighthouse on the end of the West Pier but he died in 1792 without completing the project. The lighthouse was built in 1795 by Samuel Wyatt and consisted of a 34ft circular tower of Cornish granite on a granite base. The light was displayed in a lantern room with a gallery.

In 1842 it was decided to replace this tower with a 38ft circular stone lighthouse set a short way back from the end of the pier. Operating as a rear range light, it shows a fixed red light, visible for 4 miles, when less than 10ft of water is in the harbour, and a fixed green light at other times. The lantern room is painted red with an ornate roof.

The front range light is attached to a 13ft slender red and white cylindrical pole on the end of the East pier and shows a white occulting light visible for 4 miles. Two rock breakwaters extend from the harbour, on the end of which are two 30ft cylindrical towers each carrying solar-powered lights. The North Breakwater has a green and white banded tower with a quick-flashing green light, and the South Breakwater tower has red and white banding with a red light.

The well-proportioned lighthouse at Ramsgate was built to the plans of well-known lighthouse designer John Smeaton.

although it was converted to electricity in 1920. The occulting light has a white sector visible for 19 miles, with two red sectors visible for 16 and 15 miles.

During the 1990s the station was an area control centre and the keepers were responsible for lightvessels in the Dover Strait as well as other land-based lights. North Foreland had the distinction of being the last lighthouse to be automated when, on 26 November 1998, the keepers left. A ceremony was held to mark the occasion, which was attended by Prince Philip.

The keepers' cottages are now holiday homes available for letting, while the lighthouse itself was opened to the public by the East Kent Maritime Trust in 2000. It is open to visitors at weekends from Easter to September, with additional openings in July and August.

of the first lighthouses which the corporation took over. In 1866, the tower was modernised, rendered and painted white. The keepers' accommodation was moved from the tower to two purpose-built keepers' cottages joined to the tower by a short passage. The lantern room on top contained a multi-wick burner and first-order catadioptric fixed lens that is still in place,

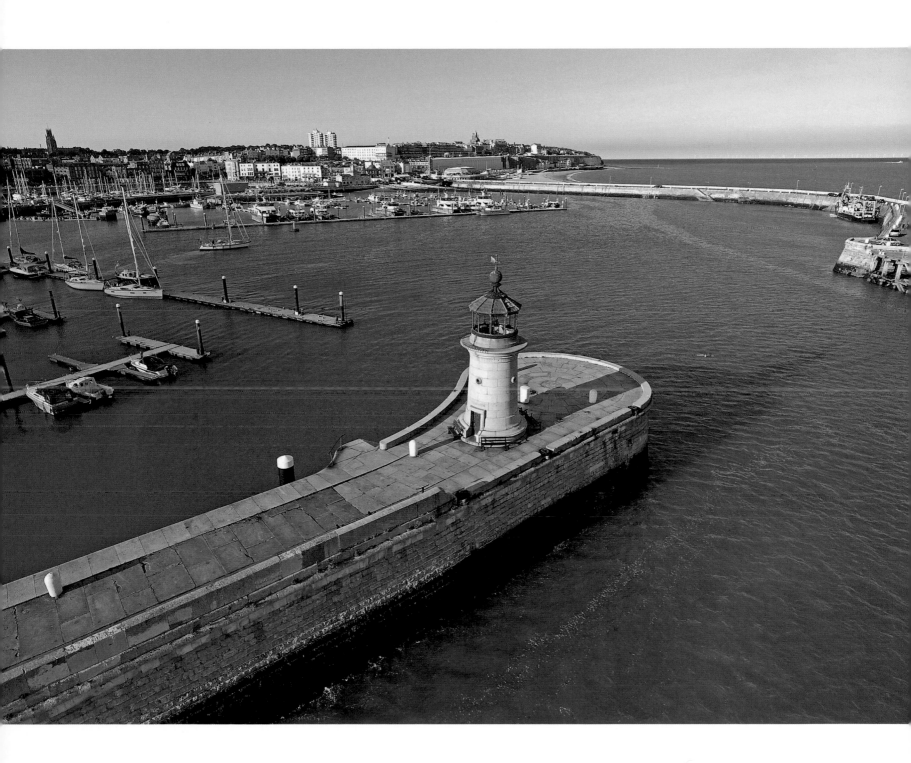

South Foreland

Established	1636
Current lighthouse built	1842
Discontinued	1988
Operator	The National Trust
Access	The high light is open March to October, and is reached by a walk of a mile from St Margaret's-at-Cliffe, or 2 miles from the National Trust car park; the low light can be seen from a distance of a quarter of a mile to the south-east

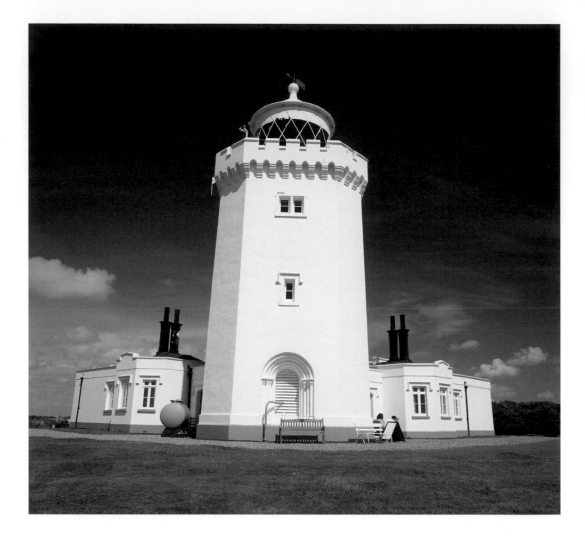

Although a navigation light at South Foreland was reported as early as 1367, when Brother Nicholas de Legh hung a lantern in a hermitage cut into the cliff to guide ships to safety, it was not until 1636 that a lighthouse was built on the cliffs overlooking St Margaret's Bay. Its construction followed a legal wrangle which resulted in Sir John Meldrum obtaining a patent to place lights at both North and South Foreland and charge ships passing between the two. Meldrum built two lights at South Foreland, one well back from the cliffs and the other 230ft from the cliff edge. When aligned, the two lights marked the treacherous Goodwin Sands. Built of wood and plaster, the towers housed open fires in fire baskets.

From about 1719 to 1730 the lights were enclosed in a lantern, but this proved unsuccessful and so they were returned to open fires. The lights were enclosed again in 1793, when they were converted to sperm oil lamps with reflectors. The high light was rebuilt in 1843 by James Walker to a Trinity House design typical of the period, with two attached kepers' dwellings joined by short corridors to the 69ft octagonal stone tower. The lantern was enclosed in a circular lantern room with a stone gallery.

The lighthouse is well known for the many experiments carried out there and, in December 1858, was the first to show an electric light using Professor Holmes's magneto-electric lamp followed by Dr Siemens's dynamo. In 1873, the main light was converted to electricity while sirens and gunshots were also tested as a fog signal over several years. Perhaps the most important experiment was carried out by Marconi on Christmas Eve 1898, when he successfully spoke by radio to the Goodwin Sands lightvessel.

In 1904, when the low light was discontinued, the high light was transformed from a fixed light to a rotating first-order Fresnel lens with a beam visible for 26 miles. The lighthouse was decommissioned in 1988 and then sold to the National Trust. The lamp and its rotating mechanism were removed, but in 2000 it was returned by soldiers of 1st Parachute Regiment, who carried it up the winding staircase so that it can be seen today.

Visitors can take a guided tour of the lighthouse, which offers not only the story of

the tower but also affords spectacular views from the tower's balcony of the famous White Cliffs of Dover and of St Margaret's village, with completely uninhibited views across the Channel.

The low light was rebuilt in 1846 to a similar design, although the attached dwellings are no more. Decommissioned in 1904, the 49ft stone tower and empty lantern room still exist in a private garden not accessible to the public, and are now almost derelict.

(Left) The octagonal lighthouse at South Foreland, decommissioned in 1988, is now owned by the National Trust and stands on the famous White Cliffs, near St Margaret's-at-Cliffe.

(Below) The South Foreland low light built by Trinity House in 1843 was 1,000ft nearer the cliff edge than the high light.

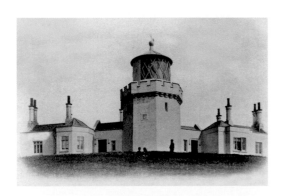

Dover

Established	1842 (harbour)
Current lighthouses built	1902, 1908, 1909
Operator	Dover Harbour Board
Access	Admiralty Pier can be walked after payment of a small fee and walking to end; Prince of Wales Pier is no longer open to the public; neither breakwater light is accessible , but all lights can be seen at a distance from various places around the busy ferry port, including from the ferries.

From Roman times there were lighthouses to guide ships into the port of Dubris, as it was then known. Between about AD 40 and AD 120 the Romans built two fortified octagonal rubblestone towers, known as the Eastern and Western Pharos, on cliffs either side of the harbour. The Western tower is now just a small mound known locally as the Brendon Stone. Part of the Eastern tower stands within Dover Castle and, at 46ft, is the tallest Roman ruin in Britain. Originally an eight-storey, 80ft tower with an open fire on top, it is now only three storeys, with part of a fourth also remaining.

The first references to harbour lights at Dover were made in 1842 for the North Pier and 1852 for the South Pier. In the early 1900s the port was extensively developed and the South Pier light was demolished when the Admiralty Pier, as it is now called, was extended to its current length and the current light erected on the end in 1908. This consists of a white, round, 72ft conical cast-iron

(Top) The lighthouse on Admiralty Pier dates from 1908.

(Right) Breakwater Knuckle light, Dover.

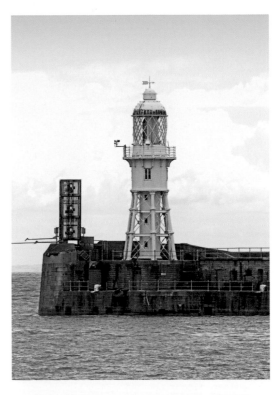

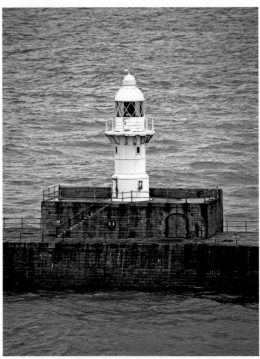

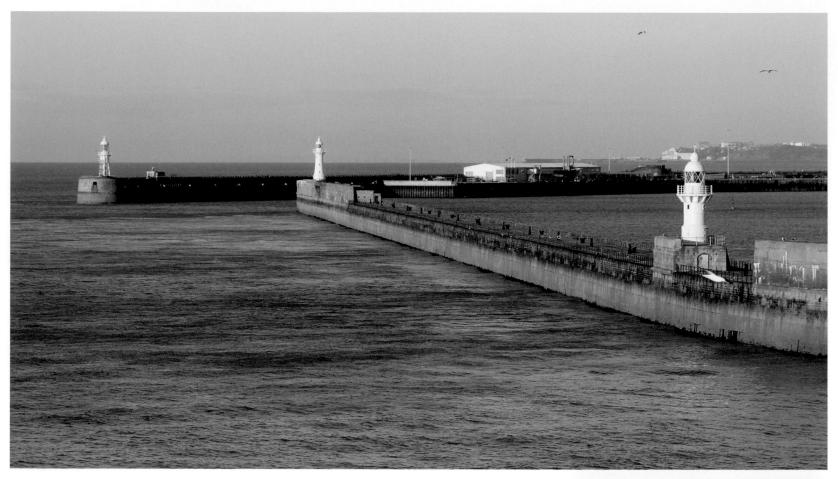

The entrance to Dover Harbour, with the three lighthouses marking the various breakwaters. The harbour has four significant lighthouses: the Prince of Wales Pier Light in Dover harbour was built in 1902, public access to the pier is no longer possible; the lighthouse on Admiralty Pier dates from 1908 and is at the end of the 4,000ft pier; the Breakwater Knuckle light is situated on the breakwater which forms the outer limits of Dover harbour. Dover's main breakwater was built in 1904 and is detached from the land. To mark the breakwater's western end and the western-most entrance to the harbour, this prefabricated lighthouse was erected in 1909.

structure complete with a lantern and gallery showing a flashing white light visible for 20 miles.

The light on the north pier was replaced by the current Prince of Wales pier light in 1902.

This 46ft circular stone tower has a white lantern and gallery which holds a quick-flashing green light visible for 4 miles. Two lighthouses were erected on the southern breakwater when it was built in 1909. The Southern Breakwater West Head, a 73ft cast-iron circular tapered tower with a white lantern and gallery, shows an occulting red light visible for 18 miles.

On the knuckle, a further white circular cast-iron lighthouse, known as Harbour Knuckle Light, was erected in the same year. This 52ft tower stands on a square stone base and has a similar lantern and gallery. Its flashing light, visible for 13 miles, has red and white sectors.

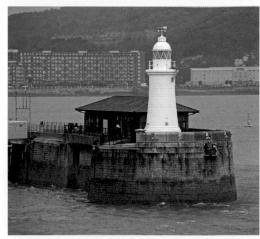

The Prince of Wales Pier Light in Dover harbour.

Folkestone

Established	1848
Current lighthouse built	1860
Operator	Folkestone Port Authority
Access	The tower can be seen from several points in the town and by walking along the pier from a flight of stairs at the end of the abandoned railway station's platform

In 1848, a rather ornate white-painted square wooden 41ft lighthouse was built on the end of the old harbour pier at Folkestone. In addition to its white flashing light visible for 13 miles, it had a square observation post on top. When the new breakwater was built in 1860, it became redundant, being eventually demolished in 1942 to make way for a gun emplacement.

It was superseded by a 28ft tapering circular stone tower on the end of the breakwater. Built in 1860, this tower has a white-painted lantern room and gallery on top, with the white flash light shown twice every ten seconds; however, during in fog or reduced viability the characteristic changes to one white flash every two seconds. The electronic foghorn mounted on the front of the stone tower gives four blasts every sixty seconds and replaced a diaphone housed in the lantern roof above the light. In 2005 the harbour area was purchased and redeveloped by Roger De Haan in a partnership with Sea Street Project. A walkway was constructed to give access to the lighthouse. The lighthouse was completely refurbished in 2011, when it was cleaned, repainted and the glass panes in the lantern were replaced as they had become smashed and dirty.

The lighthouse at the end of the pier is now called Folkestone Harbour Breakwater Head.

Dungeness

Established	1615
Current lighthouse built	1961
Automated	1991
Operator	Trinity House
Access	The sites can be easily visited, and the 1904 lighthouse, now in private hands, is open to the public during the summer

The long shingle bank known as Romney Marsh, with Dungeness at its tip, was the cause of hundreds of shipwrecks, particularly as the spire of Lydd church once caused confusion to sailors. To aid the mariner, no fewer than seven lighthouses have been built at Dungeness, five high and two low, with the fifth high one still operational. In 1615 Sir Edward Howard obtained a patent and erected a light near the tip. Initially coal fired, it failed to pay its way as dues proved difficult to collect. So Howard sold the patent to William Lamplough, who collected dues via the Customs House at nearby ports.

Converted to candle power, the light was criticised by Trinity House as being a nuisance to navigation and so in 1635 Lamplough replaced it with a 110ft wooden tower with keepers' quarters nearer the sea. He also reverted to an open coal grate but, due to the ever-shifting shingle, the sea gradually got further and further from the light. Trinity House insisted it be re-sited so, in 1792, Samuel Wyatt built a 116ft stone tower to the same design as Smeaton's Eddystone, 100 yards

(Top) The black-painted old lighthouse at Dungeness was built in 1904 and was decommissioned in 1961.

(Right) The current lighthouse at Dungeness was built in 1961; the tower is 131ft in height.

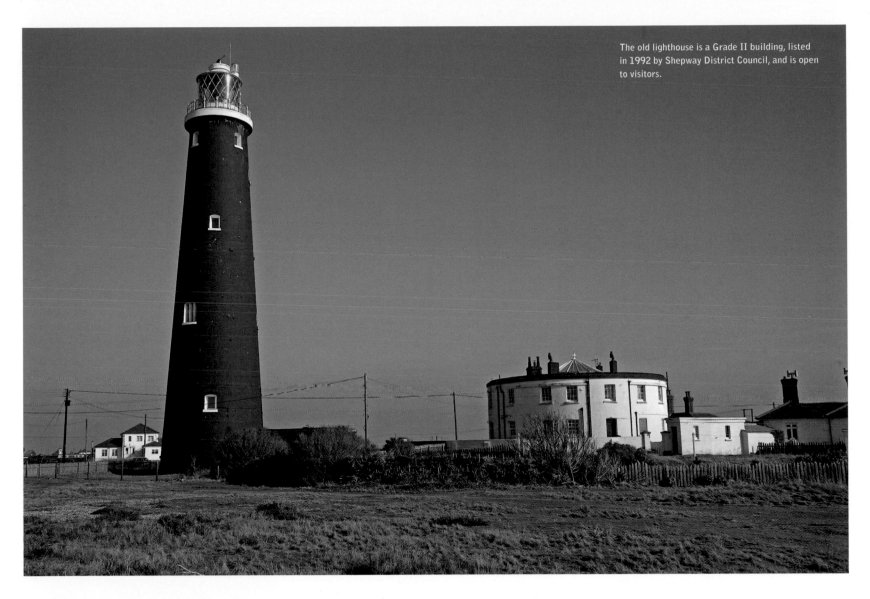

The old lighthouse is a Grade II building, listed in 1992 by Shepway District Council, and is open to visitors.

from the new shoreline. The light source was sperm oil lamps, but in 1862 it was converted into one of the first electrically powered lights. It was, however, restored to oil lamps in 1875.

By then it was about 400 yards from the shore, so Trinity House placed a movable low light on the end of the spit and the tower became the high light. Also oil fired, the low light showed a very quick flash. By the turn of the century, however, the high light was even further from the sea so, in 1904, the tower was demolished. In its place the tower now known as Dungeness Old Light was erected between 1901 and 1904, and was first lit on 31 March 1904. The circular keepers' accommodation built round the base

(Right) A mid nineteenth-century engraving of the 1792 tower which lasted for more than a century.

DUNGENESS LIGHTHOUSE.

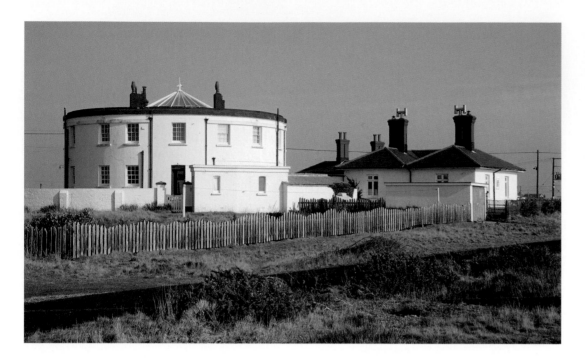

The circular keepers' building built round the base of the 1792 tower remains standing, sited between the two existing lighthouses, with the early twentieth-century keepers' cottages also still in existence.

Rye Harbour

Established	1864
Discontinued	circa 1970
Operator	Environment Agency

Rye became one of the Cinque Ports in the fourteenth century and today its harbour, which is situated halfway between the town and sea and is three quarters of a mile inland, is tidal. In 1864, the harbour master erected two lights

The Lighthouse, Rye Harbour.

of the 1792 tower remains between the two existing lighthouses.

At 143ft in height, the Old Light is one of the tallest lighthouses in Britain. Built by Pattrick and Co. of brick with a lantern room and gallery, it was originally painted with broad black and white bands, but is now all black. The building is almost 46m high to the top of the weather vane, 11m in diameter and constructed of engineering bricks with sandstone inner walls. Over 3 million bricks were used in its construction. The revolving lens gave a white flashing light with red sector visible for 18 miles. At the same time, the movable low light was replaced by a static white cast-iron circular tower on top of a white oblong brick fog signal building 400 yards from the high light.

When the nuclear power stations obstructed the light in 1961, the 1904 light had to be replaced. A 131ft circular concrete tower, impregnated with bands of black and white pigment, was erected, housing a fog signal just below the lantern. The tower was initially equipped with xenon electric arc lamps but these were not a success and were replaced by an array of sealed beam units which had a range of 27 miles. In 2000 the lighthouse was refurbished and a revolving optic was installed which gave the beam a reduced range of 21–27 miles. The tower is floodlit at night both as an additional guide to shipping and to reduce bird losses. Dungeness Lighthouse was converted to automatic operation in 1991.

Hastings

Established	Unknown
Operator	Local council
Access	The rear range light is in a park overlooking the town

on masts 930 yards apart with the rear one adjacent to his office. These lights were coded to indicate the depth of water in the harbour.

By the nineteenth century, the rear light had been replaced by a 20ft concrete tower that exhibited lights by night and balls and flags by day. This tower was destroyed in 1918 and a short while later was replaced by a hexagonal 40ft concrete tower with the old lights displayed from two windows. Visible for 3 miles, the light configuration indicated the depth of water over the bar into the river.

This light was demolished about 1970 and in 1971 was replaced by an occulting white and green polycarbonate light on a tripod. The front light was replaced by a quick-flashing green light on a square structure on the end of the east pier which is submerged at high spring tides. Today the depth of water over the bar is signalled from the roof of the harbour master's office.

Although Hastings now has no harbour, the largest beach-launched fishing fleet operates from the shingle banks known as the Stade. As an aid to navigation, the local authority maintains a pair of range lights. The rear range is a unique white-painted pentagonal close-board structure on a black concrete base with a sloping roof and pinnacle within West Hill recreational area, off Wellington Road.

Although only 20ft tall, the tower is in an elevated position which gives the light a focal plane of 160ft. Its fixed red light, shown through three elliptical windows, has a range of 4 miles. The front range is a simple fixed red light mounted on a 20ft tower 1,170 yards away on the seafront, with a range of 4 miles. Both lights can be approached on foot.

(Below) The small rear-range white-painted lighthouse at Hastings overlooks the beach on the west side of Hastings Old Town, from where the fishing fleet operates.

(Left) This lighthouse at Rye Harbour was in use from around 1918 until 1970. The lights were displayed from the two windows at the top of the concrete tower and were visible for 3 miles. Different colours were displayed to indicate the depth of water over the bar into the river: green for a depth of 7ft, red for 8ft, red and white for 9ft and white for 10ft or more. No light was shown when the depth was less than 7ft. This tower has been demolished. (Courtesy of Michel Forand)

Royal Sovereign

Established	1875
Current lighthouse built	1971
Automated	1994
Operator	Trinity House
Access	No public access is allowed onto the platform itself but trips to the site can be made on trip boats from Sovereign Harbour at Eastbourne

From as early as the eighteenth century, lightvessels have marked the many shoals and sandbanks that stretch as far as 20 miles out to sea off England's south and east coasts. Because of their high maintenance costs, they have been continually reviewed, with some retained and others replaced by buoys. One, however, Royal Sovereign, situated 5½ miles east of Eastbourne, was replaced by a fixed light.

The first lightvessel to mark the shoal was placed in position in 1875, and in 1966 Trinity House investigated the feasibility of a steel light tower to replace it. The lowest tender was for a concrete structure and so, in 1967, a tender was let to Christiani and Nielson. The concrete base tower was constructed in two sections on the beach near Newhaven, and in 1970 the lower

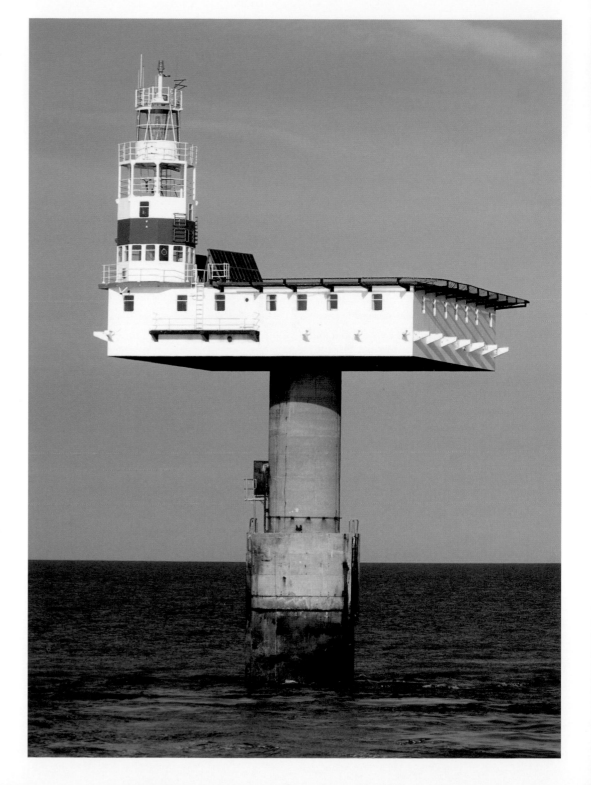

The Royal Sovereign tower with lantern and keepers' quarters supported by a cylindrical concrete column. The roof of the keepers' quarters is a helipad. The station is about 5½ miles from Eastbourne.

Beachy Head

Established	1670
Current lighthouse built	1902
Automated	1983
Operator	Trinity House
Access	Viewed by boat, trips run from Eastbourne; or from the cliffs but with care

section was sunk onto the bank with a smaller diameter inner section mounted on hydraulic rams inside. The rectangular service and accommodation section was also constructed ashore and, when completed, towed out and positioned on the centre section, which was then jacked up 40ft and locked in position.

The light tower, painted white with a horizontal red band, was constructed of steel and is located on one corner of the roof of the living quarters. The whole structure is 130ft high with the light 92ft above mean high water. The top of the lamp room is adorned with aerials including radar to monitor shipping. Initially the light was diesel powered with its rotating flashing white light visible for 28 miles. However, when automated and de-manned in 1994, it was converted to solar power with the range reduced to 12 miles.

With the need to abandon Belle Tout lighthouse in 1899, described below, Trinity House turned its attention to an alternative site and eventually chose one at the foot of the cliffs at Beachy Head for a lighthouse built to the design of Sir Thomas Matthews. A large coffer dam was erected to enable the removal of the surplus chalk which had fallen from the cliffs and therefore create a firm foundation. A steel wire was also erected from a steel platform on the shore to another on the top of the cliff. This allowed the pre-formed granite blocks to be lowered down the cliff on

a bogie. They had been shaped in Cornish quarries, brought to Eastbourne by train and driven to the site by traction engines and trailers.

The 142ft tapering tower with gallery and lantern was completed in 1902 and a light first displayed from it on 2 October that year. The tower, with its seven floors, was painted white with a broad red horizontal band. The large landing stage and base of the tower were left unpainted. For over 100 years, the white flashing light has shown its beam without incident, apart from during the war years.

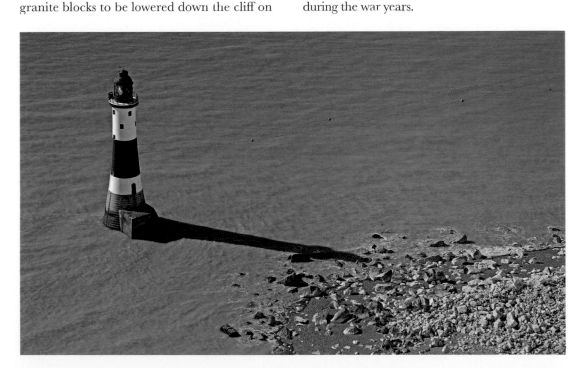

Beachy Head lighthouse stands at the foot of the famous Seven Sisters Cliffs, 3 miles west of Eastbourne, and is one of the outstanding landmarks in the area.

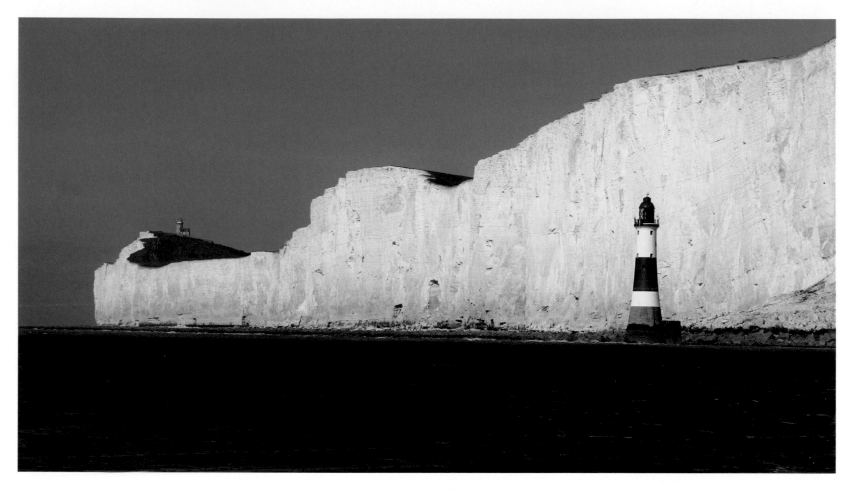

Beachy Head lighthouse as seen from the sea, with the old Belle Tout tower on the cliffs to the west.

During the Second World War, the light was extinguished unless a request came from the naval authorities for it to be shown to guide aircraft home. The problem was that it took almost fifteen minutes to light the paraffin vapour burner, the light source for the first-order optic. To overcome this, a keeper had the idea of removing the burner and illuminating the light by placing the kitchen light on a temporary wooden platform. It did not give a full light but was sufficient to be seen from an aircraft. As the light was probably only required for, at most, five minutes, it was easy to quickly extinguish it.

In 1975 an electricity cable was erected from the clifftop and the tower provided with electrical power. The paraffin burner and explosive fog gun were replaced with electrical units and now the light, which gives a flash every twenty seconds, is visible for 20 miles and the foghorn sounds every thirty seconds.

In 1999 a cliff fall severed the electricity supply to the lighthouse so a temporary generator was installed on a platform until new cables could be completed. At the same time, the system was modernised with new lamps, fog signals and emergency lights.

In 2011 Trinity House announced that it could no longer afford to repaint the distinctive red and white stripes. Because modern vessels have GPS navigational systems the day-marker stripes are no longer essential. However, a sponsored campaign to keep the stripes was launched in October 2011 raising £27,000. The tower repainting was completed using a team including two abseilers. Five coats of paint were applied to the copper lantern at the top and three on each hoop of the tower.

Belle Tout

Established	1828
Current lighthouse built	1834
Discontinued	1899
Operator	Private residence
Access	The lighthouse is on the downs and easily approached via the coast road

Although a beacon on the cliffs near Eastbourne may have been in use in around 1670, not until 1828 did local man 'Mad Jack' Fuller, under the auspices of Trinity Corporation, build a wooden lighthouse on the cliffs 3 miles west of Eastbourne at Belle Tout. Six years later, in 1834, he replaced it with a 47ft circular granite tower 100ft from the cliff edge. The flashing white light, housed in a white lantern room with gallery, was powered by thirty oil lamps and, in clear weather, could be seen for 23 miles.

Although at first the cliff edge cut off the light to any boat that ventured too close to the foot of the cliffs, subsequent erosion meant that vessels could be on the rocks yet still see the light. The light was 250ft above sea level, which meant that the frequent fog and sea mists often obscured the light, making its use questionable.

As a result, in 1899 Belle Tout light was discontinued and replaced three years later by the current Beachy Head lighthouse at the foot of the cliffs. Belle Tout was given to Eastbourne Corporation in 1948, but by the 1960s had ended

Belle Tout lighthouse was operational from 1834 to 1899, and decommissioned in 1902. It now stands 50ft inland, having been relocated in 1999 to save it becoming a victim of cliff erosion. It has been restored and renovated, and converted into a bed & breakfast with themed rooms. The lantern room provides 360-degree views of the English Channel and the nearby countryside.

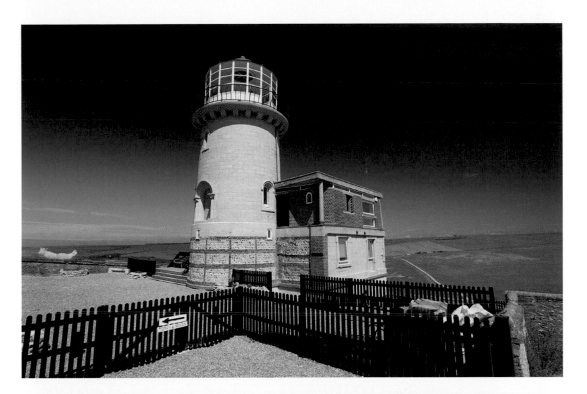

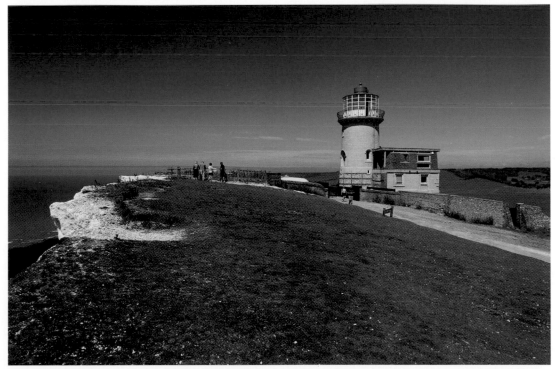

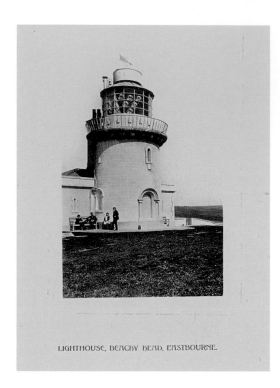

LIGHTHOUSE, BEACHY HEAD, EASTBOURNE.

An old postcard of Belle Tout when the lighthouse was in operation.

Newhaven

Established	1883
Current lighthouses built	1891 (west), 2006 (east)
Operator	Newhaven Harbour Authority
Access	Both the East Pier and the West Breakwater are open to the public

In the 1880s, the harbour at Newhaven was substantially enlarged and a light was erected on each side of the new pier extensions. The lighthouse, built in 1883 on the end of the West Pier, was a circular stone-built tower, three storeys high, with a lantern and gallery. In the 1980s, a landslip on the pier near to its base meant the lighthouse had to be demolished. A simple flashing red navigation light has since taken its place.

Also in 1883, on the end of the East Pier, a 41ft, square steel-framed tower was erected to support a circular gallery and a hexagonal black lantern with a coned top which displayed a flashing green light visible for 6 miles. In the upper section of the lattice tower, a white-painted, close-boarded wooden lookout was constructed. This light was rebuilt, or at least refurbished, in 1928.

The light at the end of the East Pier was erected in 2006 and consists of a steel plate supporting a simple polycarbonate light displaying an isophase green light.

up again in private hands. In 1999, following further erosion, it was only 9ft from the cliff edge and, in a well-documented move, a new ground-floor base was constructed 56ft inland. The tower, with its modern two-storey residence, was then moved intact onto the new base.

In 2007 Mark and Louise Roberts, who had overseen the moving of the tower, put Belle Tout up for sale for £850,000. The lighthouse was purchased in 2008 by the Belle Tout Lighthouse Co. Ltd with the intention of opening it as a bed & breakfast and tourist centre, and during 2009 the building was extensively restored and renovated. In March 2010 the lighthouse was opened for paying guests with themed rooms.

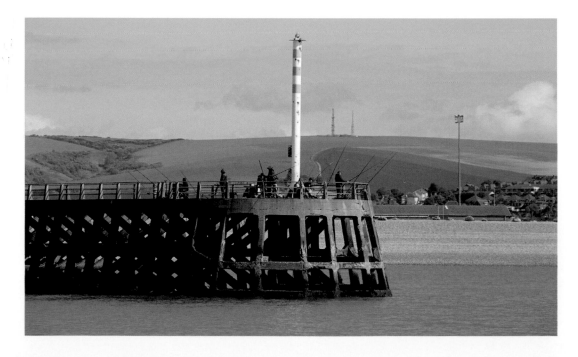

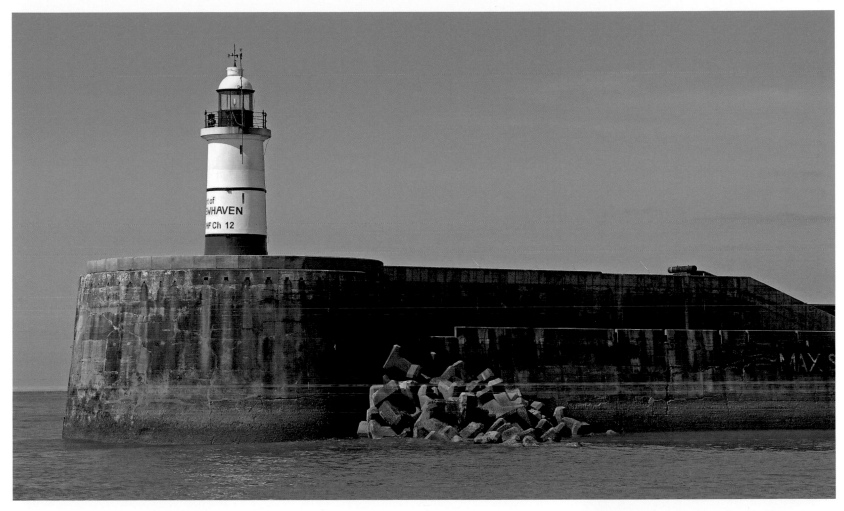

In 2002 the harbour authority wanted to close the East Pier and demolish the light because of vandalism, but this was deferred. By 2005, the situation had worsened and early in 2006 the light was demolished. In its place a 41ft circular steel pole was erected, painted white with three horizontal green bands near the top. A round steel plate on top supports a simple polycarbonate light displaying a flashing green light visible for 6 miles.

In 1891, when the long breakwater was completed, a 45ft circular cast-iron lighthouse

The Newhaven Breakwater light, which dates from 1891, is situated on the west side of the harbour.

was erected on its terminus. Painted white with two red horizontal stripes and red railings round its gallery, it displays a white flashing light visible for 12 miles from a white circular lantern with an ornate domed top. The channel to the inner berths is marked by a channel marker mounted in a wooden shed situated between the Hope Inn and yacht club.

An old postcard showing the two lights marking the entrance to Newhaven Harbour, with a cross-Channel steamer heading out of the port.

Shoreham

Established	1846
Current lighthouse built	1846
Operator	Shoreham Port Authority
Access	The lighthouse is on the seafront on open land, but the other lights are visible only from a distance as access around the port is restricted

Although Shoreham was a port in Roman times, it was not until 1816 that the cut which now forms the entrance to the harbour was excavated. And not until 1957 were the two breakwaters constructed to protect the entrance from the build-up of shingle. Although eleven aids to navigation are now operational in the port, only one can be described as a lighthouse, and that is situated on open land at the side of the main road near the lifeboat house and Middle Pier.

Built in 1846, the unpainted 42ft circular limestone tower has an ornate black lantern and balcony. In 1985 the lantern was completely refurbished. Its flashing white light is visible for 10 miles and operates in conjunction with a front light located on the end of the Middle Pier, 200 yards away. This light, housed in a square black box, is on a white 6ft lattice tower on the roof of Shoreham Port Authority watchtower. This two-storey white building also supports the harbour foghorn and traffic control lights. The white flashing light, visible for 9 miles, is supplemented by red and green navigation lights.

When, in 1957, the two breakwaters were built out from the harbour entrance, a 10ft-high concrete column with a simple light was erected on each outer end. On the east breakwater its green column shows a green flashing light visible for 8 miles and on the west its red column shows a red flashing light visible for 4 miles.

The limestone tower at Shoreham-by-Sea acts as the Middle Pier rear range light, and stands close to the lifeboat station south of the A259 main road.

Littlehampton

Established	1848
Current lighthouse built	1948
Operator	Littlehampton Harbour Board
Access	Both lights can be seen by walking the East Pier; the West Pier can be approached from the West Beach by passing the golf course

In 1848 a light on a 40ft white, square pyramidal wooden tower with a green domed roof was erected at a point which, subsequently, was to be the start of the East Pier. Visible for 10 miles, this light, which looked like a pepper pot, became the rear range for a new front range erected on the end of the East Pier. At 26ft high, this light was mounted on a similar structure to that of the rear light, and the two lights became known as 'salt and pepper'. In 1940 they were demolished as they were deemed to be a target for the enemy in wartime.

In 1948 new lights were erected in the same locations. The rear range is a 23ft unpainted circular concrete column with four tapered buttresses, complete with a circular concrete lantern. The flashing white light, which also has a yellow sector, shines through an envelope opening and is visible for 10 miles. The front range, on the end of the East Pier, was replaced by a simple fixed green light, visible for 7 miles on a 10ft-high black column. In 1948 a flashing red light, visible for 6 miles, mounted on a black metal pole, was erected on the end of the West Pier.

The original East Pier light at Littlehampton, which was used until the Second World War.

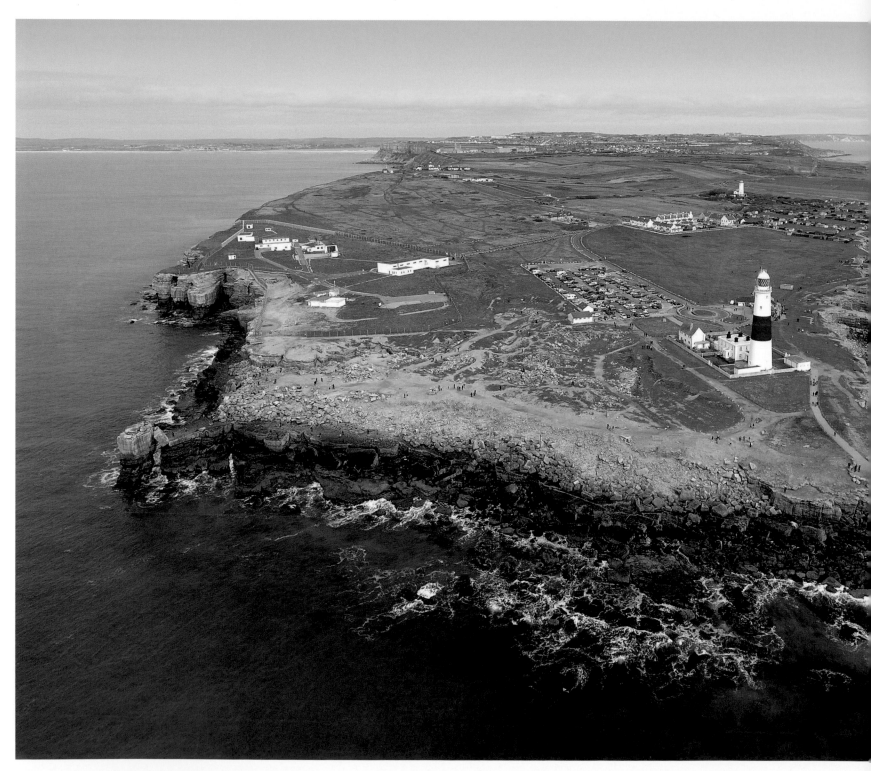

6 SOUTH COAST AND ISLE OF WIGHT

Southsea Castle

Established	1828
Current lighthouse built	1828
Operator	Portsmouth Harbour Authority
Access	The castle is open daily, but the lighthouse can be seen from the surrounding area

Built in 1544, Southsea Castle was the last of Henry VIII's coastal defences. It had various periods of decay and restoration until the 1820s, when it was substantially rebuilt. As part of the work, at the request of the Admiralty, a lighthouse was erected on the north side of the western gun platform on the western ramparts. Commissioned in 1828, the 30ft cylindrical stone tower has a gallery and lantern room with a tent-shaped top and is white with a black bands. Situated between Clarence and South Parade piers, it guides ships through the deep-water approaches to the busy harbour.

The tower displays a flashing white light, visible for 11 miles, with three fixed lights, white, red and green, to mark different channels. The lighthouse can be seen from outside the castle but a view of the base can only be seen by entry to the site. Although an active light, it is a listed building and part of the castle site.

The light on top of the western ramparts of Southsea Castle on the eastern side of Portsmouth harbour.

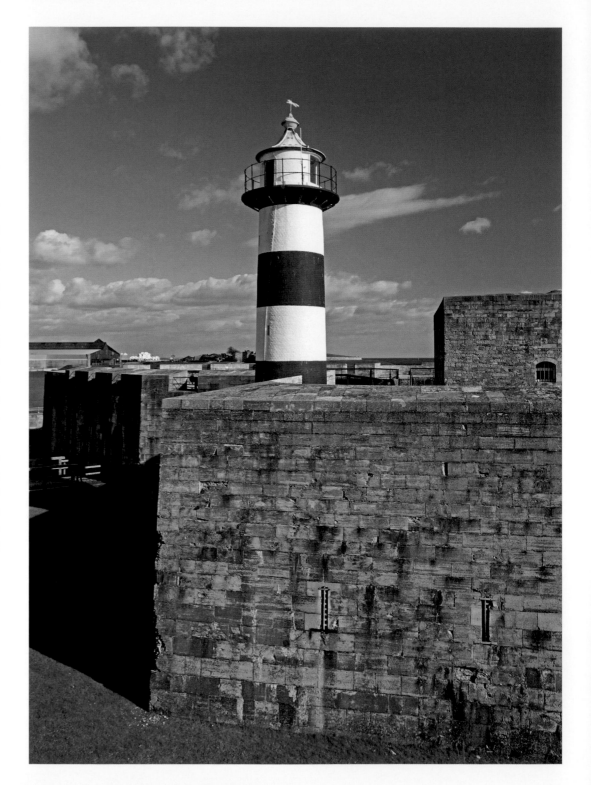

Spitbank Fort

Established	1866
Current lighthouse built	1866
Operator	Spitbank Fort Ltd
Access	The fort can be visited by boat for lunches or parties as well as on day trips; boats leave Gosport, the Historic Dockyard and the Hard at Portsmouth in the summer

In the 1860s, Lord Palmerston sanctioned the building of a series of forts in the channel between Portsmouth and the Isle of Wight. Of five proposed, only three were completed. Spitbank Fort, which guarded Spithead, was the nearest to Portsmouth. Commenced in 1860, it was not completed until 1878, although the lighthouse on the fort was built in 1866. The 24ft red circular tower with a red lantern room is perched on top of a white service building on the southern aspect of the fort. It shows a flashing red light visible for 7 miles.

In 2009 work began on transforming the fort into a luxury hotel, which was opened in 2012. It has been converted into a five-star boutique hotel with eight bedroom suites, and can be used as a wedding venue as well as for corporate events.

Spitbank Fort, one of the forts constructed in the channel between Portsmouth and the Isle of Wight, has a lighthouse mounted on top. (Maritime Photographic)

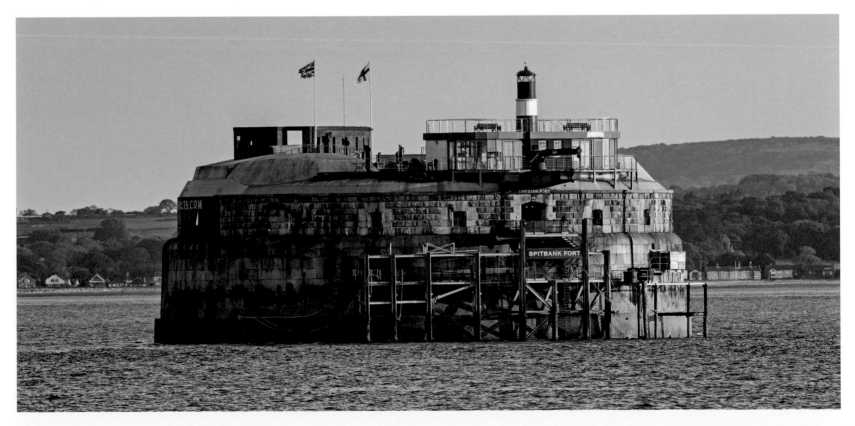

Beaulieu

Established	2000
Current lighthouse built	2000
Operator	Royal Cruising Club Pilotage Foundation
Access	From Lepe Country Park, on the corner by the entrance to the Cruising Club

The lighthouse at Beaulieu, the newest in Britain, is known by a number of names but is correctly called Beaulieu River Millennium Beacon. Its construction came about following concerns expressed by a local committee working in association with Trinity House, which looked at ways to improve the aids to navigation in the river where the Lepe joined the Solent. After much debate, they decided to mark the Millennium by providing a lighthouse.

The owner of Lepe House donated a plot of land in his garden, and a lighthouse, designed by Brian Turner and built by Mark Keeping, was commissioned in July 2000. The 25ft white tower is cement-rendered brick with a concrete gallery. The octagonal lamp room consists of glass panels with a fibre-reinforced composite roof topped by a weather vane. The Tideman ML300 lantern has a directional sector beam showing a white occulting light over a 7-degree safe channel with red and green sectors on each side. The light, which also acts as a daymark, was financed by local boat owners and the Royal Cruising Club Pilotage Foundation.

Beaulieu light at Lepe, close to a country park, is the most modern lighthouse in Britain.

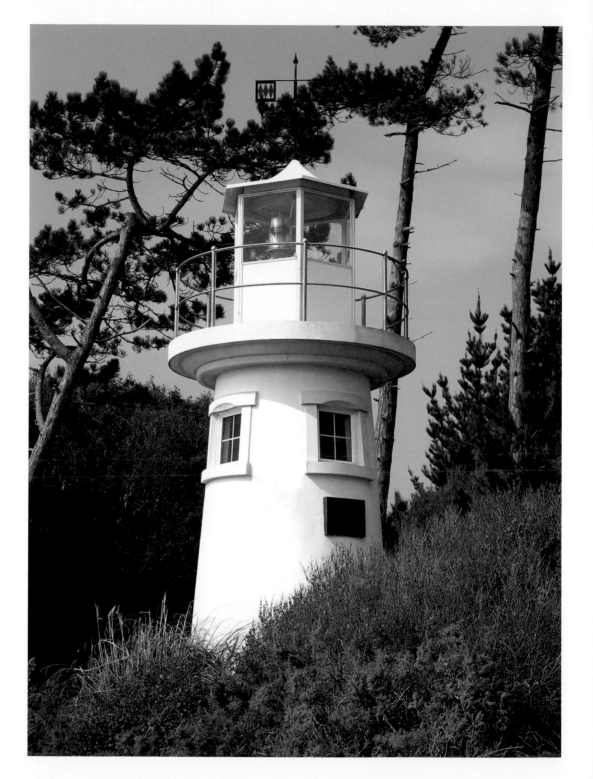

Hurst Point

Established	1786
Current lighthouse built	1867
Automated	1923
Operator	Trinity House
Access	The operational light can be approached on foot from Hurst Castle; the redundant lights require entry to the castle; boat trips run from Keyhaven

Hurst Point lighthouse, situated on the spit of land at Hurst Point, guides vessels through the western approaches to the Solent, indicating the line of approach through the Needles Channel. Although a light was shown on Hurst Point as early as 1733, not until 1781 was a meeting of shipmasters and merchants organised to submit a formal petition to Trinity House for lights in the neighbourhood of the Isle of Wight. Before they received the patent Trinity House discussed several draft agreements with William Tatnell, a merchant in London, who projected the lights.

(Right) The high light at Hurst Point was built in 1812 and is now the only operational light at the point.

(Below) The high light at Hurst Point, dating from 1812, with the original keepers' cottages that were subsequently demolished. (Courtesy of John Mobbs)

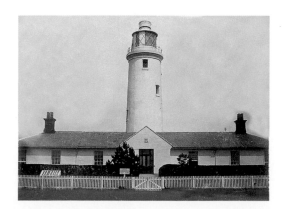

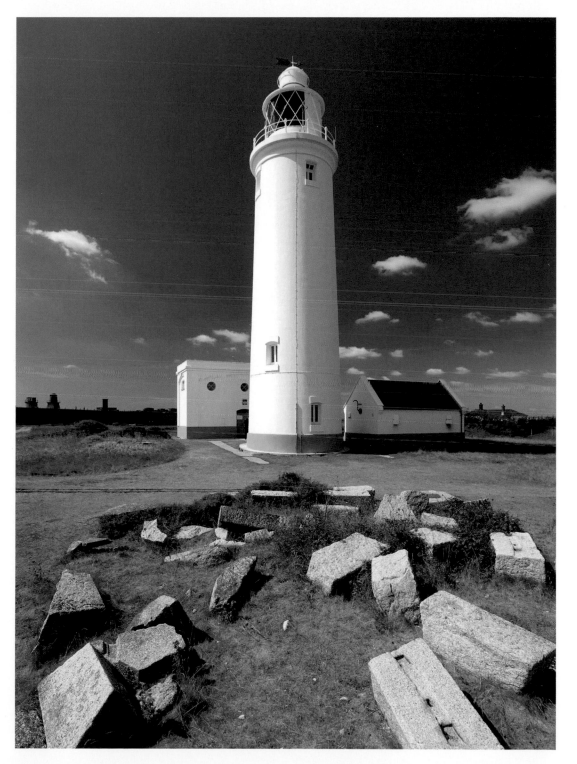

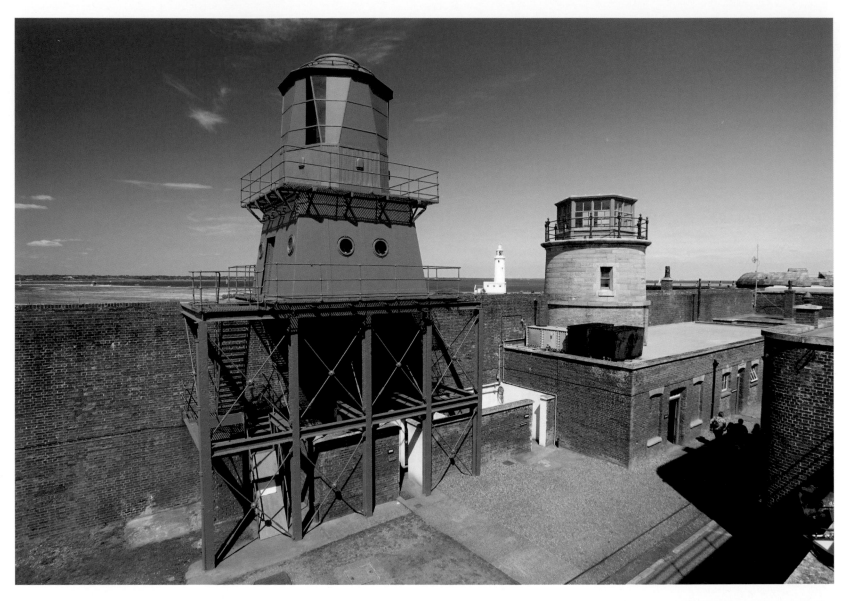

In 1785, negotiations with Tatnell fell through and Trinity House erected a lighthouse at Hurst, to the south-west of Hurst Castle, which was lit for the first time on 29 September 1786. However, as this light was obscured to shipping from certain directions, an additional light was constructed to improve matters and also serve as a guiding line to vessels. Designed by

Daniel Alexander, the high light, as it became known, was first lit on 27 August 1812.

Extensive additions were made to the castle between 1865 and 1873 necessitating the repositioning of the lights. A new low light was erected as part of the castle's defence wall and this was reached by a staircase built outside the fort. The 1812 high lighthouse was

The disused Hurst lower lights on the walls of Hurst Castle. Both lights are situated within the grounds of Hurst Castle, an English Heritage property. The 52ft metal tower at Hurst Point is now decommissioned and painted grey. The 1911 structure (left) was unusual because it could be moved along the castle walls to mark the ever-shifting Shingles Bank. The keys to the structure were handed over to English Heritage in June 2010.

Nab Tower

Established	1920
Current lighthouse built	1920
Automated	1983
Operator	Trinity House
Access	Can only be viewed by boat

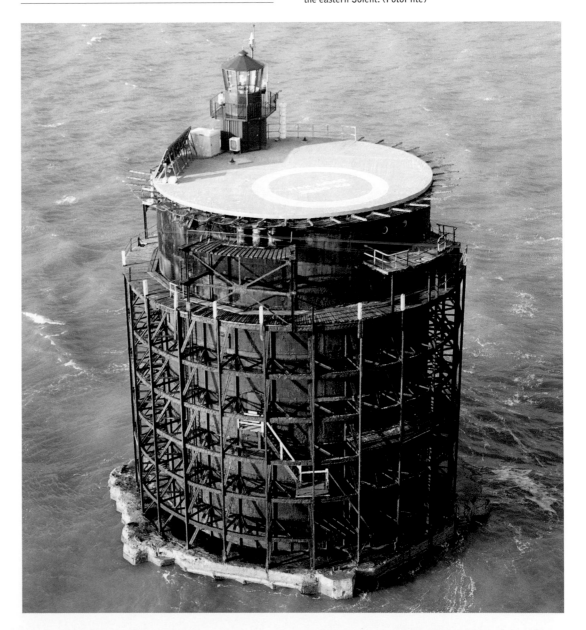

Nab Tower marks the Nab rock in the deepwater approach to the eastern Solent. (FotoFlite)

moved 50ft east and, furnished with cottages, relit in September 1867. This 85ft tower is still operational today, with its light visible for 14 nautical miles.

The shifting sands of Shingles Bank forced the 1865-built low light to be abandoned. This light was discontinued on 30 November 1911, and replaced by a new low lighthouse in the form of a square metal structure standing on a framework of steel joists attached to the wall of Hurst Castle, showing a light that was visible for 12 miles. The 52ft metal tower was originally painted red, but in 1977, when it too was decommissioned, it was repainted grey to match the surrounding background colours and eliminate navigational confusion.

In 1923, the keepers were withdrawn from Hurst and both operational lights were automated. A major modernisation of Hurst Point high lighthouse, prompted by the growth in traffic using the Needles Channel, was completed in July 1997. Following extensive consultation, high-intensity projectors were installed at Hurst, and these are exhibited day and night to mark the channel between the Needles and the Shingles Bank.

During the First World War the Admiralty, concerned about enemy submarines attacking Britain's merchant fleet, devised a plan to build eight fortified steel towers which would be sunk to the sea floor, so that a barrier could be formed by stringing nets between them on a steel cable. Although as many as 3,000 men were employed on the project, only one tower was completed, the Nab Tower, with another partially finished when the war ended. Of little use as a defence measure, the tower proved an ideal replacement for the Nab Lightvessel, which was moored at the eastern edges of the Spithead approaches.

The structure, designed by G. Menzies, was 40ft in diameter with latticed steelwork surrounding a 90ft cylindrical steel tower. It was built on a hollow 80ft-thick concrete base designed to be flooded and sunk in about 20 fathoms. Shaped with pointed bows and stern for easy towing, it was positioned near the light float in 1920. Once the sea was let into the base, the tower sank in position as planned, albeit with a 3-degree list. The alterations for use as a lighthouse included the erection of a short red octagonal tower with a gallery and lantern near the perimeter.

Operated as a rock station until 1983, the station was then fitted with an automated acetylene light and the keepers were withdrawn. In 1995, it was converted to solar power and the optic changed to a new proprietary lantern manufactured by Orga. The flashing white light is visible for 16 miles and the fog signal gives two blasts every thirty seconds, audible for 2 miles.

In 2013 Trinity House commissioned BAM Nuttall to undertake a major refurbishment programme due to extensive corrosion of the upper levels, meaning it was unsafe to land helicopters upon the helipad. The height of the tower was reduced, all external steel and cladding were removed and the existing concrete sub-structure was coated in a new layer of gun-applied concrete. On completion, new AIS and RACON beacons were fitted, along with a fixed main light with a range of 12 nautical miles.

Egypt Point

Established	1897
Current lighthouse built	1897
Discontinued	1989
Operator	Trinity House
Access	Via the promenade from West Cowes

Situated on the most northerly point of the Isle of Wight at Egypt Point on the promenade at West Cowes, this aid to navigation is a unique design. Erected in 1897, the electrically powered white light visible for 10 miles was housed in a small red circular lantern on top of a white 18in round box mounted on a red post. At its base was a white square plinth from which guy rods steadied the lantern box. The lower section was surrounded by white railings with an external ladder up to the lantern.

The whole 25ft structure is mounted on a concrete plinth built out from the promenade

retaining wall. To avoid dazzling traffic on the road, two metal flaps were welded onto the top of the upper housing. The light, which was managed by Trinity House, was deactivated in 1989 and in 1997 handed over to the council as a landmark for the area.

The unusual light at Egypt Point faces the Solent at the most northerly point of the Isle of Wight. The original lantern from Egypt Point is 0on display at Hurst Castle.

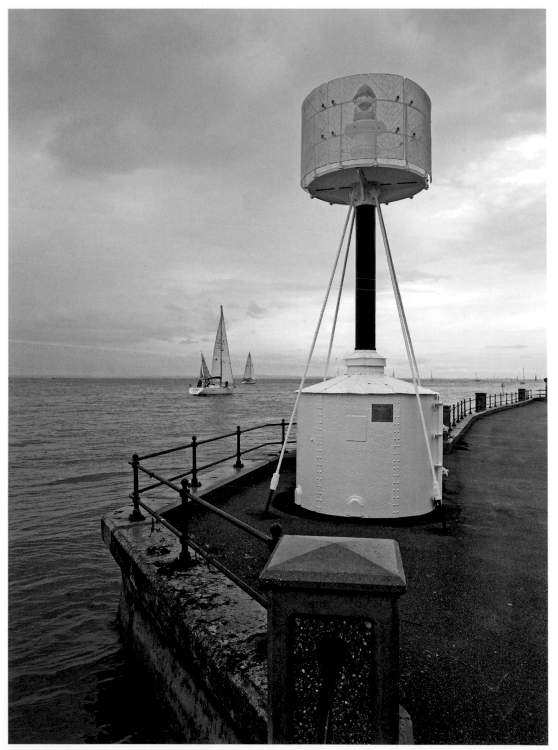

St Helens Fort

Established	1866
Current lighthouse built	1866
Operator	Privately owned
Access	Approachable by boat, or viewed from the National Trust car park in St Helens and walking to the shoreline

St Helens Fort, one of the forts built along the south coast during the Napoleonic Wars, is situated a mile off the coast, opposite St Helens on the Isle of Wight. In 1866 a white, 23ft, square pyramidal tower was erected on top of the fort, supporting a white square box housing a white navigation light. Operated privately, the light is visible for 8 miles. Nearby are the ruins of an old church tower, the seaward wall of which was painted white as a daymark.

St Helen's Fort, as seen from the Isle of Wight, carries a small navigation light.

St Catherine's Oratory

Established	1328
Current lighthouse built	1328
Discontinued	1547
Operator	English Heritage
Access	Via the coast road across St Catherine's Down from viewpoint car park near Blackgang

The first lighthouses at St Catherine's Point date from the fourteenth century. Walter de Godeton was caught receiving contraband from a wreck off Atherfield and, as punishment, was instructed to build a lighthouse and an oratory where the priests could pray for the souls of lost sailors. Situated on a hilltop at Chale, 3 miles north-west of the modern light, the lighthouse, now referred to as the Pepper Pot, was completed in 1328 and consisted of a 35ft octagonal stone building with a pyramid top. At the base were four large buttresses. Through eight openings at the top, a coal-fired light was displayed until 1547, when Henry VIII ordered the closure of all Catholic religious institutions.

The incomplete base of the proposed 1785 lighthouse is about 70 yards from the original lighthouse. This foggy scene, taken on a summer day, shows why the light was never completed. The hilltop is so enshrouded in mist that the original lighthouse, only 70 yards away, is not visible.

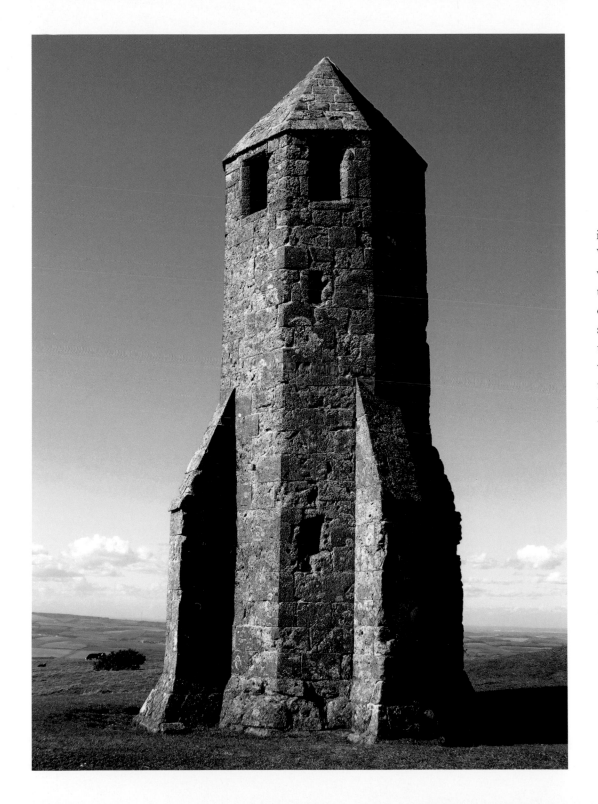

The light is now the second oldest remaining in the British Isles after the Pharos at Dover. With no light as a guide, ships continued to be wrecked, and so in 1785 Trinity House decided to resurrect the old light. They began the erection of a new lighthouse, the shell of which stands near the earlier one but a little closer to the coast. Known as the Salt Cellar, the building was never completed as experience showed that the fogs and mists rendered it almost useless. Instead it was decided to place a light nearer the sea at St Catherine's Point.

St Catherine's Oratory, built in the fourteenth century and sited 3 miles north-west of the current lighthouse, is situated on one of the highest parts of the Isle of Wight, overlooking the English Channel. (Andrew Cooke)

St Catherine's

Established	1838
Current lighthouse built	1875
Automated	1997
Operator	Trinity House
Access	Walk the coast path from Niton Undercliffe

With the lights at Chale proving inadequate, Trinity House decided that a lighthouse on St Catherine's Point would be more suitable and, following the loss of the sailing ship *Clarendon* on rocks nearby, the present lighthouse was constructed in 1838. Situated at Niton Undercliffe, it comprises a white octagonal tower, 84ft in height, with ninety-four steps up to the lantern. The main light, visible for up to 30 nautical miles in clear weather, is the third most powerful in Trinity House service and guides shipping in the Channel as well as vessels approaching the Solent. A fixed red subsidiary light, displayed from a window 23ft below the main light, faces westward over Atherfield Ledge. First shown in 1904, it has a range of 17 miles.

The main lighthouse was built of ashlar stone with dressed quoins and was built up from a base plinth as a three-tier octagon, diminishing by stages. The elevation of the light proved to be too high, however, as the lantern frequently became mist-capped, and so in 1875 it was decided to lower the light by 43ft, taking about 19ft out of the uppermost section of the tower and about 24ft out of the middle tier. St Catherine's was automated in 1997, with the keepers leaving the lighthouse on 30 July.

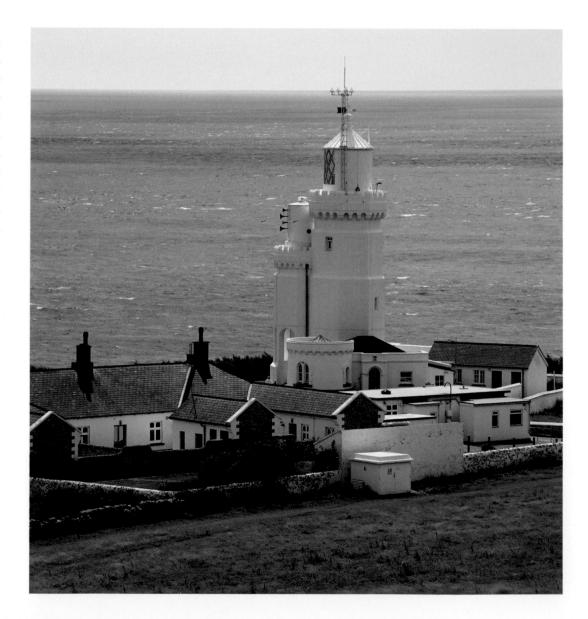

(Top) An engraving showing St Catherine's lighthouse as built by Trinity House, before it was reduced in height.

(Left and above) St Catherine's lighthouse on the southern shore of the Isle of Wight has one of the most powerful lights of any Trinity House lighthouse. The two towers that make up St Catherine's lighthouse are known locally as the 'cow and calf'.

(Right) The original lighthouse to mark the Needles and the western extremity of the Isle of Wight was at Freshwater, but it was demolished more than a century ago.

Freshwater

Established	1785
Extinguished	1859
Destroyed circa	1913

To the west of the Isle of Wight, the Needles form a narrow chalky peninsula which rises from jagged rocks to a height of over 400ft. These rocks have always been a hazard to ships passing up the Solent to Portsmouth and Southampton, and in 1781 merchants and shipowners petitioned Trinity House for a lighthouse. However, not until 1785 did Trinity House erect a lighthouse to mark the Needles.

One of three built to the design of Richard Jupp (the others were Hurst Castle and St Catherine's Point), the small 22ft brick tower with an attached keepers' dwelling was situated on top of a cliff overhanging Scratchell's Bay. Known as Freshwater lighthouse, it was first lit on 29 September 1786 but the light, which was 475ft above sea level and often obscured by mists and fogs, was of limited use. The experiment of using Argand lamps and parabolic reflectors to give improved light did not solve the problem and so it was extinguished in 1859. By 1913 its ruin no longer existed.

The Needles

Established	1859
Current lighthouse built	1859
Automated	1994
Operator	Trinity House
Access	By boat and can be viewed from cliffs at the western extremity of the Isle of Wight

To effectively mark the Needles and safeguard shipping passing the Isle of Wight, plans were drawn up in 1858 for a light nearer to sea level than the Freshwater light, which was on the clifftop. The new lighthouse, designed by James Walker, the corporation's architect, was built on the outermost rock, or 'Needle', and cost £20,000 to complete. The interior was divided into five apartments: the ground floor was used as the oil room; the first floor was for the provisions; the next level contained the dining room, kitchen and living quarters with purpose-built bunks and wardrobes; the floor above this was the watch room, with access to the lantern room. When on duty, the keepers spent the majority of their time here.

The light was first displayed on 22 May 1859. The original lantern was fitted by H. Wilkins & Son, of London, and contained a first-order dioptric lens apparatus by Chance Brothers, of Smethwick, and multi-wicked oil burner. The light was found not to be bright enough, so various coloured panels of glass were fitted to the lantern in place of a shade to remedy the situation.

The circular 102ft granite tower had perpendicular sides and was of uniform diameter with an unevenly stepped base designed to prevent the seas from sweeping up the tower. Much of the base rock was cut away to form the

foundation, and cellars and storehouses were excavated in the chalk. The tower was painted with two broad, red horizontal bands to give it added visibility against the white rock face.

Since it was first lit on 1 January 1859, various alterations to the lighthouse have been made. The most recent was the addition of a helipad, built on top of the lighthouse in 1987. The station was automated in 1994 with the keepers being withdrawn on 8 December. The second-order Fresnel lens currently displays an occulting white light with red and green sectors to mark the safe channel. A foghorn gives two sounds every thirty seconds.

In 2010 work was undertaken to reinforce the base of the tower. Storm and wave action had damaged the protective capping at the base of the tower, exposing the foundations. The remedial works involved replacing the protective capping with a steel-reinforced concrete covering, toed into the rock.

The Needles lighthouse is a well-known landmark at the western tip of the Isle of Wight, west of Alum Bay. Since 1987, the tower has had a helipad above the lantern, the supports of which conform with the astragals of Walker's lantern. (Andrew Cooke)

Anvil Point

Established	1881
Current lighthouse built	1881
Automated	1991
Operator	Trinity House
Access	Approached via the Dorset Coast Path from Durlston Head Country Park, which is signed from Swanage

Anvil Point lighthouse, on Durlston Head, a mile south-west of Swanage, was built in 1881 by Trinity House and opened by Neville Chamberlain's father, then Minister of Transport. It is positioned to provide a waypoint for vessels on passage along the English Channel coast. To the west it gives a clear line from Portland Bill towards Poole Harbour or the Solent and, to the east, guides vessels away from the Christchurch Ledge to the west. It also marks the hazards of St Aldhelm's Head and Durlston Head.

The small, squat, white-painted circular 39ft lighthouse, with a lantern and gallery, was built to the design of James Douglass and constructed from local stone. The keepers' dwellings were on the landward side, with a house for the cannon fog signal to seaward. The original clockwork-driven Fresnel lens showed a white flashing light visible for 24 miles, but this was replaced when the station was modernised and converted from paraffin vapour to electrical operation in 1960. The lens is now on display in the Science Museum at South Kensington. Today, a smaller 10in lens gives a flashing white light with a range of 19 miles.

The fog cannon was replaced in 1981 by an automatic electrical system, but this was discontinued in 1988 when a VHF radio signal, operating in conjunction with the Needles, was installed on the roof. The station was fully automated and the keepers were withdrawn on 31 May 1991, although a part-time attendant opens the lighthouse for visitors from time to time. Managed by Rural Retreats on behalf of Trinity House, the keepers' cottages are available for rent as holiday cottages.

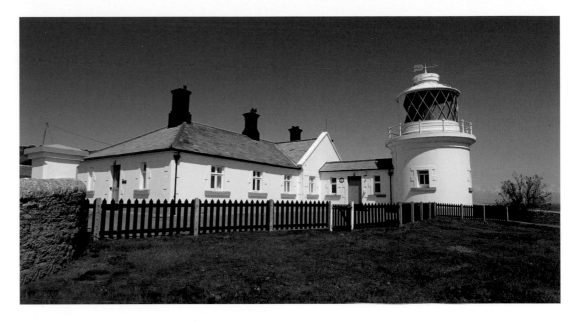

(Above) The squat lighthouse at Anvil Point marks a passage along the English Channel.

(Below) Anvil Point lighthouse is sited on the cliffs to the west of Swanage, on the South West Coast Path.

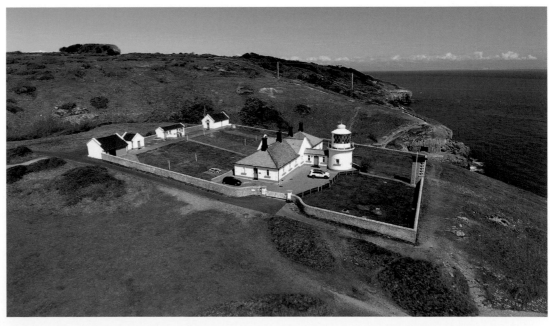

Portland Bill

Established	1716
Current lighthouse built	1906
Automated	1996
Operator	Trinity House
Access	There is a large car park near the lighthouse; the visitor centre is open to the public, with a small admission charge; half a mile up the hill is the High Light which is privately owned; 400 yards down is the Low Light, with a public room at ground level.

With Portland Bill jutting out to sea and the notorious shoal the Shambles just offshore, the Portland Race is a notorious hazard to shipping trying to make Portland Harbour. In 1716, Trinity House, in response to local petitions, issued a patent for sixty-one years so that a pair of range lights could be erected on the Bill. Both were coal fired in glazed lanterns with the lower light on the east shore marking the Shambles. However, the lights were not a success, as they were poorly maintained so, when the lease expired, Trinity House took over.

In 1789, both lights were rebuilt and equipped with a brand new innovation,

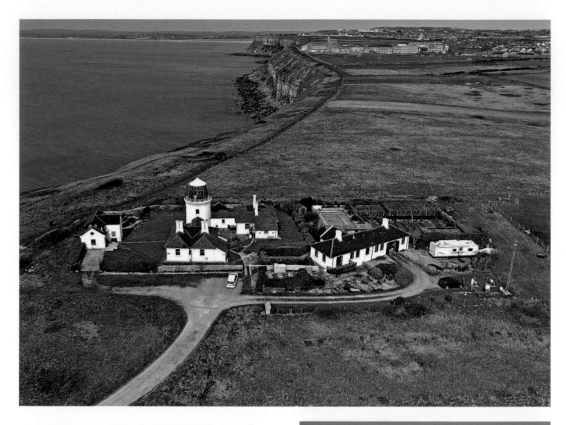

(Top) Portland Bill high lighthouse, with the old keepers' cottages attached, is now privately owned. (Tony Denton)

(Above right) The Portland Bill high lighthouse when operational, showing the lantern which was removed after the light was closed in 1906. (Courtesy of John Mobbs)

(Right) The lower lighthouse at Portland when operational, with the two separate houses for the keepers. The one on the right was subsequently demolished. (Courtesy of John Mobbs)

(Far right) The old lower light at Portland Bill has been converted for use as a bird observatory.

HIGHER LIGHTHOUSE, PORTLAN. W. A. Attwooll's Series.

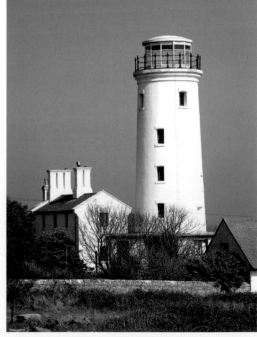

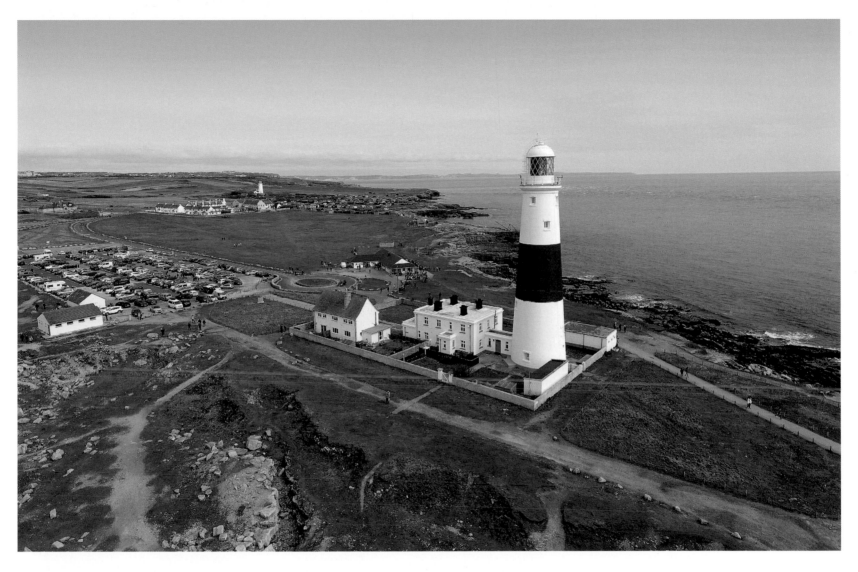

Argand oil lamps. Another innovative move were the glass lenses used in the lower light. In 1866, the High Light was again rebuilt, as was the Low Light the following year, and these structures remain today. The High Light was a 50ft white-painted circular tower with an attached single-storey service building and two-storey keeper's house. The Low Light was an 85ft white circular tower with a connecting two-storey service building and a two-story keepers' house nearby. Both lights were visible for 21 miles.

In 1906, after an appraisal of the cost of operating two lights, both were closed and replaced by the current tower at the tip of the Bill. This new light, a 135ft tapered circular stone tower with lantern and gallery, is white with a red band whilst the attached service and keepers' buildings are white. The group-flashing first-order catadioptric lens has a range of 25 miles and is unusual as the panels are arranged to give a gradual change from one to four flashes, depending on the direction. The Shambles reef is marked by a fixed red light displayed through a window. The lighthouse buildings are now a visitor centre.

The lighthouse complex at Portland, with the buildings adjacent to the tower used as a visitor centre. The current Portland Bill lighthouse is one of the most famous of any operated by Trinity House.

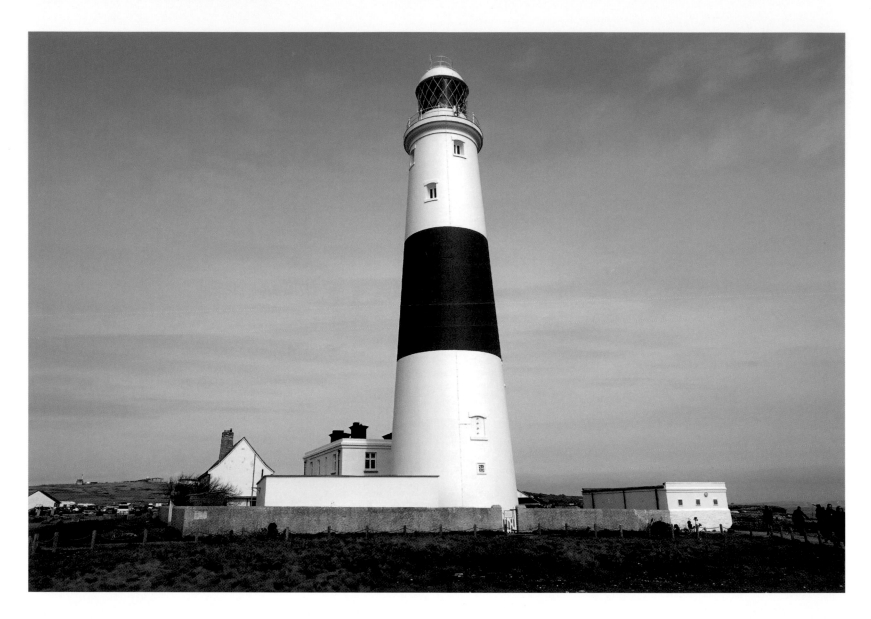

The old low light is now a bird observatory and the old high light, from which the lantern was removed on decommissioning, a private residence. It now has an observation room on top which does not resemble the old lantern room. A 29ft obelisk, built in 1844, is located on the cliff edge in front of the 1906 lighthouse and marks the low 50-yard-long reef which extends out from the Bill. The Shambles Shoal, situated approximately 3 miles to the east, was marked by two buoys in 1824, then by a lightvessel in 1859. When the red light was erected on the 1906 tower, the shoal was marked with lighted buoys at the east and west ends.

With the help of a generous grant from its Maritime Charity, Trinity House renovated the visitor centre at Portland Bill lighthouse. Opened to the public on 29 March 2015, the new main exhibit provides information about the lighthouse, its keepers and Trinity House. The new exhibition contains a number of interactive displays and historical artefacts.

Portland Harbour

Established	1905
Current lighthouse built	1905
Operator	Portland Harbour Authority
Access	No public access to either lighthouse or breakwater; they can only be approached by sea.

Portland Harbour is the second largest man-made harbour in the world; it is made up of four breakwaters, two of which stand alone, with access only possible by boat. The area was originally heavily fortified, and until 1996 was a major naval base. It is perhaps surprising, therefore, that it has only a single navigation light to guide ships into the busy harbour.

Built in 1851, the first lighthouse on the southern end of the North-east Breakwater consisted of a 26ft metal tower on the roof of a stone hut, with a lantern that showed an occulting red light visible for 6 miles. Marking the southern entry to the harbour, it was discontinued in 1905, when the breakwater was extended. Today, the channel is marked by a unique tubular cast-iron tower with hexagonal cast-iron stays, which is the only known survivor of a standard prefabricated tower design.

At 71ft tall, this white-painted tower has a white gallery and lantern topped with a weather vane and shows a flashing white light visible for 20 miles. Minor lights are sited on the north ship channel showing occulting green every ten seconds and occulting red every fifteen seconds, visible for 5 miles. The southern ship channel has, in addition the main light, a quick red light visible for 5 miles. In March 1995 the navy withdrew from Portland and the harbour is now operated by Portland Harbour Authority.

The Portland Breakwater lighthouse stands on the southern end of the North-east Breakwater at the main entrance to the harbour.

Teignmouth

Established	1845
Current lighthouse built	1845
Operator	Teignmouth Harbour Commission
Access	On the seafront near southern car park

The entrance into the River Teign over a notorious bar is not advised in rough weather, as the bar has a tendency to shift. To guide ships into the small port, a 20ft unpainted conical tower built with local sandstone was erected on the Den in 1845. The lantern room, which houses a fixed red light visible for 3 miles and has a weathervane on top, and tower are a popular subject of local postcards. Situated on the south end of the promenade at the entrance to a car park, it is the front of two range lights. The rear range light, 50ft away, is hard to identify, as it consists of a fixed red light atop a 30ft black, street light type column in front of the Lynton House Hotel in Powderham Terrace.

Another navigation aid, a 15ft stone column, is situated at the river entrance. This white structure with a black base is known as the Philip Lucette Beacon and carries an occulting red light visible for 3 miles. Located on the training wall, it can be approached on foot by crossing the river to Shaldon.

The lighthouse on the Den at Teignmouth.

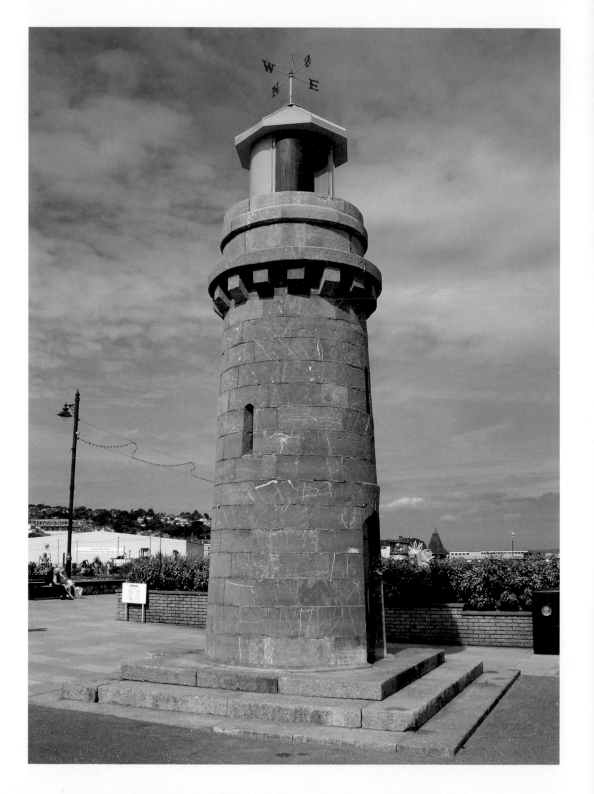

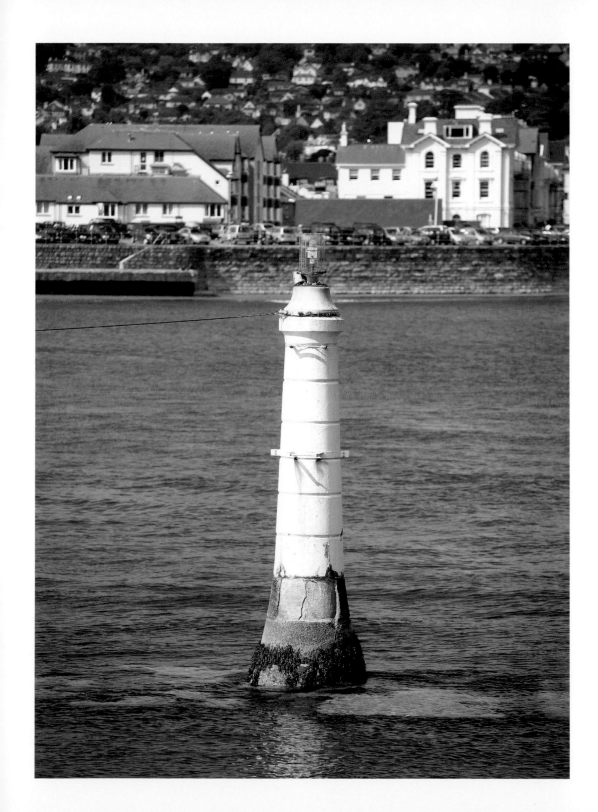

The Philip Lucette Beacon at Shaldon, on the opposite side of the river to Teignmouth.

Brixham Breakwater

Established	1878
Current lighthouse built	c. 1916
Automated	1916
Operator	Brixham Harbour Marine Services
Access	By walking the breakwater

The large harbour at Brixham is sheltered by the outcrop of Berry Head, and is notable for the long breakwater on its eastern side. To guide vessels once they have passed Berry Head, a lighthouse was erected on the end of the half-mile-long Victoria Breakwater in 1878. This was replaced in about 1916 by the current 20ft white-painted cast-iron tower.

The Victoria Breakwater was built in the mid-nineteenth century, with the foundation stone being laid in 1843. Due to lack of funds, work stopped at 1,400ft and a light beacon was erected on the end. During the great storm of 1866, which damaged the end of the breakwater, 'the beacon on the end was washed away and the local women lit a bonfire to guide their men folk home', according to contemporary accounts.

In 1909 a 600ft extension was constructed and in 1912 work started on a further 1,000ft extension. When this was completed in 1916, a lighthouse was erected on its terminus. The 20ft white circular tower complete with a gallery and lantern now shows an occulting red light, electrically powered and visible for 3 miles.

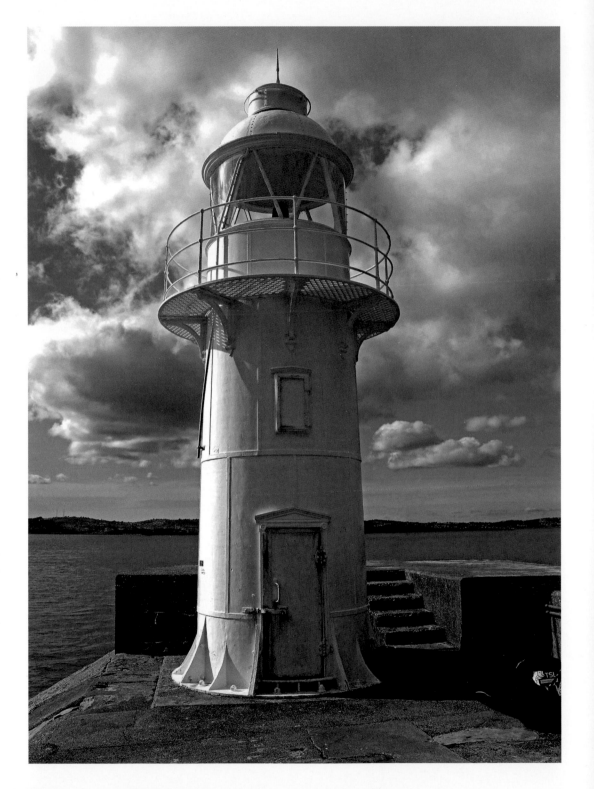

The lighthouse at the end of Brixham's Victoria Breakwater.

Berry Head

Established	1906
Current lighthouse built	1906
Automated	1921
Operator	Trinity House
Access	The light is on the headland in Berry Head Country Park

Berry Head, designated as an area of outstanding natural beauty, is an extensive limestone headland overlooking Torbay and Brixham Roads, which have long been sheltered anchorages. Fortifications were erected on the headland in 1793 to oppose a threatened invasion by the French, but were dismantled by 1820, although the ramparts remain.

At the end of Berry Head, beyond the coastguard station, is the small, squat, white-painted circular lighthouse. Built in 1906, the 15ft tower was converted to unwatched acetylene operation in 1921 and modernised and converted to mains electricity in 1994. It came to be known as the smallest, highest and deepest light in the British Isles. Despite being diminutive, the tower is 190ft above mean high water and thus requires no further elevation than that given by the headland.

Its light has the character of white group flashing twice every fifteen seconds, and this has a range of 14 miles. The third-order rotating optic is powered by a 60 watt lamp. It was originally turned by a weight which descended down a 45m shaft but when the station was automated it was changed to a small motor.

The small, squat lighthouse at Berry Head, 58m above high water, marks Torbay and Brixham Roads.

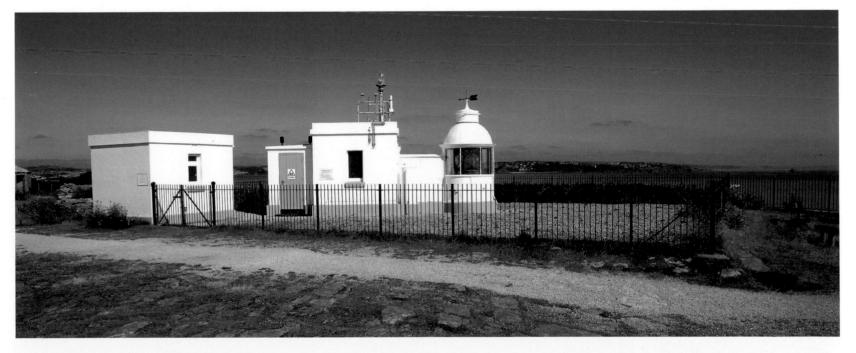

River Dart

Established	1856
Current lighthouse built	1981
Automated	1981
Operator	The Dart Harbour and Navigation Board
Access	The 1981 light at Lighthouse Beach is accessible via a flight of steps from the byroad at the top of Kingswear

The entrance to the River Dart has been fortified since the fifteenth century, when a castle was built on the Dartmouth side. This is the earliest surviving example of an English coastal castle specifically designed for artillery. It is not clear when a light was first shown from Dartmouth Castle, but one was displayed from 1856, when a fixed red light visible for 10 miles was exhibited from a white 50ft-tall square stone tower on the wall of the castle complex.

The light was not a success, as the channel was on the other side of the river, and it was discontinued after 1864 when a more useful light was erected on the Kingswear side. Some of the lighthouse buildings still exist, however, and can be visited at this English Heritage site by either parking at the castle or taking a boat trip from Dartmouth.

In 1864, a lighthouse was built within the confines of Kingswear Castle on the cliffs above.

It consisted of a 36ft white-painted hexagonal stone tower with a fixed white light visible for 10 miles. By 1980, the tower had become unstable and was demolished, although some remains are reported to exist within the castle grounds which, since the seventeenth century, have been in private hands. In 1981 the Dart Harbour and Navigation Board replaced the light with a round 30ft white glass-reinforced plastic tower with conical roof erected on Lighthouse Beach, Kingswear, 800 yards upstream from the castle. Visible for 11 miles, it shows an isophase white light over the safe channel, with a red sector to the left and a green sector to the right through a window in a square lantern on the dome.

High on the cliffs, about 800 yards inland from Inner Froward Point on the east side of the river, is an 80ft octagonal granite daymark. It can be visited by either a detour off the South West Coast Path or from Higher Brownstone.

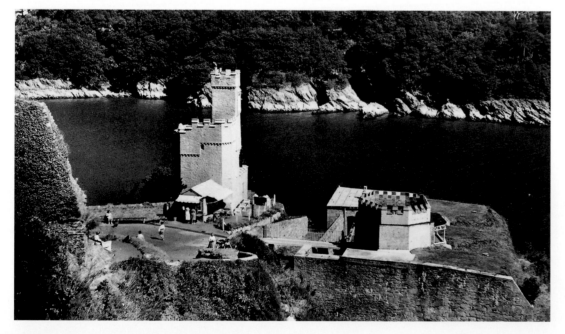

The square stone tower, built in Dartmouth Castle, from which a light was shown between 1856 and 1864. (Courtesy of John Mobbs)

Start Point

Established	1836
Current lighthouse built	1836
Automated	1993
Operator	Trinity House
Access	Approached via a long service road from Hallsands or the South Devon Coast Path

Prawle Point and Start Point are two of the most exposed peninsulas on the south coast, running almost a mile out to sea on the south side of Start Bay. This, and the presence of the Skerries Bank to the north-east, resulted in Trinity House's decision in 1836 to erect a lighthouse at Start Point. The lighthouse, designed by James Walker, is sited at the end of the headland and reached via a long, winding single-track road hewn out of the rocky ground. The 92ft circular stone tower accommodated the keepers on the first two floors. In 1871 these floors were removed and standard accommodation was provided in adjacent service buildings. The tower is of a gothic design with a castellated balcony below the lantern room.

Initially, two white lights, first shown on 1 July 1836, were exhibited; the revolving flashing white light in the main lantern room had a range of 25 miles and was for passing traffic; the fixed light shown from a window 23ft below marked the Skerries Bank. The fixed light was subsequently altered to red with a range of 12 miles. The main optic, the first of its kind to be used by Trinity House, was a form of

Start Point lighthouse, to the east of Salcombe, was built in 1836 to assist shipping passing the peninsula off south Devon.

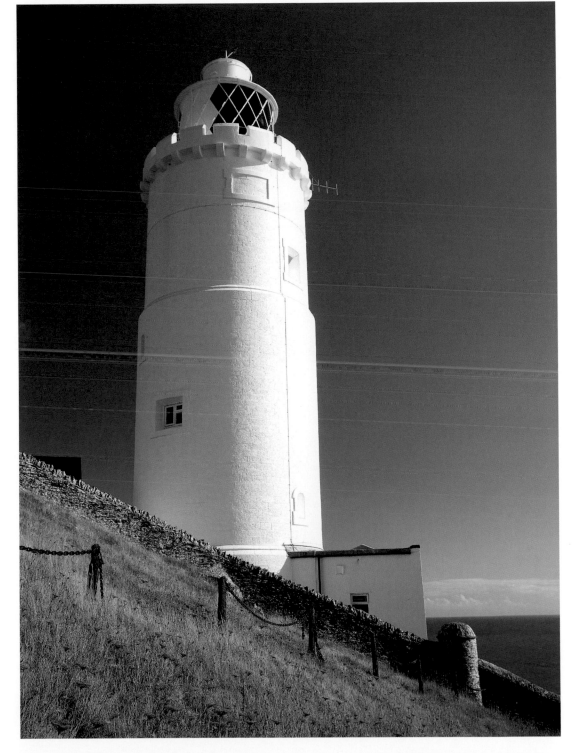

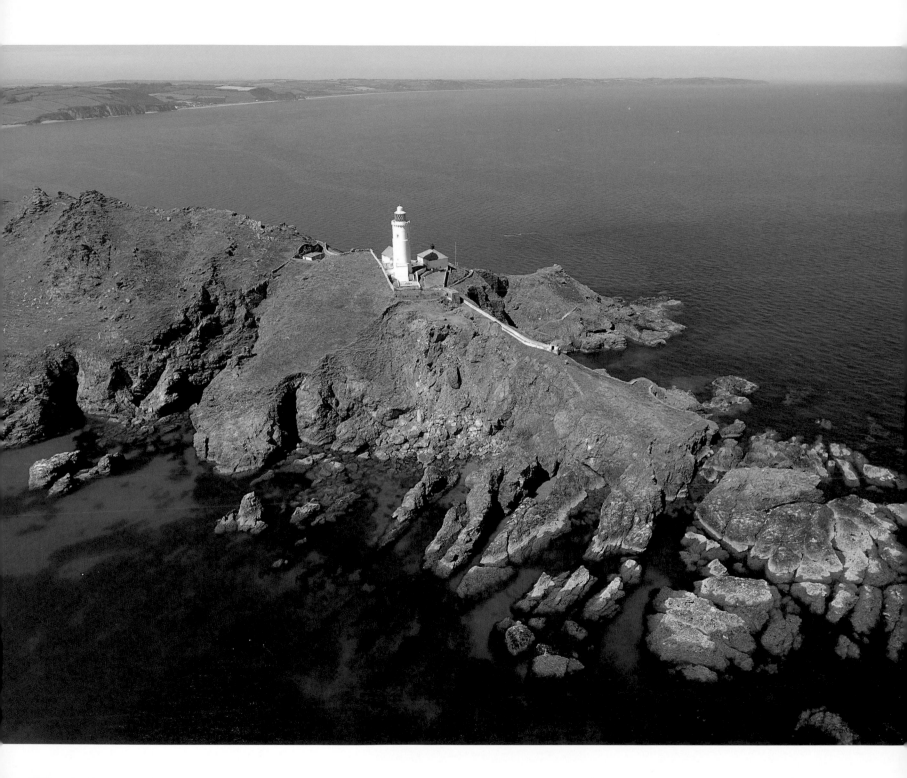

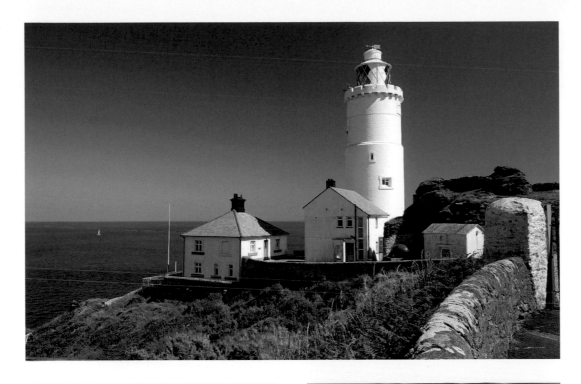

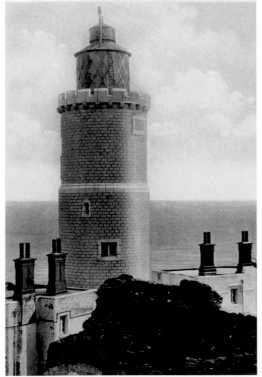

(Top) Start Point lighthouse was built in 1836 and was automated in 1992-92. There is now a visitor centre within the station, with guided tours offered for a charge.

(Above) One of the old keepers' cottages at Start Point.

(Left) Start Point lighthouse in 1882, before the standard Trinity House colours were adopted. The principal keeper's dwelling is in front of the tower.

dioptric apparatus designed by Alan Stevenson, and displayed a group-flashing light three times every ten seconds.

Because the light was found to be inadequate in fog, a bell was installed in the 1860s. The machinery for this was housed in a small building on the cliff face and operated by a weight which fell in a tube running down the sheer cliff. A siren replaced the bell after fifteen years. In December 1989, the ground under the fog signal house became insecure and caused the building to collapse. Since then, the site has been levelled, a new retaining wall built, the most southerly keeper's house demolished and the fog signal moved to the main tower.

Work began on the automation of the station in August 1992, being carried out by LEC Marine at a cost of £82,754 and completed in early 1993, when the keepers were withdrawn. The remaining keepers' cottages are available as holiday lets administered by Rural Retreats on behalf of Trinity House. Guided tours lasting approximately forty-five minutes take place during the season, and there is a souvenir shop in the lighthouse offering a selection of gifts.

Plymouth Harbour

Established	1844
Current lighthouse built	1844
Operator	Cattewater Harbour Authority
Access	The Breakwater light is only accessible by sea but can be viewed from the Hoe and other viewpoints on the front

Along the shoreline in Plymouth Harbour are numerous fixed lights on structures varying from single poles to cylindrical and lattice tower supports. However, amongst all the aids managed by the Cattewater Harbour Authority are only two active lights of significance. In the early 1800s, a large breakwater was built across the main entrance to the sound and, in 1844, a 78ft circular grey granite tower with a stepped bell bottom, called Plymouth Breakwater Light, was built by Sir John Rennie on the western end. The white-domed lantern and gallery on top shows a white flashing light visible for a mile and a half to guide ships leaving port. A red sector light visible for 2 miles shows in all other directions. In a window at 39ft, an additional white light visible for 12 miles marks the entrance channel. The tower also carries a large fog-warning bell at gallery level.

The other light is Queen Anne's Battery Rear Range, situated on the roof of the two-storey battery building, home of the Royal Western Yacht Club, on the other side of Sutton Harbour from the Barbican. With a focal plane of 46ft, the white light shines from a window in the ornate clock tower, along with red and green sector lights.

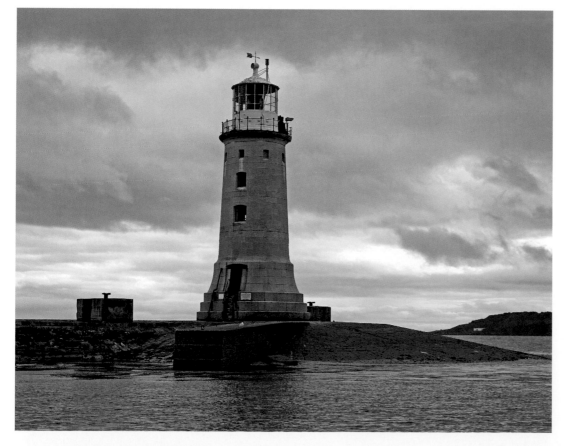

Plymouth Breakwater Light marks the south-western entrance to Plymouth Harbour.

Smeaton's Tower

Established	1759
Current lighthouse built	1882
Automated	1982
Operator	Trinity House
Access	On Plymouth Hoe, open to the public daily in summer as part of Plymouth Dome attraction

The fourth lighthouse on the Eddystone Rocks, built by John Smeaton in 1759 and used until 1879, now stands on the Hoe at Plymouth and is a major landmark in the city. After its base was undermined in the 1880s, the tower was dismantled and re-erected in its current location on the Hoe. The 72ft circular stone tower has been restored and, painted with alternating red and white bands, has a white lantern room and gallery. The tower has been a Grade I listed building since 1954 and is open to visitors, who may climb the ninety-three steps, including steep ladders, to the lantern room. The stump remains and, on a clear day, can be seen with binoculars from the Hoe.

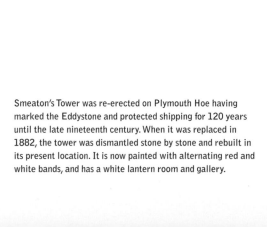

Smeaton's Tower was re-erected on Plymouth Hoe having marked the Eddystone and protected shipping for 120 years until the late nineteenth century. When it was replaced in 1882, the tower was dismantled stone by stone and rebuilt in its present location. It is now painted with alternating red and white bands, and has a white lantern room and gallery.

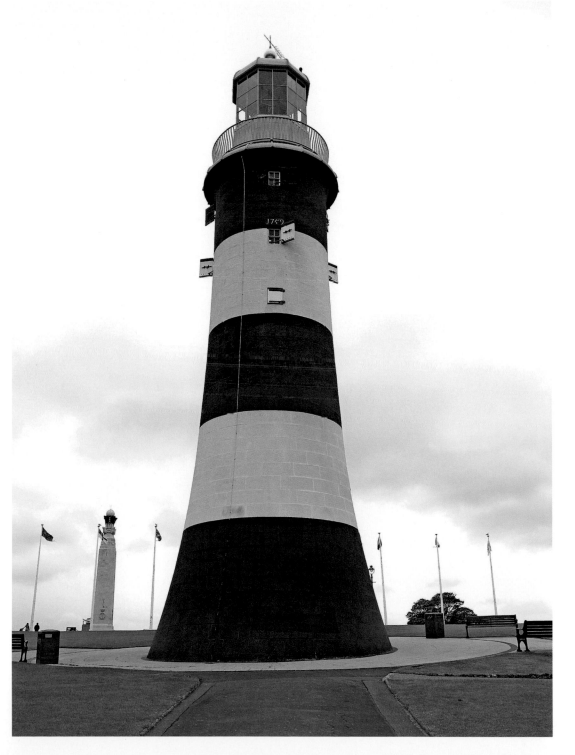

Eddystone

Established	1698
Current lighthouse built	1882
Automated	1982
Operator	Trinity House
Access	Can only be seen by boat or helicopter

Positioned 14 miles off Plymouth in the centre of the English Channel shipping lanes, the square-mile rock formation known as Eddystone provides a treacherous obstacle to shipping. Loss of life and cargoes on this hazard in the seventeenth century were only surpassed by those on the notorious Goodwin Sands. The first attempts to mark the hazardous rock were made in 1694, when a provisional agreement was reached between Trinity House and Walter Whitfield, a Devonshire boatbuilder, to build a candle-burning beacon on the rock. This attempt came to nothing when the huge scale of the project became clear.

Winstanley's Tower

The next efforts were made by the eccentric Henry Winstanley who, having had two ships wrecked on the rock, proposed the construction of a light to the Trinity House Brethren. Work started in 1696 to erect a wooden lighthouse on the highest point of the rock. At the time England and France were at war and, one foggy day, Winstanley and some of his crew were captured and taken to France. As soon as King Louis XIV found out what had happened, he quickly had the prisoners returned and the privateer thrown into the Bastille. A message was sent by Louis to William II, stating 'I might be at war with the English but not with humanity'.

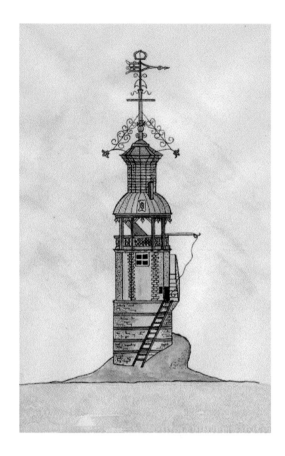

Work then proceeded, but with a revised and strengthened foundation, as Winstanley had witnessed at first hand the ferocity of the sea. Construction progressed slowly until, in 1697, Winstanley decided to increase the working day by living with his crew in the partly constructed tower. On 14 November 1698, a light, using a chandelier of tallow candles, was displayed for the first time in the 80ft ornate wooden tower, and the first rock lighthouse in the world came into operation. During the tower's first winter, 90ft waves crashed over it, breaking most of the lantern windows and shaking it so violently that the keepers thought it would be washed away.

During 1699, Winstanley returned and completely rebuilt the lighthouse, increasing

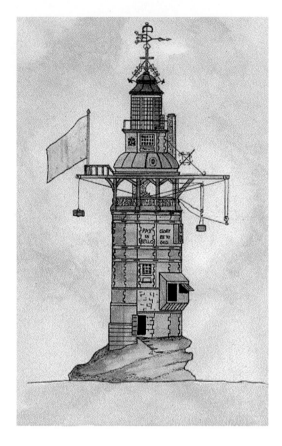

The first two lighthouses built on the Eddystone rock were designed by Henry Winstanley and are somewhat ornate in appearance. His first tower dates from 1698, while the second was built the following year after the first had been dismantled. This second tower was 120ft in height, with an 11ft octagonal lantern on top of it.

its girth to 24ft and its height to 120ft. He also increased the light source to sixty candles. Critics said the light would not last and their comments were to come tragically true in 1703, whilst Winstanley and his men were strengthening the structure. Southern England was struck by a tremendous hurricane and, when it subsided, nothing could be seen of either men or lighthouse.

Rudyerd's Tower

During the four years Winstanley's light was in place, shipwrecks virtually ceased but they assumed epidemic proportions when the light had gone. In response to pressure from shipowners, Trinity House agreed a patent with John Rudyerd for a new light, and work began in 1706. Thinking one of the errors in Winstanley's design was the ornate additions which increased resistance to the sea, Rudyerd designed a simple cone-shaped tower and also had a solid stone base, 28ft tall, constructed.

His design stood for forty-six years until the night of 2 December 1755 when, with the keeper attending the candles, an updraft caused the lantern to set alight; within a few hours the whole wooden structure was destroyed. Seeing the flames from the harbour at Plymouth, a Mr Edwards hired a local fisherman to take him out and he managed to haul the keepers from the rock after they had spent a night huddled below the burning structure with debris falling round them. On returning to shore, one keeper ran away and the other, Henry Hall, died twelve days later. It was later discovered he had a 7oz piece of lead in his stomach, having swallowed it when the lead roof of the lantern melted.

Smeaton's Tower

The consequence of this fire brought about what is now accepted as the most important

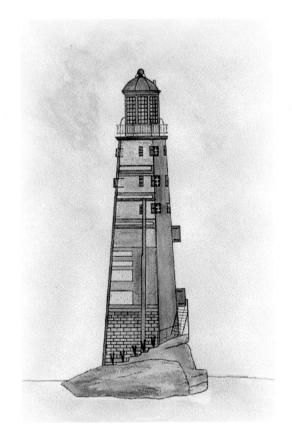

milestone in rock lighthouse construction – Smeaton's Tower. John Smeaton, who became known as the father of civil engineering, made a technological breakthrough when he suggested building a solid granite tower which would use its great weight for strength. Hitherto, it had been believed that flexibility was the key to enabling the tower to withstand the extreme forces of the sea, so many doubted Smeaton's idea. But he also used his knowledge of joinery to suggest dovetailing an indent in the underside of each block of granite with a corresponding raised dovetail on the top of the block below. In this way he could protect the jointing material from the action of the sea.

Work began in August 1756 and, as a temporary measure, a lightvessel was moored

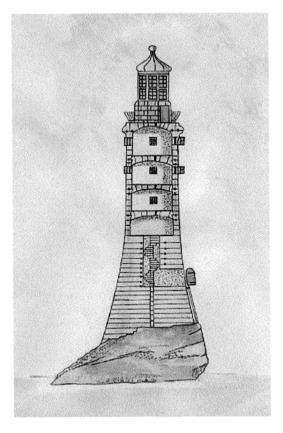

The third and fourth towers built on the Eddystone rock. The third was John Rudyerd's tower and lasted from 1709 until December 1755, when it was destroyed by fire. The fourth tower, designed by John Smeaton, now stands on Plymouth Hoe.

2 miles north of the rock. With England and France still at war, Smeaton had to obtain an exemption certificate to stop his workforce being press-ganged. One of his revolutionary ideas was to shape the tower like a tree with a curvature at the base which deflected the waves away from the tower, thus reducing the force on it. This principle has been applied to all subsequent rock towers. Smeaton also visited Portland Quarries and experimented in the use of crushed limestone and clay to form a mixture which, when mixed with sand,

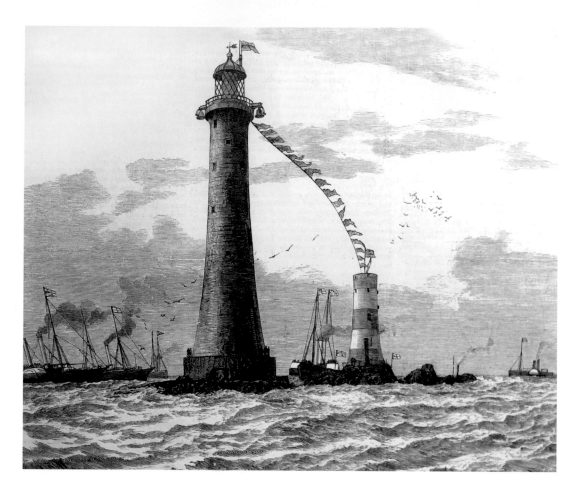

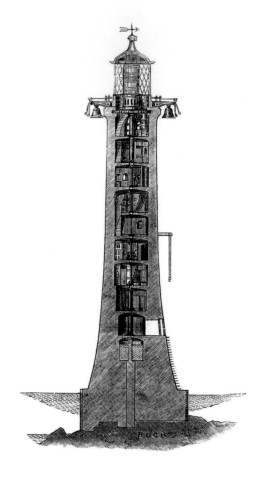

produced a paste which dried to form a solid compound. This was then used to cement the blocks, and became the forerunner of Portland cement.

The first granite block was set in place on 12 June 1757 and by 17 August 1759 the last of the forty-six courses was in place, giving the tower a height of 70ft. The lantern was placed on top and, on 16 October 1759, John Smeaton stood on Plymouth Hoe and saw it displayed for the first time. The light was initially provided by a chandelier of candles, but in 1810 it was changed to oil, with a series of reflectors.

An engraving showing the formal opening of Douglass' tower on Eddystone on 18 May 1882 by HRH Duke of Edinburgh.

James Douglass' Tower

Smeaton's lighthouse remained standing for many years, but by 1877 it was discovered that, although the lighthouse was sound, the rock base below was being undermined. To remedy the situation, one suggestion was to blow up the rock and remove it, but this idea was dismissed as the light was an important seamark. So James Douglass, Engineer-in-Chief to Trinity House, was sent to the rock and his recommendation for

Cutaway drawing of the Eddystone lighthouse produced when the tower was first built.

a new lighthouse on a new site on the rock was accepted. Thus began the process of erecting the tower that is in use today.

Having designed the lighthouse, Douglass appointed Thomas Edmonds as resident engineer. Work started on the new tower on 17 July 1878 with the excavation of the rock and construction of a coffer dam which would mean the working day could be extended.

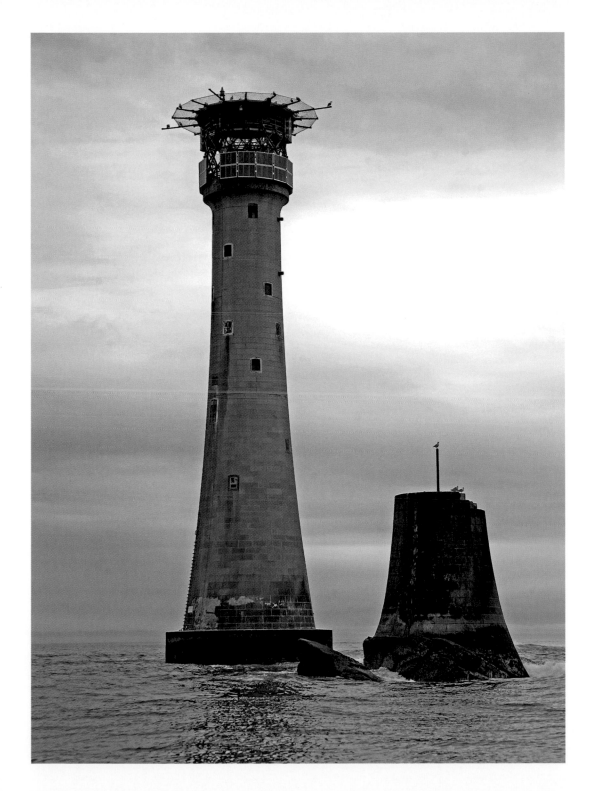

The coffer dam took a year to complete and, on 19 August 1879, Prince Albert placed various memorials and coins into a cavity below the first stone to be laid. The 168ft granite tower was divided into eight storeys and surmounted by a magnificent 16ft 6in high by 14ft-diameter lantern designed by Douglass and constructed in steel covered in gunmetal. The lantern also supported two 2-ton fog bells, but these were replaced by fog guns in 1891.

The revolving oil-fired optic was driven by a weight on a chain which, in the early days, had to be wound by a keeper, an operation which took fifteen minutes in every hour. A secondary light on the fifth level, powered by two Argand oil lamps and reflectors, shone through a window and marked Hands Deep to the northwest. The lights were converted to paraffin in 1906, which halved the fuel consumption and trebled the illumination.

In 1952 the lights were electrified with diesel generators and 110-volt mercury vapour lamps installed. In 1969, the bi-form optic was replaced by an AGA fourth-order catadioptric apparatus, which increased the visibility of the group-flashing white light to 22 miles. In 1980 a helipad was constructed on top of the lantern and, in 1982, the lighthouse became the first of the major Trinity House lights to be automated when the keepers were withdrawn.

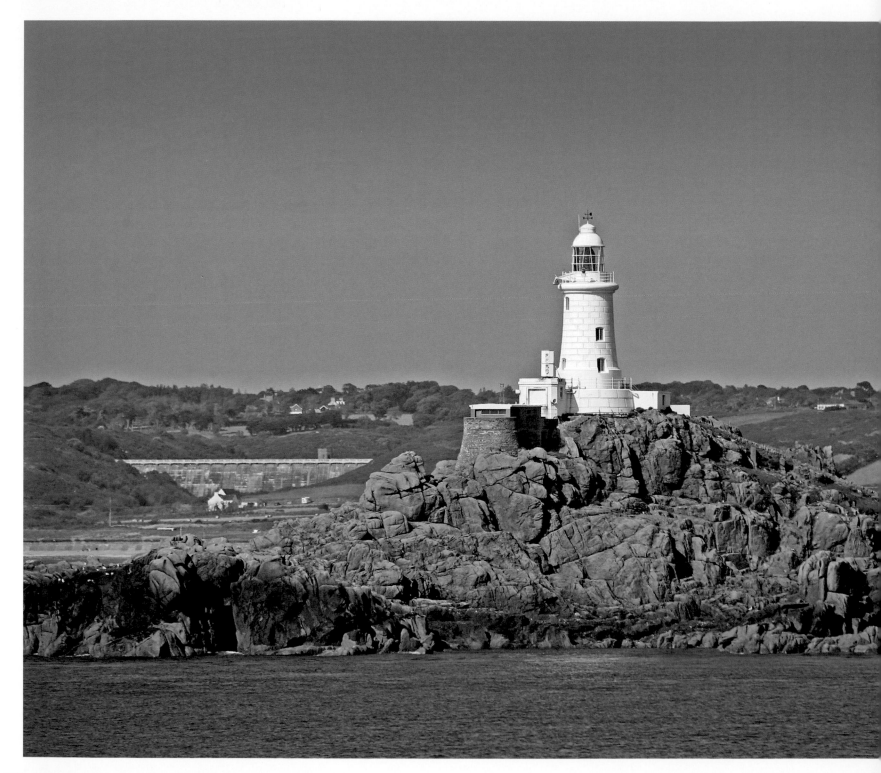

7 CHANNEL ISLANDS

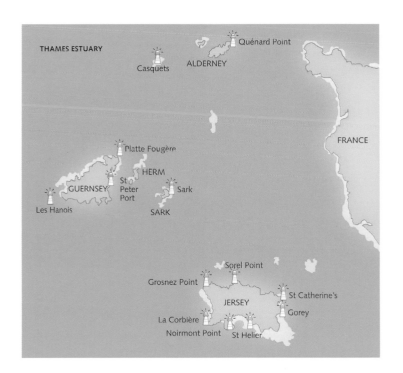

THAMES ESTUARY

Quénard Point

Casquets

ALDERNEY

FRANCE

Platte Fougère

HERM

St
Peter
Port

GUERNSEY

Sark

Les Hanois

SARK

Sorel Point

Grosnez Point

JERSEY

St Catherine's

La Corbière

Gorey

Noirmont Point

St Helier

Casquets

Established	1724 (three towers)
Current lighthouse built	1723–24
Automated	1990
Operator	Trinity House
Access	Accessible only by helicopter or boat, site and towers closed

The Casquets Rocks lie 8 miles north-west of Alderney and present a significant danger to shipping. During the eighteenth century the rocks were owned by Thomas Le Cocq. In 1722 shipowners petitioned Le Cocq to build a lighthouse and offered him half a penny per ton when vessels passed the light. Le Cocq approached Trinity House and a patent was obtained from them on 3 June 1723.

As a distinctive light was needed to ensure it differed sufficiently from those shown from both England and France, three separate towers in a geometrical pattern, making up a horizontal triangle, were proposed. Three towers were erected, each about 30ft high, containing coal fires burning in glazed lanterns. These three lights were called St Peter, St Thomas and Donjon (a possible corruption of St John), and were first exhibited on 30 October 1724. The fires were replaced by oil lamps in 1770.

The lease granted to Le Cocq by Trinity House lasted for sixty-one years at a rent of £50 per annum. In 1785, at the end of Le Cocq's lease, the three Casquets lights reverted to the ownership of Trinity House and the brethren introduced various improvements. The lights were converted to house metal reflectors and Argand lamps, which first came into operation

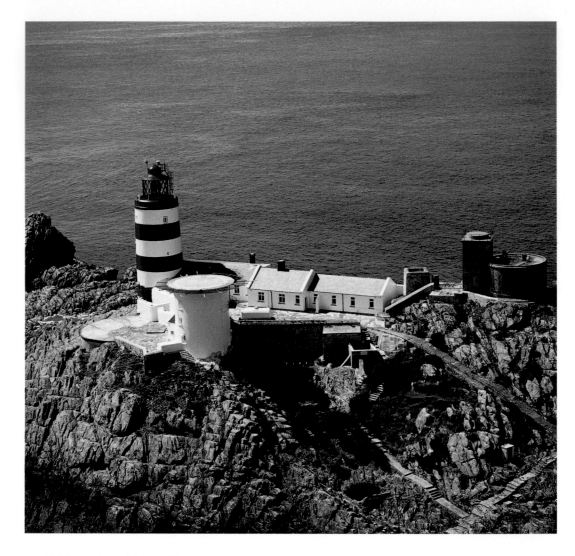

on 25 November 1790, and in 1818 a revolving apparatus was fitted to each tower. In 1854 the three towers were raised by 30ft to increase the range of the lights, but in 1877 the North West Tower was raised again and the lights in the other two towers discontinued.

The light was electrified in 1952, while all three towers remain in use, although only the North West Tower now exhibits a light. The East Tower houses fog-signal equipment,

The Casquets lighthouse complex with the three towers, one of which houses the current light.

which has a range of 3 nautical miles, and a helideck is mounted on the third tower. The operational tower is 75ft in height, 120ft above mean high water, and the light has a range of 24 nautical miles. Casquets was automated in November 1990.

Quénard Point, Alderney

Established	1912
Current lighthouse built	1912
Automated	1997
Operator	Trinity House
Access	On the eastern point of Alderney, the light is a forty-minute walk from Braye; guided tours available

Alderney lighthouse, sited on Quénard Point, to the north-east of the island, was built in 1912 to act as a guide to passing shipping and warn vessels of the treacherous waters in the locality. The Alderney Race, a notorious strait of water between Alderncy and Cap de la Hague in France, includes the strongest tidal streams in Europe, caused by the tidal surge from the Atlantic building up in the gulf of St-Malo and squeezing between Alderney and Cap de la Hague. Water flows through at speed at high tide and is sucked back as the tide recedes. An uneven seabed adds to the turbulence with further hazardous rocks a few miles offshore.

The tower itself, complete with lantern and gallery, is 106ft in height and painted white with a central black band to make it distinctive during daylight. The flashing white light, which was converted to electrical operation in 1977, gives four flashes every fifteen seconds and has a range of 23 miles. There is also a foghorn, which gives a blast every thirty seconds. Two sets of keepers' dwellings and service buildings are attached to the tower by short corridors. The cottages are used as holiday lets.

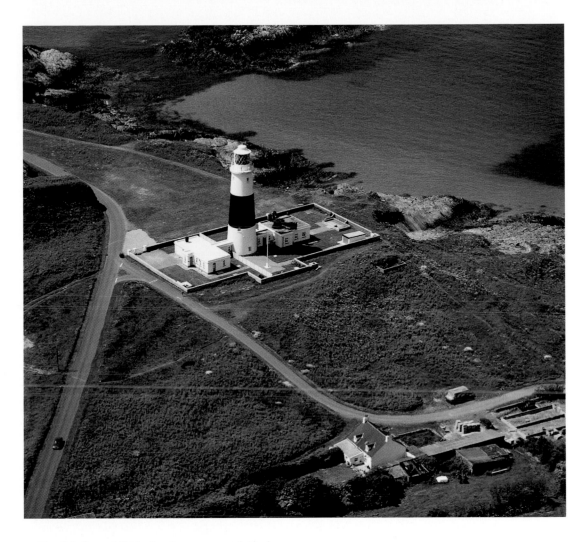

On 21 June 1940 the keepers and their families were taken from the lighthouse in boats which, after calling to collect the residents of Sark, Casquets and Hanois lighthouses, together with some refugees from these locations, safely reached Southampton on 23 June and landed the evacuees. The lighthouse was occupied by the Germans until, after VE day, the keepers returned. They operated the light until 30 September 1997, when it was automated.

Alderney lighthouse at Quénard Point is a notable landmark on the small Channel Island. Alderney is only 8 miles from the French coast and has just one town, St Anne. (Brian Green)

Point Robert, Sark

Established	1913
Current lighthouse built	1913
Automated	1993
Operator	Trinity House
Access	The island is car free, so a walk, bicycle or horse carriage ride to the north-eastern point is necessary; the site and tower are closed

The lighthouse on Sark, often referred to as Point Robert because of its location, is in an unusual station which, together with the lighthouse on Alderney, acts as an aid to navigation for ships approaching the Channel Islands. Built in 1913, it also guides shipping away from Blanchard Rock, which lies a few miles east.

The site is located halfway down a precipitous cliff face; the area was prepared by hewing two flat areas into the rock face, with stone walls supporting the front, together with a rear retaining wall. The two-level flat-roofed service rooms and keepers' dwellings are in a stepped formation. The 55ft octagonal tower has a gallery and lantern rising from the roof of the higher building.

The top of the lantern is an unusual shape, with a central circular section rising from the middle of the octagonal dome. The retaining walls are unpainted, while the buildings, tower, gallery and lantern are all white with the standard Trinity House green. Access to the site is via a precipitous flight of steps. Because of its isolated location, when manned the lighthouse was operated as a rock station.

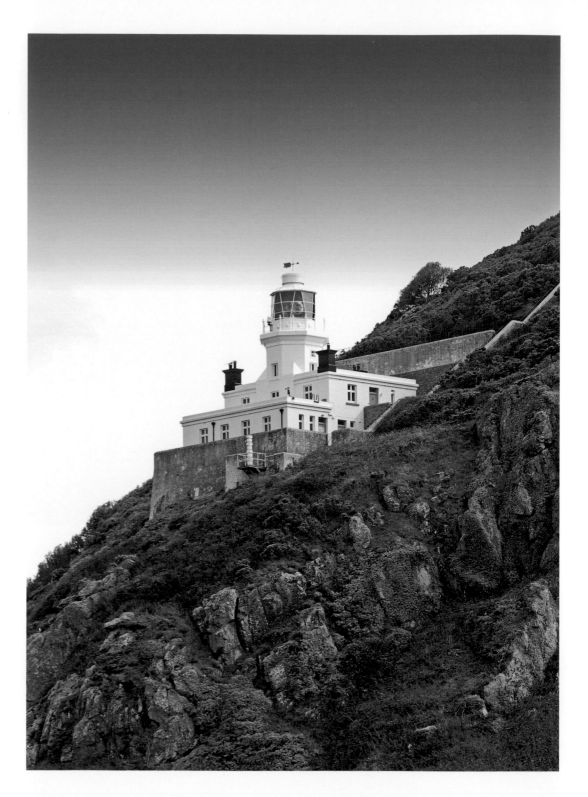

The lighthouse at Point Robert on the south-east side of the island of Sark. (Brian Green)

Les Hanois, Guernsey

Established	1862
Current lighthouse built	1862
Automated	1996
Operator	Trinity House
Access	No public access; only accessible by helicopter

From 1940 to 1945, during the German occupation, the lighthouse keepers were withdrawn and the site was manned by Germans. Two holes were cut into the surrounding walls to form gun emplacements, the area was mined and the store was used as a prison. On 27 October 1945, after the area had been tidied up and two local assistant lighthouse keepers trained, the flashing white light, visible for 20 miles, and the fog signal were again operational. The lighthouse was automated in 1994.

The only way to visit the site on this car-free island is by ferry from St Peter Port, followed by a walk, bicycle or pony and trap ride to the clifftop at Point Robert. It is then a descent down 165 steep steps to the light itself, which is not open to the public.

Situated just off the south-western corner of Guernsey is the jagged reef of rocks, Les Hanois. In 1862 Trinity House built a lighthouse to the design of Nicholas Douglass on the largest of the reefs to guide ships in the English Channel and also mark the Channel Islands. The construction was revolutionary, taking Smeaton's methods at Eddystone a stage further by dovetailing solid granite blocks both horizontally and vertically. Hitherto, each

successive layer of stones had been joined by sockets and pins. But by cementing each block in place, Douglass produced an almost solid tower, and his method became the standard for all future rock lighthouses.

The 117ft tapered granite tower, with seven tiers of accommodation and machinery rooms, was complete with a gallery and lantern. It had a wind vane, but this was removed in 1979 when a helipad was built. In total, 24,542cu.ft of

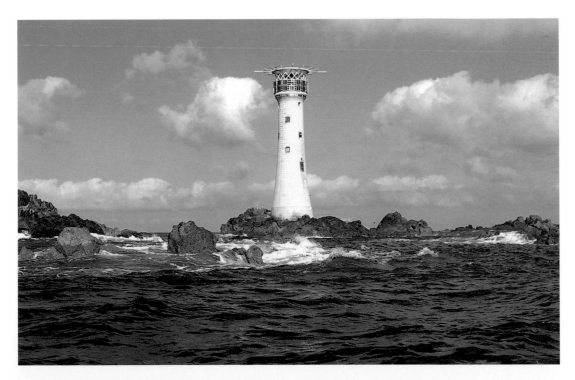

Les Hanois reef off the coast of Guernsey, marked by the 33m lighthouse built in 1862. (Brian Green)

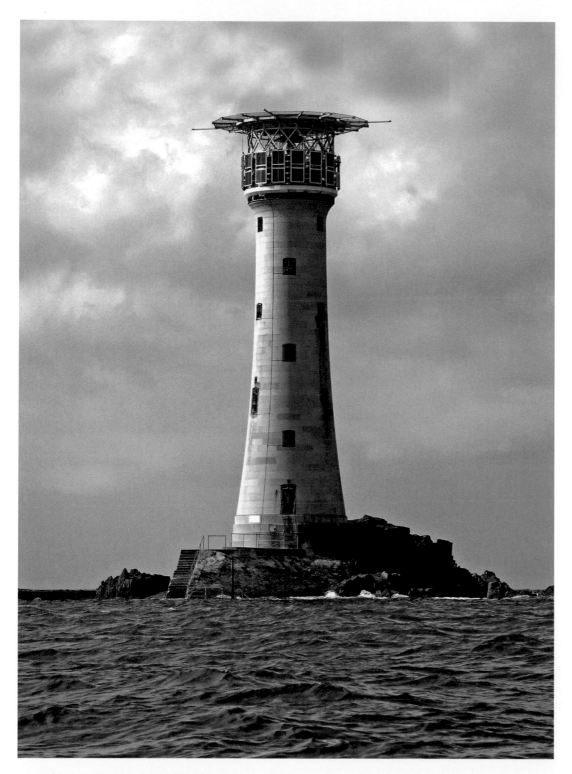

masonry was used to build the tower, which was 32ft 7in in diameter at the base, with the light gallery course 20ft 6in in diameter. The tower cost £25,296 to complete.

The original lantern was a first-order optic built and supplied by Chance Brothers of Smethwick. The light was first shown at sunset on 1 December 1862 for two hours, and a week later was officially shone for the first time.

Like other Channel Island lighthouses, Les Hanois was occupied by the Germans during the Second World War and used for solitary confinement. Rumour has it there is a bullet hole in one ceiling where a soldier or prisoner shot himself. During this time, the large paraffin vapour burner was damaged by gunfire, but in 1964 it was replaced by an electrically powered fourth-order catadioptric optic, with a paraffin vapour burner as standby.

Another couple of notable events at Les Hanois came in 1996 when the tower was the first rock lighthouse to be equipped with solar power, and on 4 January that year it became the last rock station to be automated and de-manned. At this point, the rotation of the light was reduced, changing the character of the light from two flashes every five seconds to two every thirteen seconds, which enabled the length of the flash to be increased, thus retaining the existing range of 20 miles.

Platte Fougère, Guernsey

Established	1910
Current lighthouse built	1910
Automated	1950
Operator	Guernsey Port Authority
Access	Can only be visited by boat

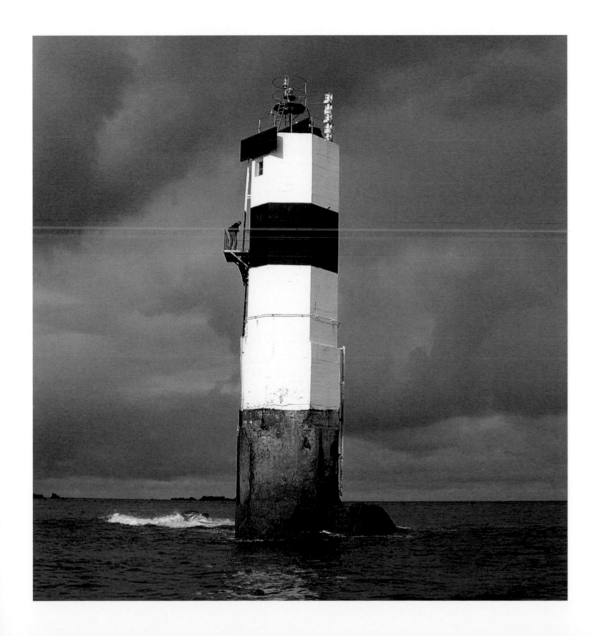

Situated about a mile offshore near the most north-easterly point of Guernsey, the lighthouse at Platte Fougère was built in 1910 to mark the notorious reef after which it is named. Managed by the Guernsey Port Authority, it consists of an 82ft octagonal concrete tower painted white with a black band on the landward side. There is no lantern and the apparatus mounted on top consists of a light, a fog signal and a racon beacon. The light shows flashing white and flashing red sectors.

When the station was commissioned in 1910, the fog signal was operated by electricity via a submarine cable from Fort Doyle but the light was gas powered with supplies delivered by boat. In 1950, the cable was replaced and the light converted to electrical operation. There is a suggestion that the tower was replaced but old and new photographs suggest this was not so.

The lighthouse at Platte Fougère lies just over a mile offshore but can be seen from Fort Doyle. (Rob Alder)

St Sampson, Guernsey

Established	1874
Current lighthouse built	1874
Operator	Guernsey Port Authority
Access	Both lights can be seen from the road, and the lights are situated on public land

The harbour of St Sampson, to the north of St Peter Port, was developed in the eighteenth century for the export of granite from the nearby quarries. In 1790 a breakwater was built out from Mont Crevelt to form what is now the outer harbour, which is still used for commercial traffic even though it dries out at low tide. The inner harbour was constructed in the mid nineteenth century and today houses a yacht marina.

The channel into the harbour is marked by a pair of range lights, the front of which is situated on Crocq Pierhead. Probably erected in 1874, it is a 20ft cast-iron tower, with a domed roof, mounted on a stone base which houses an equipment room. A fixed red light with a range of 5 miles shines through an oblong window.

In 1874 a building, originally the harbour master's office, was so positioned at the rear of the harbour that the rear range light could be shown from there. Mounted in the copper-domed roof of the clock tower, the fixed green light has a focal plane of 42ft and a range of 5 miles.

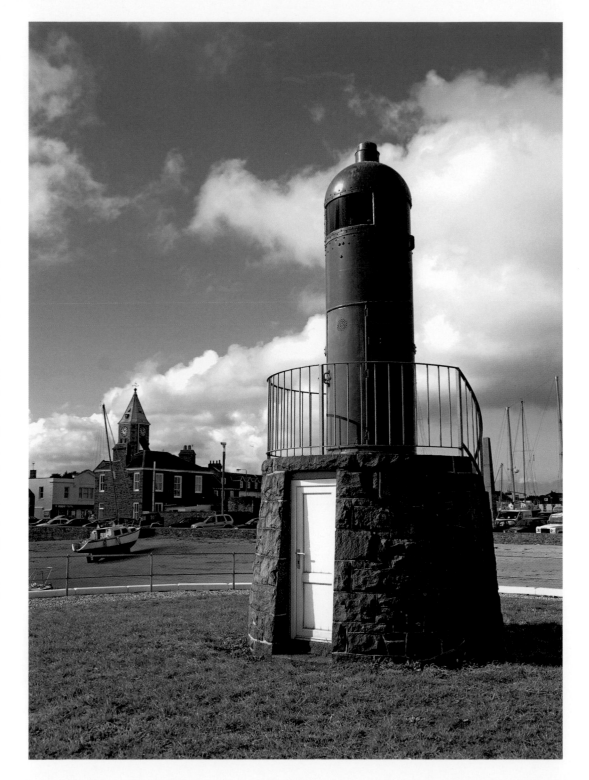

The front range light at St Sampson is displayed from the red-painted circular tower on Crocq pierhead.

St Peter Port, Guernsey

Established	circa 1860 (castle breakwater), 1908 (White Rock Pier)
Current tower built	circa 1860 and 1908
Automated	1908
Operator	Guernsey Harbour Authority
Access	Castle Breakwater is open to the public and its lighthouse can also be seen from the ferry; the other lights in the harbour can all be reached by foot

St Peter Port is the principal town on Guernsey, and the harbour is not only an extensive marina but also the island's ferry port. To guide vessels into the harbour, a range light is sited on the Castle Breakwater at the southern side of the entrance. Called Castle Breakwater Light, or more accurately St Peter Port Harbour Front Range, it consists of a 40ft tapered circular granite tower and a lantern with a coned top.

To act as a daymark, the outer facing side of the tower and lantern are painted white, with the gallery black. The electrically powered light, operated by the Guernsey Port Authority, is fixed white followed by fixed red. The rear range is a white occulting light called Belvedere, which is situated on a short metal tower on the hill behind the harbour and gives a bearing of 220 degrees. Nearby at Belvedere House, a fixed white light gives a bearing of 223 degrees.

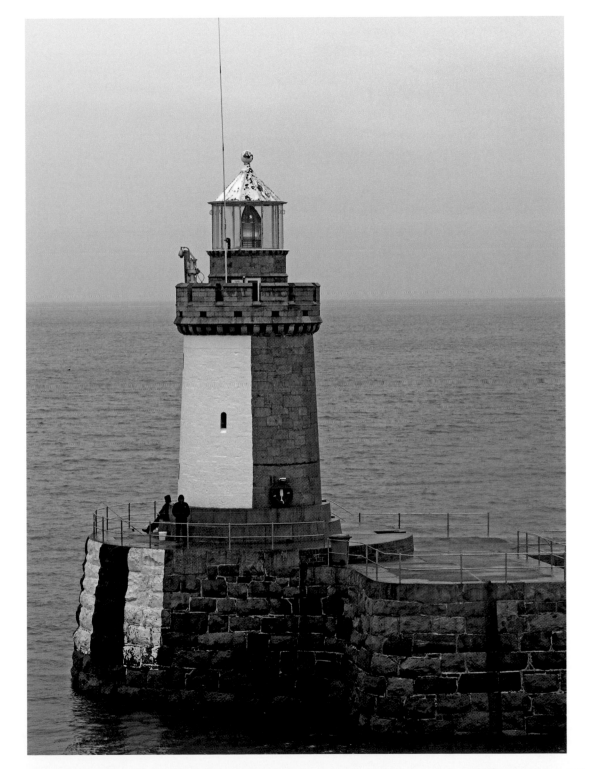

The granite-built tower at the end of the Castle Breakwater at St Peter Port houses the harbour light.

This unusual tower is built into the pier wall on the end of White Rock or North Pier at St Peter Port Harbour.

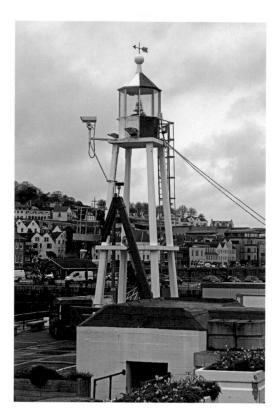

The 30ft four-legged wooden tower adjacent to the car park on the North Quay in St Peter Port Harbour.

La Corbière, Jersey

Established	1874
Current lighthouse built	1874
Automated	1970
Operator	Jersey Harbour Authority
Access	The lighthouse can be reached via a causeway, but is only accessible at low tide

The lighthouse at La Corbière is perhaps better known for its picturesque location than its history. Situated on an outcrop of rocks 6 miles east of St Helier, it guards the shipping routes between Guernsey and the British Isles. Built in 1874 by Imre Bell to the plans of Sir John Goode, the 62ft white-painted tower was the first

The light on the North or White Rock Pier is displayed from a tower built into the end face of the pier wall and supported by an inverted stepped base. The 36ft circular stone tower has a small entry door halfway up with a set of steps and a walkway along the top of the harbour wall to gain entry to the light. Located in a white dome-topped lantern and operated by Guernsey Port Authority, the electrically powered optic shows a flashing green light.

Adjacent to the car park on the North Quay is a directional light on a 30ft four-legged wooden tower with an octagonal lantern topped by a weather vane. The structure is painted white, apart from the two seaward sides of the lantern, which are red. The electrically powered optic shows a narrow fixed white light with a quick-flashing green sector to the north and quick-flashing red sector to the south. The lights in the harbour are all accessible.

(Right) La Corbière lighthouse was originally attended by four keepers, who lived in a nearby cottage, but after the light was automated they were no longer needed and left.

(Below) The seas off La Corbière are treacherous, with many outcrops of rocks and a vicious tidal race making the area hazardous for passing vessels.

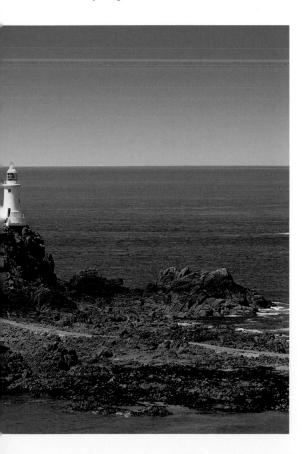

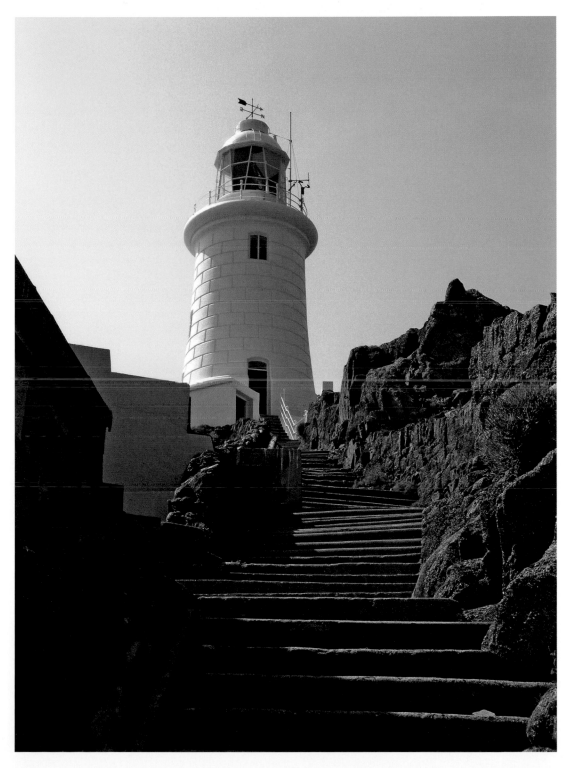

Noirmont Point, Jersey

Established	1915
Current lighthouse built	1915
Operator	Jersey Harbour Authority
Access	It is theoretically possible to walk to the tower at low tide but only with extreme caution

concrete lighthouse in the British Isles. That it has withstood the savage seas in this exposed spot, with virtually no damage since its erection, is testament to its design and construction.

The light, maintained by French lighthouse authorities, has an isophase light with both red and white sectors visible for 18 miles. Originally paraffin oil fired, it was converted to electricity and the keepers removed in 1970. Access to the lighthouse is via a causeway which is only passable at low tide after which a klaxon sounds to warn visitors to return to the mainland. All the materials for the construction of the causeway, the tower and the service building were transported from St Helier by barge and landed on a lower working platform by jackstay. The mixed concrete was raised to the site by an inclined railway and the tower was cast in situ. The light, first shown on 24 April 1874, is 119ft above mean high water, giving it a range of 18 miles.

During the Second World War the lighthouse was camouflaged. The light was dimmed on 4 September 1939 and extinguished in June 1940, remaining so for the duration of the German occupation until relit on 19 May 1945.

On 28 May 1946 the keeper Peter Edwin Larbalestier lost his life saving a holidaymaker who remained too long on the causeway. A plaque at the landward end of the causeway marks his life.

To the east of St Aubin's Bay on Jersey's south-west coast lies the rocky headland of Noirmont Point. This estate was retained by the Duke of Normandy and is now a memorial to those who gave their lives in the two world wars. It is the site of a Napoleonic tower and a series of German bunkers are maintained by the Channel Islands Occupation Society. For seafarers, a lighthouse was erected in 1915 on a rocky outcrop to mark the Sillettes Reef about a mile to the south.

The light is a stubby tapering stone tower, 32ft high, which originally had a lantern; today an electrically powered light is mounted on a short mast on top of the black with a white band tower. The light, operated by Jersey Harbour Authority, has been refurbished recently and converted to solar power.

Noirmont Point light is displayed from a squat tower sited at the western end of St Aubin's Bay.

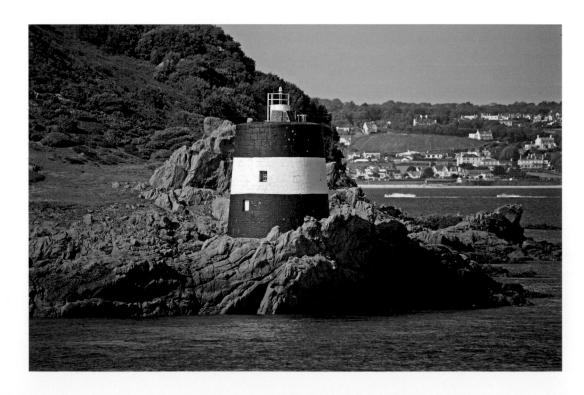

Demie de Pas, Jersey

Established	1904
Current lighthouse built	1904
Operator	Jersey Harbour Authority
Access	The light lies off St Helier and is only accessible by boat

On a rock off St Helier Harbour, a 44ft cone-shaped concrete tower was erected in 1904 by the Jersey Harbour Authority, to guide vessels entering the harbour. Originally it was painted white with a gallery and a lantern but, in about 1984, the lantern and gallery were replaced by a small navigation light. The base of the tower was repainted black and the upper part deep orange.

In 2002, the RAF provided funds to enable a new solar-powered light, fog signal and radar beacon to be fitted. This increased the height as it was mounted in a circular tube on top of the cone. The light shows a red or white sector dependent on direction. The area inland of the light is hazardous so the white flashing light shows a red sector over 180 degrees to landward. The white light has a range of 14 miles, and the red 10 miles.

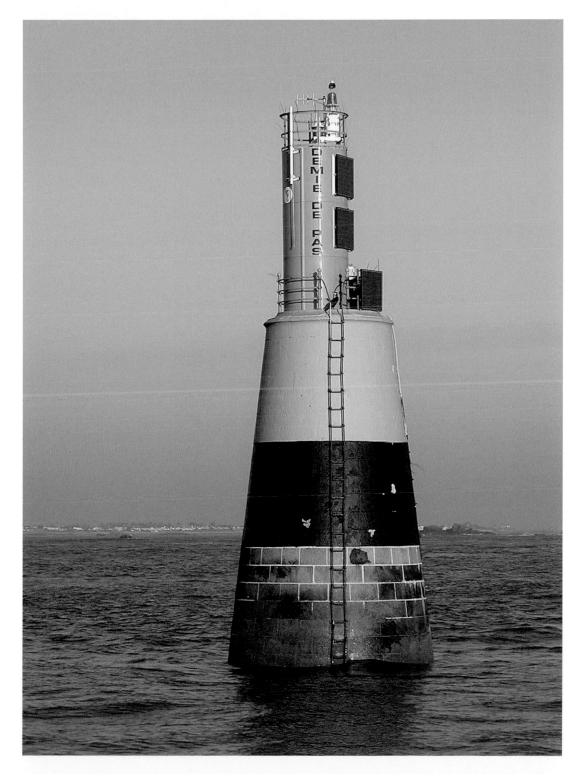

Demie de Pas light is situated off St Helier. (Ian Lamy)

La Grève d'Azette, Jersey

Established	1896
Current lighthouse built	1896
Operator	Jersey Harbour Authority
Access	Approached from St Helier via the promenade, visible from the coast road

For vessels approaching St Helier Harbour from the west, a pair of range lights guides them through the channel from Noirmont Point. The front range, called La Grève d'Azette Front-Range Light, is situated about a mile to the east of the harbour on the seafront close to Le Marais Estate. Built in 1896, the solid concrete base is built into the promenade sea wall and the 64ft high lattice steel tower has a gallery and a lantern with a hooded light. Painted white, the tower has a red daymark on the side facing the sea. The electrically powered light shows an occulting white beam at five-second intervals visible for 14 miles. During daylight, the light can be used in conjunction with the Dog's Nest Beacon situated to the east of the harbour entrance. At night it is used in conjunction with the rear range light at Mont Ubé.

(Below) La Grève d'Azette light stands on the beach, adjacent to the promenade and the A4 main road.

Mont Ubé, Jersey

Established	1896
Current lighthouse built	1896
Operator	Jersey Harbour Authority
Access	The light can be seen through a field from the road to Le Hocq

For vessels approaching St Helier Harbour from the west, a pair of range lights guides them through the channel from Noirmont Point. The rear range, called Monte Ubé Rear Range Light, is just over a mile to the east of the front range, on the top of a hill in St Clements. Built in 1896, the 46ft white lattice steel tower on a concrete base has a gallery and lantern with a hooded light. It shows an electrically powered red light occulting every five seconds and visible for 12 miles. During daylight hours, the front range daymark on La Grève d'Azette is used in conjunction with the Dog's Nest Beacon, east of the harbour entrance. At night, the Mont Ubé light is used with the front range.

(Opposite) Mont Ubé Rear Range light is situated on a hill in the St Clements district of Jersey.

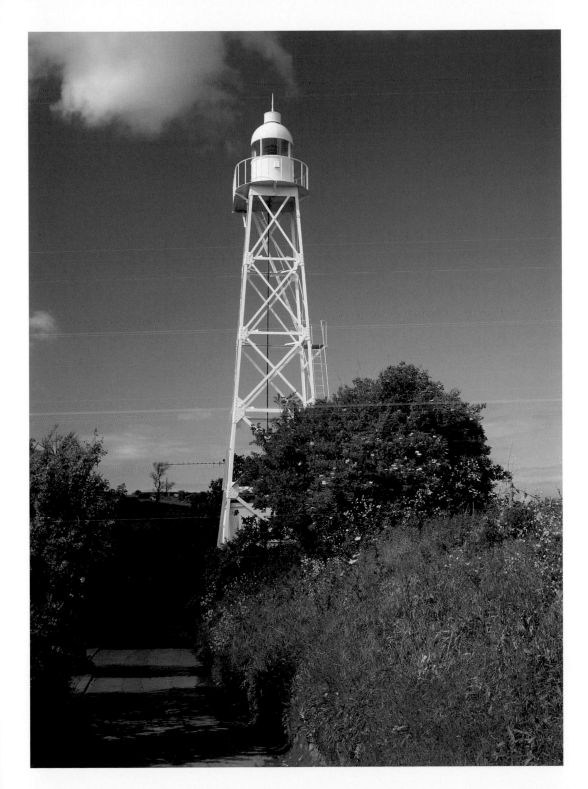

St Catherine's, Jersey

Established	1856
Current lighthouse built	1996
Operator	Jersey Harbours
Access	At the end of St Catherine's Breakwater, which is open to the public

The development of the harbour at St Catherine's came about during the 1840s as a result of rivalry between Britain and France. The government and Admiralty decided to build large naval bases on Jersey and Alderney. St Catherine's on Jersey was chosen for one of

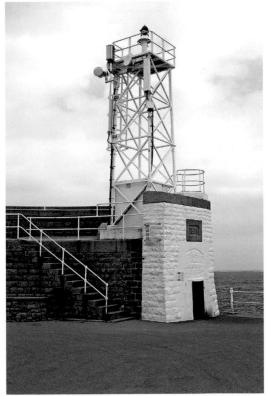

(Above) The modern light at the end of St Catherine's Breakwater.

The nineteenth-century lighthouse, which was originally located on St Catherine's Breakwater, is now displayed outside the Maritime Museum in St Helier.

MARITIME MUSEUM

these harbours, just 14 miles from France. Work began in 1847 and eight years later 640m of the northern breakwater had been completed. But bad weather and lack of finance delayed the project and, as the British and French were now allies, no further work was carried out.

A lighthouse, sometimes known as Verclut Breakwater Head, was imported into the island on 5 November 1856 and by 12 December 1856 had been installed on the end of the breakwater. It consisted of an ornate eight-sided 30ft metal tower which showed a flashing white light visible for 8 miles. This tower was replaced in 1950 by a modern, square 25ft lattice tower with an open platform from which a small light shows a white flash every one and a half seconds, visible for 8 miles.

The original lighthouse is now on display outside the Jersey Maritime Museum in St Helier. A plaque on the tower, dated 9 November 1996, reads: 'Apart from the five years of German occupation this light, from St Catherine's Breakwater, shone brightly for over 100 years to warn seamen of danger. Today it stands as a monument to those islanders who died in concentration camps far from their island home. A symbol of remembrance and a beacon of hope for the future.'

Sorel Point, Jersey

Established	1938
Current lighthouse built	1938
Automated	1938
Operator	Jersey Port Authority
Access	Jersey Coast Path passes the site, and is easily accessible

Situated on the most northerly point on the island, Sorel Point faces the Normandy coast and offers magnificent views. However, the Paternoster Reef and its associated dangers, which lie in the direction of Sark, are nearby. To guide vessels through this dangerous area, a lighthouse was constructed in 1938 on the east side of the headland. Built by Jersey Harbour Authority, it was an unusual 10ft circular concrete pillbox with a flat concrete roof.

Originally, the light shone through a long window but today it is in a small yellow lantern on the roof. The tower also acts as a daymark, painted in alternate black and white squares. During the 1990s, the light was converted to solar power, with the panels situated on the roof just behind the light, which shows a flashing red or flashing white dependent on direction.

The unusual black and white lighthouse at Sorel Point marks the most northerly tip of Jersey.

Gorey, Jersey

Established	1948
Current lighthouse built	c. 1990
Automated	1948
Operator	Jersey Port Authority
Access	A short walk from nearby car park, down the stone pier

In 1849 a fine hexagonal stone tower lighthouse, approximately 30ft in height, was erected on the end of the stone pier at Gorey. It stood on a raised pedestal and was topped by a cone-shaped lantern with a gallery. This lasted until 1964, when the whole structure fell into the sea.

In 1966 a new light was displayed from a 30ft white square skeleton tower with a small red lantern showing a green or red light. This was the front of two lights, with the rear range consisting of a red occulting light on a 3ft square white panel with an orange surround, mounted on Mont Orgueil (Gorey Castle) 1,600ft away.

The small square tower at the end of Gorey pier, marking the entrance to the small harbour.

Grosnez Point, Jersey

Established	1948
Current lighthouse built	c. 1990
Automated	1948
Operator	Jersey Port Authority
Access	A short walk from nearby car park

For visitors to Jersey, the first sight of the island is often Grosnez Point on the north-west corner. While the best-known lighthouse in the area is Corbière, the simple lighthouse erected by the Jersey Port Authority on the headland at Grosnez in 1948 is a significant aid to navigation. It originally consisted of a 6ft square, 7ft tall, white concrete hut with the light in a cylindrical lantern on top. In about 1990, this hut structure was replaced with a white 9ft oval metal column with a small double lantern on top. The flashing light has both white and red sectors visible for 19 and 17 miles respectively.

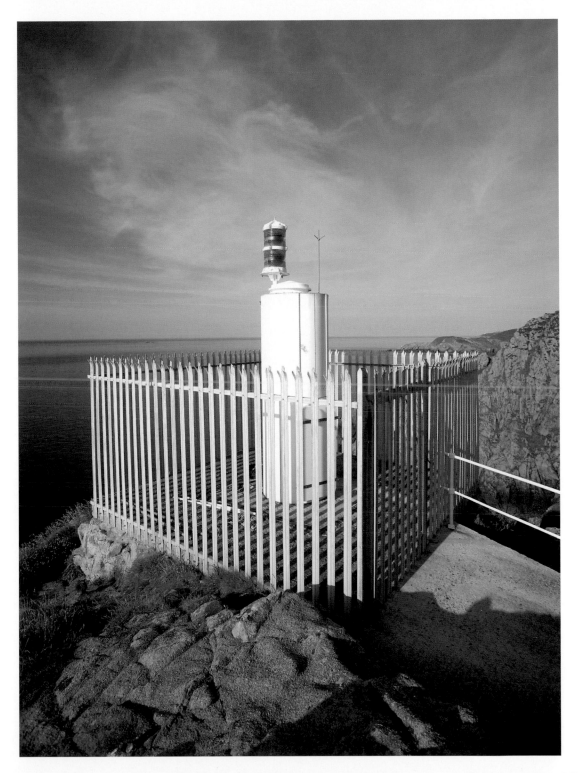

The light at Grosnez Point is situated on the edge of the Les Landes SSSI, and bird watchers also come to the area.

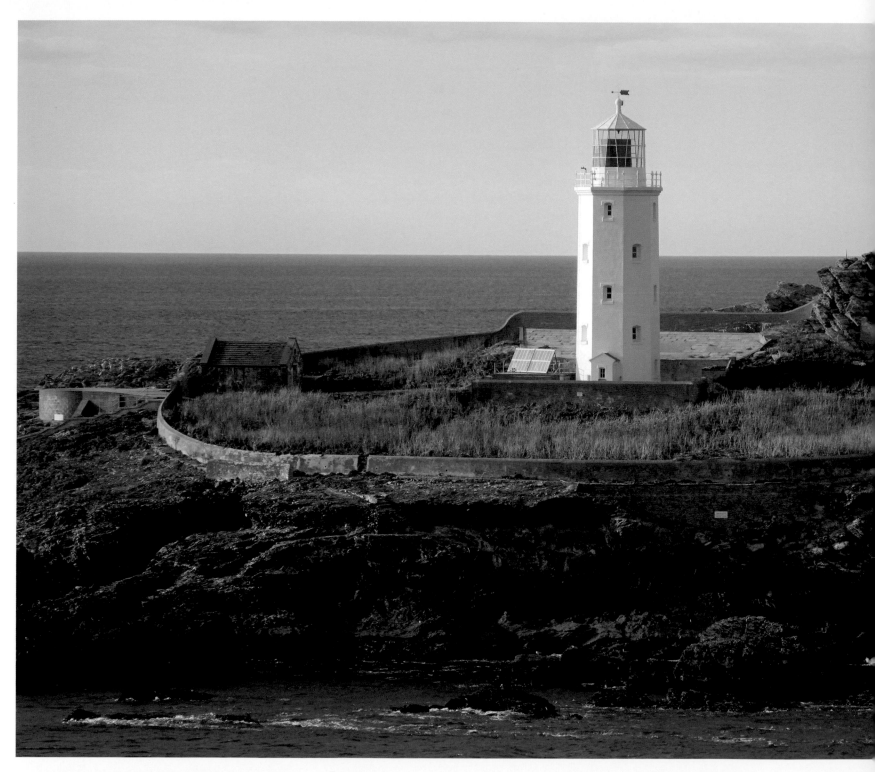

8 CORNWALL AND ISLES OF SCILLY

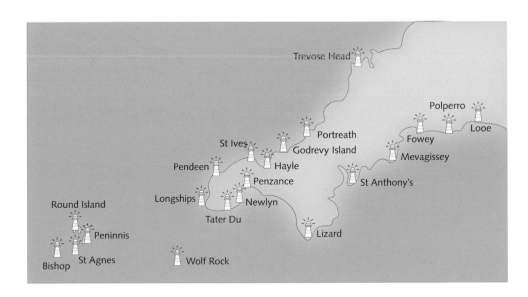

Looe

Established	1860
Current lighthouse built	1860
Operator	Looe Harbour Authority
Access	The pier is open to the public and it is possible to walk up to the light

Although the River Looe dries out at low tide, this does not stop the town having a thriving fleet of small boats. When conditions are too dangerous to haul boats ashore, a flag is flown from a flagstaff and, in bad weather, storm signals are shown from the coastguard station. The entrance to the river on its eastern side is channelled by the Banjo Pier, on the end of which is a 20ft red, cylindrical cast-iron light with a white-railed gallery.

Erected in 1860, the light is accessed via a sloping metal ladder. A white sight board is situated to seaward. Apart from the angle of the ladder, it is similar to the light at Whitehouse Point, Fowey. The light displays flashing white sectors both to landward and seaward to mark the safe channel. On the opposite side of the river at Nailzee Point is a fog signal, which was erected in about 1980. This consists of a white 10ft square concrete pillbox, with a square opening. The horn, sounded when fishing boats are at sea, produces a three-second blast every thirty seconds.

The small harbour light at the end of Looe's Banjo Pier.

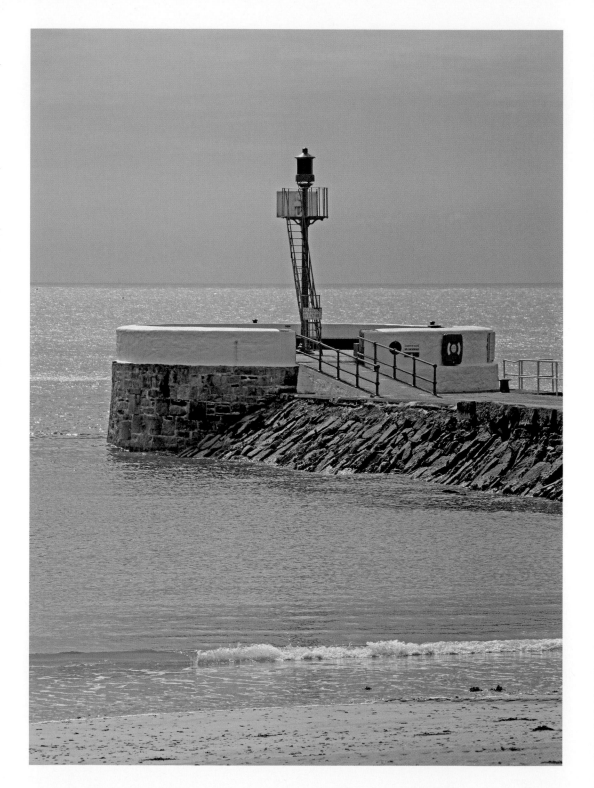

Polperro

Established	1911
Current lighthouse built	1911
Operator	Polperro Harbour Trust
Access	Via the coast path east of the village for about 1,000 yards, with a short detour to the right

The village of Polperro with its tidal harbour survived for centuries on fishing and smuggling. The smuggling ceased at the end of the eighteenth century and the local economy now relies largely on tourism and a fishing fleet of small boats. With vessels needing to avoid the East Polca and Peak rocks at all tides, and the Raneys at low tide, the local harbour trust, set up in 1894, erected a lighthouse on the headland at Spy House Point in 1911.

Named after the point, this light is supported on a white 12ft-high cylindrical brick tower with a doorway at the base which is now blocked up, and is mounted on a stone-paved surround with guard rails. The automatic light is contained in a small white cylindrical lantern with black trim and shows both red, to the west, and white, to the east, quick-flashing sectors visible for 8 miles.

The harbour is protected by one outer and two inner piers which form an 8ft opening into the inner tidal basin. The centre section has a hydraulic gate which is closed in bad weather. On the end of the western pier is a 4ft unpainted, stone cylindrical pedestal which supports a squat, round lantern and simple navigation light. This light, visible for 4 miles, flashes white when the harbour is open and red when it is closed.

The small light at Spy House Point marks the entrance to the small harbour at Polperro.

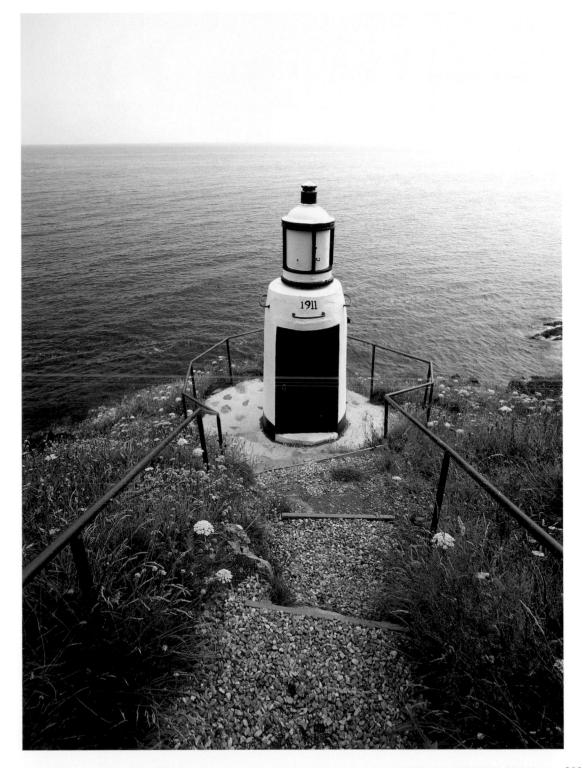

Fowey

Established	1904 (St Catherine's Point)
Current lighthouse built	1904
Operator	Fowey Harbour Commission
Access	From the town centre, a short walk towards St Catherine's Head along the Esplanade Road will pass Whitehouse Point where the light is clearly visible; continue towards Readymoney Bay and take the South West Coast Path; after about a mile do not be confused by a small metal box surmounted by a red light beacon called St Catherine's Point Light on the walls of St Catherine's Castle ruins, but continue to the lighthouse, on the seaward side of the path

The port of Fowey handles exports of china clay and is one of Cornwall's major ports. To mark a safe passage into the River Fowey, a series of navigation lights is operated by the harbour authority. The approach from the sea is marked by a lighthouse on the headland at St Catherine's Point, which is known as Fowey Entrance Light or Fowey Light, presumably to avoid confusion with St Catherine's Point on the Isle of Wight.

In medieval times a light was displayed in the now demolished St Catherine's Chapel, but today the light is sited just to the west on the headland. Erected in 1904, this light is shown from a 20ft red, cylindrical cast-iron lantern

The light at St Catherine's Point, on the headland at the entrance to Fowey harbour, marks the entrance to the river Fowey. (Paul Richards)

Mevagissey

Established	1896
Current lighthouse built	1896
Operator	Mevagissey Harbour Trust
Access	The outer harbour piers are accessible

sitting on an octagonal concrete base with a white service building to the landward side. Through a letterbox opening, it shows a white flashing light visible for 11 miles over the safe entry channel. To each side it shows red flashing sector lights visible for 9 miles.

The entry channel is marked by a light on the headland at Whitehouse Point which, when erected in 1904, was second-hand, having been manufactured in 1892. It consists of a red cast-iron cylinder with a letterbox opening on top of a narrow red column. The area is surrounded by red iron railings, with a vertical external ladder up to the light. It shows a white flashing light visible for 8 miles, with two sector lights, green to the right and red to the left. Electricity is supplied via an overhead cable from a dwelling nearby.

Despite Mevagissey having a thriving fishing industry, the first Harbour Act was not passed until 1774, when the inner harbour was built, and it was not until 1888 that the piers were constructed to form what is now the outer harbour. Although the two piers were newly built, they were completely destroyed by a blizzard in 1891. This resulted in the construction of the two Victorian outer piers that make up the harbour.

The piers were not completed until 1897, but a lighthouse was constructed on the end of the south pier in 1896. Known as Mevagissey Victorian Pier Head Lighthouse, it consists of an ornate white 29ft hexagonal cast-iron tower with a gallery and lantern with the lower part painted black. In keeping with the rest of the tower, the lantern has an ornate top complete with weather vane. The Harbour Trust, which with Looe is one of only two registered harbour charities, operates the white flashing light, which is visible for 12 miles. The tower also carries a fog signal that sounds every thirty seconds.

A historic postcard view of Mevagissey light. (Courtesy of John Mobbs)

MEVAGISSEY, CORNWALL.

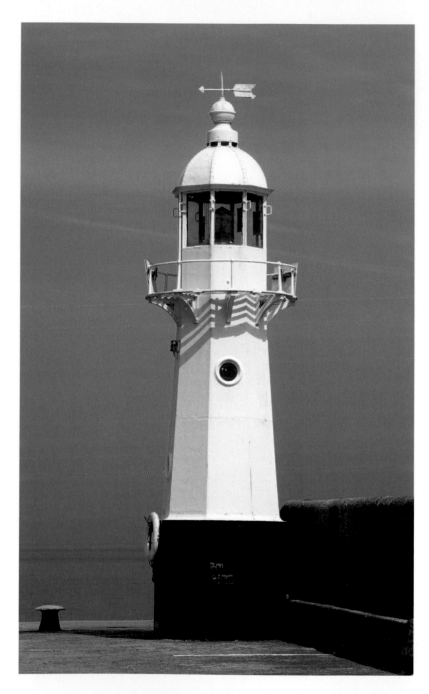

The ornate tower at the end of Mevagissey's south pier. It is possible to take a thirty-five minute ferry journey across St Austell Bay from Fowey to Mevagissey to view the lights and daymark at Gribben Head from the sea. (Paul Richards)

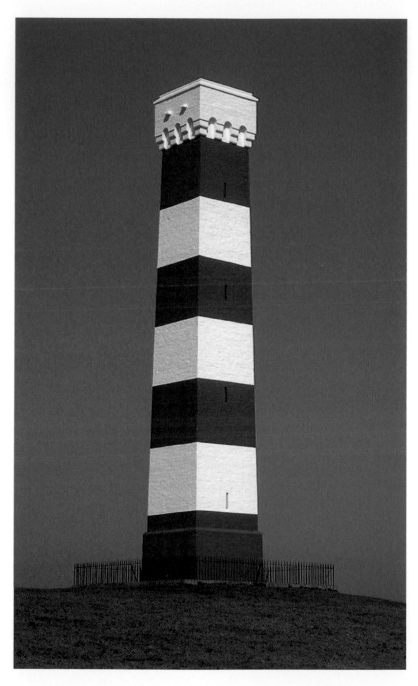

The Gribbin Head daymark marks the eastern limits of St Austell Bay and the western entrance to the Fowey Estuary. Built in 1832, the 85ft castellated stone structure has a doorway and set of steps to the top. Painted in red and white horizontal bands, it is now owned by the National Trust and, on occasion, open to the public. (Paul Richards)

St Anthony's

Established	1835
Current lighthouse built	1835
Automated	1987
Operator	Trinity House, maintained by the National Trust
Access	Located at the end of Military Road off the A3078, reached via steep footpath from National Trust car park which is signposted from Trewithian; keepers' cottages can be rented as holiday homes

(Right) St Anthony's lighthouse, built in 1835, guards the eastern approach to Falmouth Harbour. (Nick Chappell)

(Below) A historic image of St Anthony's lighthouse, with the fog bell in place at the front of the tower. This was dismantled in 1954 and donated to a local church. (Courtesy of John Mobbs)

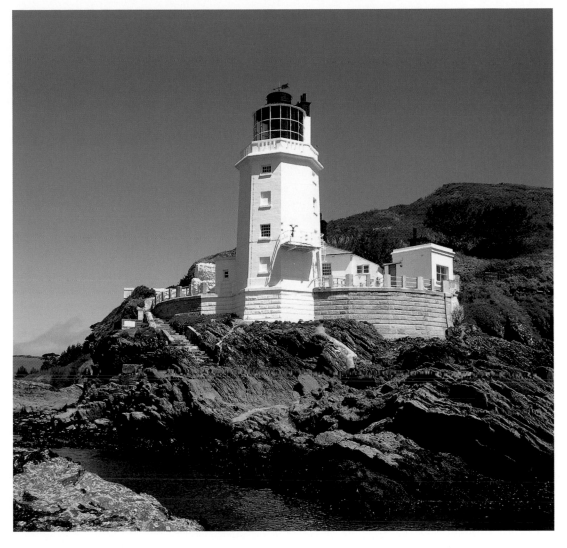

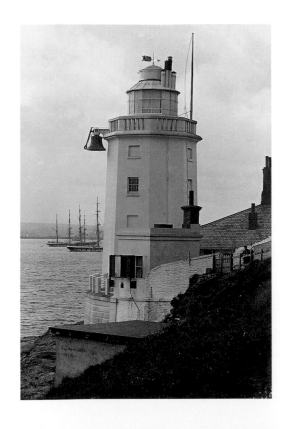

As early as the seventeenth century, simple aids to navigation were employed to assist vessels entering Falmouth Harbour. The hazards in the area include the Manacles Rocks off the southern approaches and the Black Rock in the centre of the channel. The town council therefore petitioned Trinity House in 1830 for a light to be built, and the corporation had a lighthouse designed by James Walker. Construction, which started in May 1834, was undertaken by Olver of Falmouth, with each stone being shaped in Penzance and transported to the site by boat. Within a year, work was finished and a light was first shown in April 1835.

The location at St Anthony's Head was such a difficult one that it was treated as a rock station. The octagonal 62ft tower was built into the rock, with a raised area to the rear for the two-storey keepers' dwellings. The lantern was blanked off at the rear by two chimney

Lizard

Established	1619
Current lighthouse built	1752
Operator	Trinity House
Access	The lighthouse is signposted from Lizard village

stacks, which were subsequently enlarged to accommodate the fog signal. Thirty years after the light was commissioned, a large fog bell operated by an automatic hammer was installed. This was replaced in 1882 by an even larger bell that weighed 2 tons. Suspended from the gallery, it was replaced in 1954 by an electrical Nautophone foghorn mounted on a platform. The bell was taken to Falmouth for display, but after years of wrangling was melted down.

The light was originally provided through the catoptric system, with eight Argand lamps and parabolic reflectors which revolved by clockwork and were used to produce the flashing light. This was changed to a petroleum vapour burner and eventually to electricity when mains power was installed in 1954. The fixed Fresnel lens showed an occulting white light, which was visible for 22 miles, with a red sector visible for 20 miles to mark the Manacles. It is battery powered, with the batteries charged from the mains electricity supply. The station was fully automated in 1987 and in 2000 was further modernised when the light configuration was changed to isophase.

The Lizard Peninsula is the most southerly point in Britain, and its dangers to shipping are well known, with a series of jagged ridges of rock jutting out to sea for nearly 400 yards. The Lizard was used as a passage mark for ships wishing to dock in Falmouth or make passage up channel, and was therefore an ideal location for a lighthouse. Building a tower, however, was not easy, as locals were keen to hold on to revenues gained from salvaging cargoes from the many wrecks that occurred off the point.

As early as 1570, local landowner Sir John Killigrew was granted a patent to build a light, but local opposition stopped any action.

In 1619, his grandson applied again for a patent and, despite the locals refusing assistance, built a coal-fired light. However, maintenance costs were prohibitive and with no income ensuing from dues, which passing ships only had to pay on a voluntary basis, the light was extinguished for periods in 1620 and 1621. Despite an appeal to the king, nothing was done to ease the cost burden and by 1630 the light was derelict.

The distinctive twin towers of the Lizard Lighthouse stand at either end of the service buildings and cottages. The active lighthouse is the south tower, while the north tower has had its lantern removed.

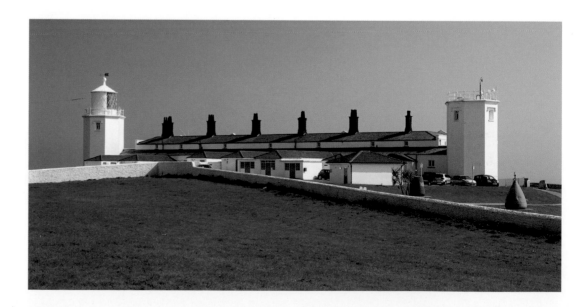

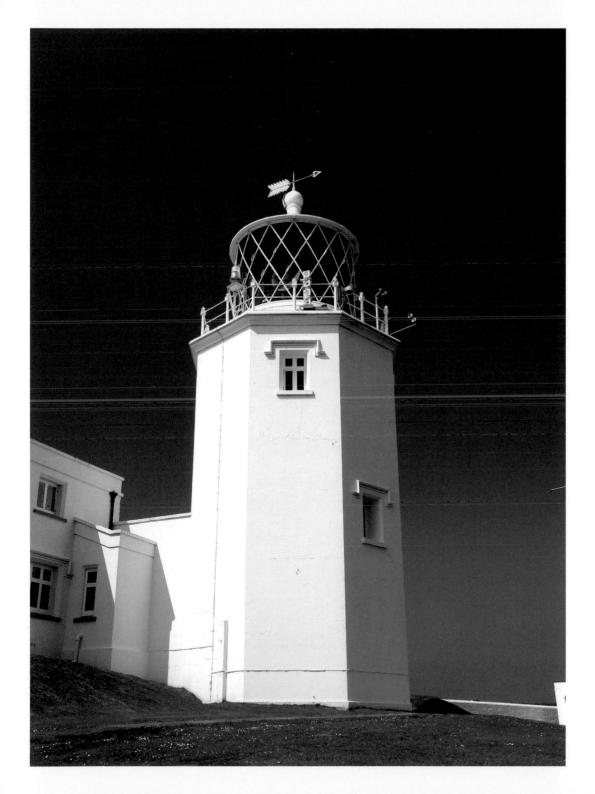

In 1748, Richard Parish together with the then owner of Lizard Point, Thomas Fonnereau, applied to Trinity House for an agreement to build a total of four lights although, after protracted discussions, it was agreed only two were needed, so that the coast would be marked by a single light at St Agnes, a twin light at the Lizard and three lights at Casquets. Even then, the task of building the lights was not made easy by a strong difference of opinion, which continued until 1771, between the two sides. Disagreements were over who should pay for what, whether the light should be extinguished should an enemy appear and, more importantly, who would own the lights. Nevertheless, the twin lights, which can still be seen today, were completed and first lit on 22 August 1752.

Built on top of the original light, the twin 62ft eight-sided stone towers were joined by a block of two-storey dwellings. They were topped with a gallery and wooden glazed lantern. Although the glazing reduced the light intensity, it considerably decreased the coal consumption. In 1771, Trinity House took over responsibility for the lighthouses. In 1812, the coal fires were

The operational light at the Lizard, England's most southerly point, is housed in one of two octagonal cylindrical stone towers connected by keepers' quarters.

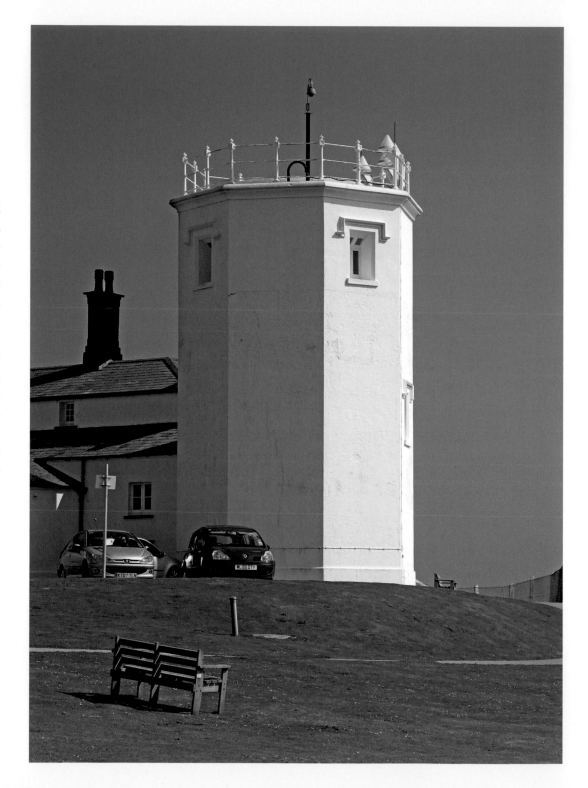

replaced by Argand lamps and reflectors and the accommodation was modernised to give a corridor from one light to the other. In 1878, the Lizard became one of the earliest lighthouses to be converted to electricity with the twin lights being, it was claimed, some of the brightest in intensity anywhere.

In 1903, a revolving light was commissioned in the east tower and the light in the west tower was discontinued. The revolving light was so powerful that it could be seen beyond the horizon and, today, its reduced-power white flashing light with first-order Fresnel lens is visible for 26 miles. The lantern on the west tower was removed and the tower itself later converted to a fog signal station. The station was automated and de-manned in 1998, with the compressed air fog signal, the last in service, being replaced by an electric one.

The original engine room, the only such engine room still in existence, houses an historic equipment display which is part of the on-site visitor centre. Visitor facilities were operated by the Trevithick Trust until 2004, when the lighthouse was closed for renovations and the trust went out of operation. Trinity House took over the operation and reopened the lighthouse on 1 May 2005. The centre is now open from Sunday to Thursday, April to October.

Penzance

Established	1853
Current lighthouse built	1853
Operator	Penzance Harbour Authority
Access	By walking the pier, which is not restricted

The lighthouse at Penzance is situated on the end of the south pier, which is also known as Lighthouse Pier. Commissioned on 1 August 1855, the 31ft iron tower was cast by Sandy & Co at the Copperhouse Foundry in Hayle. The lantern, made of sheet steel, is mounted on a square cast-iron pedestal and has a white conical roof which supports a weather vane. It was fitted with a fifth order lens, which was a great improvement on the Argand lamp in the old light. The white flashing light had a sector light which steered vessels clear of the Gear Rock and the Raymond.

Sperm oil was used in bad weather as it burned for longer, so the keeper did not have to stay overnight. The lighthouse was modernised in 1914, when a new, more powerful 1,000 candle-power electric light was installed. The flashing light, which is red to each side to mark the Gear Rock with a white inner sector to mark the safe channel, is visible for nine miles.

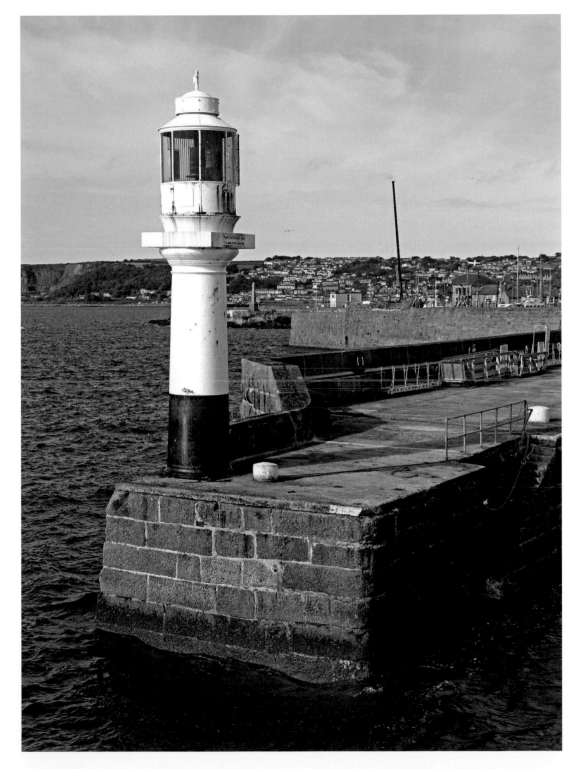

The light at the end of Penzance South Pier, near the Isles of Scilly ferry terminal.

Newlyn

Established	1884
Current lighthouse built	1915
Operator	Newlyn Pier and Harbour Commission
Access	The South Pier is closed so the light has to be viewed from the Victoria Pier

The first of the piers that form Newlyn Harbour was the 600ft South Pier, which was built in 1884 complete with a lighthouse. In 1914 the pier was extended by 100ft and a new lighthouse on the end, first lit on 29 April 1915, was commissioned. The white, 34ft circular cast-iron tower has a round lantern complete with gallery.

The cupola is painted red, as is the base of the tower. The original occulting white light, visible for 15 miles, was first displayed on 20 March 1887. The quick-flashing light has a range of 9 miles. The red and white building alongside, also built in 1914, houses the Ordnance Survey datum equipment as this spot is the starting point for all their geographic data. On the end of the North or Victoria Pier is a simple light on top of a cast-iron column.

(Right) The light at Newlyn at the end of the south pier.

(Below) A historic image of Newlyn south pier and the light. (Courtesy of John Mobbs)

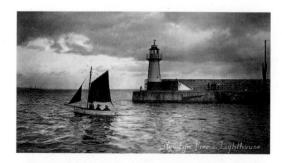

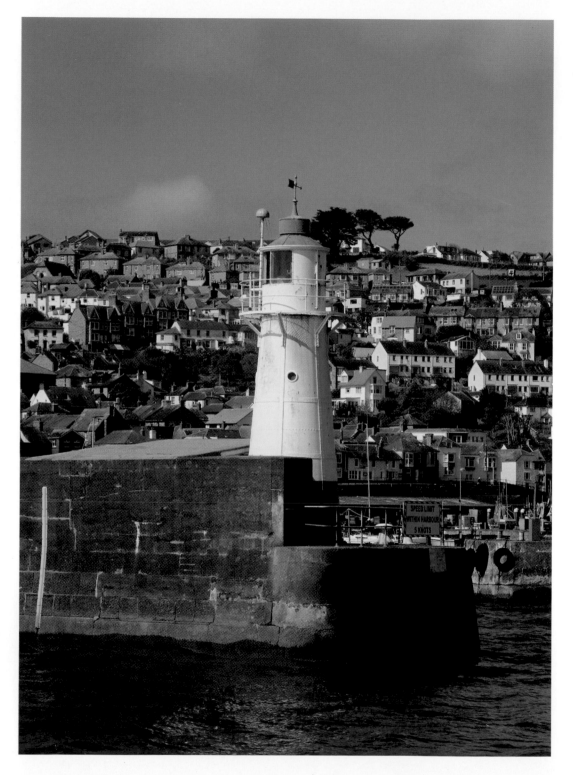

Tater Du

Established	1965
Current lighthouse built	1965
Automated	1965
Fully automated	1996–97
Operator	Trinity House
Access	Via South West Coast Path; tower closed

Tater Du is Cornwall's most recently built lighthouse. (Paul Richards)

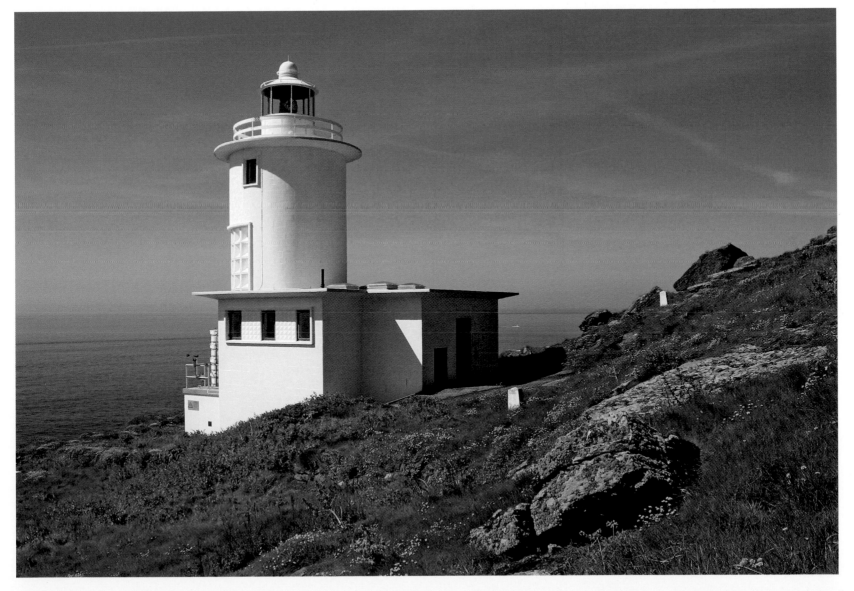

Longships

Established	1795
Current lighthouse built	1875
Automated	1988
Operator	Trinity House
Access	Can only be viewed by boat

Although the Runnelstone Rocks, which lie just offshore, have been marked by a buoy and the Gwennap Head beacons since the eighteenth century, it was not until the Spanish ship *Juan Ferrar* was wrecked off Boscawen Point in 1963, with the loss of eleven lives, that Trinity House marked the area with a lighthouse. After the tragedy, the Newlyn and Mousehole Fishermen's Association put pressure on the corporation for a lighthouse to be built, fearful that similar tragedies could happen again.

Tater Du lighthouse is on a headland 2 miles west of Lamorna Cove. The name originated from an old Cornish term for black rock. Built in 1965 to the design of Michael H. Crisp, the lighthouse was constructed of white concrete blocks and consists of a 50ft circular tower with a gallery and small lantern mounted on the roof of a rectangular service building. There is a long, steep access road from the top of the cliffs.

The main light is a fourth-order 250mm rotating optic which, powered by a 70-watt lamp, gives out a 294,000-candela flashing white light visible for 23 miles. About 10ft lower is a sector light covering the Runnelstone Rocks, which shows a fixed red light visible for 13 miles. Power to the lights is via batteries recharged from the mains. Although in the event of a power failure the batteries will operate for five days, there is also a standby generator.

Looking from Land's End towards the Isles of Scilly on a summer's day, the tranquil scene with waves gently breaking over the Longships reef belies the dangerous nature of the area in stormy weather. The rocky outcrops about a mile out to sea present a formidable obstacle, especially when the Atlantic throws its might landwards, completely submerging the reefs. Many ships have been lost on these rocks, and so in 1794 Trinity House, who at the time supported private lighthouse ownership, gave Lieutenant Henry Smith a patent to build a tower.

The site chosen by Smith was Carn Bras rock, the highest point on the most northerly outcrop known as Longstones. Designed by Trinity House architect Samuel Wyatt and completed in 1795, it was a 28ft tapered circular tower of three storeys below a wooden and copper lantern that held eighteen parabolic reflectors and Argand lamps in two tiers. In order to save oil, no lights were shown landward, with that side of the lantern blanked off. Later that year, Smith was declared incapable of managing the light, and sent to jail as a bankrupt. Although Trinity House then took over control, the corporation continued to pay him and later his family the substantial light dues until 1836. Then, empowered by Act of Parliament, the corporation bought out the remaining nine years of the lease for £40,676.

As the light was not a total success, with the sea often breaking over it or the light being obscured by sea spray, a new tower was built alongside the existing one in 1875 under the guidance of Sir James Douglass. At 115ft, the circular grey granite tower was considerably taller and thus eliminated the earlier problems. The lantern was originally fitted with a domed roof, which in 1974 was replaced by a helipad. The old lighthouse, retained during construction of the new one, was never actually demolished, because, shortly after the new light had been commissioned, it slid into the sea.

The new light originally came from a pressurised vapour lamp with an incandescent mantle, but was converted to diesel-powered electrical operation in 1967. The white isophase light is visible for 18 miles to sea, with a red sector visible for 14 miles marking the safe fair weather passage to the landward side of the rocks. The lighthouse was automated in 1988 and in 2005 was converted to solar power, with a new emergency generator being installed.

Longships lighthouse, one of England's most famous, can be seen from Land's End, but getting close to the grey granite tower, built under the supervision of Sir James Douglass, can only be achieved by boat or helicopter. (Tim Stevens)

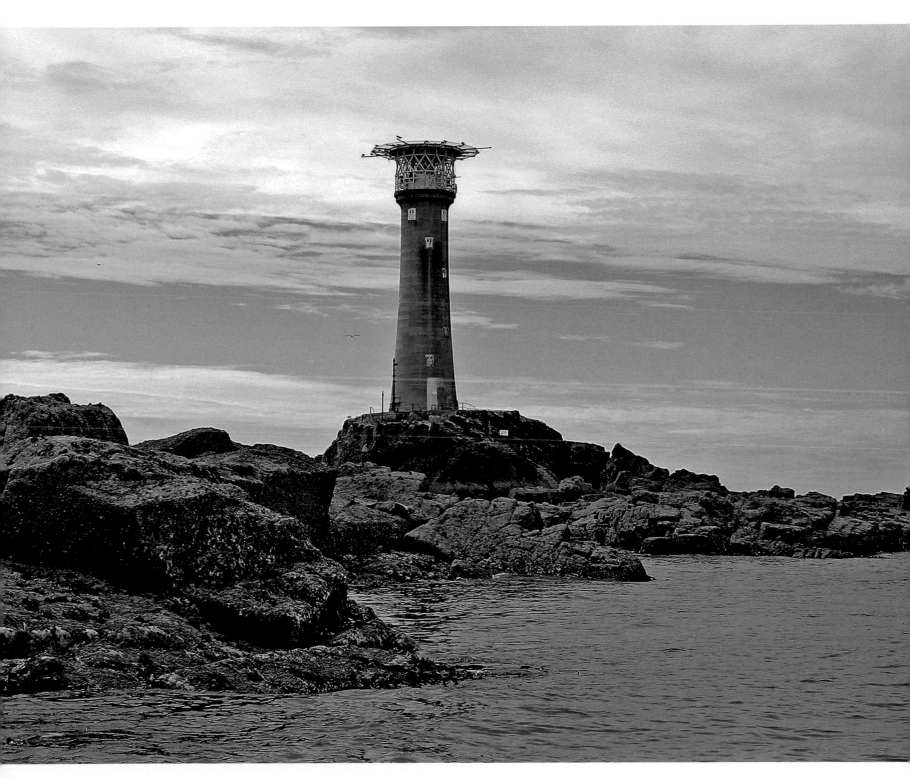

Wolf Rock

Established	1795
Current lighthouse built	1869
Automated	1988
Operator	Trinity House
Access	Can only be viewed by boat

Wolf Rock, a large pinnacle of rock about 8 miles off Land's End, has been a constant danger to shipping. Its name derives from the noise made when a chimney of rock was successively filled with and emptied of water, making a sound like a wolf's howl, although the name has only been in use since about 1800. The first beacon, put here in 1795, was a bare wrought-iron pole. In 1791, a proposal to build a stone lighthouse on the rock came to nothing, as Lieutenant Henry Smith, the builder of Longstone lighthouse, thought it beyond his ability. However, in 1795, he did erect a 20ft wrought-iron mast, fixed with molten lead in a hole drilled in the rock and supporting a model of a wolf, but this was soon washed away.

John Thurburn built another beacon between 1836 and 1840, during which time only just over 300 hours could actually be worked. The hollow iron-coned tower filled with rubble was completed in summer 1840 but gales swept it away in November 1840. A further attempt was made to mark the rock with a cast-iron beacon in 1844, but that too was swept away, as was another tower built in 1850. As the rock was surrounded by deep water and covered by

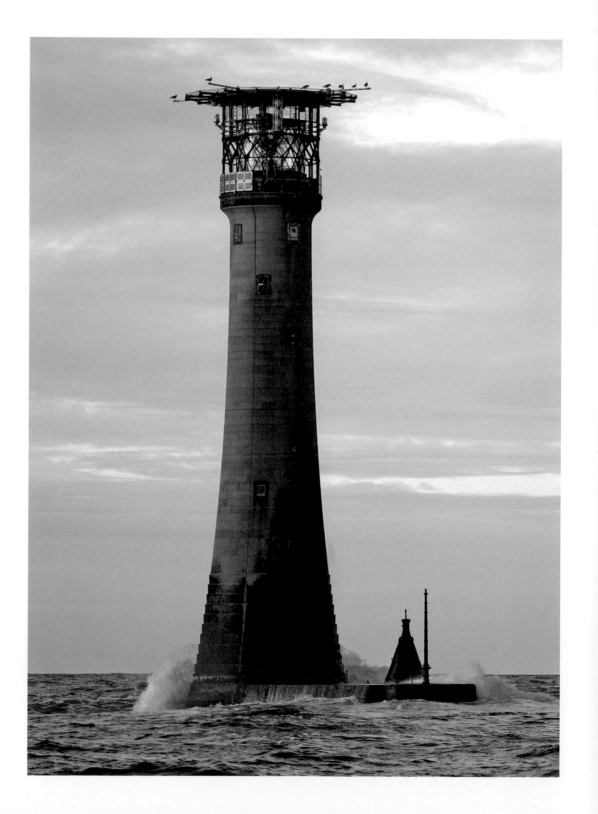

The famous Wolf Rock lighthouse, 9 miles south-west of Land's End. (Tim Stevens)

A late nineteenth-century engraving showing the keepers being brought off the Wolf Rock lighthouse by tender, long before the helicopter platform was built over the lantern.

a swell even in good weather, building anything on it was a difficult undertaking.

Despite the problems, the rock still needed marking and so in July 1861, following the successful design of Smeaton's Eddystone tower, James Walker surveyed it and produced plans for a 115ft granite stone tower. Work started on the tower in March 1862, but only twenty-two landings were managed on the rock that year because of the swell. To avoid deterioration of the joint material due to wave action for the lower 35ft, the upper surface of each stone was

given a wide rabbit and the stone above dropped into the recess, thus protecting the joints.

The stones were dressed at Trinity House Depot in Penzance and taken out to the rock at a painstakingly slow pace. The tower took eight years to complete and a further year before, in 1870, a light was displayed. During the initial construction, when each gang arrived for a day's work, one of the men had to swim to the rock with a rope before the others could land. Not until 1864 had the masons fixed enough foundation stones to the rock, using iron bolts, to enable a landing area to be constructed.

The flashing white light, visible for 20 miles, was converted from paraffin to electrical operation in 1955 when diesel engines were installed. The lighthouse is noted for being the first in Britain equipped with a helipad, which was fitted in 1972, with the design becoming the prototype for subsequent such structures.

In 1988 the station was de-manned and now the only access is via helicopter. In 2003 the light was extinguished temporarily during the conversion of the station to solar power. Lightvessel No.22 was stationed nearby and exhibited a light with the same characteristics during the conversion work.

Peninnis, Scilly

Established	1911
Current lighthouse built	1911
Operator	Trinity House
Access	Walking from Hugh Town, St Mary's

The light on the outer head at Peninnis Head on St Mary's is sited at the most southerly point of the island. It helps vessels entering St Mary's Sound and on their way to Hugh Town Harbour. Built in 1911 to replace St Agnes light, it consists of a white, circular 45ft steel tower on an open lattice foundation. The lantern has a white gallery with a black-domed top, while a small white and green service building stands to one side. The white flashing light is visible for 16 miles.

Peninnis was one of the first gas-powered stations: the original light source was acetylene with a unique gas-powered optic. In 1992 it was converted to electricity. The light can be seen by walking about a mile and a half along the headland from Hugh Town. The only other light on the island is a simple harbour light, visible for 3 miles, on a pole at Hugh Town pier. It was originally white, but in 1907 was replaced by a red light that stood 6ft higher.

At night, a vantage point on the east of the island shows up the V-shaped light configuration of the lights round the mainland.

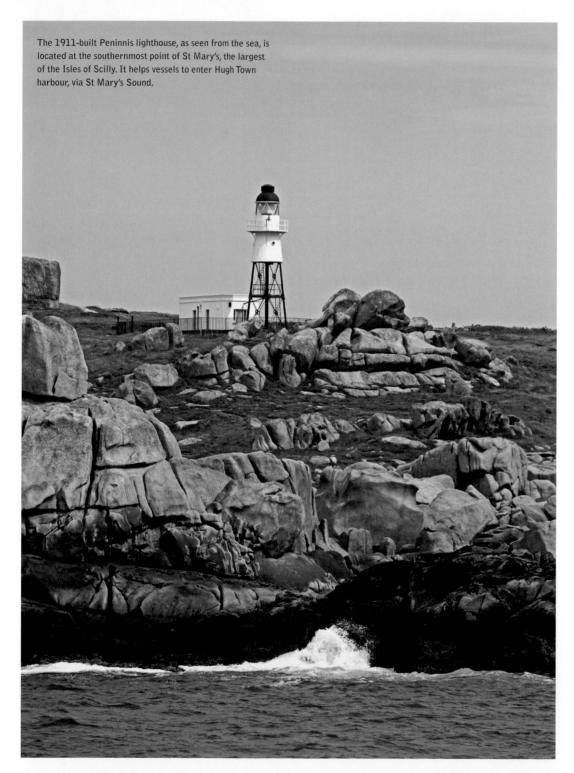

The 1911-built Peninnis lighthouse, as seen from the sea, is located at the southernmost point of St Mary's, the largest of the Isles of Scilly. It helps vessels to enter Hugh Town harbour, via St Mary's Sound.

Round Island, Scilly

Established	1887
Current lighthouse built	1887
Operator	Trinity House
Access	Trip boats pass the island but access is restricted

Round Island is north-east of Tresco and is the most northerly point on the Scillies where a lighthouse could be located. Although technically a rock, there is enough room to accommodate not only a conventional lighthouse with separate keepers' quarters but also a small garden and free-standing helipad. Despite the size of the island, Trinity House found the process of getting materials to the site just as hazardous as a true rock station because the top of the island is 130ft above sea level and surrounded by precipitous sides.

(Right) Sunset over Round Island lighthouse, built on the most northerly of the Isles of Scilly, to the north-east of Tresco. Despite its elevation, severe gales in January 1984 whipped up seas which smashed the lower doors of the fog-signal house. (Nick Chappell)

(Below) The lighthouse complex on Round Island, showing the keepers' quarters near the tower, when the station was manned. (Courtesy of John Mobbs)

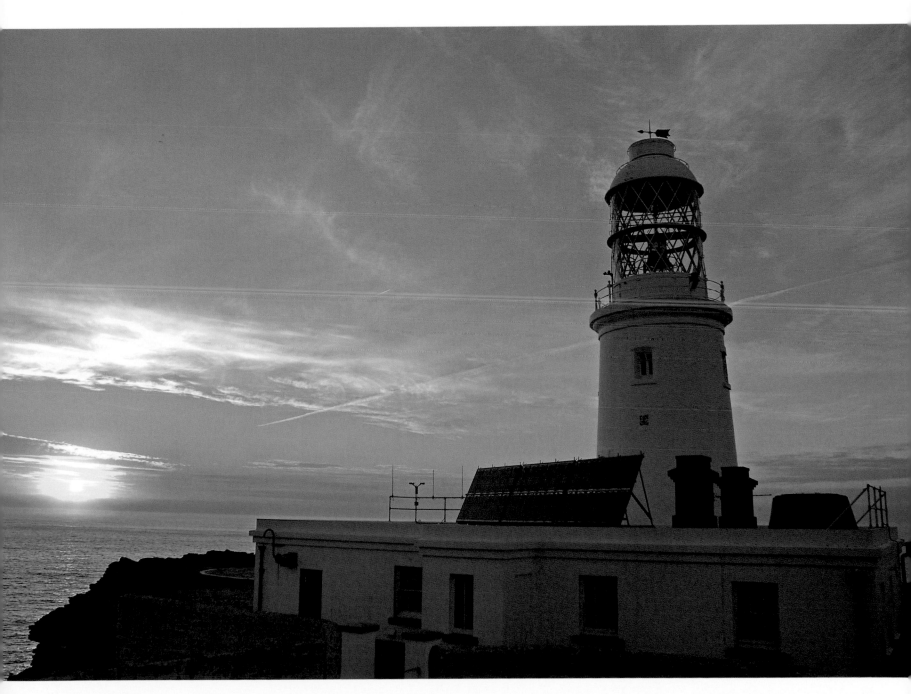

The old lighthouse dominates the small island of St Agnes. The lighthouse, one of the oldest in existence, is still owned by Trinity House, although the adjacent keepers' cottages are now private residences. (Paul Richards)

The 63ft white circular tower, complete with a lantern and balcony, was designed by Sir James Douglass. Completed in 1887, the tower unusually exhibited a red flashing light. Initially, because red has weaker propagation qualities, the light was intensified by a huge hyperradial lens of a sort only fitted to two other Trinity House lights. This optic was replaced in 1967 and in 1987 the lens was again replaced when the light was automated and changed to flashing white. The white single-storey keepers' dwelling, now a service block, is free-standing and linked by a corridor to the light tower, with a fog signal room nearby.

Trip boats from Hugh Town pass the rock and, on the return journey, it is worth stopping off at the adjacent island of St Martin's where, on St Martin's Head, a 40ft red and white conical stone tower was built by Thomas Elkins in 1683. This two-storey tower is now a daymark; although the doorway is blocked, the tower is hollow with a stone stairway to the upper floor, which has two windows. It was therefore likely to have been a watchtower or to have even shown a light at some point.

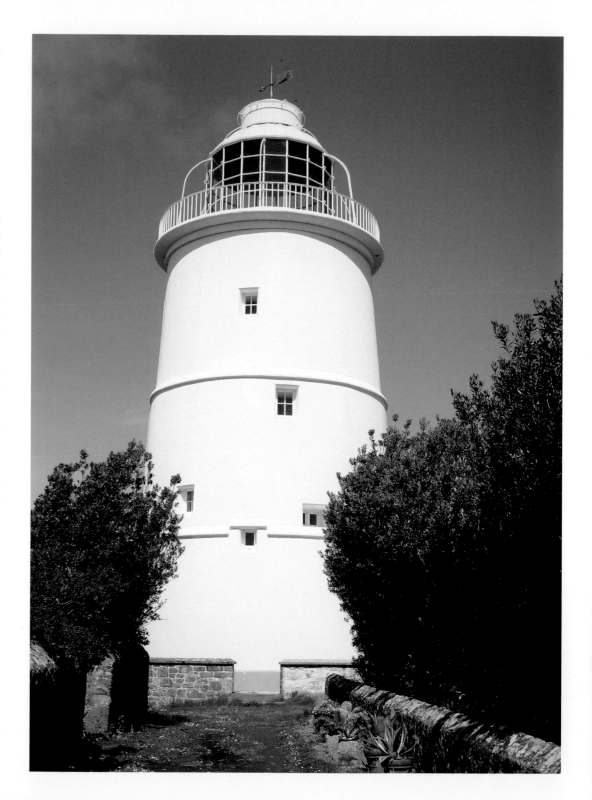

St Agnes, Scilly

Established	1680
Current lighthouse built	1680
Discontinued	1911
Access	Trip boats from St Mary's go to St Agnes, and the lighthouse, visible from most of the island, can easily be reached on foot

Bishop Rock, Scilly

Established	1858
Current lighthouse built	1887
Automated	1991
Operator	Trinity House
Access	Trip boats operate out of Hugh Town on St Mary's to view the rock

Despite opposition from local wreckers, Trinity House obtained a patent to build a lighthouse on St Agnes in 1680. The corporation constructed a four-storey, 74ft white tower with a lantern and gallery complete with attached dwellings on the highest point of the island. The provision of 6ft-thick walls at the base and use of best English heart oak throughout proved so expensive that Trinity House was impoverished. Initially coal fired with a ventilated glass lantern, the light quickly covered the glass with soot and the local keepers were neither always sober enough nor inclined to maintain it properly.

The situation improved in 1790, when the lighthouse was converted to oil with a parabolic reflector making the flashing white light visible for 18 miles. But its usefulness was relatively short-lived. In 1858 the Bishop Rock light was completed to cover the area to the west and from 1911 the Peninnis light on St Mary's performed a similar function for the eastern area. The St Agnes light was therefore discontinued. The two attached dwellings are now leased, with the tower itself retained as a daymark. The original lighthouse grate is on display as a plant feature in Tresco gardens.

The presence of a lighthouse on St Agnes provided a degree of security to vessels approaching the Isles of Scilly, but the light's position did not give adequate warning from the west and many vessels foundered on the rocks before the St Agnes light was visible. In 1847 Trinity House decided to rectify this and Engineer-in-Chief James Walker began to erect a light on the Bishop Rock, largest of the westerly outcrops, to mark a rock ledge 46m long by 16m wide, 4 miles west of the Isles of Scilly. Walker proposed an iron screw-pile structure, designed to offer minimal resistance to heavy seas; it was within days of having its lantern installed when, during a storm in February 1850, it was washed away.

Undaunted, Walker designed a circular granite tower, 150ft tall, complete with lantern and gallery similar to that at Eddystone. This structure took seven years to complete, with construction being supervised on site by James Douglass, whose reputation as a lighthouse builder later became legendary. The 2,500 tons of interlocking granite blocks were dressed and assembled on the mainland before being shipped out to the rock. The light, visible for

16 miles, was first shown on 1 September 1858 and was successful in reducing but not eliminating shipwrecks.

However, the tower was not a total success as at times it was obscured by spray and suffered damage in the frequent storms. The keepers also became increasingly concerned about the state

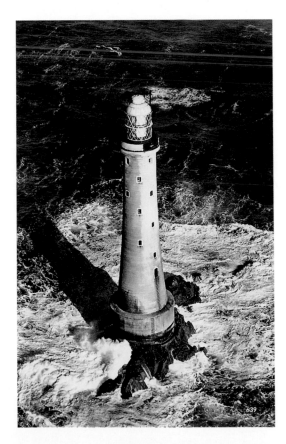

Bishop Rock lighthouse before the helipad was added above the lantern. (Courtesy of John Mobbs)

of the foundations which had been anchored to a relatively small cross section of rock. It was therefore decided that a completely new tower should be built outside the existing one, with a large round granite stone base attached to the rock by iron bolts as a firm foundation.

The new tower was built between 1883 and 1887, and resulted in an increase in the tower's height to 162ft. The flashing white light, which is visible for 24 miles, was first shown in October 1887. The optic, which floats on a bed of mercury, was fuelled by a multi-wick paraffin burner until electrified in 1973.

The silhouette of the lighthouse altered in 1976 when a helipad was added. Although there were still a few times when the keepers could not be relieved by air, use of a helicopter relief was easier than relief by sea when storms made access impossible. In 1964 a BBC crew went to film for a day, but it was four weeks before they could be taken off. The lighthouse was converted to automatic operation in 1991, with the last keepers leaving the lighthouse on 21 December 1992. The fog signal was discontinued on 13 June 2007.

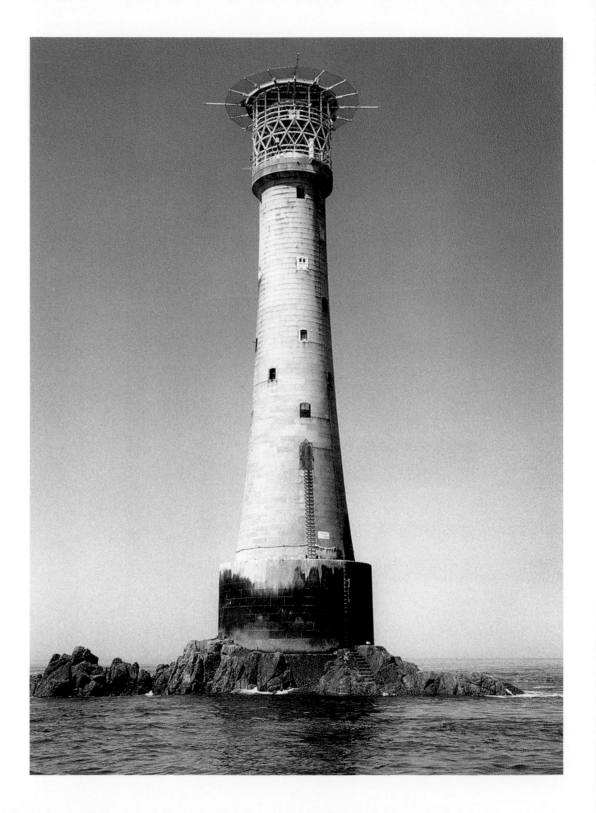

The impressive Bishop Rock lighthouse has a large round granite stone base attached to the rock by iron bolts. (Phil Weeks)

Pendeen

Established	1900
Current lighthouse built	1900
Operator	Trinity House
Access	The lighthouse is situated at Pendeen near St Just with parking adjacent

The lighthouse at Pendeen Watch on Cornwall's north coast.

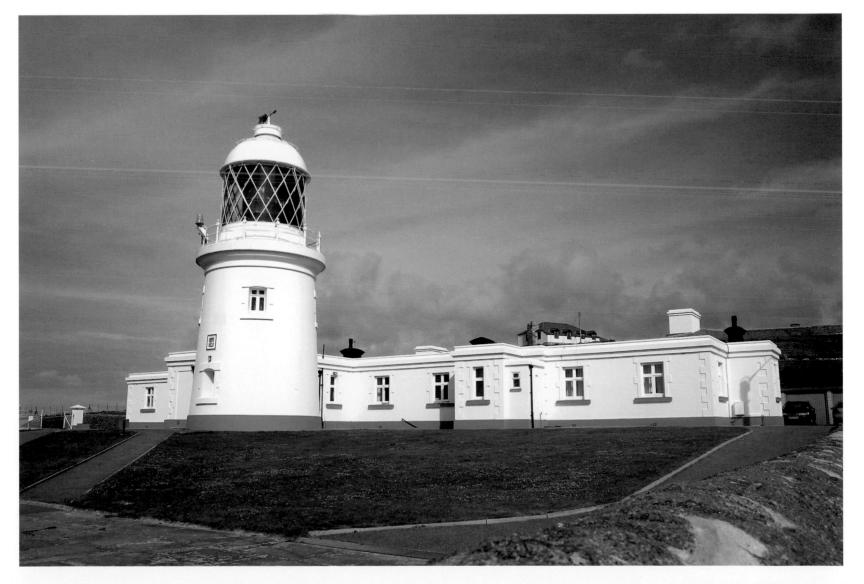

St Ives

Established	*c.* 1538
Current lighthouse built	1890
Operator	Penwith District Council
Access	The East Pier has public access and the lighthouses can be easily approached

The stretch of coast from Cape Cornwall to St Ives Bay is particularly inhospitable. The Three Stone Oar off Pendeen and Gurnard's Head at the western entrance of St Ives Bay are the principal dangers to shipping, but it was not until the late nineteenth century that a lighthouse was built to warn of these hazards. Until then, maritime safety depended on a rocket apparatus at the coastguard station and the lifeboats of Sennen Cove, Hayle and St Ives coming to the aid of a ship after it was wrecked.

The high cliffs along this coastline prevented passing vessels from catching sight of either Trevose Head to the east or Longships to the west and thus many were lost, unable to determine their position. Sunken and exposed rocks near Pendeen Watch proved particularly hazardous, and this was brought to the attention of Trinity House as the nineteenth century drew to a close. The corporation decided to erect a lighthouse and fog signal at Pendeen at a time when it was increasing the number of aids to navigation under the principle of having a major light every 20 miles.

The light at Pendeen was designed by Sir Thomas Matthews, Trinity House Engineer, and construction was undertaken by Arthur Carkeek of Redruth, with the lantern supplied by Chance of Birmingham. Before work on the buildings could begin, the cap of the point had to be removed and the headland flattened. A retaining wall was completed on the seaward side and then the buildings, which occupy a large area, were completed. Although Carkeek's men had only reached the halfway mark by the start of 1900, the lantern was ready and work progressed more rapidly until the light was commissioned on 26 September 1900.

The squat circular tower is 56ft high, white-painted, built of rubble stone cement and divided into two rooms, one over the other. Above them is the lantern, which originally contained a five-wick Argand lamp to which oil was pumped from the room below. An electric lamp was installed in 1926 and the original oil lamp was later displayed at the now-closed Trinity House National Lighthouse Centre in Penzance. Around the lamp revolves an apparatus containing the lenses which floats in a trough of mercury so that it can be set in motion by the slightest touch.

Pendeen was automated in 1995 and the keepers left the station on 3 May. The original optic has been retained, with a range of 16 nautical miles, but a new lamp plinth was installed along with an emergency light and a new fog signal with fog detector. A terrace of four cottages was built on the site, three to house the resident keepers and their families, and one as an office. They are now let as holiday cottages.

Although St Ives had the largest fishing fleet in Penrith district in the fourteenth century, it did not have a harbour until 1770, when John Smeaton built the first section of the East Pier.

(Below) The lighthouse on St Ives' East Pier, built in 1830, was deactivated in 1890 and restored in the late 1990s after being nearly destroyed by fire in 1996.

But not until 1830 did James and Edward Harvey build a lighthouse on the pier's end. It consisted of a square stone base with an octagonal stone gallery room, as distinct from a lantern room. The top section consisted of an all-round observation area topped by a black-domed roof with weather vane. The light in this 20ft building was converted to gas in 1835 and was then visible for 7 miles. It was, however, only used until 1890, becoming redundant when the pier was lengthened; it is now located halfway along the extended pier.

When the pier was extended, a new light was erected on the end. This light, a 32ft octagonal cast-iron tower, was prefabricated in Bath and brought to the site, where it was mounted on a black base. The remainder of the tower, including the domed top, is white. The lights, now managed by Penwith District Council, are two simple fixed green lights mounted horizontally and visible for 3 miles. There are two similar red lights on a single pole on the end of the West Pier. The lantern from an earlier light, which was displayed from a post on the East Pier in the mid 1880s, is on display in the St Ives Museum. The lights are easily viewed by walking the piers.

The 1890-built lighthouse at the end of Smeaton's Pier in St Ives.

Hayle

Established	1840
Current tower built	1840
Access	Can be reached by following the South West Coast Path

Godrevy Island

Established	1859
Current lighthouse built	1859
Operator	Trinity House
Access	Reached only by boat, but can be viewed from the coast path

The commercial harbour of Hayle, which is privately owned and now in decline, is little used these days, extraction of sand being the main activity. Notwithstanding this, a steady stream of vessels enters the small port, guided into the estuary by a series of perch poles mounted along the training wall. In addition, two lights are sited on the western side of the river entrance which, when in line, mark a safe channel.

The rear light, a replacement for the original 1840 light, consists of a square concrete box with a flat roof mounted on four legs, with four concrete stays, one on each side. The white-painted structure has a horizontal band across the middle and shows a fixed white light visible for 4 miles through a window in the seaward side. Situated 120 yards in front is a similar structure with similar light characteristics. They are located in the sand dunes on the golf course at Lelant and can be visited by parking near the cemetery and following the South West Coast Path on foot, alongside the railway line.

(Below) The small and rather unremarkable rear light at Hayle.

Godrevy Island, 3½ miles across St Ives Bay and partly covered with grass as it slopes down to the sea, is home to a number of seabirds and flora despite often taking the full force of Atlantic gales. The island's lighthouse was built to mark a dangerous reef, called the Stones and extending outwards towards St Ives, on which many vessels have been wrecked.

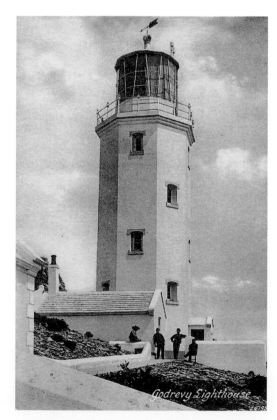

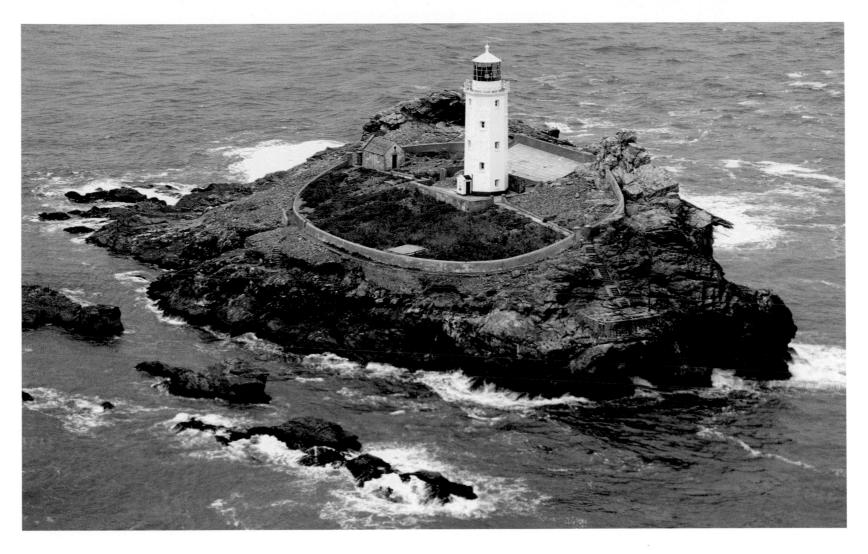

(Above) An aerial view of Godrevy Island and its lighthouse. Situated at the north-eastern entrance to St Ives Bay, it was built in 1859 together with keepers' houses, which have since been demolished.

(Left) Historic close-up view of Godrevy Island lighthouse when the station was manned. The keepers' cottages have subsequently been demolished. (Courtesy of John Mobbs)

On 30 November 1854, the iron screw steamer *Nile* was totally wrecked on the reef with the loss of all passengers and crew. As a result, pressure was brought to bear on Trinity House to erect a lighthouse. The station, built at a cost of £7,082 15*s* 7*d*, was designed by James Walker and its light was first exhibited on 1 March 1859. Two keepers were originally appointed to maintain the two lights, one flashing white every ten seconds, and the other a fixed red light, which marked the Stones Rocks. The lights had a range of 17 and 15 miles respectively.

The white octagonal 120ft tower is made from rubble stone bedded in mortar, and is sited together with its adjoining keepers' cottages almost in the centre of the largest of the rocks. The original optic revolved on rollers and was driven by a clockwork motor. This motor was in turn driven by a large weight running down a cavity in the wall of the tower. The station was equipped with a bell as a fog signal which sounded once every five seconds. The lighthouse was automated and altered in 1939, when a new second-order fixed catadioptric lens was installed with an acetylene burner, the fog bell was removed and the keepers were withdrawn.

Trevose Head

Established	1847
Current lighthouse built	1847
Automated	1995
Operator	Trinity House
Access	There is a signed toll road from the B3276 with parking nearby; the coast path passes the station

Somewhat surprisingly, in the early 1800s only two lights – at Longships and Lundy Island – marked the dangerous North Cornwall coast to guide ships towards the Bristol Channel. Despite the Padstow area being considered by Trinity House in 1813 and 1832 for a light, not until 1847 was the situation addressed. Trevose Head, to the west of the River Camel, was chosen and two lights were erected on the headland. Built by Jacob and Thomas Olver, of Falmouth, the high light consisted of an 89ft circular tower on a stone base with gallery and lantern. The fixed white light, visible for 20 miles, shone towards the south-east and was powered by a wick oil lamp made by H. Wilkins & Sons of London. The large first-order dioptric system was made by Henry Lepaute. Two pairs of single-storey dwellings, each joined to the tower by a corridor, were constructed.

To identify the light as Trevose, a second light was built and was first exhibited just before the high light. Situated about 50ft in front, it was connected to it by a corridor and, because of the slope to the ground, the lantern was at the same height as the base of the high light. It too exhibited a fixed white light through a similar apparatus and was visible for 17 miles.

As the lights were still difficult to distinguish, in 1882 a major review resulted in the characteristic of the high light being changed to occulting and

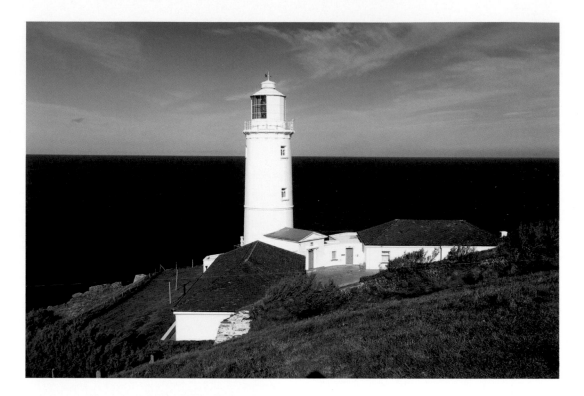

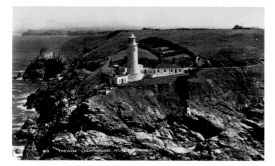

(Above) Trevose Head lighthouse was originally the high light of a pair of lights. The low light was discontinued in 1882. Trevose Head and the 220-acre headland are in the care of the National Trust.

(Left) A historic view of Trevose Head lighthouse, the light from which is visible from Cape Cornwall to Hartland Point. (Courtesy of John Mobbs)

the discontinuance of the low light, which was subsequently demolished. A further change took place about the turn of the century when the light was altered to red flash by the installation of red panels. Between 1911 and 1913 the station, including the keepers' dwellings, was modernised. A new first-order catadioptric lens with three symmetrical panels was installed and in about 1920 a new type of Hood oil vapour burner

complete with an autoform mantle was installed in this lens. This gave satisfactory service until 1974, when the station was electrified.

The lens mechanism, driven by weights installed in 1912, was retained until the station was de-manned in 1995. The original optic was also retained but the red panels were removed to give a white flashing light powered by a metal halide lamp mounted in a two-position

lamp changer. As an emergency standby light, a Tideland ML300 lantern with a range of 10 miles was mounted on the gallery railings.

The area is prone to fog and so during a refit in 1913 a new type of foghorn was installed in a specially built fog signal house. It consisted of an air-powered trumpet 36ft long with an aperture 18ft by 2ft, devised to give a wide horizontal spread. In 1963 this was replaced by a supertyphon air-driven foghorn with eight horns.

The station was de-manned in 1995 and the keepers were withdrawn on 20 December. The existing optic was retained but the rotation speed was slowed to alter the character to one flash every seven and a half seconds; the red screens were removed to give a white light. The fog signal was changed from an air-operated system to an electrically operated omnidirectional one giving two blasts every thirty seconds. Once the keepers' houses were vacant they were converted into holiday cottages available for letting.

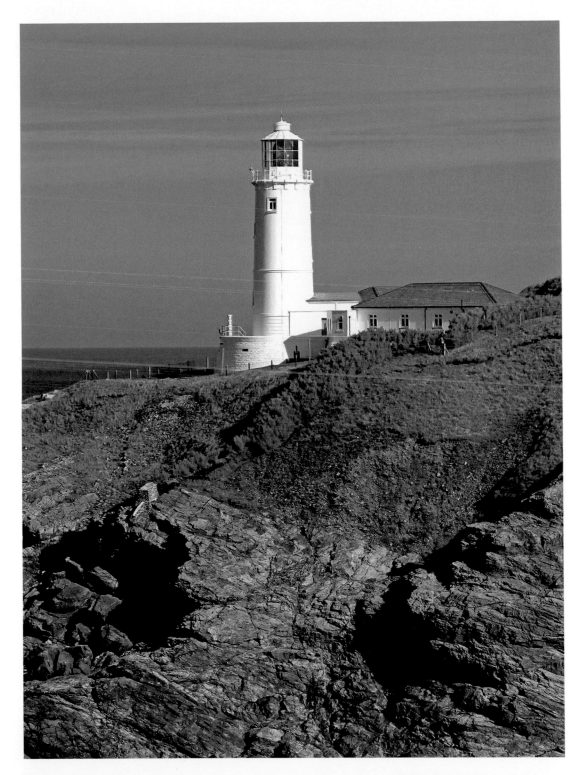

Trevose Head lighthouse was originally the high light of a pair of lights. The low light was discontinued in 1882.

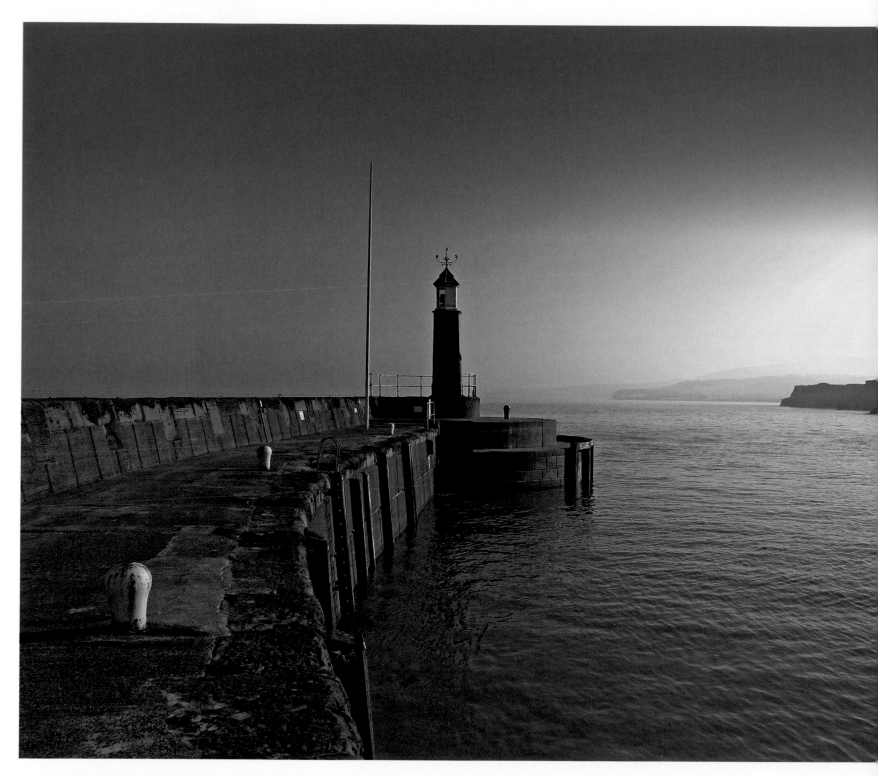

9 NORTH DEVON AND THE BRISTOL CHANNEL

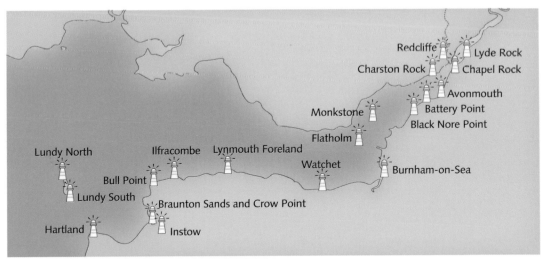

Hartland Point

Established	1874
Current lighthouse built	1874
Automated	1984
Operator	Trinity House
Access	Can be viewed from the coast path

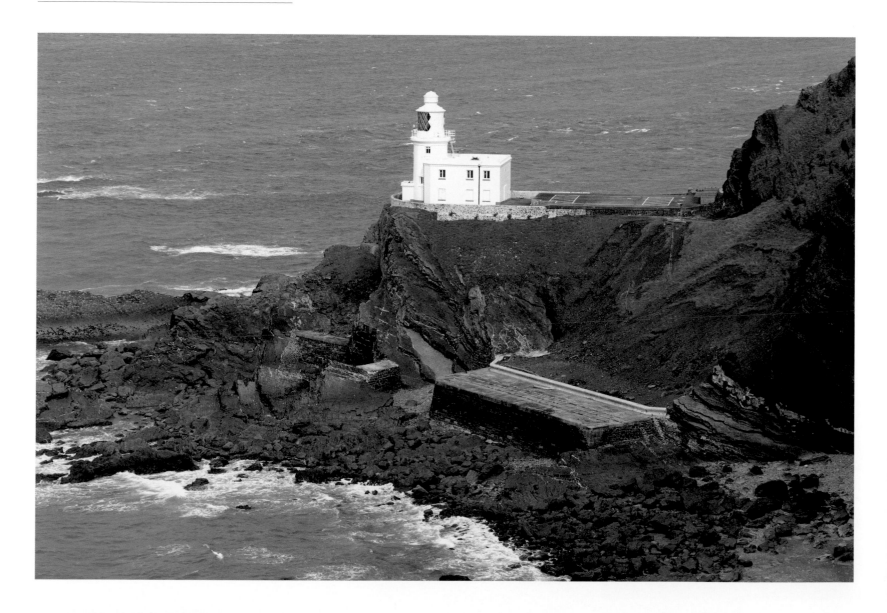

Braunton Sands

Established	1820
Current lighthouse built	1954
Automated	1984
Operator	Trinity House
Access	Via the nature reserve toll and car park on Braunton Sands

Hartland Point lighthouse, about 3 miles north-west of Hartland, guides vessels approaching the Bristol Channel and marks the passage between the Devon coast and Lundy Island. The lighthouse was built by Trinity House in 1874 under the direction of Sir James Douglass and was sited at the tip of the point just below the most commonly occurring cloud formations. The 59ft brick tower houses a light with a range of 25 miles.

At one time, the light was threatened by the undermining action of the sea. Trinity House therefore had to have the rock broken away from the cliff head behind the lighthouse so that it fell on the beach and formed a barrier against the waves. This procedure had to be repeated frequently, as the original deposits were washed away whenever a north-westerly gale coincided with a high spring tide. In 1925, a permanent barrier and sea wall, 100ft long and 20ft high, was constructed to solve the problem.

The station was automated in 1984, having been manned by four keepers who lived with their families in dwellings attached to the lighthouse. The dwellings were then demolished, making space for a helipad next to the tower.

(Opposite) Hartland Point lighthouse was built in 1874 on a large rock and is now on land belonging to the National Trust.

The rivers Taw and Torridge flow into Bideford or Barnstaple Bay between the sand dunes of Northam to the south and Braunton to the north. To guide ships through this area, which can only be accomplished after half tide, a pair of lighthouses was constructed by Trinity House in 1820 on the Braunton side near Crow Point.

These lights were called Braunton High and Low, but were often referred to as Braunton Sands or Bideford Lights, and latterly as Crow Point light. The original high light, situated on the riverbank near Crow Point, was a unique 86ft octagonal wooden tower protruding through the roof of a wooden keeper's dwelling which was supported by a strut from the tower to each corner of the dwelling's roof. White with a red stripe on the seaward side, it originally showed the light through a window in the tower but later

(Below) The old Braunton high light, sometimes called Bideford, was superseded in 1954 and demolished in 1957. (Courtesy of Michel Forand)

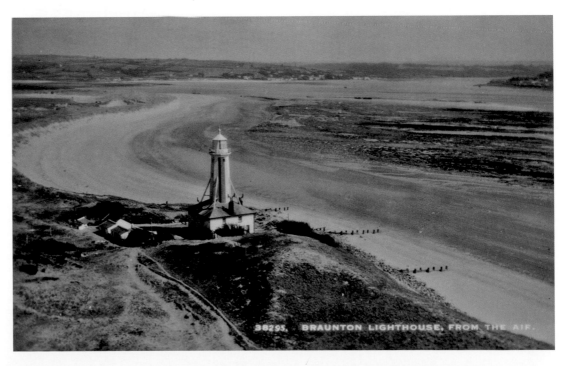

a gallery and dome-topped lantern were added. The fixed white light was visible for 15 miles. Built by Joseph Nelson, it was altered in 1889 but became unstable in 1945 and was de-manned. It was superseded in 1954 and demolished in 1957.

The low light was also built in 1820 and again was, for Trinity House, unusual. It consisted of a 15ft close-boarded hut on wooden legs with the light displayed through a window. Like the high light, it was painted white with a red stripe

and was altered in 1832 and 1902. The fixed white light was visible for 14 miles. Because the channel could only be navigated above half tide, a ball on a mast was used which the keeper raised when the tide was sufficient to enter. This was later altered to a red and green light. The light was deactivated in 1954 and demolished three years later.

In 1954 a new automatic unmanned light at Crow Point was erected to replace the 1820

Crow Point light, which stands opposite Instow at Braunton Sands, was built as an unmanned structure in 1954 as a guide to vessels navigating the Taw and Torridge estuary in North Devon.

lights. It consisted of a 25ft square skeleton tower with a gallery but no lantern, and was situated opposite Instow. The light, originally acetylene powered, was converted to solar power in 1987 and further modernised in 2001.

Instow

Established 1820

Operator Torridge District Council

Access The high light is visible from the bypass and the low light from the car park in Anstey Way

Because the channel from the sea to the Taw and Torridge is so difficult to navigate, Trinity House erected a pair of range lights at Instow on the east side of the estuary to mark the narrow passage. The rear range is sited on a hill beyond the bypass road and consists of a 28ft skeleton tower on the roof of a square concrete equipment hut. The tower has a white daymark on the seaward side and supports a sealed beam light on an open lattice gallery. The occulting white light is visible for 15 miles.

The front range is situated near the river next to the cricket ground and consists of a 58ft open lattice tower on the roof of a small equipment hut. A white daymark near the top of the tower contains a sealed beam light unit giving an occulting white light visible for 15 miles. Lights were shown here from 1820 but these towers were erected later.

Instow front range is situated close to the local cricket ground.

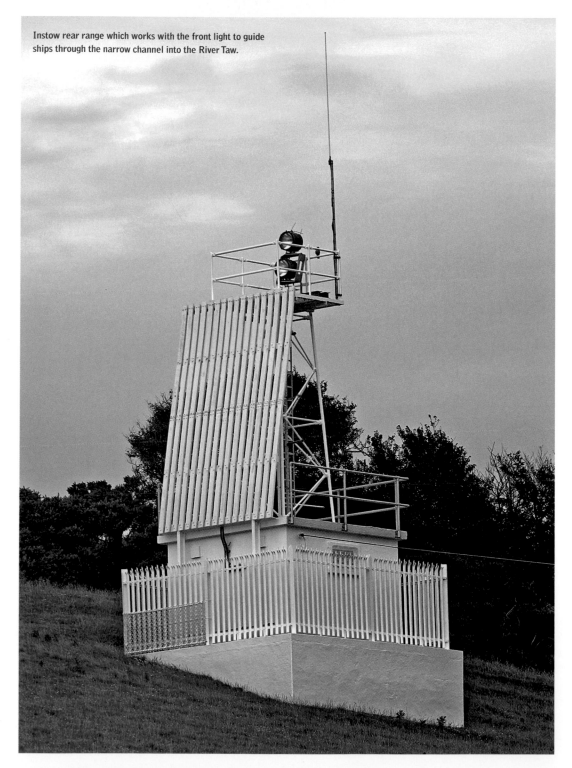

Instow rear range which works with the front light to guide ships through the narrow channel into the River Taw.

Bull Point

Established	1879
Current lighthouse built	1976
Automated	1976
Operator	Trinity House
Access	Via the coast path from Mortehoe

The headland to the north of Hartland Bay is marked by Bull Point lighthouse, which guides vessels navigating the North Devon coast. It has a red sector light marking the Rockham Shoal and the Morte Stone off Morte Point. The light, established in 1879 on the headland near the village of Mortehoe, forms a triangle of lights together with Lundy and Hartland Point.

The lighthouse gave good if unremarkable service until 18 September 1972, when the principal keeper noticed movement in the ground near the engine room and the passage leading to the lighthouse, and saw 2in fissures opening up. In the early hours of 24 September 50ft of the cliff face fell into the sea and a further 50ft subsided, causing deep fissures to form inside the boundary wall. Walls cracked and the engine/fog signal station partly collapsed, leaving it in a perilous condition and putting the fog signal out of action.

A temporary measure was soon implemented to maintain the light. An old Trinity House light tower, which had been in use at Braunton Sands and subsequently given to the Nature Conservancy, was reacquired, moved to Bull Point, and the optic installed on top of it, an arrangement which was used for nearly two years. A hut was constructed for the three diaphone fog signals as a temporary measure.

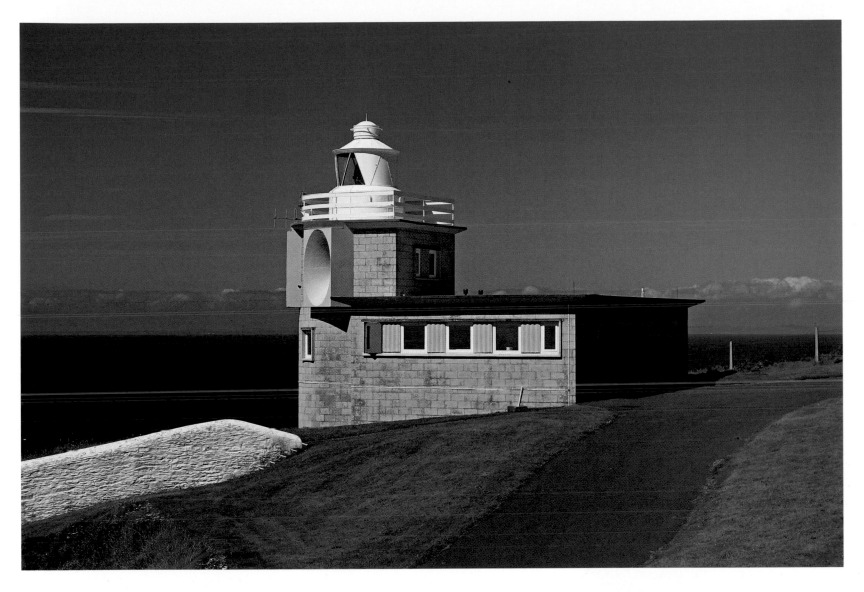

In 1974, work began on a new lighthouse, which was built at a cost of £71,000. The new tower, 55ft tall and 180ft above mean high water, was designed and built so that the equipment from the old lighthouse, including the generator and fog signal house, could be utilised, albeit with modifications. Much of the equipment dates from 1960, when the station was electrified, while the optic, with a range of 24 miles, is

(Above) The modern lighthouse at Bull Point dates from the 1970s.

(Right) The Bull Point lighthouse of 1879 which was destroyed by clifftop erosion in the September 1972. (Courtesy of Michel Forand)

now in its third site at Bull Point. With the new lighthouse, the station was automated. The fog signal was discontinued in 1988.

Lundy Island

Established	1820
Current lighthouses built	1897 (North and South)
Automated	1976
Operator	Trinity House
Access	Lundy Island is managed by the Landmark Trust and day visits by boat from Bideford, Ilfracombe or Clovelly are possible in summer or by helicopter from Hartland Point in winter; the south light is accessible by a short climb up a rocky path, the old light by a hike to the summit; the north light is a few miles over rough terrain from the landing pier

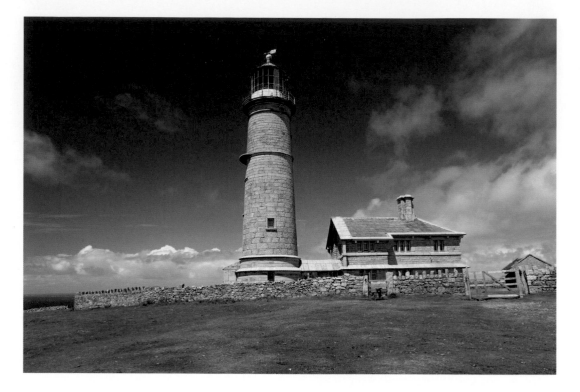

Lundy Island is 3½ miles long, three-quarters of a mile wide and lies in the Bristol Channel, west of Ilfracombe. In the eighteenth century, hundreds of ships passed, and sometimes foundered on, this rocky outcrop. It was little wonder, therefore, that in 1786 a syndicate of Bristol merchants started to erect a lighthouse on its summit, Chapel Hill. But their efforts came to nothing and it was not until 1822 that Trinity House had a lighthouse built by Joseph Nelson and designed by Daniel Alexander.

The 96ft slightly tapering granite tower was completed with a gallery and lantern, and a window on the west side for a secondary light. The adjacent keepers' dwellings were also in granite and connected to the tower by a short corridor, with an additional keeper's cottage nearby. The main light was originally a catoptric system giving a flashing white light visible for 31 miles, but this was later changed to a dioptric apparatus. The problems with this light were, firstly, that it revolved so quickly that at a distance it appeared fixed, and secondly, the fixed red light which shone from the window in the tower merged with it to form what appeared to be one beam. The theory was that the window shielded this light so it was only visible at 4 miles. Any ship seeing it steered clear until it was no longer visible, thus avoiding the island. The merging of the lights caused more harm than good, however, and the light was moved to the bottom of the tower, to no avail.

Another problem was fog which obscured the light. To overcome this problem, a pair of fog cannons was installed on the western cliff, one of which, together with its associated buildings, is still in place. Trinity House continued to receive complaints regarding visibility, and so in 1897, with the theory disproved that the higher the light the better, replaced the single light with two lights, one at each end of the island, lower down the cliff. The old light was stripped and is now

(Above) The old lighthouse on Lundy Island is situated in the middle of the island and was operational from 1819 until 1897. The lighthouse keepers' quarters are divided into the two original flats, Lower and Upper.

(Right) Lundy North lighthouse, In which the lantern is no longer in use; since 1991 a solar-powered light has been displayed from the roof of the small fog signal hut on the north side of the tower.

a daymark, while the old keepers' cottages have been refurbished and can be rented.

Lundy North lighthouse was constructed in a remote area on a plateau overlooking the Hen and Chickens. A landing stage was built at the base of the rocks with a wire stretched from the top of the cliff so that stores could be delivered via a traveller controlled from a winch housed at the top. A small railway ran the 100 yards to the lighthouse. Designed by Sir Thomas Matthews, the light was the most advanced in the world

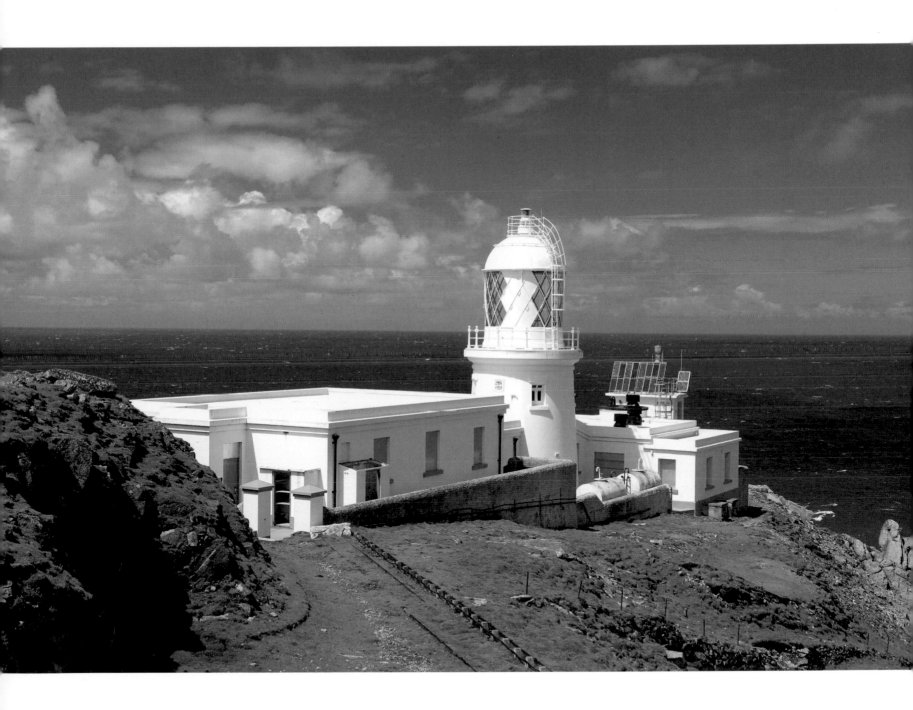

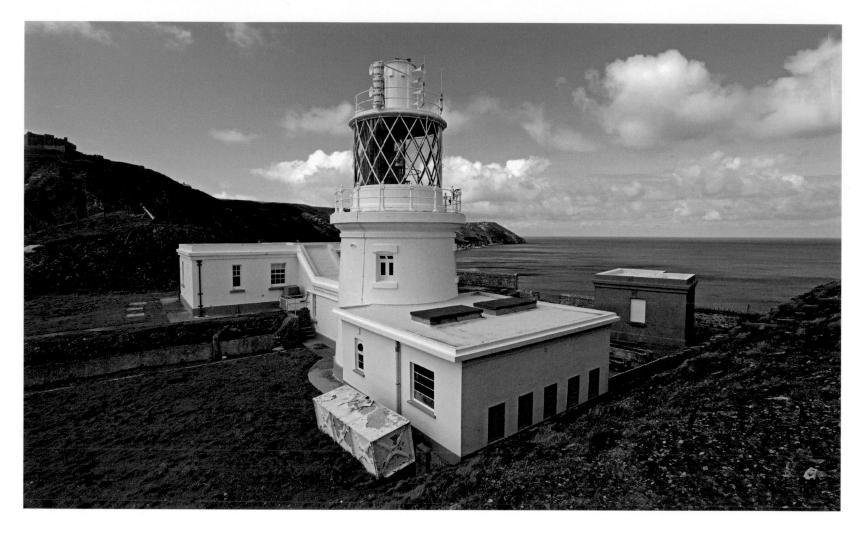

at the time. It consisted of a 56ft circular stone tower with split-level single-storey keepers' dwellings and equipment rooms on each side.

The light was initially a petroleum vapour burner but was converted to electricity in 1971. It was automated and controlled from Lundy South in 1985. When modernised in 1991, it was converted to solar power and the light in the lantern, which revolved on a bed of mercury, was removed. The light was mounted on the roof of the redundant fog signal building where a rotating beacon made by Orga produces a

flashing white light visible for 17 miles. The station was made fully automatic in 1994.

In order to build Lundy South lighthouse, an area of rock near the south-east corner of the island was levelled so that the light could be seen from all directions, which proved useful later when a helicopter pad was installed. The lighthouse was more compact than that in the north, with a 53ft circular stone tower attached to single-storey keepers' dwellings. The foghorn system was mounted in a cylindrical tower on top of the lantern. The majority of the equipment

Lundy South lighthouse, one of a pair of lights currently maintained by Trinity House, is 53m above mean high water.

from the 1822 lighthouse was transferred here. The light was initially a petroleum vapour burner but was converted to electricity in 1971. When modernised in 1994, the station was automated and converted to solar power with the light in the lantern converted to an Orga rotating beacon producing a flashing white light visible for 15 miles.

Ilfracombe

Established	*c.*1650
Current lighthouse built	1819
Operator	Trinity House
Access	Via chapel on Lantern Hill

The resort of Ilfracombe boasts a large harbour, much of which dries out at low tide. To the west of the entrance is a series of rocky outcrops and a conical land mass called Lantern Hill. In 1319, the stone-built, slate-roofed chapel of St Nicholas was constructed on its pinnacle. From about 1650, a light was displayed on its western end to warn vessels of the rocks as they approached the harbour. In 1819, Trinity House took over this light, replaced it with a circular lantern on the roof and twenty years later converted it to gas.

Mounted on the chapel's roof, the lantern is 37ft high with a focal plane of 130ft. The flashing green light, now electrically powered and visible for 6 miles, is shown during the winter months. In addition to this light, other pole-mounted aids to navigation are located on the Promenade Pier and the Inner Pier Head. To the south-east of the harbour is a pair of harbour leading lights, the front one on a pole and the rear one in a simple box on the hill.

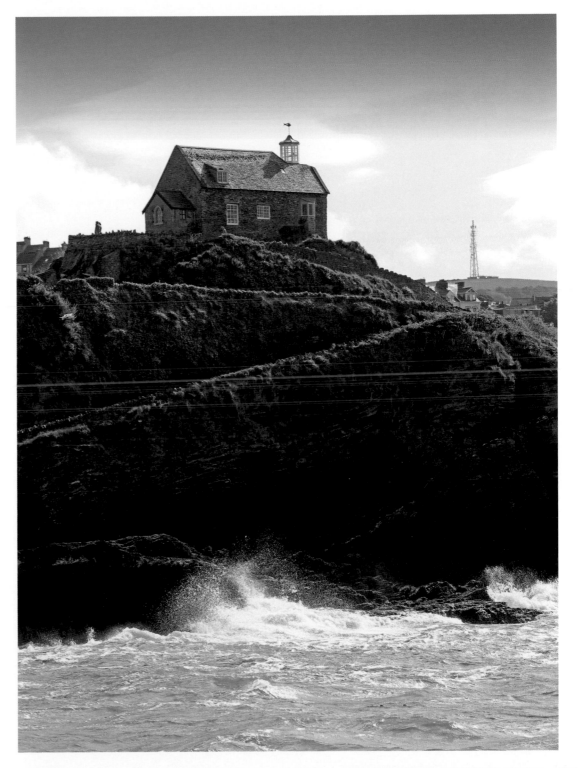

Lantern Hill overlooks Ilfracombe Harbour and the chapel dates from about 1320. The chapel houses an aid to navigaton, with the current light added by Trinity House in 1819.

Lynmouth Foreland

Established	1900
Current lighthouse built	1900
Automated	1994
Operator	Trinity House
Access	Via the South West Coast Path from Countisbury, or by walking down a service road off A39

The southern approaches to the Bristol Channel were marked by Hartland Point in 1874 and Bull Point in 1879. In 1900, Trinity House supplemented this cover with a new lighthouse 2 miles east of Lynmouth at Foreland Point. Called Lynmouth Foreland, it was erected on a ledge two-thirds of the way down a 900ft cliff, with the unusual arrangement that the light was placed below the terrace of single-storey stone-built keepers' dwellings and service buildings. The circular 49ft white tower, with gallery and lantern, originally housed an oil-powered light. In 1975, the station was electrified and a first-order dioptric installed, giving a white flashing light visible for 18 miles. An electric fog signal was built into the front of the tower.

Its remote location under the north-facing cliff means the station only receives sunshine for three months of the year, and so a special arrangement was applied whereby no keeper was assigned to the station for more than three years. This ceased in 1994, when the station was automated and the keepers withdrawn. The cottages are managed by the National Trust and available to let, but the tower is closed.

Lynmouth Foreland lighthouse at Foreland Point, to the north-east of the small town of Lynmouth. The lighthouse keeper's cottage is now a National Trust holiday cottage.

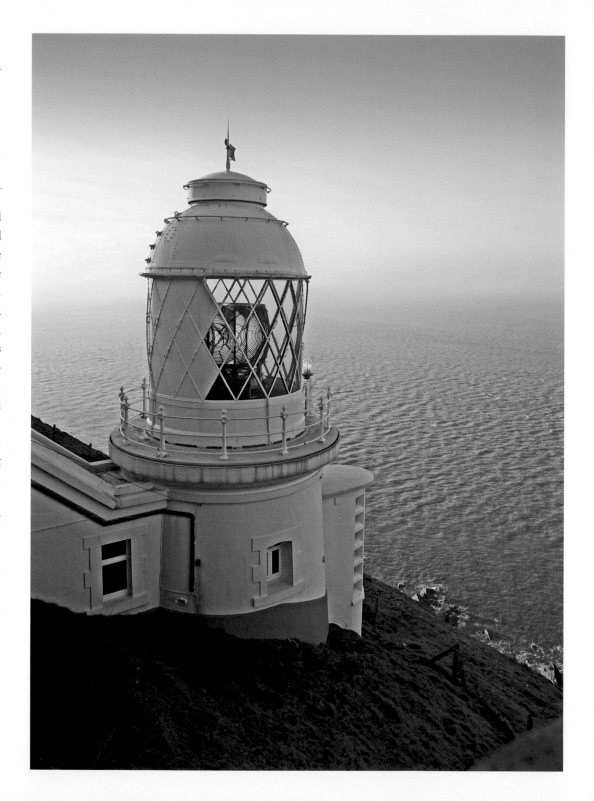

Watchet

Established	1862
Current lighthouse built	1862
Operator	Watchet Harbour Authority
Access	The harbour piers are open to the public

Built in 1862, the eye-catching lighthouse on the end of the west breakwater pier at Watchet consists of a red 22ft hexagonal cast-iron tower supporting a white lantern complete with a green cupola roof. The light, which dates from 1862, is topped by an ornate weather vane and shows an electrically powered fixed green light, visible for 9 miles. On the end of the east pier is a single 9ft grey pole that carries two simple red lights, displayed vertically.

The red cast-iron light at the end of Watchet pier was built in 1862 and marks the entrance to the modern marina.

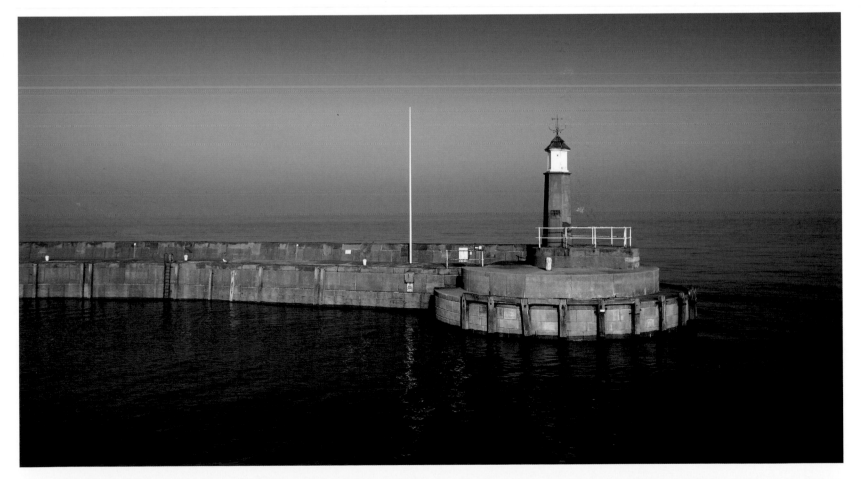

Burnham-on-Sea

Established	1801
Current lighthouses built	1832
Access	The high light is to the north of the town in Berrow Road, and can be viewed from the road; the low light is on the beach half a mile north of the town

The lighthouses in Burnham-on-Sea had an unusual beginning when, around 1750, an old fisherman's wife living in a cottage close to the church put a candle in her window to help her husband find his way home. It saved his life and from then on the grateful sailors decided to pay her small sums of money to keep a candle burning. Later, the sexton of the church gave the fisherman's wife £5 for the rights to place a light on the church tower. Thus came about what is now known as Burnham-on-Sea Seafront Rear Range light. It is now shown as a fixed red light visible for 3 miles and is mounted on the 36ft tower of the Church of St Andrew, on the seafront. The tower has a slight lean due to subsidence. The front range is a simple light on a street lighting column on the promenade in front of the church.

In 1801 David Davis, the local curate, built a lighthouse at the north end of the churchyard in what were then sand dunes. Originally a four-storey white castellated masonry tower, it showed a fixed white light through a window at the top. It was deactivated in 1832 when new lighthouses were built to the north and, to avoid confusion, the top two levels of Davis' tower were removed.

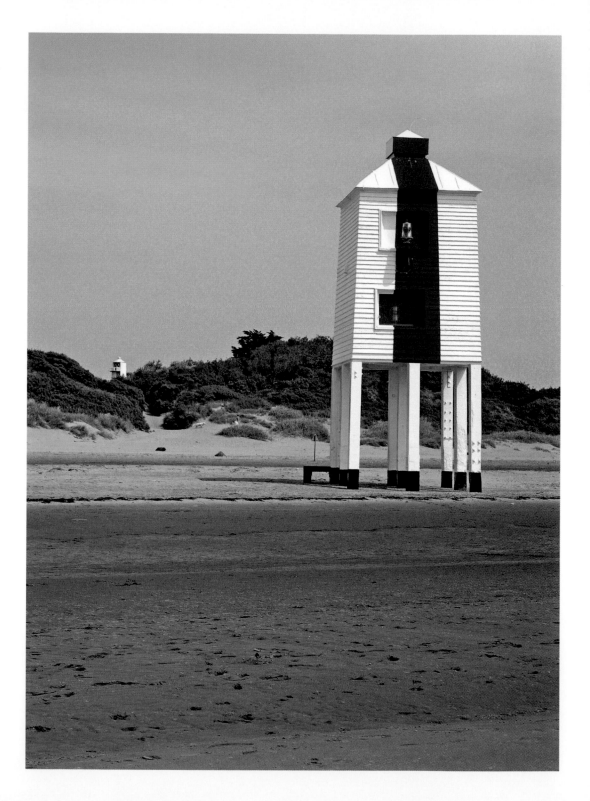

The low light at Burnham-on-Sea supported on wooden piles with the high light background left.

It stands behind the esplanade buildings just to the north of the Church of St Andrew, as part of another building.

In 1832 a pair of lighthouses was built to mark the channel into the River Parrett between Berrow Flats and Stert Flats. The high light, known locally as the Pillar Lighthouse, was a 99ft tapered white-painted brick tower.

Although some keepers' quarters were incorporated into the tower, cottages were also attached. The white paraffin-fuelled light, displayed through a window and half gallery, was visible for 17 miles. There is also a red visibility stripe up the front of the tower. The light was discontinued in 1996 and the lighthouse is now a private dwelling.

When the high light was commissioned it was found that too low a vantage point had been selected to account for the rise and fall of the tide so a low light was built in 1832. This 36ft square close-boarded wooden tower with a conical roof supported on nine wooden-pile legs is situated on the beach 800 yards in front of the high light. Known locally as the 'lighthouse on legs', the structure is white painted with a vertical red stripe. The flashing white light was displayed through a window at a focal plane of 23ft with directional red, white and green lights displayed at a focal plane of 13ft.

The light was discontinued in 1969 but reinstated in 1996, when the high light was made redundant. Bridgwater Port Authority renovated it, changed the window display by opening a new window lower down the tower, with the flashing light being displayed externally. The structure is a Grade II listed building.

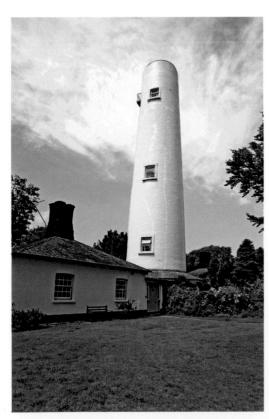

(Left) The high light at Burnham-on-Sea is now used as a private dwelling.

(Far left) The 1801-built tower, which has been inactive since 1832, was originally four storeys tall.

Flatholm

Established	1737
Current lighthouses built	1820
Automated	1988
Operator	Trinity House
Access	Visiting the island, a historical and nature reserve, is possible via boat trips from Barry Dock

The island of Flatholm lies in the centre of the shipping channels, where the Bristol Channel meets the Severn Estuary and it is perhaps surprising that considerable wrangling took place before a light was displayed there. As early as 1733, John Elbridge, a member of the Society of Merchant Venturers of Bristol, petitioned for a light but to no avail. In 1735, William Crispe informed Trinity House he had taken a lease on the island and wished to build a light in their name but at his expense. He did of course wish to recoup his costs from ship dues.

The small island of Flatholm in the middle of the entrance to the Severn Estuary has a distinctive lighthouse, operated by Trinity House, as its main feature. Flatholm lighthouse was built in 1727 and rebuilt in 1820.

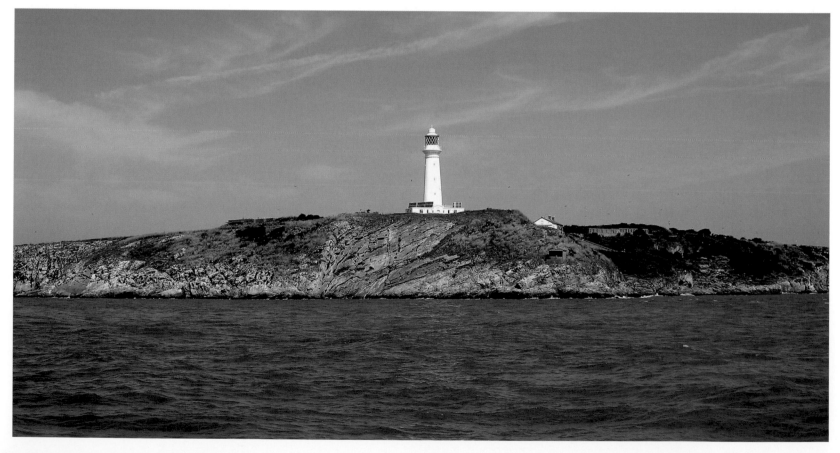

This again was rejected but, after sixty soldiers were drowned in a wreck near Flatholm in late 1736, a further proposal by William Crispe was accepted and a 70ft stone tower was built and its coal light was first displayed on 1 December 1737. Unfortunately for Crispe and his partner, they went bankrupt and released the lease to Caleb Dickenson. In 1790, a severe lightning storm damaged the lighthouse and for a time the light had to be displayed from ground level.

Following complaints about the inadequacy of the light, Trinity House took over the lease in 1819 and increased the height of the white stone tower to 90ft by 1820 and installed a lantern and Argand lamp with reflectors showing a fixed white light. In 1825, the height of the light was increased by a further 5ft and a fountain oil lamp installed. The light was altered to occulting in 1881. A Douglas multi-wick burner was installed in 1904 which in 1923 was superseded by a Hood paraffin burner.

Single-storey equipment rooms were attached to the tower and the keepers' families were housed in cottages adjacent to the lighthouse. In 1929 the lighthouse was redesignated a rock station and the families withdrawn. The light was automated in 1988 and, in 1997, converted to solar power. The current flashing white light is visible for 15 miles, with a red sector visible for 12.

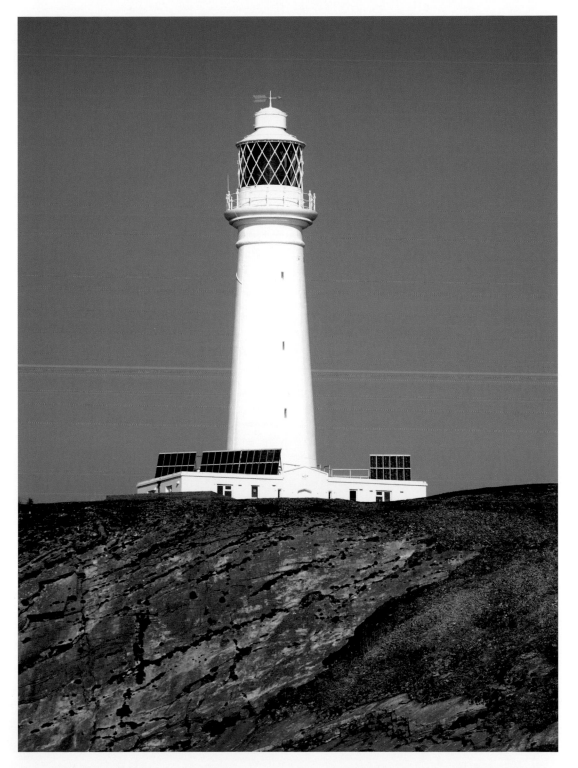

Monkstone

Established	1839 (as a beacon)
Current lighthouse built	1925
Operator	Trinity House
Access	Can only be reached by boat

Monkstone rock is a submerged reef, only visible at low tide. Located about 3 miles east-north-east of Lavernock Point and 5 miles south of Cardiff near Flatholm, it is not the only obstacle to shipping in the area, as many sandbanks, passable at high tide, can catch out the unwary. The lighthouse, therefore, not only marks the rock's position but forms a reference point for the other hazards.

The original 45ft granite tower, built in 1839, was an unlit beacon until 1925, when it was fitted with an iron lantern and automatic acetylene light. It was reinforced with horizontal and vertical iron bands which were painted red. In 1993 it had a unique update, with the lantern being replaced by a red prefabricated 30ft tall fibreglass unit complete with main and auxiliary lights powered by solar power. This increased the height to 75ft and the range of the flashing white light to 13 miles.

The light on Monkstone Rock, pictured at high tide when most of the tower and all of the rock are covered.

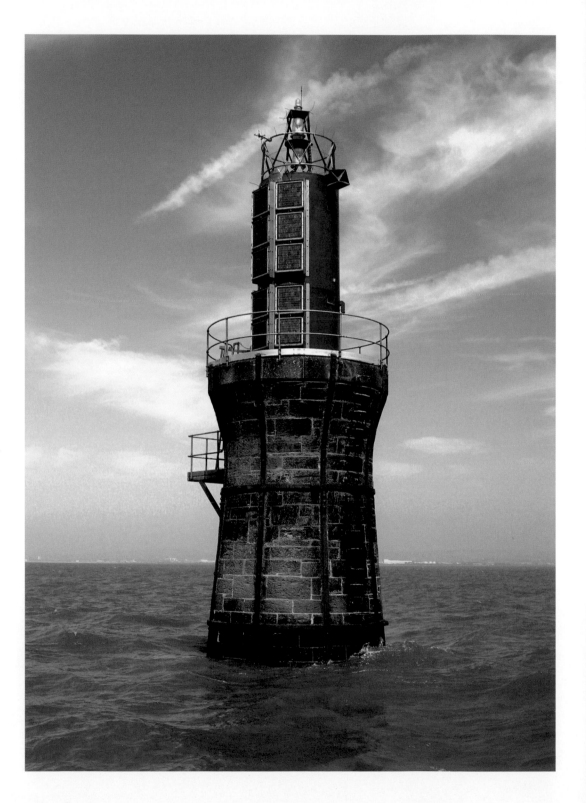

Black Nore Point

Established	1894
Current lighthouse built	1894
Operator	Trinity House
Access	Via the coast path from Portishead; or by private footpath from Nore Road

When the lighthouse at Black Nore Point, just south of Portishead, was built in 1894 by Trinity House to guide ships into the Avon, it was the only light in the area. As a consequence, it was often referred to on early postcards as Portishead Lighthouse and care has to be taken not to confuse it with the lighthouse built later at Portishead Point. One of a number of prefabricated lights, it consists of a white 36ft hexagonal cast-iron tower on a six-legged cast-iron lattice frame mounted on a simple plinth with a lantern and gallery. The owners of Black Nore farm used to visit the light twice a day to light and extinguish it. The flashing white light was initially powered by mains gas but was converted to electricity in 1941, using probably the world's smallest biform optic.

The original lens rotating mechanism remained in place until 1970, when it was replaced by an electric motor. The fourth-order biform dioptric and 100-watt lamp showed a white group-flashing light twice every ten seconds, with a range of 15 miles. After an appraisal of navigation requirements by Trinity House, it was decommissioned on 27 September 2010 and in October 2011 was sold to a trust for preservation at a cost of £1.

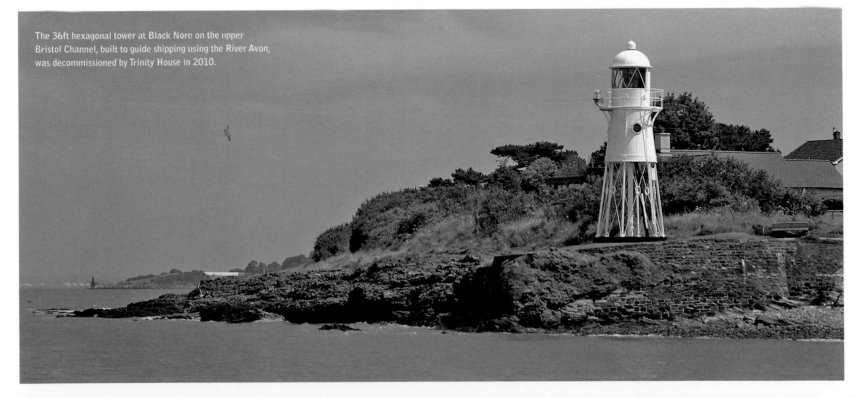

The 36ft hexagonal tower at Black Nore on the upper Bristol Channel, built to guide shipping using the River Avon, was decommissioned by Trinity House in 2010.

Portishead Point

Established	1930
Current lighthouse built	1930
Operator	Bristol Port Company
Access	Via the esplanade at Portishead

Portishead Point and Battery Point adjoin each other and, when the light on Portishead Point was built in 1930 by the Bristol Port Company, it was soon referred to as Battery Point. This saved confusion with Black Nore Point light, a mile to the south-west, which itself had become known as Portishead Light. The Battery Point tower is of an unusual design consisting of a black 30ft square lattice tower on a ferro-concrete base.

The control equipment is housed in two metal enclosed areas, one at the base and one at the top of the tower. A narrow walkway on concrete supports connects it to the shore.

The flashing white light, visible for 16 miles, is a simple lens mounted on top. The sixth-order Chance Brothers flashing beacon was originally powered via an electrical circuit directly from Portishead power station but the light is now powered by batteries recharged from a mains supply. Sometime before 1954, a large fog bell was added and this is now suspended on an iron frame mounted on the concrete base. The lighthouse is near Lake Grounds and the swimming pool on Portishead seafront.

Battery Point light, located on the south side of the river Severn, just off Portishead Esplanade.

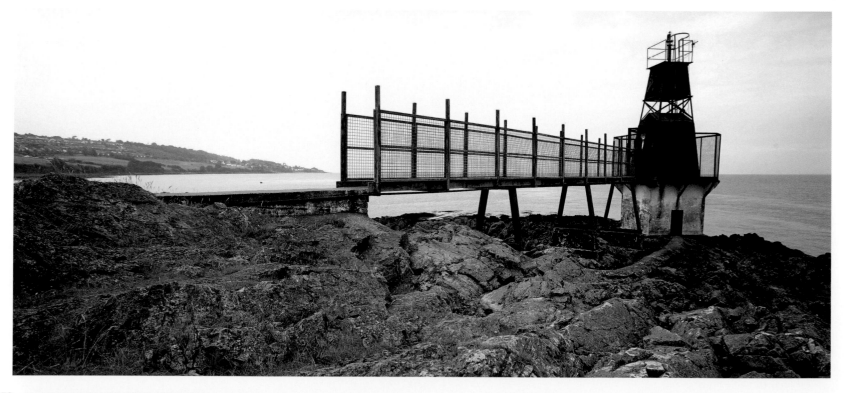

Avonmouth

Established	1839
Current lighthouse built	1907
Operator	Bristol Port Company
Access	Avonmouth Docks is a restricted area; vantage points on Avonmouth waterfront offer views of the lights

Trinity House built the first light at Avonmouth in 1839. Situated where Avonmouth Docks are today, it consisted of a fine, white 65ft castellated octagonal brick tower with two six-roomed keepers' cottages attached by short corridors. The light was visible for 14 miles and marked the entrance of the river Avon into the Bristol Channel. It was demolished in 1902 when work started on the docks.

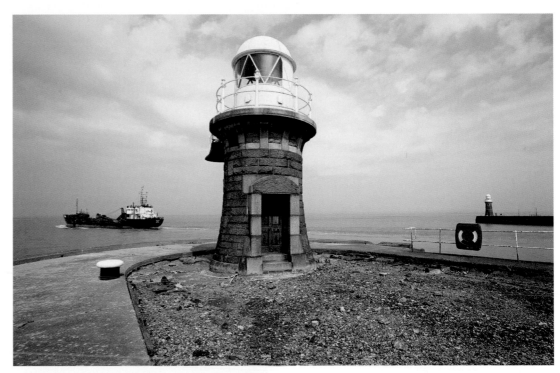

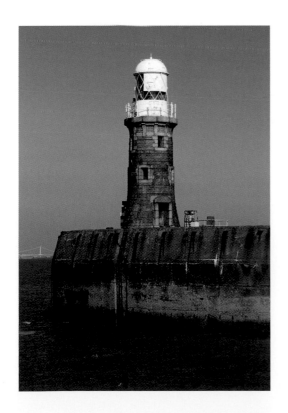

(Above) The entrance to Avonmouth Docks, marked by two fine-looking lighthouses.

(Left) The North Pierhead light, marking the entrance to Avonmouth Docks, was built in 1908.

As a temporary measure during the construction work, a light was displayed on a wooden structure until 1908, by which time a pair of lighthouses had been constructed on the dock piers. These new lighthouses, called

(Above) The South Pierhead Light marking the entrance to Avonmouth Docks with the dredger Welsh Piper departing the port.

Avonmouth Docks North Pier Head and Avonmouth Docks South Pier Head, were both ornate circular structures built of Norwegian granite. The slightly tapered towers have solid doorways and windows, complete with a granite balcony. The lights are housed in white circular lanterns with domed roofs and white railings round the galleries.

Responsibility for the lights' operation changed from Trinity House to Bristol Port Company. Situated in Royal King Edward Docks, the South Pier Light, completed in 1907, is 30ft tall and the occulting electric light, visible for 10 miles, has red and green sectors. The North Pier Light is taller at 52ft and was completed a year later. Its flashing white electrical light is visible for 18 miles.

Charston Rock

Established	1886
Current lighthouse built	1886
Operator	Gloucester Harbour Trustees

The approach to Gloucester Docks via the River Severn requires careful navigation, particularly through the Shoots between the two motorway road bridges. To help navigation, four fixed lights, initially provided by the Sharpness Canal Company in 1886, were erected on the Welsh side of the river. Responsibility for the river navigation was invested in Gloucester Harbour Trustees in 1890 and these lights, together with aids further up river, were handed over to the trustees in 1891. The trustees subsequently provided a number of improvements, particularly at the Shoots.

The most southerly of the four lights is Charston Rock, situated on a rock just offshore from Portskewett and sometimes incorrectly referred to by the name of the adjacent Black Rock. It was built in 1886 on a stone tower owned by the Great Western Railway Company. The 23ft white-painted stone tower has a vertical black line and the oil-burning light is operated in conjunction with Redcliffe to show a leading line through the Shoots. The light was converted to acetylene in 1926 and in 1966 to battery power using the lantern and lens from Redcliffe.

In 1980 the lantern was removed and replaced by an all-round lens powered by batteries and solar panels. After complaints had been made regarding visibility, for a period between 1927 and 1928 the light was changed to red flashing. However, since 1928 it has shown white flashing with the intensity increased to today's values giving a 5-mile range with a leading edge range of 8 miles.

On the shore, about a mile north of Charston, the light at Redcliffe was erected in 1886 and, in conjunction with the Charston light, formed a pair of leading lights through the Shoots. The fixed white light, powered by oil, was mounted on a wooden post which, in 1910, was replaced by 33ft lattice steel tower. It was converted to acetylene gas with a flashing white light in 1926 and to mains electricity in 1965. The white flashing light was changed to red for an experimental period in 1927 but remained white flashing until changed to fixed blue in 1966. In 1982, when a back light was installed, the intensity of the light was increased by the installation of twelve fluorescent tubes. The back light, 150 yards behind, consists of a 100ft column with the bank of fluorescent tubes.

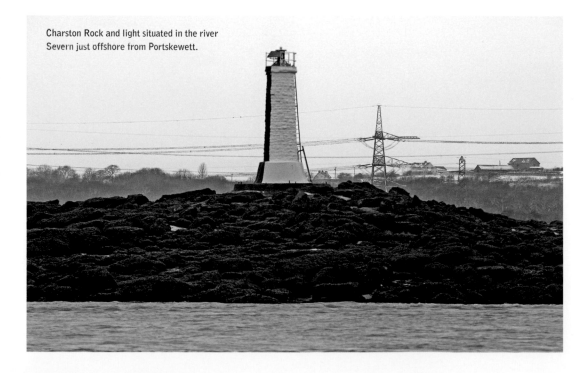

Charston Rock and light situated in the river Severn just offshore from Portskewett.

Chapel Rock

Established	1886
Current lighthouse built	1907
Operator	Gloucester Harbour Trustees

Lyde Rock

Established	1896
Current lighthouse built	1947
Operator	Gloucester Harbour Trustees

The light on Chapel Rock, just off Beachley Point, was first erected on a wooden structure in 1886. It had an oil-fired fixed white light with green sectors on each side to guide vessels clear of the rocks as the Wye and Severn channels diverged. In 1907, the wooden structure was replaced by a black lattice steel tower.

The light was converted to battery operation in 1947 and, to save battery life, flashing operation. However, following problems, it was converted to acetylene in 1951. It was converted to mains electricity in 1983 when a more powerful flashing white light with red and green sectors was installed in the remains of the lantern housing. The white sectors have a range of 8 miles and the coloured sectors 5 miles.

(Below left) Chapel Rock light is situated off Beachley Point near the ruins of an old chapel, downstream from the old Severn Bridge.

(Below right) The light tower marking Lyde Rock, also known as the Hen and Chickens, on the north side of the river Severn off Beachley.

Erected in 1896 on an iron-framed structure, the oil-powered light on Lyde Rock, equipped with a fixed white light with red sectors to each side, guided vessels past the Hen and Chickens Rock. Following a ship collision in 1947, the iron tower was replaced by a black 40ft steel lattice tower with a battery-operated light and, to save battery life, it was converted to flashing. Battery life was a problem and in 1951 the light was converted to acetylene gas. In 1983 the light, housed in a yellow lantern, was converted to mains electricity and increased in intensity. Both white and red sectors now have a range of 5 miles.

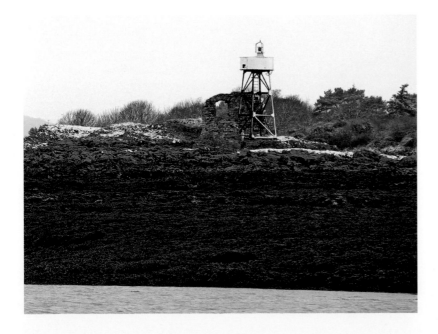

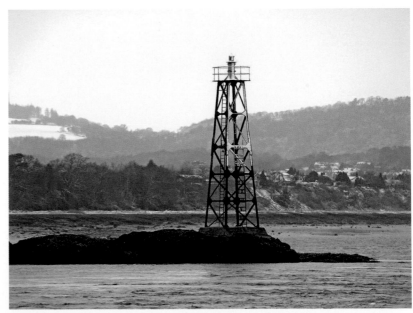

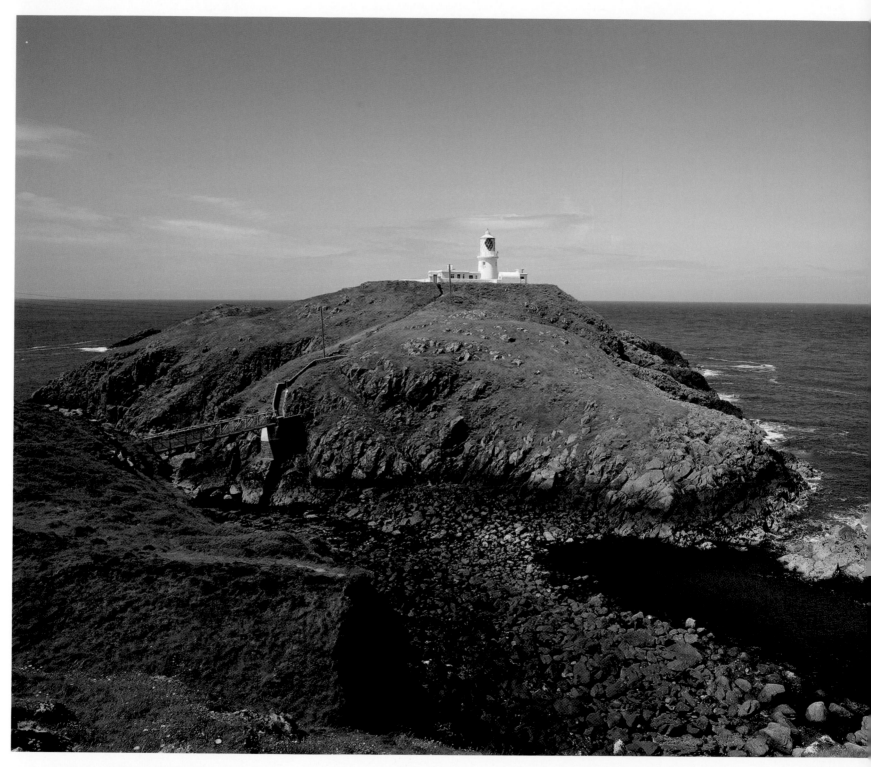

10 SOUTH AND MID WALES

New Quay
Strumble Head
Fishguard
South Bishop
Smalls Milford Haven Saundersfoot Burry Port
Skokholm Swansea Goldcliff
 St Ann's Head East Usk
Caldey Island Whitford West Usk
 Point Mumbles
 Porthcawl Barry Dock
 Nash Point

Goldcliff

Established	Unknown
Access	Approached by taking road from Newport through village of Goldcliff then turning right to park; a short walk west along the embankment

This unique light is situated on a grassy bank just south of the village of Goldcliff, to the south of Newport. Operated by the local port authority, it consists of a 9ft oblong sheet steel box with a pyramid roof. There is no lantern and the simple light is mounted on top in a circular lamp holder.

When active, the white light had a range of 6 miles. Some indication of its age can be assessed by the fact that it was powered by mains electricity but it has been redundant for several years. The light originally marked the most southerly part of the headland to the east of the river Usk.

The minor aid to navigation at Goldcliff stands on a promontory just over a mile south of Whitson.

East Usk

Established	1893
Operator	Newport Harbour Commissioners
Access	Take road from Newport to Uskmouth Power Station, park in nature reserve car park; then a walk through the reserve

Situated on the river bank east of the River Usk where it joins the Bristol Channel, the East Usk lighthouse is operated by Newport Harbour Commissioners. Erected in 1893, it consists of a 36ft white prefabricated cylindrical steel tower mounted on six screw-pile legs.

The tower is topped by a gallery and hooded lantern which houses an electrically powered flashing white light with red and green sectors. Visible for 15 miles, the light was operated in conjunction with the older light on the opposite bank at West Usk. The area around the tower is a nature reserve.

The East Usk light on the east side of the entrance to the river Usk, operated by Newport Harbour Commissioners.

West Usk

Established	1820
Discontinued	1922
Access	Now a bed and breakfast, reached via the B4239 from Newport towards St Brides, then turning left after 2 miles through a farm gate and following a winding track

In 1807 a patent was sought to build a light to mark the dangerous waters off St Brides where the Usk meets the Severn and the tidal race is one of the fastest in the world. This application came to nothing, but in 1820 it was renewed and Trinity House commissioned a lighthouse on what was then an island on the west bank of the Usk. Although correctly called West Usk lighthouse, it is also known as St Brides lighthouse. The light, the first designed by James Walker, was a slightly tapered 56ft circular brick tower with gallery and lantern. Two lights, visible for 11 miles, were displayed from the lantern, one white and one red, with another white light 14ft lower down on the tower.

Some time before the end of the nineteenth century, keepers' dwellings were added in the form of a two-storey oval building surrounding the tower. This unusual structure, together with the fact that it was James Walker's first lighthouse, makes the lighthouse something of an architectural gem. Although the brick buildings and tower were rendered and painted white, the lantern, complete with its conical roof, was painted black. The light was discontinued in 1922 and the lantern removed. The lighthouse

The now disused West Usk lighthouse, built in 1821 to the design of James Walker, has been converted into accommodation.

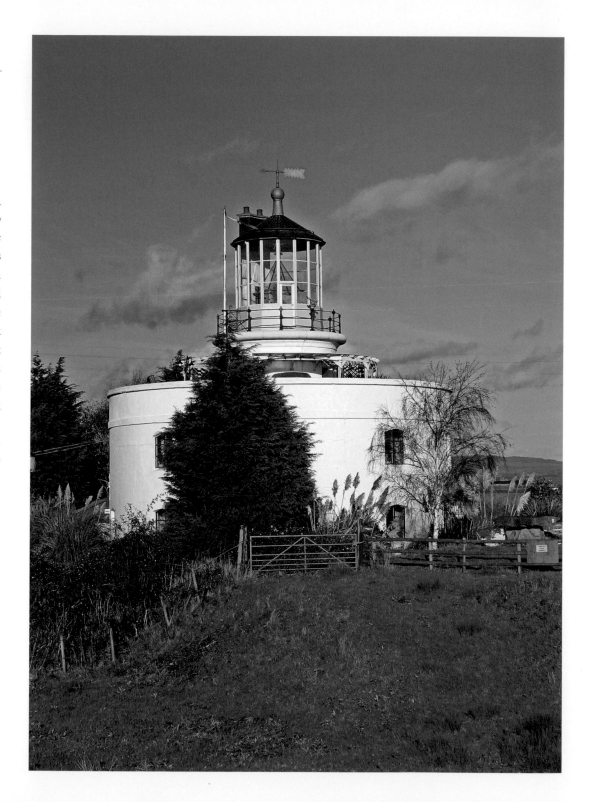

Barry Dock

Established	1890
Current tower	890
Operator	Associated British Ports
Access	Breakwater is closed to the public; access to the dock is via a long flight of steps from the main road above

was then cropped at gallery level and a shallow pitched roof added, while the cast-iron gallery railings were retained.

Because of its location, the whole structure was mounted on a circular bed of solid granite blocks with a cast-iron handrail. The handrail was cut off just above ground level after the light was decommissioned. In 1995 the present owner purchased the deteriorating building and carried out a successful restoration. The pitched roof was removed from the tower and a replica lantern was installed with a cone-shaped roof, not dissimilar to the original apart from the whole structure being painted white. It is now privately owned and has been converted into a bed & breakfast and small wedding venue.

In the late 1800s the size of the South Wales coal trade was such that the Taff Vale Railway and Cardiff Docks were so congested they virtually ground to a halt. As a result, in 1889 a new port was opened at Barry Dock.

As part of this development, a stone breakwater was built out from Barry Island,

and in 1890 a 30ft white circular cast-iron tower with gallery and lantern, complete with cupola roof and weathervane, was built on the end by Chance Brothers to a standard design. Painted white with a red lantern roof, it shows an electric quick-flashing white light, visible for 10 miles.

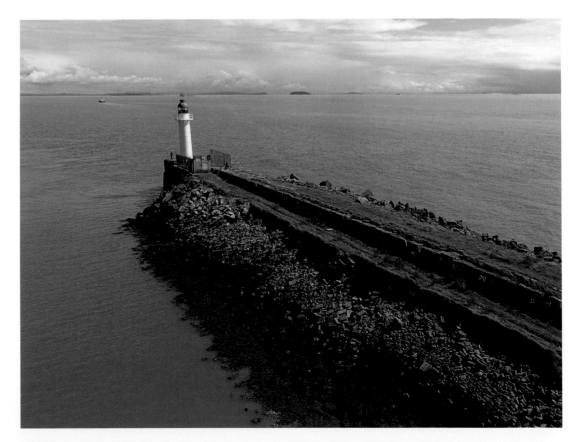

Barry Dock West Breakwater light marks the entrance to the port of Barry Dock, with Flatholm visible in the background.

Nash Point

Established	1832
Current lighthouse built	1832
Operator	Trinity House
Access	Located near St Donat's, the light is reached via the B4237 through Monknash, then along a toll road; the keepers' dwellings are available as holiday lets

(Left) Nash Point High Light was the last operational lighthouse in Wales to be automated, and regular tours of the lighthouse are carried out most weekends.

(Centre) The low light at Nash Point, inactive since the early 1900s.

(Right) The 1832-built high lighthouse at Nash Point with the fog signal.

The entry to the Bristol Channel is impeded by a series of sandbanks known as Nash Sands, where the channel begins to narrow off at the headlands between Porthcawl and Barry. To aid navigation through this area, Trinity House established a pair of range lights at Nash Point in 1832. Designed by James Walker, they were built by Joseph Nelson, who died a year after their completion.

The high light situated to the east is a 122ft cylindrical stone tower complete with gallery and lantern. Initially it was painted with broad black and white horizontal bands, but was repainted white when the low light was disconnected. In 978-0-7509-8697-7 1851, manning levels at Nash were increased and the attached keepers' dwellings added. In conjunction with the low light, it showed a fixed white light over the safe passage with a red light over the sands. When it became the sole light, the light configuration was amended to occulting white visible for 16 miles with a red sector visible for 10 miles. In 1867, the glazed lantern was installed.

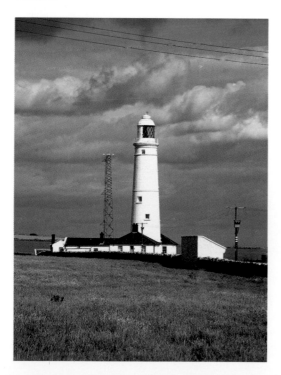

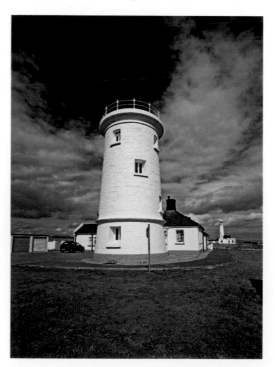

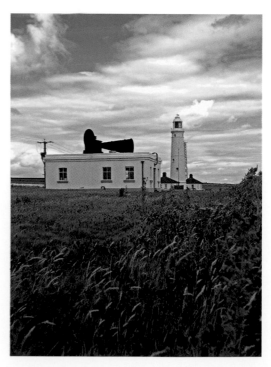

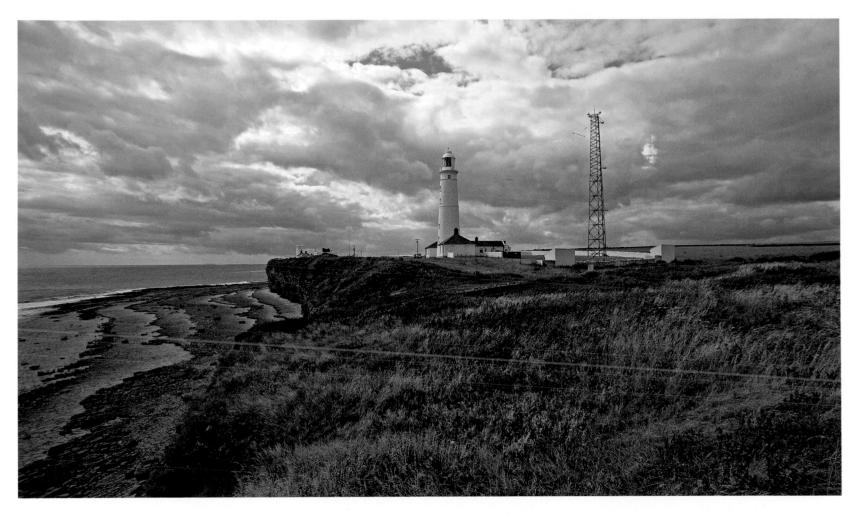

The initial light source was Argand lamps but these were replaced by a rotating optic in 1968 when the light was electrified. The ranges then increased to 21 and 16 miles. Nash Point was the last South Wales lighthouse to be de-manned, with the light automated in 1998 and the keepers leaving on 5 August 1998. For a while during the automation programme the station controlled Mumbles and Flatholm lighthouses as well as Breaksea Lightfloat.

The low light was situated about 300 yards to the west and consisted of a white-painted 67ft conical tower complete with lantern and gallery.

Unlike the high light, the attached keepers' dwellings were erected in 1832 when the light was commissioned. Its light characteristics were identical to the high light, as were the optics. It was discontinued in the 1920s when the high light was reconfigured.

By the 1970s, the lantern had been removed. The 1903 Ruston Hornsby 20hp generator and fog signal compressor from the station were acquired by Leicester Industrial Museum in 1966. The modern foghorn is mounted on top of a white square building to the seaward side of the road.

The towers at Nash Point were built at the same time and a light was exhibited from each to provide a clear set of leading lights for vessels sailing eastwards up the Bristol Channel, guiding them south of the dangerous Nash Sands.

As well as having a visitor centre offering guided tours of the station, Nash Point lighthouse is notable for being the only Trinity House lighthouse registered for weddings. The fog signal is sounded at 2 p.m. on the first Saturday and third Sunday of each month, weather conditions permitting.

Porthcawl

Established	1860
Current lighthouse built	1890
Operator	Bridgend County Council
Access	By walking along the breakwater, which in heavy weather can be dangerous

Although the harbour at Porthcawl was established in 1825 to service the metal trade, it was not until 1860 that a lighthouse, called Porthcawl Breakwater Light, was erected on the end of the stone breakwater. Although appearing ordinary at first glance, it is in fact one of only two surviving cast-iron lighthouses in Wales. It consists of a 30ft hexagonal tapered tower without a gallery. Access to the light is via a cast-iron doorway and an internal ladder.

When first commissioned, the light shone through a plain opening and the top had a

Porthcawl light is situated at the end of a stone breakwater (as seen opposite), which protects the entrance to the small harbour and is a favourite spot for local anglers.

pitched roof. It was painted to imitate a stone structure. The light was replaced in 1911 by the current arrangement, whereby the top was removed and a replacement round-domed lantern with a Chance Brothers optic was crudely attached to the top of the tower.

The light, visible for 6 miles, is displayed through a glazed window and shows a fixed white light over the channel with red and green sectors to the sides. It was coal and then gas fired before, in 1974, being converted to mains gas. It was eventually electrified in 1997, making it one of the last in Wales to be so converted. The tower is currently painted white with a broad black band at the base.

Swansea

Established	1792
Current lighthouse built	1909 and 1971
Operator	Trinity House
Access	The lights are part of the difficult-to-access dock complex, although they can be seen from the outside of the marina

Although no lighthouses can be seen at Swansea today, a number of interesting lights have been built here. In 1792, when the West Pier was to be built, a lamp was erected on a post at its proposed termination. In 1803, with the pier complete, a 20ft cast-iron octagonal tower was erected on the end. Designed by William Jernegan and cast at Neath Abbey, it stood on a stone plinth and had a small octagonal lantern. It was lit by candles in 1810, then by oil in 1845. Maintained by Swansea Harbour Commissioners, it was moved to the end of the pier when the pier was extended in 1878.

On display as a floating exhibit at the National Waterfront Museum is the old Helwick Lightship No.91, 104ft in length and built in 1937 by Philip & Son, Dartmouth. It has a hexagonal tower complete with lantern and gallery.

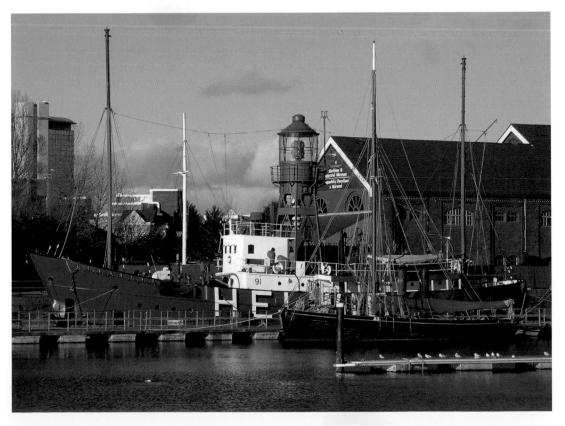

Mumbles

Established	1794
Current tower	1794
Operator	Trinity House
Access	Best viewed from vantage points along the adjacent coastline

In 1909 the pier was again extended and the light replaced by a cast-iron lantern with a domed top, mounted on a wooden platform supported by a wooden trellis. In 1971, the east pier was reconstructed in reinforced concrete and a light, called Swansea East Pier, consisting of a concrete post with a simple light, was erected on the end. Showing a flashing red light, it is visible for 9 miles.

In the early nineteenth century, a 20ft white tower existed on the end of the inner east pier. In 1909 it was replaced when the pier was extended as a breakwater and a light, which still exists, was erected on the end. This consists of a 23ft wooden framework which supports a simple lantern showing a fixed green light visible for 7 miles. These lights are within the dock complex and are difficult to approach, although they can be seen from the outside of the marina.

The first-order Fresnel lens, which was installed at Mumbles Head Lighthouse, was given to the Swansea Transport and Industrial Museum in 1987; it is not on display but stored at the Museum. Between 2002 and 2005 the museum was rebuilt as the National Waterfront Museum and on display as a floating exhibit is the old Helwick Lightship No.91, 104ft in length and built in 1937 by Philip & Son, Dartmouth. It has a hexagonal tower complete with lantern and gallery.

To guide ships past the Mixon Sands and Cherry Stone Rock, where hundreds of ships have been lost, Swansea Harbour Trustees were given a licence to erect a lighthouse on the outer of the two outcrops at Mumbles Head in the late eighteenth century. Work started in 1792 but in October that year the partly constructed lighthouse collapsed.

Plans for a new light by William Jernegan, who also built the Swansea light, were drawn up and in 1794 Trinity House gave the harbour trustees a ninety-nine-year lease on the lighthouse, which was completed later that year. In addition to the tower, a pair of two-storey keepers' houses was built. Two coal-fired lights were proposed, one above the other, to be distinguishable from the two lights at St Anne's Head and the single light at Flatholm. Thus came about the peculiar shape of the 56ft white stone octagonal tower, which is stepped halfway up, with a gallery at each stage.

Keeping two coal fires lit was expensive and so in 1799 a single oil light was fitted, with Argand lamps and reflectors in a cast-iron lantern above the higher of the two galleries. Further improvements were carried out in 1860 when a dioptric light was fitted. In 1905 the lantern was converted to an occulting light and, to produce the flashing light, a hand crank was used to wind a series of weights. These were attached to a lever mechanism that raised and lowered a metal cylinder around the light, but within the Fresnel lens, thus making the light appear to flash. The periods of dark and light could be adjusted to give different light characteristics.

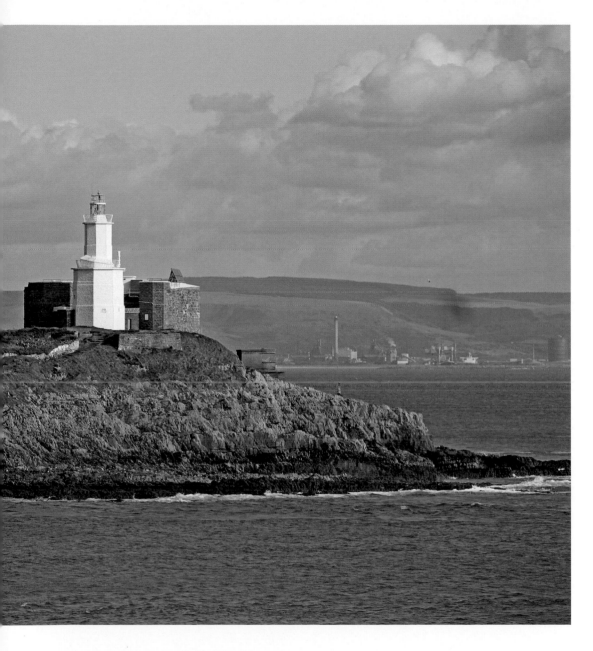

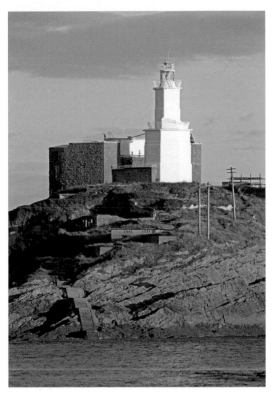

The lighthouse at Mumbles dates from the late eighteenth century and marks the entrance to Swansea Bay.

Further changes were made in 1934, when, on the retirement of the last keeper, the station was modernised and the optic replaced. By 1977 the original cast-iron lantern had deteriorated and was removed. It was superseded in 1987 when the lantern and light from Lightvessel No.25 was transferred to Mumbles. The original first-order Fresnel lens was given to the Swansea Transport and Industrial Museum for display.

In 1995 the station was converted to solar power and the main and emergency lights replaced by a pair of biformed Tideland M300 lanterns powered by quartz halogen lamps, one housed in the lantern room and another above. The group-flashing white light is visible for 16 miles. At the same time, fog detector equipment was installed; the fog signal, with a range of 2 miles, gives three blasts every sixty seconds. Control of the lighthouse was the responsibility of the British Transport Docks Board until Trinity House took over on 1 November 1975.

Between 1859 and 1861 one of Palmerston's forts was built around the tower, but it was decommissioned in 1957. Today, solar panels for the light are fixed to the top of its remains. Also on the island are the ruins of gun emplacements as well as the original keepers' dwellings.

Whitford Point

Established	1854
Current lighthouse built	1866
Operator	Llanelli Harbour Trust
Access	With care, the lighthouse can be visited at low tide by walking across Whitford Burrows

In the nineteenth century, Llanelli was an important port and many ships entering the Loughor Estuary were lost off Whitford Point and its extensive sandbanks. As a consequence, Captain Luckraft, the Llanelli harbour master, designed a wooden lighthouse to be positioned about half a mile north of Whitford Point. Sometimes known as Chwittfford but more correctly as Whitford Point, it was erected in 1854 but so severely damaged by storms the following year that it had to be abandoned. After being repaired in 1857, it was later struck by the vessel *Stark* and extensively damaged.

By 1864 the lighthouse was such a problem that the local commissioners agreed to plans by John Bowen, a local engineer, for a new lighthouse 300 yards to the south. Built by Bennet & Co., it was first lit in November 1866 and consisted of a 44ft ornate tapered cast-iron tower with a gallery and lantern. Its flashing white light was converted to automatic gas operation by the Llanelli Harbour Trust in 1919, after which it was visible for 7 miles. In 1921, the trust built a new lighthouse to the south at Burry Holms, and the Whitford Point Light was extinguished in 1926. The Burry Holms light was itself discontinued in 1939.

The disused cast-iron light at Whitford Point, on the south side of the Loughor Estuary.

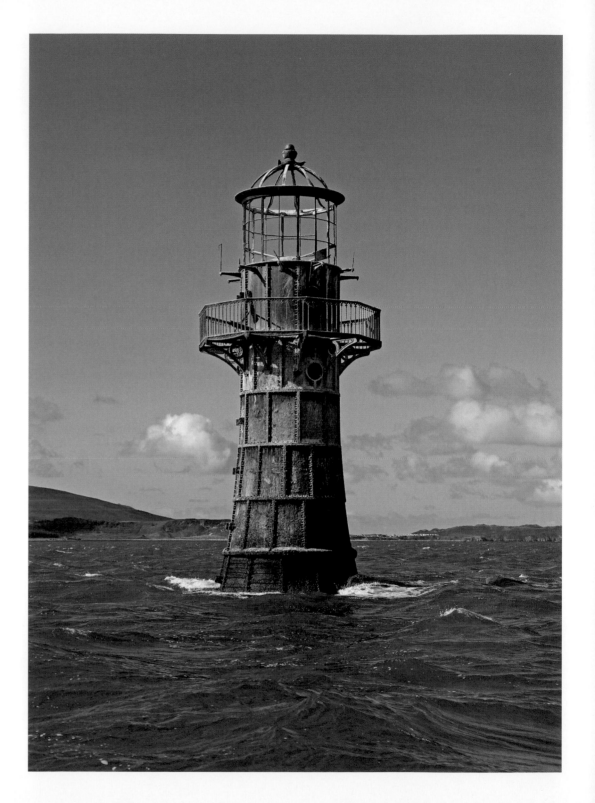

Burry Port

Established	1842
Current lighthouse built	1842
Restored	1996
Operator	Carmarthen County Council
Access	On west side of outer harbour by West Dock, reached via the breakwater

During its operational life, the lighthouse's cast-iron panels kept loosening. Bands were placed round the tower from 1880 onwards and by 1885 it was reported that 150 had been fastened round the cracking plates. The foundation on soft sand also gave concern, and concrete and stones were placed around the base in 1886. Despite these problems and seventy years of disuse, this, the only offshore cast-iron lighthouse in Britain, still exists, having been a listed monument since 1979.

Whitford Point lighthouse is listed by Cadw, the Welsh government's historic environment service, as Grade II, as a rare survival of a wave-swept cast-iron lighthouse in British coastal waters, and an important work of cast-iron architecture and nineteenth-century lighthouse design and construction. It is also a Scheduled Ancient Monument.

The harbour at Burry Port was built between 1830 and 1836 to replace that at Pembrey, 400 yards to the west. In its heyday, Burry Port was the main coal-exporting port for the valleys, but now the dock houses the only marina in Cardiganshire, for which extensive dredging was carried out in 2005. In 1842, Trinity House gave permission for the Burry Port Harbour Authority and Navigation Commissioners to erect and maintain a lighthouse on the end of the west breakwater of the outer harbour.

Sometimes known as Burry Inlet, but more correctly Burry Port, the light consisted of a 24ft white-painted stone tower with a black gallery and red lantern. In 1995–96 the tower was restored by Llanelli Borough Training with the support of the nearby Burry Port Yacht Club, and a light donated by Trinity House was installed. The restored light was formally opened on 9 February 1996 by the Mayor of Llanelli, Councillor David T. James. The current white flashing light is visible for 15 miles.

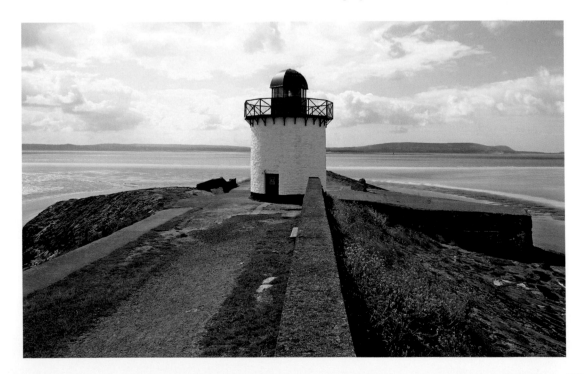

Burry Port lighthouse at the entrance to the dock, which is now home to a small marina, on the north side of the Loughor Estuary.

Saundersfoot

Established	1848
Current lighthouse built	1954
Operator	Saundersfoot Harbour Commissioners
Access	The pier is open to the public

The small picturesque harbour at Saundersfoot was built in the 1840s to export coal and lime. In 1843 the Saundersfoot Harbour Commissioners erected an 11ft circular rubble-stone lighthouse on the end of the south harbour wall. Initially lit by candles, the light was housed in a peculiar lantern made up of iron glazing bars with an arched stone top bolted to the top of the tower. An interesting feature was the use of a tide gauge, which obscured the light when there was insufficient water to enter.

The light was converted to oil in 1861 and discontinued in 1947 following the closure of the local mines. It was relit in 1954, when the harbour was again used, this time by pleasure craft. The old lantern was removed, the top of the lighthouse was rebuilt in rubble stone and a polycarbonate holder showing a flashing red light visible for 7 miles was displayed from the roof. This increased the height to 17ft.

The small light situated at the end of Saundersfoot South Pier.

Caldey Island

Established	1829
Current lighthouse built	1829
Operator	Trinity House
Access	Trip boats from Tenby Harbour take about twenty minutes to reach the island and run from Easter to October, Mondays to Saturdays; the island is closed on Sundays

Although the lighthouse on Caldey Island is in a prominent situation to the south on the highest point, it is the monastery that attracts most visitors. Monks first came to Caldey in the sixth century, and in the twelfth century, Benedictines from nearby St Dogmaels set up a priory on the island, remaining until the Dissolution of 1536. In 1906, pioneering Anglican Benedictines purchased Caldey and built the present abbey, but their stay was relatively short, as financial difficulties forced them to sell in 1925; the present monks are Cistercians.

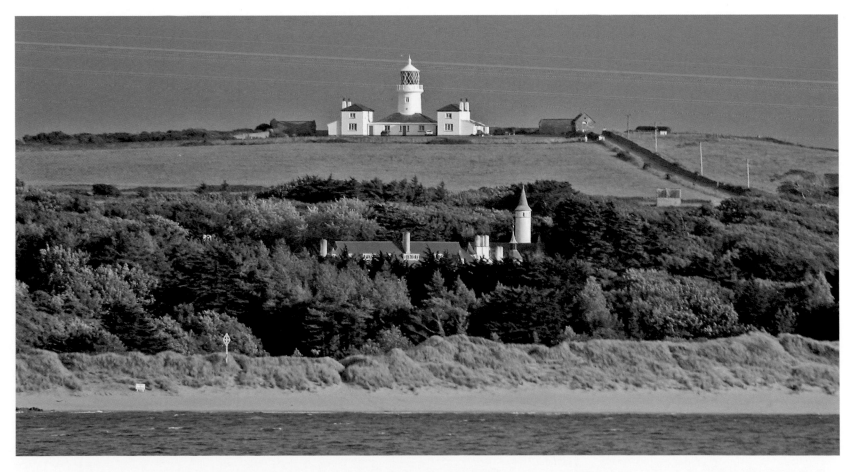

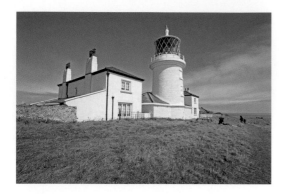

Caldey Island lighthouse with the keepers' dwellings marks the western entrance to Carmarthen Bay and can easily be seen from Tenby.

Milford Haven

Established	1870
Current lighthouse built	1870 and 1970
Operator	Milford Haven Conservancy Board
Access	West Blockhouse and Watwick are approached via Dale and the road to St Ann's Head; turn left into Maryborough Farm road, then right to both locations. East and West Castle Head are approached via the Pembrokeshire Coast Path from St Ishmael's; other lights are located in industrial areas

The lighthouse, sometimes called by its Welsh name Ynys Byr, operates in conjunction with Lundy North and guides ships past St Gowan Shoals to the south-west and Helwick Sands to the south-east. Designed by Joseph Nelson and built by Trinity House in 1829, it consists of a 52ft circular white-painted tower with lantern and gallery. A single-storey service building at its base is attached to a pair of two-storey keepers' dwellings. The light was initially oil powered, but was converted to acetylene in 1927 when the keepers were withdrawn and the cottages sold.

A part-time keeper maintained the light until, in 1997, the lighthouse was modernised and automated and the light source changed to mains electricity. The flashing white light, visible for 13 miles, has two flashing red sectors visible for 9 miles to mark shoals and sands.

Vessels entering Milford Haven pass St Ann's Head before turning into the haven. To mark the channel, a pair of range lights on the north shore at West Castle Hill, 4 miles west of Milford Haven town, was designed by James Douglass and erected by Trinity House in 1870. These lights were eventually handed over to Milford Haven Conservancy Board, which operates them today.

The front range is a 17ft square stone tower without a lantern, situated on the cliff edge with dwellings attached to the rear. Painted white, the tower has a black vertical stripe and the buildings are trimmed with a black cornice. Two lights are displayed, one through a narrow window and a sector light on the roof. One is fixed red, white or green dependent on direction, while the other is a flashing white light. Since 1970, the lights have been

The reinforced concrete towers at West Blockhouse Point display lights marking the entrance to Milford Haven.

St Ann's Head

Established	1714
Current lighthouse built	1841
Operator	Trinity House
Access	On Pembrokeshire Coast National Park; also accessible by road

sealed-beam units, visible for 14 miles, mounted on the roof alongside a radar antenna.

The rear range, 170 yards behind on the ramparts of an Iron Age fort, was a 42ft square tower of similar design without a lantern. The flashing white light, visible for 16 miles, was shown through a window, but was discontinued in 1970 when new aids to navigation were erected in the area. In order not to obscure the new rear range light, the tower was reduced to 21ft.

The improvements carried out involved the erection of three new reinforced-concrete towers, designed by Posford Pavry, with sealed-beam units, two near Dale at West Blockhouse Point and Watwick Point, with the third at East Castle Head. This was the new East Castle Rear Range light, which replaced the old West Castle Head Rear Range light and worked in conjunction with the front range to mark the safe channel.

The light, three quarters of a mile from the original one, is a circular 85ft white tower with a large board containing a vertical black band and two lines of solar panels near the top. The sealed-beam light units mounted on a gallery on top of the tower give an occulting white light visible for 15 miles. These lights are somewhat off the beaten track and access is easiest from the Pembrokeshire Coast Path via St Ishmael's, Sandy Haven and a gated footpath.

St Ann's Head is the oldest lighthouse on the Welsh coast and stands on the western side of the entrance to Milford Haven, one of Britain's finest deep-water harbours which is used by tankers. The approach to the port can be hazardous, with dangerous reefs, situated almost mid-channel and in two groups, having to be negotiated. One of the greatest dangers, 7 miles south-east of St Ann's Head, is the Crow Rock and Toes off Linney Head, a reef which has claimed many vessels. In addition to providing guidance for vessels using the Haven, the lighthouse is an important mark for passing coastal traffic, warning of the offshore dangers. The first attempts to provide a light for the area were made in 1662, when Trinity House

St Ann's Head lighthouse stands at the entrance to Milford Haven waterway, one of Britain's deep water harbours. It was built in 1844, replacing two leading lights established in 1714.

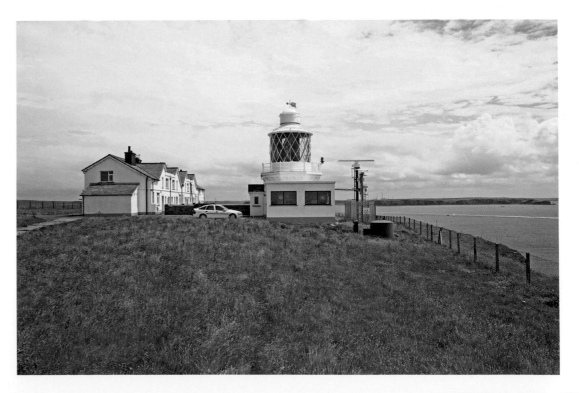

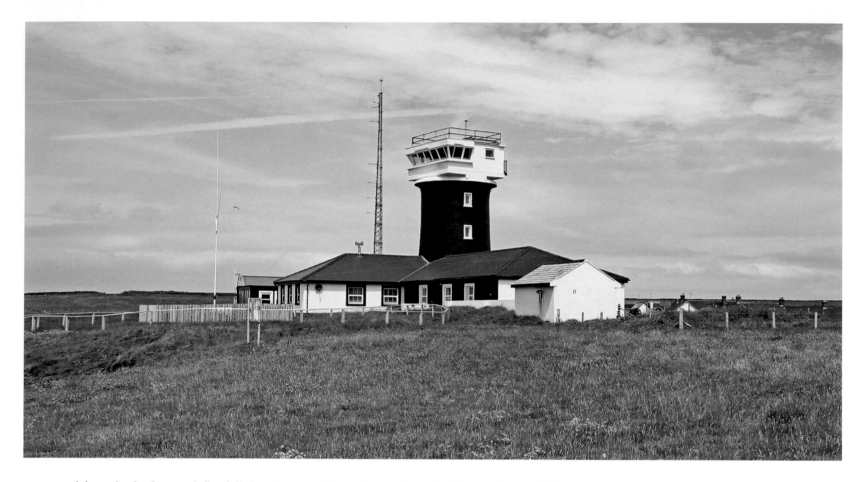

approved in principal a coal-fired light at St Ann's Head, supported by voluntary payment of dues, to guide Milford-bound shipping. However, the owners extracted dues illegally from shipowners and the light, then the only one on the west coast, was ordered to be extinguished by Parliament in 1668, a somewhat extreme measure given the lack of any other lights on the coast. Drawings suggest that this tower formed the western tower of a destroyed chapel, which is said to have commemorated the landing of Henry Tudor in the Haven in 1485 to claim the English throne.

Forty years passed before another light was established, although the local merchants petitioned many times for lights to be provided throughout the period. However, not until 15 March 1713 was a patent granted to Trinity House to build a lighthouse at St Ann's Head. Following its policy of the time, Trinity House leased the patent to the owner of the land, Joseph Allen, for ninety-nine years at an annual rent of £10. Allen agreed to build two lighthouses and keep them in good repair. To fund the lights, he was permitted to collect dues from the shipmasters at Milford Haven amounting to one penny per ton of cargo on British vessels and two pence on foreign vessels.

Allen established two towers near the old disused lighthouse and coal fires were lit on

The disused lighthouse at St Ann's Head dates from 1714; the lantern room has been converted into an observation gallery. The former lighthouse has been converted into a five-bedroom property with a three-bedroom annex.

them for the first time on 24 June 1714, before the lease was actually signed, highlighting the urgency of the matter. The use of two lights was to distinguish St Ann's from the single light at St Agnes in the Isles of Scilly. The high light was a 75ft white-painted tapered masonry tower with a single-storey keepers' building attached, and the light was visible for 20 miles. In 1800, Trinity House organised the installation of reflected Argand lamps mounted in lanterns, the

Skokholm Island

Established	1916
Current lighthouse built	1916
Automated	1983
Operator	Trinity House
Access	Overnight accommodation available at the observatory; island only accessible by boat

£600 cost of which was repaid out of the light dues. The Brethren also managed the lights at a charge of £140 per annum.

The front or lower light was rebuilt in 1841, when cliff erosion endangered the old tower. The new 42ft octagonal masonry tower with lantern and gallery, attached to a two-storey keepers' house, was situated 30ft from the cliff edge and this serves as the present lighthouse. When the rear light was discontinued in 1910, a Matthews burner was installed in the front light, and in 1958 the station was converted to mains electricity with generators for standby. The lantern in the discontinued light was removed early in the Second World War and the room was converted into an observation room.

The automation of the lighthouse was completed on 17 June 1998, when the keepers were withdrawn. The white and red light flashes every five seconds, with the white light having a range of 18 nautical miles and the red 17 miles. An area control station between 1983 and 1998, St Ann's was manned by four keepers and supported helicopter operations to the offshore lighthouses of the Smalls, Skokholm and South Bishop after their automation. Although unmanned, the lighthouse remains an operating base for Trinity House's maintenance teams. The light station is now used for holiday accommodation.

The small island of Skokholm lies just off the Pembrokeshire coast and the lighthouse is situated on its south-west point. The island's high cliffs rise sheer from the sea to well over 100ft in places and it is a renowned seabird sanctuary. The lighthouse makes up the landward corner of a triangle of lights with South Bishop and the Smalls, guiding ships clear of a treacherous stretch of coastline into Milford Haven or up the Bristol Channel.

The station was built during the First World War to the design of Sir Thomas Matthews and its light was first displayed in 1916. The white-painted brick, hexagonal masonry tower, 58ft in height, is adjacent to two-storey keepers' buildings. Before the lighthouse could be built, a

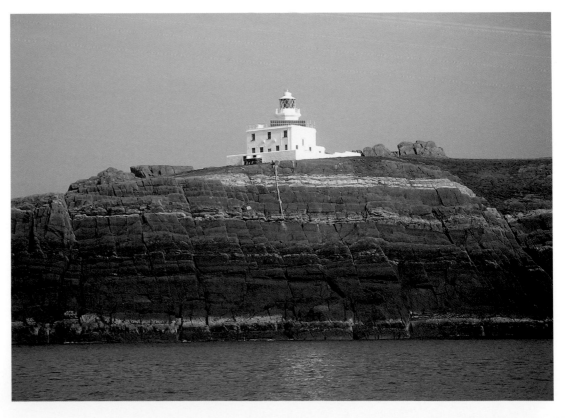

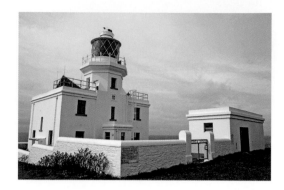
Skokholm lighthouse is situated on the south-western point of the island which also has Britain's oldest bird observatory. (David Wilkinson)

jetty had to be constructed on the island so that building materials could be landed safely.

Once the work had been completed, the jetty was used for landing stores and supplies, which were taken the mile to the lighthouse on two small trucks running on a narrow-gauge railway. The trucks were originally pulled by a not always cooperative donkey, which was subsequently replaced by a tractor. When the station was manned, relief was by tender from Holyhead, but now it is serviced by helicopter.

The lighthouse was automated in 1983 and the light, visible for 20 miles, flashes every ten seconds, white or red depending on the direction. Although keepers no longer live at the lighthouse, Skokholm, which is Britain's oldest bird observatory, is visited by ornithologists from all over the world to enjoy the great variety of birdlife for which the island is famous.

Smalls

Established	1776
Current lighthouse built	1861
Automated	1987
Operator	Trinity House
Access	Accessible only by boat or helicopter

The Smalls is one of Trinity House's more remote offshore lighthouses and has an unusual and intriguing history. The rock on which the lighthouse stands, situated about 21 miles west of St David's Head, is one of two tiny clusters of rocks lying close together in the Irish Sea, the highest of which projects only 12ft above the highest tides.

For more than two centuries a lighthouse on the Smalls has warned passing ships of the rock's dangers, with the first lighthouse erected there in 1776. The plans for this lighthouse

The elegant nineteenth-century circular stone lighthouse on the Smalls when painted with red and white bands, which were removed in 1997.

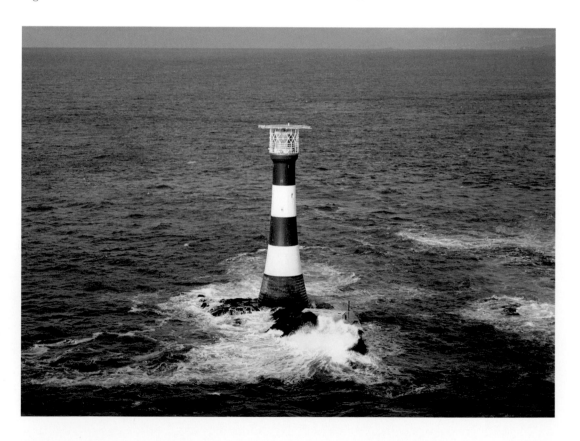

were made by Welshman John Phillips, an assistant dock manager at Liverpool and agent for the Skerries lighthouse. He advertised for a tower design and selected that proposed by Henry Whiteside, a musical instrument maker from Liverpool who, in 1772, designed a model for the Skerries tower, although what became of this is not known.

Whiteside's design for the Smalls consisted of an octagonal timber house or hut perched atop nine legs or pillars, five of wood and three of cast iron, spaced around a central timber post, allowing the sea to pass beneath. The whole structure was 66ft in height and 17ft in diameter. The keepers' living accommodation was at the top, just below the lantern.

A group of Welsh miners was employed to dig the foundations and undertake much of the construction work, although progress was initially slow because of bad weather during the winter of 1775–76 and the exposed nature of the Smalls. While postholes were being dug at the rock itself, the tower was built on the mainland at Solva, a small harbour on the mainland 25 miles away. In spring 1776,

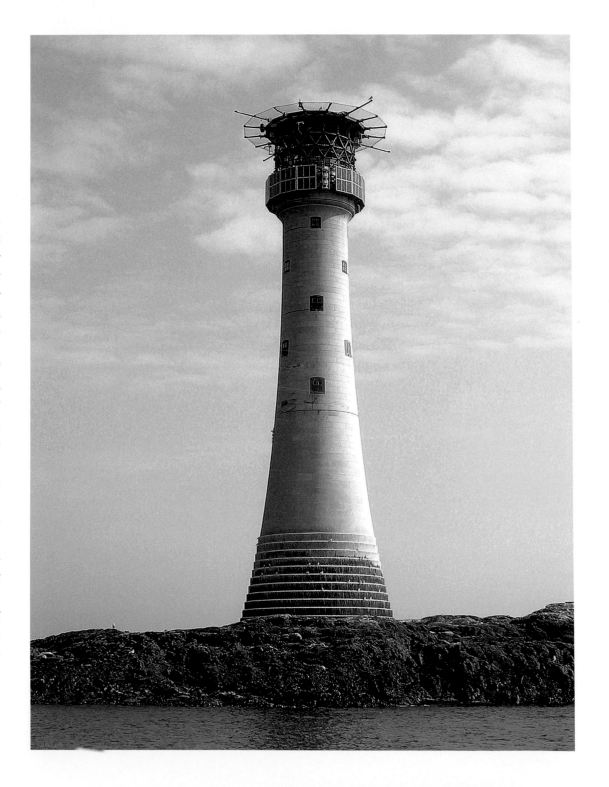

The Smalls, with the solar panels mounted near the lantern added since automation in the 1986, remains one of the most important aids to navigation. (Mat Jackson)

South Bishop

Established	1839
Current lighthouse built	1839
Automated	1983
Operator	Trinity House
Access	Can only be viewed by boat

as a result of the preliminary assembly work during which the parts had been fitted together, the whole structure was brought to the rock for assembly.

By September 1776, the oil lamps were lit, but Whiteside's tower was not strong enough to cope with the conditions on the rock and had to be abandoned in January 1778 after a series of storms. The repairs and alterations needed after the storms could not be carried out, as Phillips had no funds, and so he withdrew the keepers and workmen, extinguished the light and abandoned the scheme. He then handed over his interest to a group of Liverpool merchants who, realising the importance of the light, persuaded Trinity House to take it over.

The Brethren obtained an Act of Parliament in 1778 which authorised the repair and maintenance of the light and the collection and levying of dues. Phillips was then granted a lease on 3 June 1778 for ninety-nine years at a rent of £5. The tower was reinforced and relit in September 1778 and remained in operation until 1861, when it was replaced. It suffered considerable damage a number of times and had to be strengthened. Trinity House bought the lease in 1836 for £170,468.

The light is supposedly the scene of a tragic episode which occurred around 1800 and involved two lighthouse keepers, Howell and Griffith. Apparently, Howell unexpectedly died one night and Griffith, fearing that he might be suspected of murder if he committed the body to the deep, put it into a coffin which he made from the interior woodwork of the house and lashed to the lantern rail outside. Passing ships noted this strange object, but raised no alarm before the usual relief boat arrived. The story suggests that storms prevented a landing at the rock, and by the time the usual service boat arrived, several months later, Griffith had been driven mad. After this, three keepers were always appointed to lighthouse teams.

The present lighthouse, 141ft tall, was built under the supervision of Trinity House's then Chief Engineer, James Douglass, to a Walker design based on Smeaton's Eddystone tower. The circular stone tower took just two years to build, a considerable feat, and was completed in 1861. It was painted red and white to distinguish it from other similar towers, but in June 1997 the stripes were no longer considered necessary for navigation and so the tower was grit blasted back to natural granite. Various improvements were made during the 1960s and a concrete helipad was built over the station's water and oil tanks. This was replaced in 1978 by an elevated helipad constructed above the lantern, and the lighthouse was automated in 1987.

The rocky outcrop of South Bishop, also known as Emsger, is situated in St George's Channel, almost 5 miles south-west of St David's Head. The lighthouse operates mainly as a waymark for vessels navigating offshore and marks the northern entrance to St Bride's Bay. It also acts as a guide for vessels navigating around the Bishops and Clerks group of rocks, of which South Bishop is the largest and most southerly.

The lighthouse dates from the 1830s, when an application for a light at South Bishop was first made to Trinity House in 1831 on behalf of shipping interests trading to Cardigan. Another application was made in 1834 on behalf of those using the port of Bristol and St George's

(Right) The isolated lighthouse on South Bishop in St George's Channel. (Courtesy of Trinity House)

(Below) An old postcard of South Bishop lighthouse, before it was converted to electric operation in 1959.

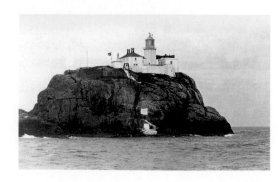

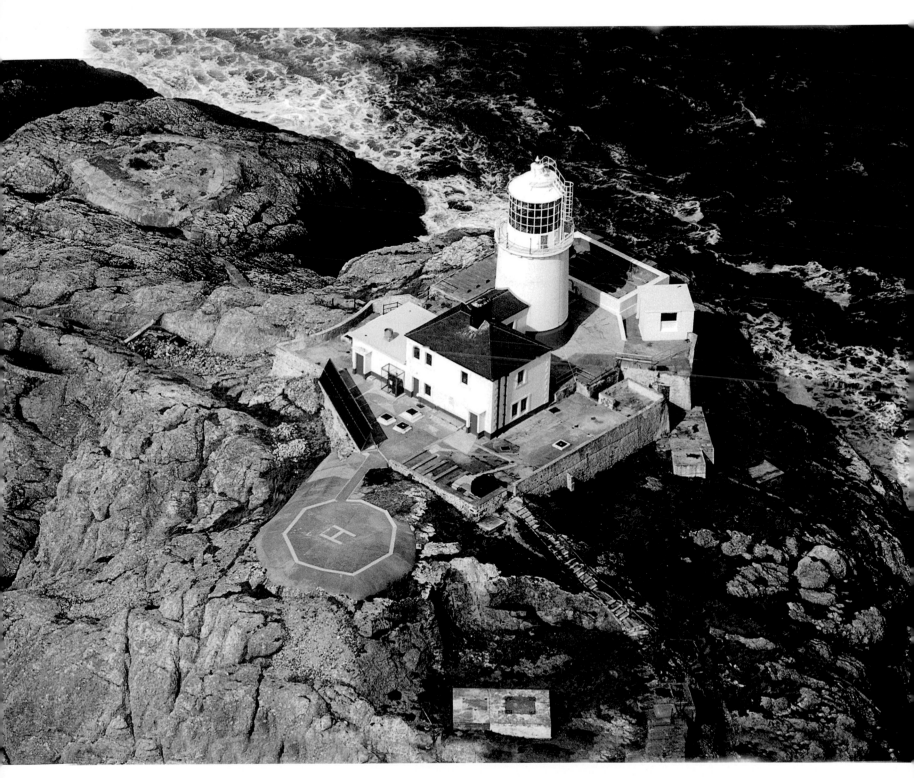

Strumble Head

Established	1908
Current lighthouse built	1908
Automated	1980
Operator	Trinity House
Access	The island itself is not open, but the lighthouse can easily be seen from the coast path

Channel, but a further five years passed before a light was constructed. Designed by James Walker, the 36ft white-painted brick tower was completed and lit for the first time in 1839.

The lighthouse has a lantern and gallery attached to a single-storey keepers' house, which was intended for two families. However, it is doubtful if anyone other than the keepers lived on the rock, which is so exposed that the seas sometimes flood the courtyard and break lower windows. In 1971 a helipad was constructed on the island, but the pad was very exposed and often flooded in high tides and heavy seas, and so landing was not always practicable. Before helicopters, the keepers, and their supplies, were landed by tender and had to climb steps cut into the sheer rock face. The light was converted to electric operation in 1959, and automated and de-manned in 1983. The current light, which is white, flashes every five seconds and has a range of 19 miles.

South Bishop lighthouse stands on the route of migrating birds which, attracted by the light's rays, flew into the lantern's glass panels. Many were killed and so, to reduce the dangers posed by the light, Trinity House, in conjunction with the Royal Society for the Protection of Birds, built special bird perches on the lantern for use during the migrating season. This has considerably reduced the mortality rate.

With the completion in 1905 of the new North Breakwater at Fishguard, Trinity House looked at the aids to navigation required to safeguard shipping entering and leaving Cardigan Bay, particularly as steamers to Ireland were on the increase after the harbour opened in 1906 and Rosslare Harbour was developed on the Irish side. They chose to build a lighthouse on the rocky outcrop called Ynys Meicel, or St Michael's Island, situated off the headland of Strumble Head. Completed in 1908, the light was designed to work in conjunction with South Bishop, 5 miles off St David's Head in St George's Channel.

A narrow footbridge was built to connect the island to the mainland, but even then the rocky outcrop made the building of the lighthouse as difficult as it would have been for a true offshore station. In order to get equipment across the gap and to the top of the outcrop, the builders constructed a jackstay cable between two winches, one on the headland and one adjacent to the lighthouse. This method is no longer used and all of the associated equipment has been dismantled and removed. Heavy items are now brought to the station by helicopter. Another unusual feature is that one handrail on the

bridge doubled as a pipe carrying oil into the tower's basement.

The lighthouse consists of a 56ft white circular stone tower complete with gallery and lantern. A pair of white stone flat-roofed keepers' dwellings is attached to the tower on the seaward side. To one side is a white single-storey flat-roofed service building built in 1967 to house a foghorn which replaced an earlier explosive fog signal. The charges for this signal

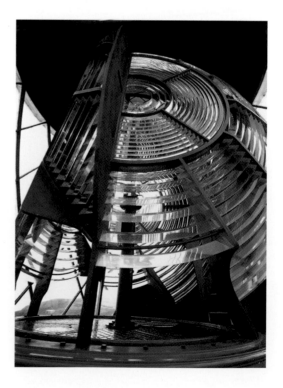

The lens in Strumble Head lighthouse.

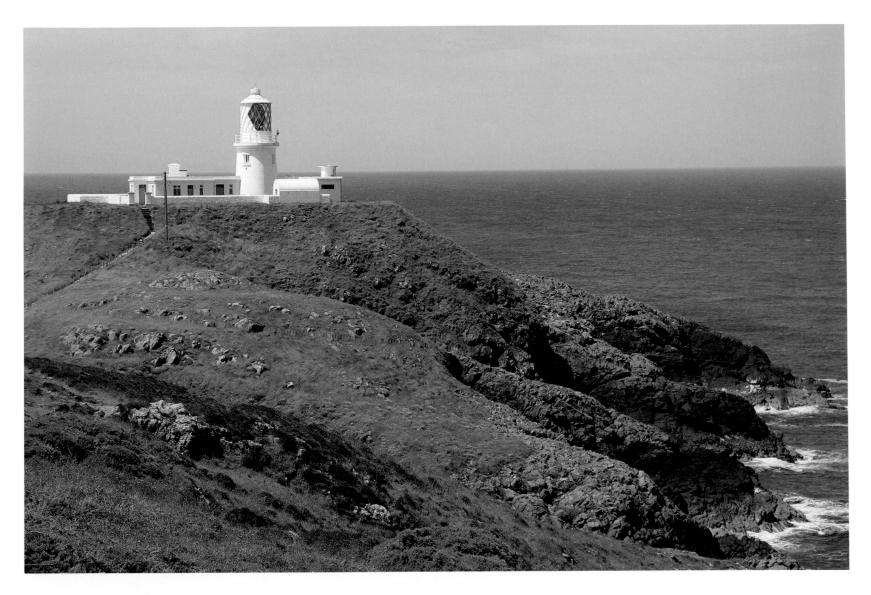

were kept in a wood-lined white stone service building which can still be seen. It was originally classified as a rock station.

The original light source was paraffin, with a large mechanically driven revolving lens system weighing 4½ tons and supported on a bed of mercury, showing a flashing white light. A massive clockwork mechanism rotated it, driven by a quarter-ton weight which,

suspended on a cable, dropped gradually down a cylinder running from top to bottom through the tower. The drive had to be rewound every twelve hours.

The light was converted to electricity in 1965, and the first-order catadioptric unit produces a flashing white light visible for 26 miles. The light was fully automated in 1980 and is now controlled from the Control Centre at Harwich.

Strumble Head lighthouse is situated about 3 miles north-west of the port of Fishguard.

Fishguard

Established	1913
Current lighthouse built	1913
Operator	Stena Line
Access	North breakwater is not accessible; access to east breakwater is on the roundabout at Parrog adjacent to the ferry terminal entrance

In the early years of the twentieth century an ambitious plan was formulated to construct a harbour at Fishguard which would rival Southampton and Liverpool and thus accommodate ocean-going liners. In 1905 the Great Western Railway constructed not only a railway terminal at Goodwick, just to the west of Fishguard, but also a fine 800-yard long stone breakwater out from Pen Cw, or the Cow and Calf, to enclose a huge area of water to the north-west of the old harbour at Lower Fishguard.

A year later, on 30 August 1906, the first ferry to Rosslare set sail from the harbour and in 1909 the liner *Mauritania* stopped on her voyage from Liverpool to New York. She was unable to dock due to lack of water depth but passengers were ferried off by boat and a carnival procession took place in the town.

When the North Breakwater was built, a substantial lighthouse was constructed on the end, consisting of an octagonal 46ft stone tower with a double gallery and single lantern. The tower was reduced in width at each gallery. The area below the lower gallery remains its natural stone colour, but the area above and the domed lantern are painted white. For such a fine lighthouse, surprisingly little is known about its history and today its flashing green light, visible for 13 miles, is powered by electricity with solar panels nearby.

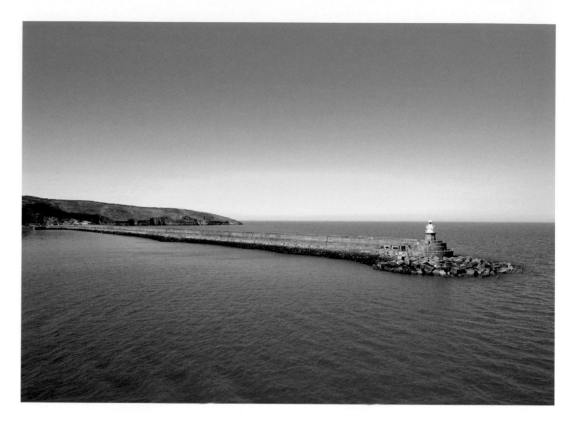

(Above) The lighthouse at the end of the North Breakwater, a 900m-long structure completed in the early 1900s, marks the entrance to Fishguard.

(Left) The small light marking the East Breakwater in Fishguard Harbour.

The East Breakwater itself was built about 1913 and it is likely that the light on the end is of the same date. This light consists of a 36ft open lattice steel tower which supports a small solar-powered red flashing light, visible for 10 miles. The solar panels are mounted to each side of the light. On the hillside above the ferry terminal is a pair of white triangular range marks, each of which has a small, fixed green range light, visible for 5 miles. These range lights originally marked an Admiralty mooring buoy to the north-north-east of the North Breakwater light, but this was removed in about 1990. The range lights remain as aids to navigation. An electric-powered compressed-air foghorn is sited approximately a mile to the north-west at Pen Anglas point.

New Quay

Established	1839
Current tower	Not in existence
Operator	Harbour Trustees
Access	The site is open to public and is on the end of the pier

In the eighteenth and nineteenth centuries, the resort of New Quay in Cardiganshire, not to be confused with Newquay in Cornwall, was a bustling fishing port. In order to improve the anchorage, several proposals were put to the harbour authorities for a larger pier or breakwater. In 1820 the engineer John Rennie proposed a breakwater and pier to enclose a large area of sea, but his scheme proved too expensive. Instead, a smaller breakwater, completed in 1835, was commissioned from Daniel Beynon.

In 1839, a 30ft tapered circular tower, operated by the Harbour Trustees and made of rough stone, was erected on the end. The white-painted tower did not have a lantern as such and the fixed white light, visible for 6 miles, was displayed through a window in the red-domed top. In 1859 a violent storm swept away the end of the pier as well as its lighthouse. Both pier and lighthouse were rebuilt and the light continued to shine until 28 February 1937, when it was again washed away.

With trade in decline and the harbour silting up, it was decided not to rebuild the light, which had become known as the Pepper Pot. It was replaced by a polycarbonate navigation light on a wooden post, which carries a plaque as a memorial to those lost in the two world wars. In 2017 a campaign was started to get the lighthouse rebuilt, with plans also including the restoration of the pier.

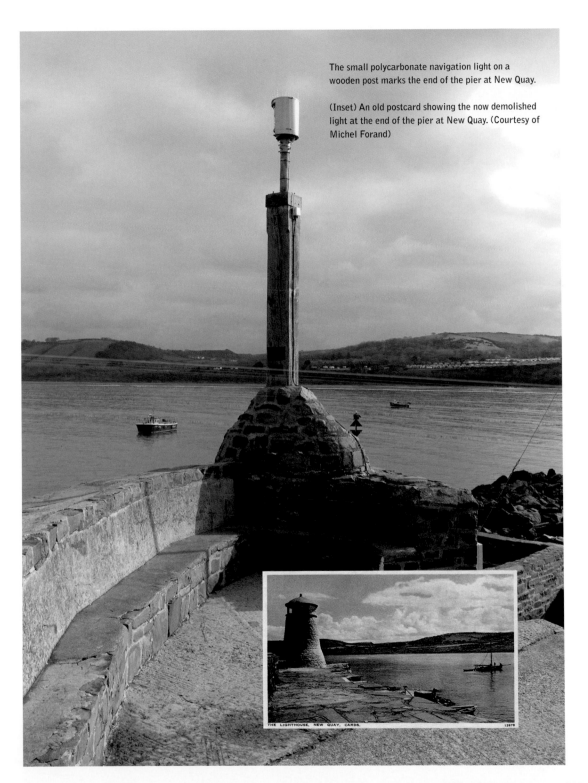

The small polycarbonate navigation light on a wooden post marks the end of the pier at New Quay.

(Inset) An old postcard showing the now demolished light at the end of the pier at New Quay. (Courtesy of Michel Forand)

THE LIGHTHOUSE, NEW QUAY, CARDS.

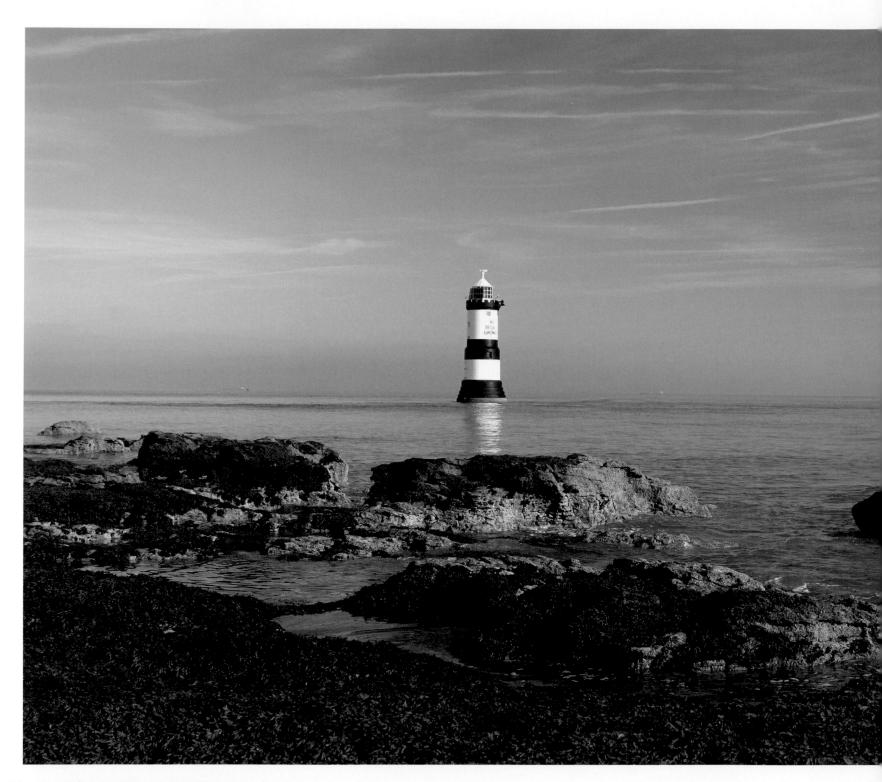

11 NORTH WALES

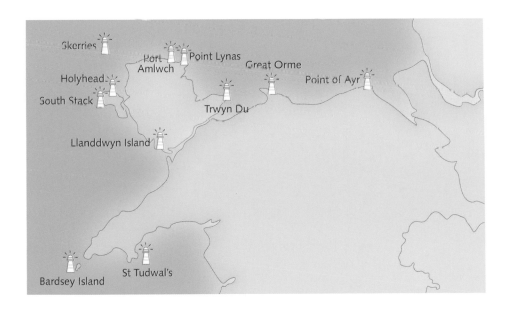

St Tudwal's Island

Established	1877
Automated	1995
Operator	Trinity House
Access	Landings are not allowed on the island and so the light can only be seen from the sea

St Tudwal's lighthouse is situated on St Tudwal's Island West, one of two small islands in Tremadog Bay on the southern side of the Llŷn Peninsula. According to tradition, the island is named after the saint who lived there in the sixth century. The light was established to assist the schooners that carried general cargo and slate from the quarries of North Wales at a time when such trade was commonplace. It was needed because Bardsey light to the west

The small lighthouse on St Tudwal's Island, 151ft above high water, has been operational since 1877. The island is about 3 miles south-east of the village of Abersoch on the Llŷn Peninsula and is privately owned.

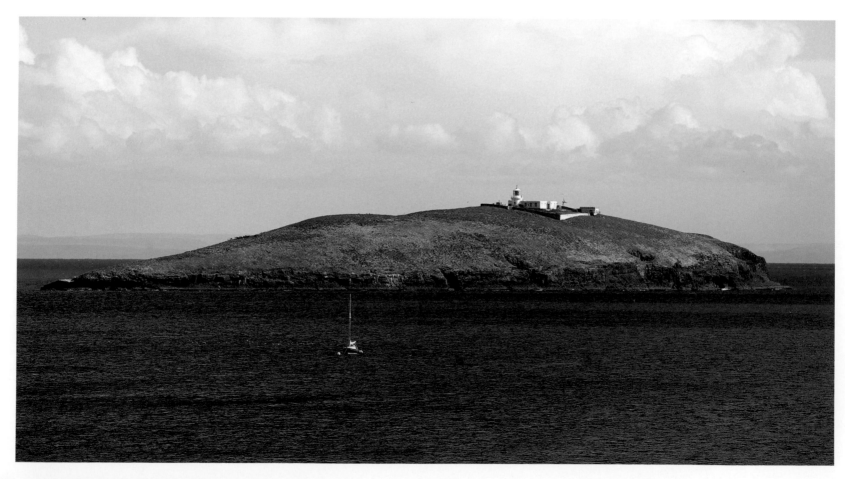

Bardsey Island

Established	1821
Automated	1987
Operator	Trinity House
Access	Bardsey is part of a national nature reserve and is only accessible by passenger ferry from Porth Meudwy; several cottages are available for overnight accommodation but the light itself, at Pen Diban, is accessible by walking the island from the ferry landing site

was obscured from some directions to ships traversing the west side of Tremadog Bay.

The site for the lighthouse was purchased by Trinity House in 1876 for £111. A 36ft cylindrical masonry tower, with lantern, gallery and single-storey keepers' dwellings, was completed the following year to the design of James Nicholas Douglass. The light displays one white and one red flash every twenty seconds; the white light has a range of 14 miles and the red light 10 miles.

The light is most notable for its conversion to acetylene operation in 1922 and subsequent operation by means of a sun valve. This mechanism, invented by the Swedish lighthouse engineer Gustaf Dalén, consisted of an arrangement of reflective gold-plated copper bars supporting a suspended black rod; when lit by the sun during hours of daylight, the black rod absorbed the direct heat which reflected from the other bars and expanded downwards, thereby cutting off the supply of gas.

Following the introduction of the acetylene equipment, the lighthouse was de-manned and the keepers' dwellings next to the tower were sold in 1935 as a private residence. The lighthouse was modernised and converted to solar-powered operation in 1995. The lighthouse keepers' cottages are now privately owned and used as a holiday home.

The impressive lighthouse on Bardsey Island marks the northern entrance to Cardigan Bay.

The small island of Bardsey, separated from the mainland by Bardsey Sound, was a place of ancient pilgrimage known as 'the island of 20,000 saints', with a journey there regarded as the equivalent of one to Rome. However, the Welsh name for the island, Ynys Enlli, means 'island of the tides'; as it is situated at the end of the Llŷn Peninsula, opposing currents can create boiling seas in the sound with the often

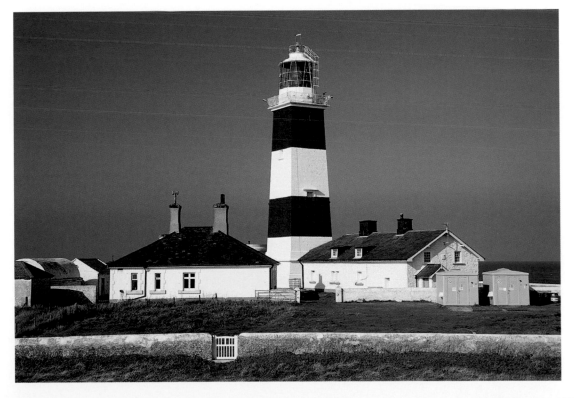

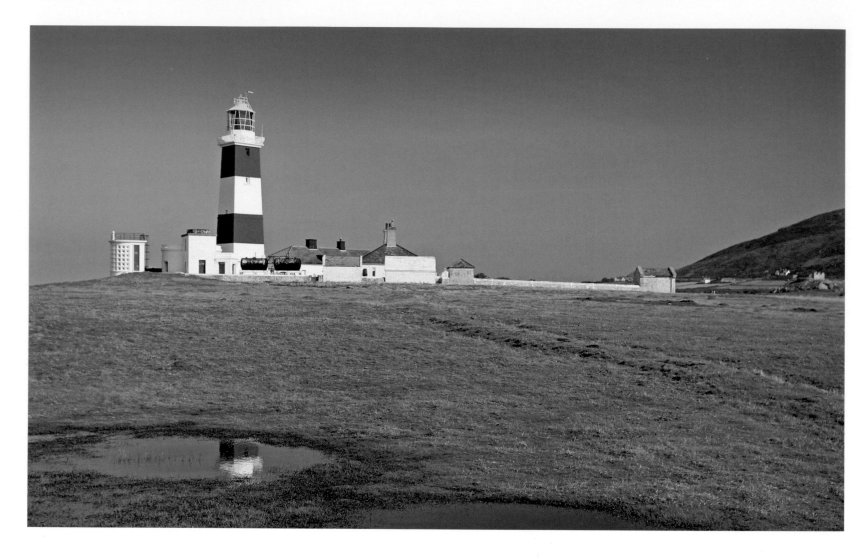

dangerous combination of wind over tide making navigation hazardous.

The 2-mile-long island is surrounded by outcrops of sharp rocks, and the lighthouse, on the southerly tip where the land is flat, guides vessels through St George's Channel and the Irish Sea. The 99ft tower and single-storey keepers' houses were erected by Trinity House under the supervision of Joseph Nelson in 1821. The tower cost £5,470 12s 6d, with a further £2,950 16s 7d for the lantern which, in 1910,

was raised to increase its range. Following this change, the Cardigan Bay lightvessel to the south was removed. The lighthouse tower, unusual in being square in plan, is striped in red and white bands. The white light has a range of 26 miles.

In 1965 the lighthouse was electrified; in 1987 it was converted to automatic operation and until 1995 was monitored from the Trinity House Area Control Station at Holyhead, but it is now monitored from Harwich. A local part-time attendant carries out routine maintenance.

Bardsey lighthouse stands on the southerly tip of Bardsey Island, off the Llŷn Peninsula in Gwynedd, and guides vessels passing through St George's Channel and the Irish Sea.

Llanddwyn Island

Established	1845
Current light established	1975
Automated	1987
Operator	Trinity House
Access	Within the Llanddwyn Island National Nature Reserve; the nearby pilot house contains a small display of local history

Llanddwyn Island is more of a peninsula than an island, except at the highest tides. It is situated on the south shore of Anglesey, about 3 miles west of the southern entrance to the Menai Strait. At the southern tip of the peninsula, a short distance east of the active beacon, is the original lighthouse, which was built in 1845 at a cost of £250 7s 6d and first exhibited a light on 1 January 1846.

The white-painted circular 36ft tower has a conical slate roof with living quarters within the tower, and is similar in appearance to several Anglesey windmills. It displayed a lantern from the window until 1975, when the light, which was visible for 7 miles, became redundant. The optic consisted of a silver-plated reflector and Fresnel lens and was originally lit by six Argand lamps with reflectors.

On the extreme seaward perimeter of the island, south-east of the 1845 tower, is a tall white-painted conical tower, built between 1800 and 1818, made of rough stone and with a domed top, that may have originally been used as a daymark. It has a directional navigation light on the top which was placed there in 1975 and is currently operated by Trinity House.

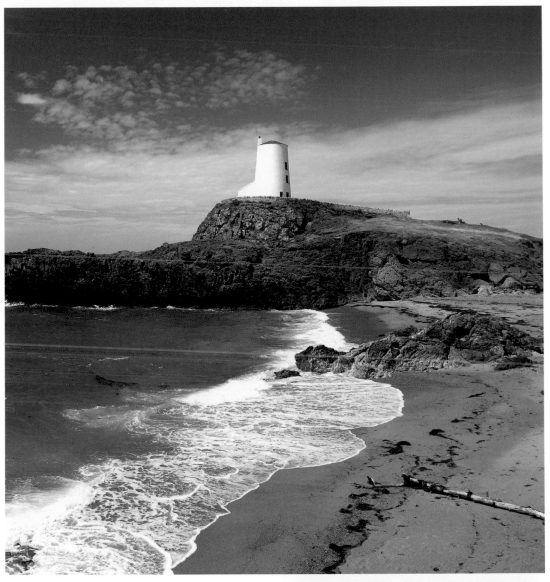

(Above) The tower of 1845 at Llanddwyn Island displayed a light until 1975 and today serves as a daymark.

(Right) The tower on Llanddwyn Island which supports a small directional navigation light.

South Stack

Established	1809
Automated	1984
Operator	Trinity House
Access	Visitor centre nearby and tower open to guided tours, April to September daily

The South Stack Rock is separated from Holy Island, on the north-west coast of Anglesey, by 100ft of chaotic seas, and forms a significant danger to shipping using Holyhead Harbour. A lighthouse to mark the rock was first proposed in 1665, when a petition for a patent to erect a light was presented to Charles II; this was not granted. Almost 150 years later, on 9 February 1809, the lighthouse, built at a cost of £12,000 to the design of Daniel Alexander, first showed a light. The 92ft white-painted stone tower, with a single-storey keepers' quarters and service building attached, was originally fitted with Argand oil lamps and reflectors.

Around 1840, a railway was installed, which enabled a lantern with a subsidiary light to be lowered down the cliff to sea level when fog obscured the main light. In the mid 1870s the

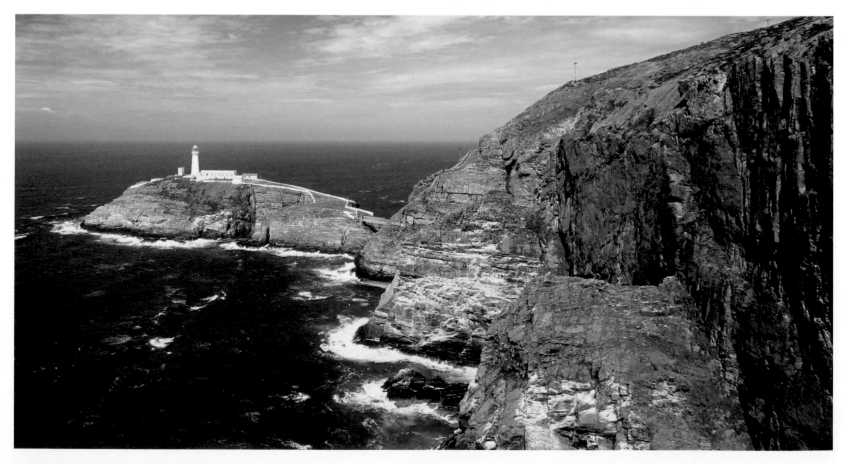

lantern and lighting apparatus were replaced by a new lantern, and in 1909 an early form of incandescent light was installed. In 1927, this was replaced by a more modern incandescent mantle burner. The station was electrified in 1938 and automated on 12 September 1984, when the keepers were withdrawn.

Various methods of crossing the chasm between the mainland and the rock have been employed, starting with a hempen cable along which a sliding basket, carrying a person or stores, was drawn. This was replaced in 1828 by an iron suspension bridge, and then in 1964 by an aluminium bridge. The present footbridge, completed in mid 1997, was funded largely by the Welsh Development Agency. With the completion of the footbridge, the island and lighthouse were reopened to visitors after thirteen years of closure.

The station is a Trinity House Visitor Centre, the only one in Wales, and this was newly reopened in 2017 offering tours of the former lighthouse engine room and the chance to climb to the top of the lighthouse.

(Left) South Stack lighthouse, sited on the summit of a small island off the north-west of Holy Island.

(Right) South Stack lighthouse seen from the sea, with the fog signal in front of the tower.

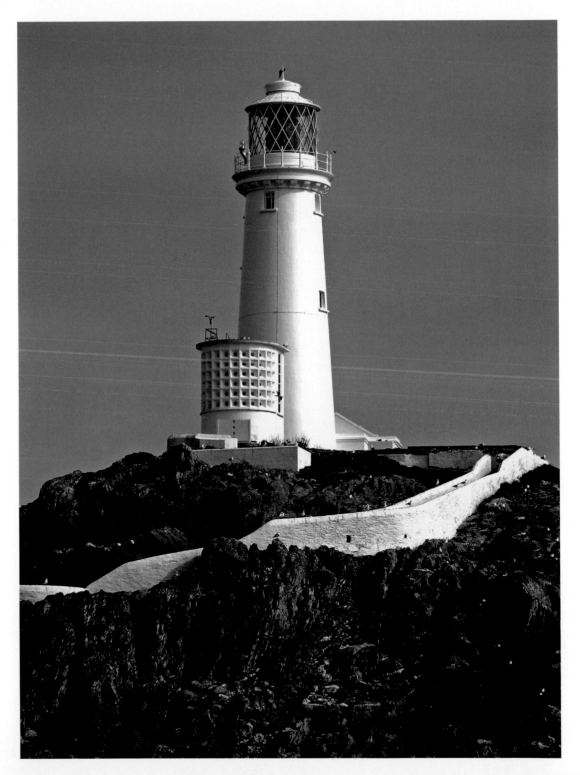

Holyhead Admiralty Pier

Established	1821
Automated	1821
Operator	Stena Line
Access	The pier is in port operator Stena Line's area and access is restricted, but the light can be seen from the fish dock pier

Until the early 1800s, vessels at Holyhead moored in the creek beyond Salt Island, and although a lighthouse was built to guide them, little is known about it. By 1821, work had commenced on what is now the inner harbour while the Admiralty or Mail Pier was built out from Salt Island. In the same year, John Rennie replaced the old lighthouse with the one that stands today on the end of this pier. He constructed a similar lighthouse on the pier at Howth, the mail terminal for Dublin.

The Holyhead light consisted of a 48ft tapered stone tower with a gallery and lantern. The iron railings around the gallery were ornate and the lantern, with a copper-domed roof, was made up of four tiers of lightly glazed panels. When the outer harbour was completed in 1873, this light, often referred to as Holyhead Mail Pier Light, or Salt Island Light, was subsidiary to the new breakwater light and was reduced to a signal light. Originally showing a white light visible for a mile, it later showed a red light.

At one time, two signal lights mounted on a pole were displayed above the lantern and these showed a white light when the inner harbour was open and a red light when it was closed. These lights have been removed and the lantern now shows lights in the configuration shown on the pole.

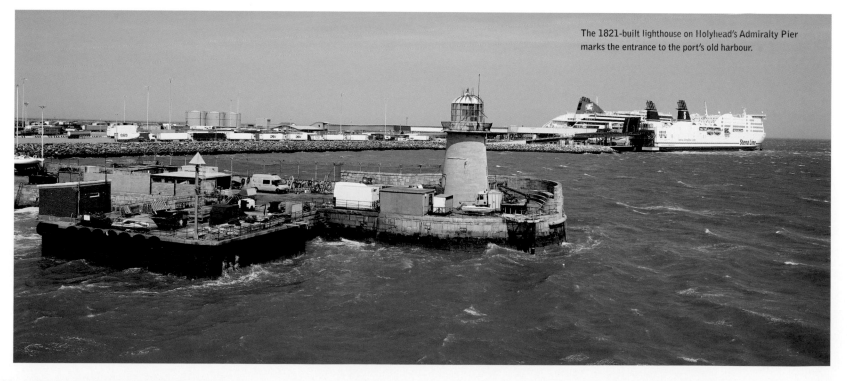

The 1821-built lighthouse on Holyhead's Admiralty Pier marks the entrance to the port's old harbour.

Holyhead Breakwater

Established	1873
Automated	1873
Operator	Stena Line
Access	Access to the breakwater on foot is possible, but only in fine weather

Holyhead Port, which now caters for ferry traffic to Ireland, was developed in the nineteenth century. Building the huge breakwater, which at 1.87 miles long is the UK's longest such structure, took twenty-eight years from 1845 to 1873, with an average of 1,300 men employed on the project using limestone blocks from Anglesey's eastern coast. Situated at the north-western end of the town, the breakwater was topped by a promenade leading from Soldier's Point and culminating in an impressive lighthouse. The tower, painted white with a single black horizontal band, was completed in 1873 as work on the breakwater was coming to an end.

The lighthouse was manned until November 1961 and was built square to make the living quarters more comfortable. One of the last keepers was David John Williams, who subsequently became a Trinity House speaker giving talks on the service. The tower is 63ft high and 70ft above the high-water mark. The light has a range of 14 miles and is the responsibility of the port authority. Inside, much of the original living accommodation remains intact.

(Below left) Holyhead Breakwater is the longest such structure in the UK, and the lighthouse, dating from 1873, was the last major building completed on it.

(Below right) The black and white lighthouse at the end of Holyhead Breakwater has a circular lantern.

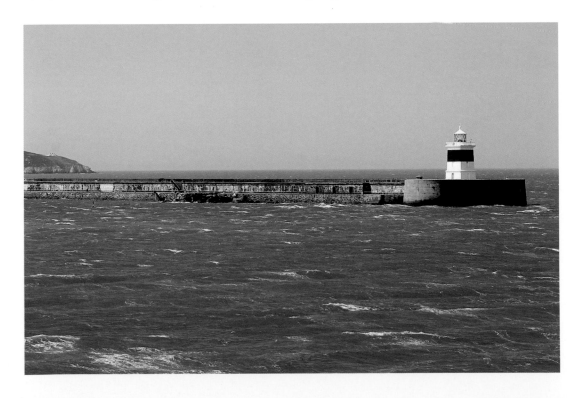

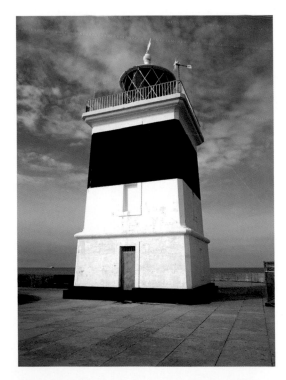

Skerries

Established	1717
Automated	1987
Operator	Trinity House
Access	Trips to the Skerries are available by charter boat out of Port Amlwch

The Skerries are a small group of rocky islets, 7 miles off Holyhead, to the north-west of Anglesey, which have some of the oldest lighthouse buildings in existence. In 1658 a proposal was made for a light by a speculator who wanted to profit from ships' dues. This request and another in 1705 were refused, but in 1713 a sixty-year lease was agreed, and in 1717 the first light, erected on the highest point of the island, was completed by the builder William Trench. Coal fired, it was not a financial success and the owner died in severe debt.

In 1759 Trench's tower was rebuilt in limestone at a cost of £3,000 after the owner had been enabled by Act of Parliament to increase the dues to shipping to maintain the light. The light was displayed in a coal brazier. This tower was increased in height in 1804 by owner Morgan Jones, and an iron balcony was added with railings enclosing the oil-burning lantern. The oil burner was enclosed in a glazed lantern room and covered by a cupola.

In 1838 Trinity House began purchasing private lighthouses but the owner of the Skerries refused to sell as his light had proved to be very profitable. By 1840 it was the only private light left in England, but in 1841, after the death of the owner, the corporation purchased it. Trinity House then had the station remodelled and extensively restored by James Walker. A free-standing keepers' house was built, enclosed by a castellated, walled cobbled courtyard and private facilities, which still stand. A new cast-iron lantern, almost 14ft in diameter, was glazed with square panes around a dioptric light with mirrors. The light was shone from a height of 119ft above high water.

In 1903 a solid circular tower was added to the south-west of the tower to carry a sector light, and in 1927 the light was converted to electricity. The original generator was later augmented by solar power. The 76ft tower, which stands atop the outcrop, is painted white with a broad red band, as is the adjoining engine room. The lighthouse was automated in 1987 and a helicopter pad was built in one of the walled gardens. The flashing white light is visible for 22 miles.

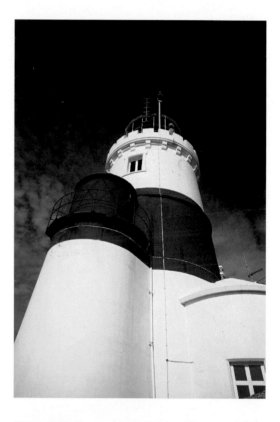

Skerries lighthouse, now operated by Trinity House, was the last private lighthouse in Britain when the Corporation purchased it in 1841. The treacherous Skerries rocks present a major hazard to vessels using the shipping lanes of North Wales.

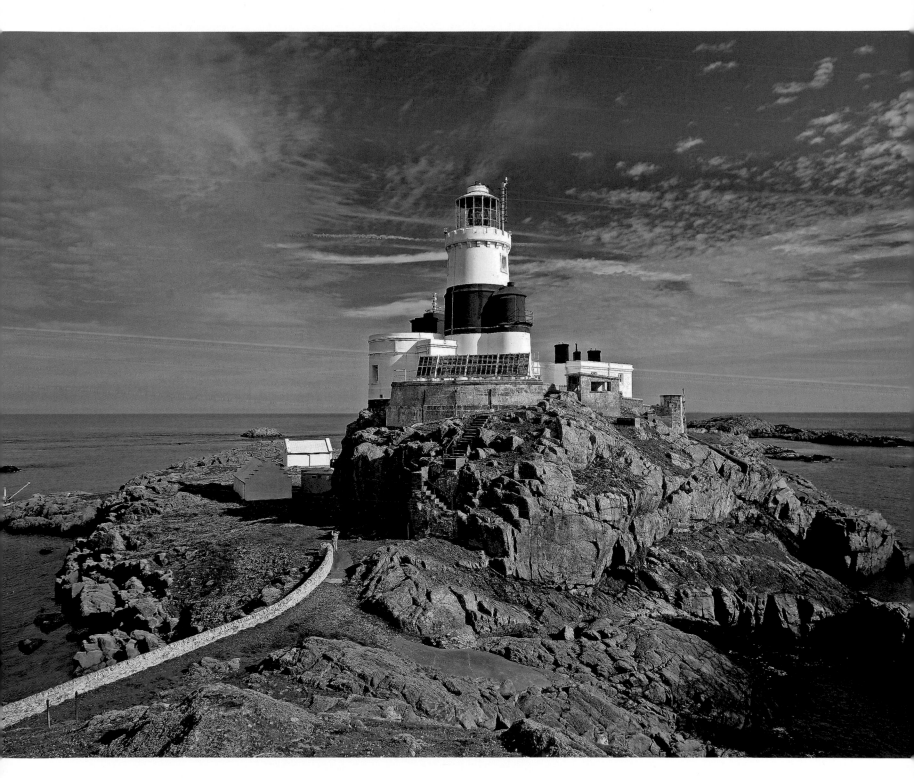

Port Amlwch

Established	1853
Discontinued	c.1972
Operator	Isle of Angelsey Council
Access	At the end of the short pier in the harbour

Port Amlwch with its small harbour was once a busy port. Its expansion began in 1768, when the Parys Mountain copper mine was opened and the harbour was enclosed by two small piers. At the end of each pier, a small stone octagonal tower was built displaying a white light from the top. With increasing trade, the port was extended in 1816 with a new outer pier. On the end of the new outer pier, a 16ft square stone tower, with a white light visible for 4 miles, was commissioned the same year.

This building, also used as a watchtower, was altered in 1835, and in 1853 the tower which exists today was built on the western end. This tower is not instantly recognisable as it consists of a 15ft slightly tapered tower with a rendered-brick lantern room roofed in local slate.

The light, which is displayed through a window only visible from the seaward side, has a range of 6 miles. A new fixed navigation light mounted on a white metal column was placed on the new dock, about 100 yards to seaward, when that was constructed in 1972 for the Liverpool pilots after they had moved to Amlwch from Point Lynas. In the local churchyard is a lighthouse memorial gravestone.

The harbour light at Port Amlwch dates from 1853 and is the fourth to serve the port. The pier was built in 1816.

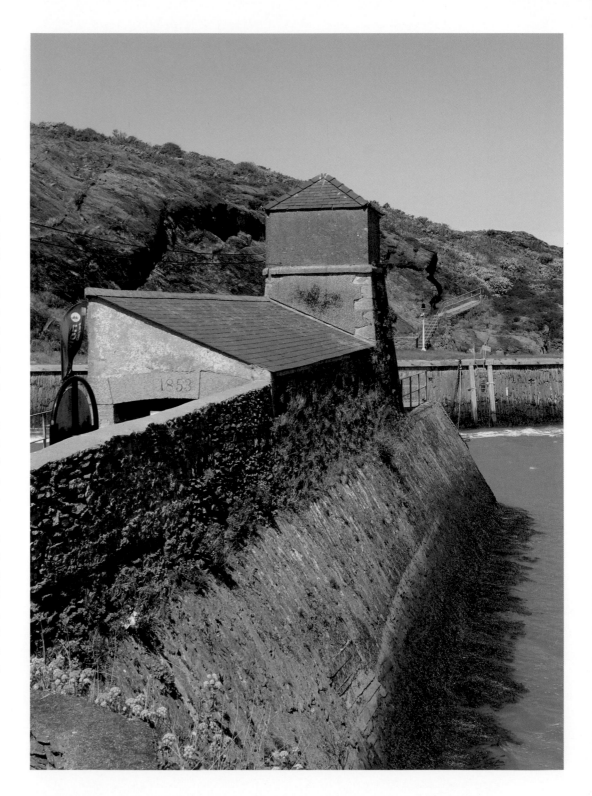

Point Lynas

Established	1779
Automated	1989
Operator	Trinity House
Access	Access to the inside of the complex is restricted, but the lamp room can be seen

Point Lynas, on Anglesey's eastern coast, was an ideal site from where pilots could board ships on their way in or out of Liverpool. In 1779 Liverpool Town Council set up a pilot station at the Point, and leased a house from which, in order to assist shipping, two lights were shown out of windows. Two years later, in 1781, the first part of the current castellated complex was built further up the hill to provide accommodation for the pilots.

As the 1779 lights were often obscured by smoke from nearby industries, the council built a two-storey extension in 1835 onto the north side of the pilot station complete with a ground-floor 12ft semi-circular lamp room. This lamp room was increased in size to 15ft in 1874 and completely refurbished in 1879. The original argon-powered light, visible for 16 miles, was converted to oil in 1901. In 1951, generators were installed and the lamp was converted to electricity. It was not until 1957 that mains electricity was connected and the occulting light, which was visible for 20 miles, uprated.

During the refurbishment of the site in 1879 the local signal station was moved into the complex and a set of signal lights displayed from a 75ft pole. This multipurpose site was taken into the care of Trinity House in 1973 and the pilots were moved to Amlwch Pier. The keepers' houses are available for renting as holiday lets.

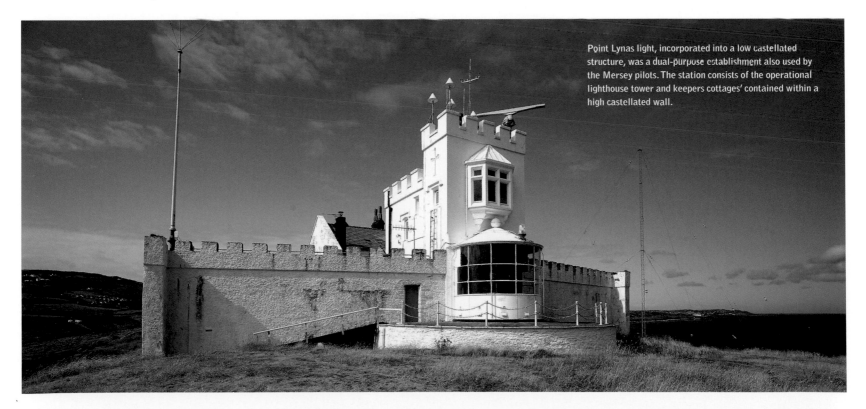

Point Lynas light, incorporated into a low castellated structure, was a dual-purpose establishment also used by the Mersey pilots. The station consists of the operational lighthouse tower and keepers cottages' contained within a high castellated wall.

Trwyn Du

Established	1831
Automated	1922
Operator	Trinity House
Access	North of Beaumaris, Trwyn Du is reached via a toll road from Penmon; trip boats in summer run from Beaumaris

In the early nineteenth century, the eastern tip of Anglesey was a graveyard both for ships entering the Menai Straits from the north and for those in Red Wharf Bay awaiting fair weather before rounding the Skerries. Consequently, in 1831, Trinity House erected a lighthouse on a reef off the mainland between Trwyn Du, or Black Head, and Puffin Island. It was a 96ft circular black and white stone tower, stepped at the base with a single step halfway.

The castellated gallery is painted black with the white lantern showing a flashing white light, visible for 12 miles, topped by a conical roof complete with a weather vane. The lighthouse, sometimes known as Penmon, was originally acetylene powered. It was converted to automated acetylene in 1922 and to solar power in 1996. It still sounds a bell as a fog signal.

Trwyn Du lighthouse was built between Black Point near Penmon and Puffin Island, at the eastern extremity of Anglesey, marking the passage between the two islands.

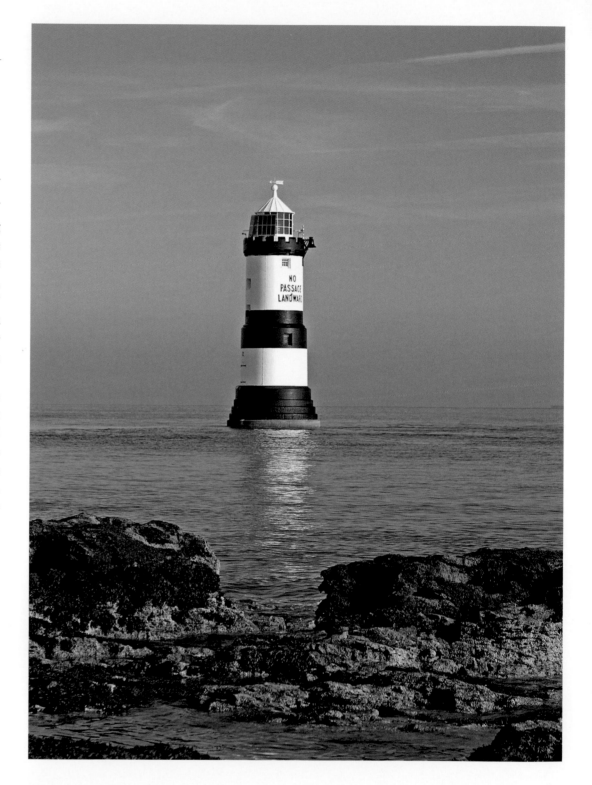

Great Orme

Established	1862
Automated	1965
Discontinued	1985
Access	The one-way anti-clockwise toll road gives a partial view of the lighthouse after about 2 miles; the lamp room is part of the bed and breakfast

The lighthouse at Great Orme Head, near Llandudno, dating from the 1860s, with the surviving lantern room almost the only evidence that the building was once an aid to navigation.

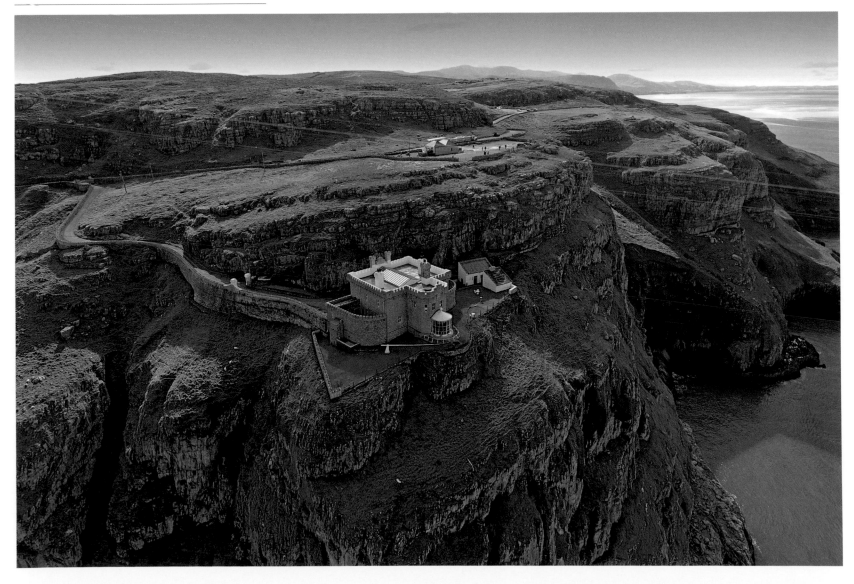

Lighthouse, Gt. Ormeshead, Llandudno,

THIS LIGHTHOUSE
WAS ERECTED
BY THE MERSEY DOCKS & HARBOUR BOARD
1862
G. F. LYSTER, ENGINEER

(Top) An old postcad showing a paddle steamer passing the Great Orme lighthouse. (Courtesy of John Mobbs)

(Above) Stone plaque built into the wall of the lighthouse on the Great Orme.

The lighthouse on the Great Orme at Llandudno is perhaps noteworthy more for its internal than external appearance. Constructed in 1862 for the Mersey Docks and Harbour Company by George Lister, who also worked on alterations to the Point Lynas light in 1871, it was cut into steep limestone cliffs on the most northerly point of Great Orme's Head, 325ft above sea level, and became the highest lighthouse in Wales.

The need for a lighthouse on the Great Orme was first recognised in 1861, and a letter recommending its establishment was approved by Trinity House. Constructed with dressed limestone, the building's 37ft high walls were topped with a castellated edge and the two-storey accommodation had a flat roof. The light was displayed from a semi-circular lamp room attached to the seaward side of the building at ground level. An interesting internal feature was the extensive use of Canadian pine boarding inside the accommodation block which, at 20ft high, provided privacy between the main keeper's and second keeper's accommodation.

The flashing white light, visible for 24 miles and first shown on 1 December 1862, was created by paraffin wick burners. These were replaced in 1904 by vaporising petroleum mantle burners, which were in turn superseded in 1923 by dissolved acetylene mantle lamps. The station, electrified in 1965, passed into Trinity House's control in 1973. The light was extinguished on 22 March 1985 and control of the building reverted to the Mersey Docks and Harbour Company, which sold the property.

The Fresnel lens is now an exhibit at the Orme's Summit Visitor Centre, where it can be seen illuminated to give an idea of its intensity. Situated in the Great Orme Country Park, the lighthouse is now a bed and breakfast, in which the old lamp room is used as the sitting room offering sea views. The bedrooms are named after the use the rooms were put to during the light's operational era.

Point of Ayr

Established	1777
Discontinued	1883
Operator	Flintshire County Council
Access	Located on Talacre Beach, it can be reached on foot from the car park at Talacre, just off the A548 coast road

Situated at Talacre, to the east of Prestatyn, on the northernmost point of the west side of the Dee Estuary, Point of Ayr lighthouse was one of a series of lights guarding Liverpool Bay. Owing to the considerable changes in the coastline, it is difficult to appreciate how the lights at Hoylake, Bidston Hill, Leasowe and Point of Ayr interacted. Point of Ayr was known locally as the Lake Light to distinguish it from the two lights at Leasowe, which were referred to as the Sea Lights. Built in 1777, it was initially on land and the 68ft circular stone tower was supported on screw piles driven into the sand. A small stone service building with a sloping slate roof was built to landward, but this was demolished and access is now via a raised walkway.

When the light was operational, the tower was painted in alternate red and white bands with a red gallery and a white lantern with a red roof. One white light, shining seaward towards Llandudno, was displayed at a height of 63ft, with a second at 8ft, facing down the River Dee towards Dawpool in Cheshire. Today, due to the change in the coastline, it is difficult to appreciate how lights at Hoylake, Bidston Hill and Leasowe interacted with Point of Ayr, or Y Parlwr Du, Talacre. Locally, it was known as the Lake Light to distinguish it from the two lights at Leasowe, which were

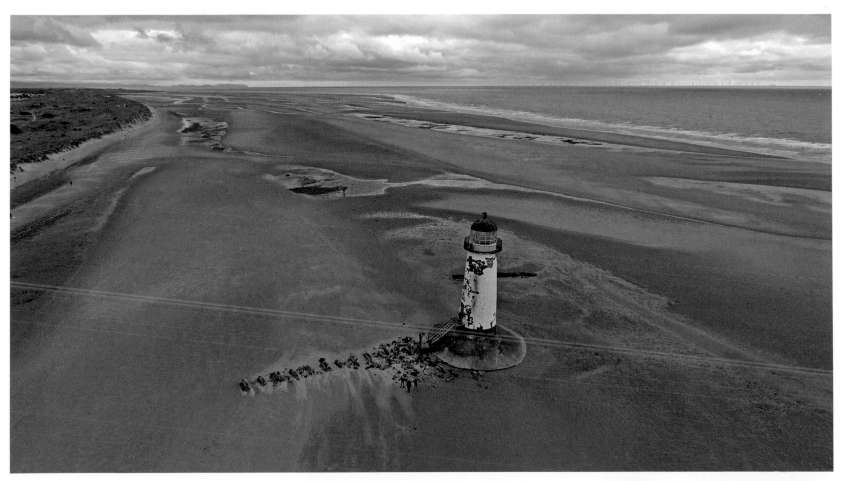

The Point of Ayr lighthouse at Talacre stands on the beach at the entrance to the River Dee and is within the boundaries of an RSPB reserve. It once displayed two lights but is now inactive.

referred to as the Sea Lights, but the lights discontinued in 1883.

In 1996 the tower was restored and, as a historic attraction, the site is managed by Flintshire County Council. The beach is a popular visitor spot and can get busy in the summer, with the tower its most prominent feature; it is also the northernmost point of mainland Wales.

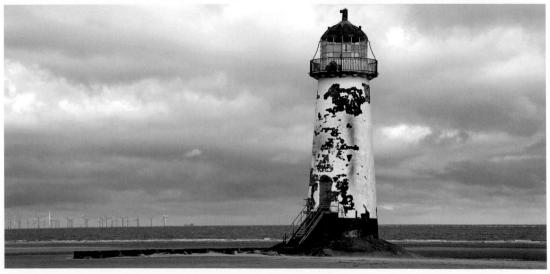

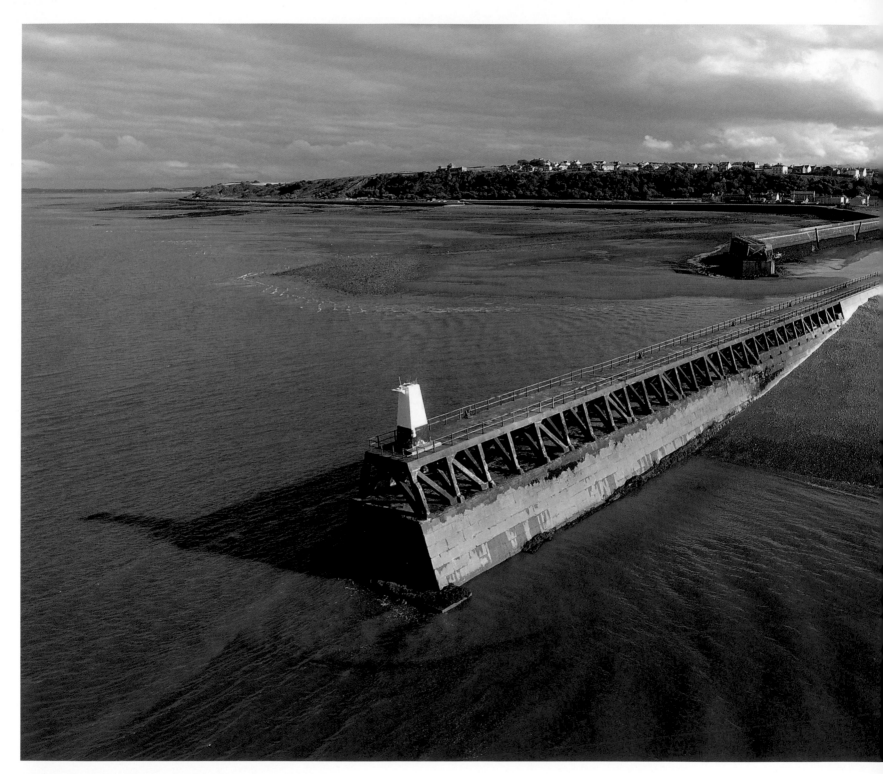

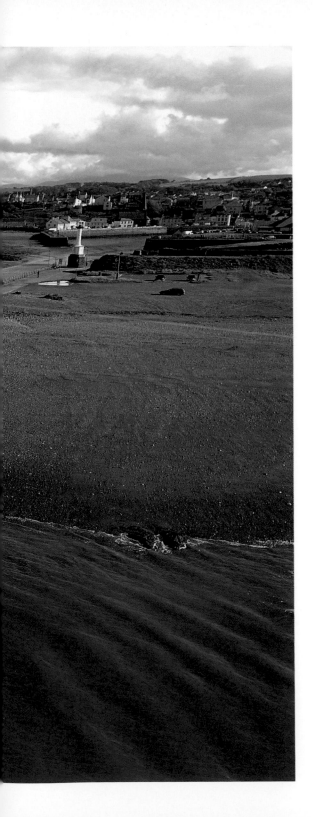

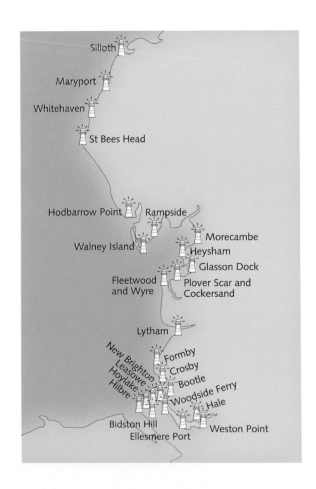

12 NORTH WEST COAST

Hilbre Island

Established	1927
Current lighthouse built	1995
Automated	1927
Operator	Trinity House
Access	The island can be visited with care at low tide by walking across from West Kirby

Hilbre Island, now owned by Wirral Borough Council, is the largest of three islands to the east of the mouth of the Dee Estuary off Hoylake. Although now uninhabited, the island was first occupied as early as Roman times. Monks provided lights on the island at one time, but it is unclear whether they were used for navigation purposes. However, in 1813 two beacons were erected on the north side to guide vessels through the Hilbre Swash, a small channel between Hoylake sands and the Dee.

In 1828 the Trustees of Liverpool Docks obtained a lease on the island and, in 1856, bought the island, having established a telegraph signalling station there in 1841. In 1927 they erected a navigation light which forms a port landmark for the Swash. Situated at the north of the island, the light was originally described as a 10ft metal lattice tower, but today it is in an enclosed metal box with solar panels mounted on top. Originally acetylene powered, it was transferred to Trinity House in 1973 and converted to solar power in 1995. The red flashing light is visible for 5 nautical miles. Visitors should check the tide times carefully before embarking on the walk to the island.

Hilbre Island's small automatic light provides a port landmark for the Hilbre Swash in the Dee Estuary and stands at the north-western end of the small island.

Hoylake

Established	1764
Current lighthouse built	1864
Extinguished	1886
Operator	Mersey Docks and Harbour Board
Access	The old high light is 500 yards inland at Valencia Road

The town of Hoylake takes its name from the large pool in which ships moored to offload their heavier cargo prior to sailing up the rivers Mersey or Dee. Thus, when two lighthouses were built by the Mersey Harbour Authority in 1764 they became known as the Lake Lights. The lower or front light was originally a wooden structure about 25ft high. It was situated on the shoreline and could be moved backwards or forwards as required. It was destroyed by sea erosion in 1771, but was rebuilt in the late 1770s or early 1780s as a 42ft hexagonal castellated brick structure and its light had a range of 11 miles. This light was deactivated in 1908 and in 1909 sold to Charles Bertie Burrows for £936. It has since been demolished.

(Right) Hoylake high lighthouse remains standing and is now part of a private dwelling.

(Below) The low light at Hoylake, to the left of the lifeboat house, was used until 1908 and has since been demolished. (Courtesy of Michel Forand)

Shore & Lighthouse. Hoylake.

Bidston Hill

Established	1771
Current lighthouse built	1873
Extinguished	1913
Access	East of M53 junction 1, on Eleanor Road which is at junction of Worcester Road and Boundary Road

The higher or rear light was situated 500 yards to the north-east inland in Valencia Road. The original 55ft brick tower was replaced in 1864 by the present 72ft octagonal brick tower with attached buildings. The tower had accommodation for two families on four floors, as the lighthouse keepers were responsible for both lights. The light, visible for 9 miles, was extinguished in 1886, and the tower was sold to Captain Edward Cole Wheeler for £800 in 1909. The lighthouse still exists as a private dwelling. Both lights were originally coal fired but were later converted to Hutchinson's catoptric reflectors. Visitors may be distracted by a lighthouse structure in Stanley Road to the west end of the town, but this is a replica.

The Bidston Hill lighthouse was built on a hill, more than 2 miles inland, to mark the Lake Channel, working in conjunction with Hoylake high light after the low light was destroyed in 1771. The light, which was shown from a 55ft-high octagonal tower, was first lit in 1777. In 1797 Liverpool's first female lightkeeper, Elizabeth Wilding, succeeded her husband Richard, who had been the first keeper.

This tower was demolished in 1872 but replaced the following year by the present 69ft stone tower, and adjacent dwellings were constructed by the Mersey Docks and Harbour Board. There was accommodation for three keepers and two families. The lighthouse was part of a complex which housed a signal station; semaphore signals could be sent between Holyhead and Bidston to warn if an enemy was approaching. It took only eight minutes to send a message between Holyhead and Liverpool.

In 1858, the service was superseded by the electric telegraph, and the lighthouse and telegraph services were amalgamated. An oceanic observatory was opened on the site in 1866. The lighthouse was deactivated in 1913 and, although they were subsequently restored and opened as a museum, the buildings became disused following the closure of the complex. However, the building has since been acquired by private owners, who maintain the building.

(Top) The inscription and date stone above the door of the old lighthouse at Bidston.

(Above) An old postcard showing Bidston Hill lighthouse and the observatory. (Courtesy of John Mobbs)

(Right) Bidston Hill lighthouse, now disused, and the signal station complex.

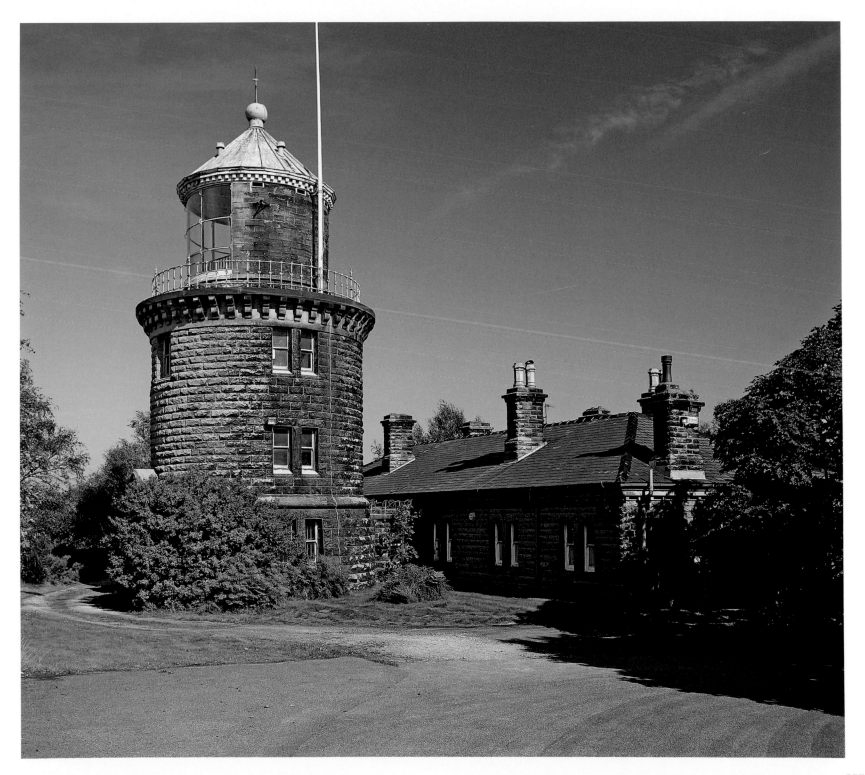

Leasowe

Established	1763
Current lighthouse built	1763
Discontinued	1908
Access	On the seafront west of Wallasey, with a car park nearby

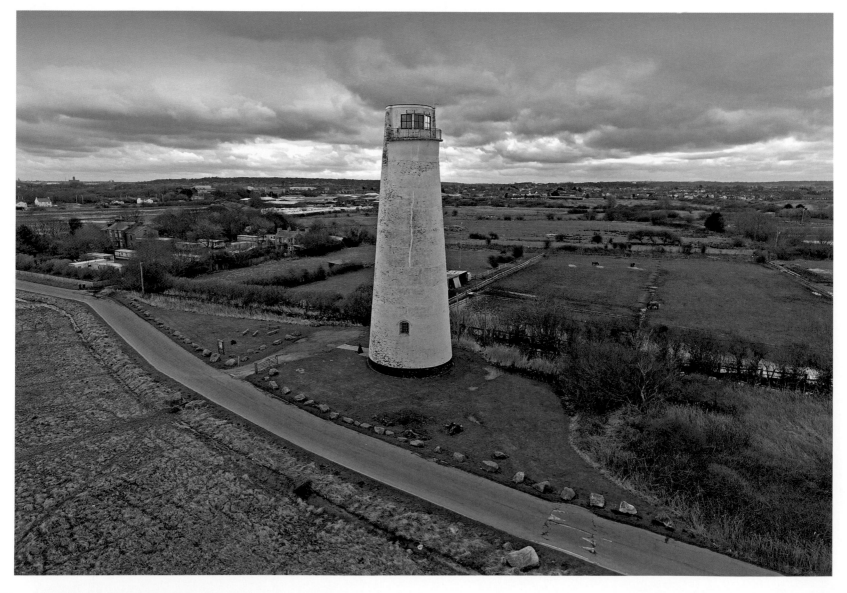

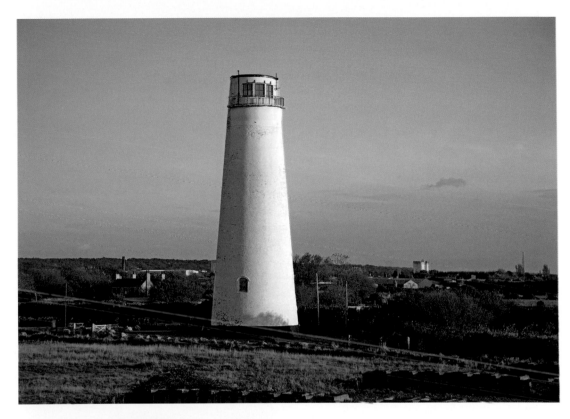

In 1763, two lighthouses were erected at Leasowe by Liverpool Corporation to mark the entry into the Rock Channel and then into Liverpool Docks. The lower light, situated on the shoreline, was destroyed by coastal erosion, and so in 1771 a light was built on Bidston Hill to replace it. The Leasowe higher light then became the front light and the alignment with Bidston provided a safe approach to the port.

The higher light, a white-painted 110ft structure with a range of 15 miles, was the first brick-built tower lighthouse in Britain and still stands, thanks to the Friends of Leasowe Lighthouse and Wirral Borough Council. The tower houses a visitor centre, which was opened in 1989 with public access to the top since 1996. Although now fully restored, the light deteriorated when in private hands between 1908, when its was extinguished, and 1930, when it was purchased by Wallasey Corporation. In 1988 the Wirral Borough Council granted £30,000 for the light's restoration, which was completed in 1996.

(Left and above) The brick lighthouse at Leasowe is now open as a visitor centre with access to the top of the tower.

(Right) Leasowe lightouse, which dates from 1763 and was operational until 14 July 1908, pictured when in service. (Courtesy of John Mobbs)

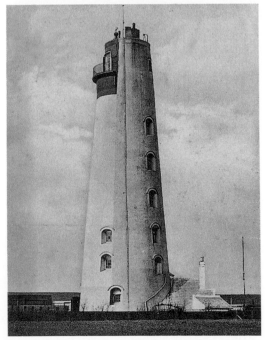

In August 2016 the Trustees of the Friends of Leasowe Lighthouse Charitable Incorporated Organisation successfully negotiated, signed and completed a ninety-nine-year lease arrangement with Wirral Council for the use of the lighthouse building and its surrounding grounds, which covered the daily running of the building and its upkeep. The lighthouse is open on the first and third Sunday of each month for guided tours, and the organisation has plans for further restoration and improvement projects.

New Brighton

Established	1683
Current lighthouse built	1830
Extinguished	1973
Access	Can be approached at low tide from New Brighton front adjacent to the Mersey

Because of its close proximity to the North Channel, where the Mersey opens out into Liverpool Bay, a light was erected on Black Rock by Liverpool Corporation in 1683. The light was mounted on a wooden 'perch' and the rock was renamed Perch Rock. In 1830 a new 90ft conical granite tower, to the same overall design as Eddystone, was completed and, after three years in construction, the New Brighton lighthouse quickly became Perch Rock lighthouse. Today, it is one of the most recognisable landmarks at the entrance to the Mersey.

The lower unpainted section of the tower is solid, while the upper section housed the keepers.

(Right) The Perch Rock lighthouse, or Rock Light, at New Brighton is a familiar landmark at the entrance to the river Mersey.

(Below) An old postcard of the Rock Light tower on the Mersey, pictured when operational.

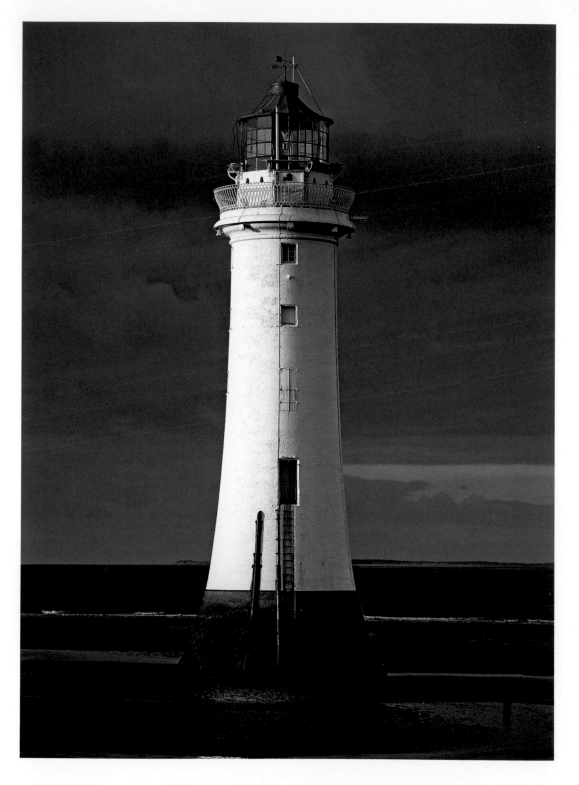

Woodside Ferry Terminal, Birkenhead

Established	c. 1849
Current lighthouse built	1980s (replica)
Discontinued	c. 1864
Access	The replica is on the landing stage of the Woodside Ferry terminal at Birkenhead

Access is via a vertical ladder which does not reach to ground level. The light was originally fixed white, but in 1878 was altered to flashing white. Eventually electrically lit, the revolving light, housed in a red-painted lantern room and visible for 14 miles, was extinguished in 1973 after which the lighthouse went into private ownership. The light was used as a Morse code station and the nearby Perch Fort has a museum displaying photos of Liverpool shipping.

During 2015 an application was made for funding to enable the discontinued light to be reinstated, with the result that solar-powered light equipment and LED lamps were installed. They reproduced the original light character of two red and one white light, but were masked on the seaward side so as not to be visible along the River Mersey. The light was first shown again at an event held on 23 April 2015.

A light was established at Woodside Ferry terminal on the west bank of the Mersey, where the Liverpool–Birkenhead ferry crosses the river, in about 1849, when a stone jetty was erected. The light, mounted in a red lantern on top of a

The replica lighthouse at Woodside Ferry Terminal overlooks the Mersey.

conical stone tower, was only lit for fifteen years or so but the tower remained for a further 120, despite major alterations to the terminal itself.

In the mid 1980s, when a redevelopment of the landing stage took place, the original tower was refurbished in its original location and the now red-painted light housing, which was non-operational, was transferred from the landing stage. This old landing stage light stood on a wooden trestle with a large bell attached.

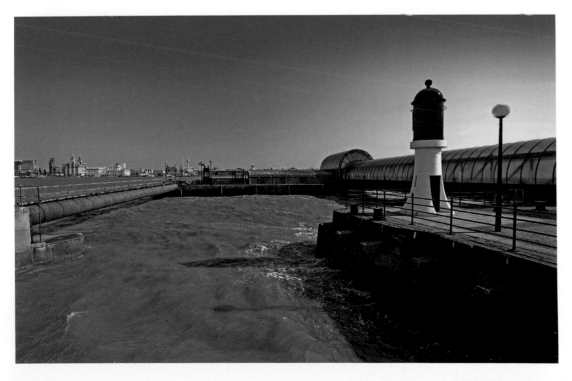

Ellesmere Port

Established	1880
Discontinued	1894
Access	The tower and associated buildings are part of the National Waterways Museum

The red-brick lighthouse at the entrance to Whitby Locks at Ellesmere Port was situated at the entrance of the Shropshire Union Canal. When Thomas Telford built the docks in 1796, ships navigated into them directly from the Mersey. A 36ft octagonal red-brick lighthouse with adjoining buildings was erected by J. Webb in 1880. This light, with its unusual bell-shaped roof, was visible for 19 miles. When the Manchester Ship Canal was constructed across the entrance in 1894, ships had to enter the docks via the canal 3 miles away at Eastham, making the light redundant; it was therefore discontinued but the tower remained.

Between Ellesmere Port and Runcorn, on the south side of the Mersey, another light was built to mark Ince Bank, or Ince Marshes, an area found to be difficult to navigate. The lighthouse was built in 1838, but was demolished in June 1865 and replaced by a new light, which itself ceased operation on Christmas Eve 1877. It was demolished prior to 1919 as the building of the Manchester Ship Canal in 1894 made it unnecessary; no trace of it survives.

In 1971 the Boat Museum Society opened the Boat Museum in the docks and the lighthouse became part of the National Waterways Museum. The lighthouse, which stands within the museum grounds, has been restored and refurbished.

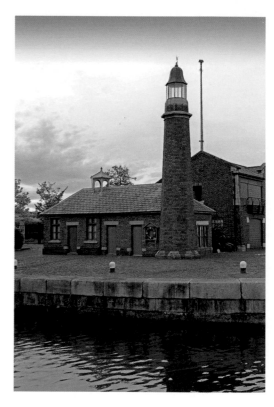

Telford's lighthouse, which originally marked the entrance locks to the Shropshire Union Canal, on South Pier Road at Ellesmere Port overlooking the Manchester Ship Canal.

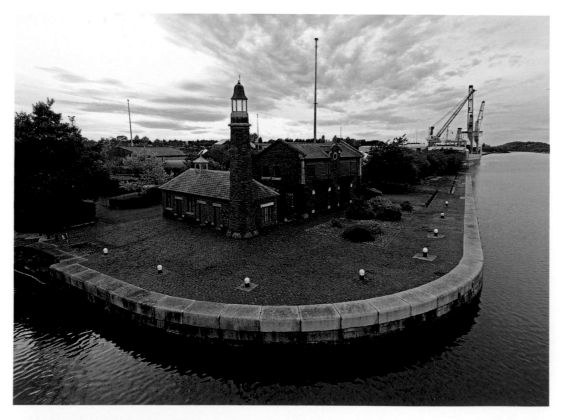

Weston Point

Established	1843
Discontinued	1911
Demolished	1960

Hale Head

Established	1838
Current lighthouse built	1906
Extinguished	1958
Access	Hale Head can be reached on foot from Hale Church via Lighthouse Road; the Mersey Way Coast Path also passes by

Just before Runcorn, the Mersey swings north and the River Weaver enters on the southern shore. Before Hale lighthouse had been built on the north shore, a lighthouse was proposed for this point. Although mentioned as early as 1796, not until 1810 was a light shown, but exact details are not known. In 1843 a 30ft red, circular sandstone lighthouse was built on a small island for the Weaver Navigation Co. It stood on a broad circular sandstone plinth and had three levels before a metal gallery and hooded lantern with a domed roof. The light was shown through a window on the Mersey side.

The light was deactivated in 1911, since by then the Manchester Ship Canal had taken Weaver traffic from the Mersey. The lighthouse was demolished in 1960 and the only guide to its location is the church. The lighthouse was built on a site close to where the Weaver entered the Mersey, but this river junction was moved north.

(Below) A contemporary postcard depicting the now demolished Weston Point lighthouse, which stood on an island along with the now derelict All Saints Church at the entrance to Weston Marsh Docks. (Courtesy of Michel Forand)

Situated on the north bank of the River Mersey, where the river bends between Liverpool and Runcorn, the head at Hale juts out, thus acting as an important landmark for shipping. To offer guidance, a lighthouse was built there in 1838. It consisted of a squat hexagonal 18ft tower, complete with gallery and lantern, attached to an adjacent cottage by a short corridor. The tower was demolished and the current lighthouse built in 1906.

The new lighthouse was 58ft in height with the circular, slightly tapered brick tower supporting a gallery and lantern. It was attached to the adjacent keeper's cottage by a corridor. When the light was operational, a fog bell was attached to the gallery and a weather vane was placed on top of the metal roof. In addition, a flag pole was attached to the lantern. The oil-powered fixed white light was visible for 6 miles. It is rumoured that, during a Second World War air raid, the keeper was fired on as she tried to close the shutters. In 1958 the light was extinguished, initially on a trial basis, but was never relit. The lighthouse is now a Grade II listed building but the cottage is a private residence.

The lighthouse at Hale Head dates from 1906 and was operational until 1958, but is now part of a private residence.

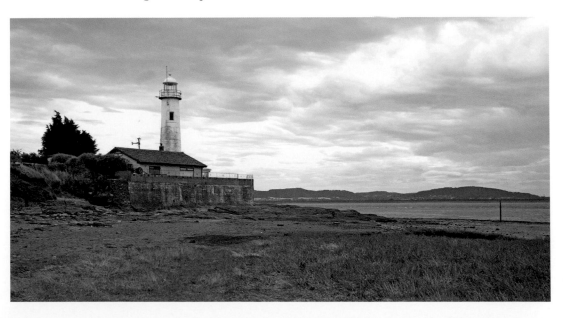

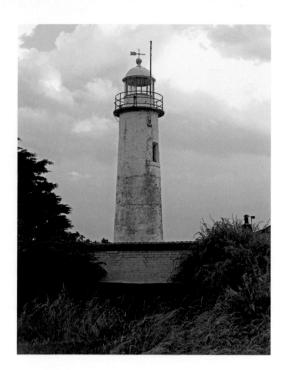

The lighthouse at Hale Head dates from 1906 and was operational until 1958, but is now part of a private residence.

The light mechanism and fog bell have been removed from the lantern and are on display at the Merseyside Maritime Museum in Albert Dock, Liverpool. The remainder of the structure survives in good condition. When operational, the lighthouse was directly on the foreshore, but since then a substantial seawall to prevent erosion has been constructed around the area.

Bootle

Established	1877
Discontinued	1927
Operator	Mersey Docks and Harbour Board

Looking at twenty-first-century Bootle, it is difficult to imagine what it looked like in the nineteenth century, when Liverpool was only just starting to encroach on the village, which had at that time an extensive sea frontage. To assist ships entering the docks, which were then in the process of being expanded, a lighthouse was erected on the North Wall, near the lock gates to Hornby Dock.

Built in 1887 by the Mersey Docks and Harbour Board, it was an ornate square two-storey red-brick building trimmed with yellow bricks. The substantial gallery supported a large lantern which had a domed roof, bringing the height to 75ft. To deflect the light seaward, the rear of the lantern was solid. Known as North Wall Light, it showed a fixed white light visible for 12 miles.

As the docks were further expanded, the light was extinguished, and in 1927 the tower was demolished when the new Gladstone Dock was constructed. During its operational days, it was known locally as the Bootle Bull because of its very deep foghorn. Today, a simple 29ft white concrete post supports a navigation light to the north of the dock entrance.

(Far left) The 1838 lighthouse at Hale was demolished in 1906 but the keepers' cottage was used as part of the new tower.

(Left) An old postcard depicting the lighthouse at Bootle, built on the seawall in 1877 by the Mersey Docks and Harbour Board and discontinued in 1927. (Courtesy of Michel Forand)

Crosby

Established	1839
Destroyed	1898

Formby

Established	1719
Last lighthouse built	1856
Demolished	1941

The Crosby, or Little Crosby, lights were some distance north of Crosby village near Hightown and were referred to as Hightown Lights. The first, built in 1839, was a 96ft slender wooden tower supported with wooden outriggers in the sand dunes not far from the railway station. Erected by the Liverpool Dock Authority, it showed a fixed red light visible for 16 miles.

With ever-changing channels in the area, a proposal was made to replace it with a movable light but this came to nothing. However, the light was replaced only eight years after being built by one just over half a mile to the north-east. Built by the Mersey Docks and Harbours Board and designed by its Chief Engineer Jesse Hartley, this light was of a much more stable construction, consisting of a 74ft tapering square brick tower with an iron gallery on which stood a wooden lantern, making the whole structure 95ft in height. An attached keepers' dwelling was, like the tower, painted white. The fixed white light, visible for 12 miles, was displayed from 1847 until 1851 and then again from 1856.

On 2 February 1898 tragedy struck when a fierce gale broke the lantern room windows causing burning oil from the light to fall onto the wooden floor. The whole lighthouse went up in flames and the keeper, his wife and a friend were killed. No sign of this light exists and the much-changed coastline makes it impossible to identify its exact location.

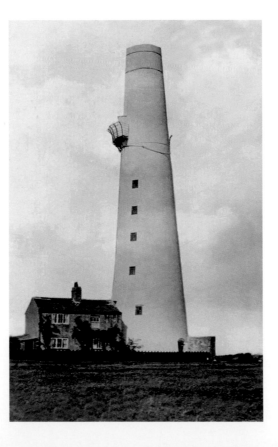

The northern approach to the river Mersey is strewn with shifting sandbanks and channels, so to aid shipping a pair of tapered circular white-painted brick towers was erected in 1719 in the sand dunes at Formby Point, about a mile from the end of what is today Albert Road. The high tower was 120ft tall and the low tower 80ft. When in line they marked the channel between Mad Wharf Sands and Burbo Bank.

In 1833 the Mersey Docks and Harbour Board converted the high tower into a lighthouse operating in conjunction with the Formby lightvessel. First lit on 1 August 1834, it showed a yellow light visible for 12 miles. On 1 February 1838 it was altered to fixed red, but was discontinued on 10 October 1839 after the channel had changed. It was resurrected for a time, from 16 October 1851 to 6 October 1856, but was then permanently extinguished. The tower was demolished by the War Office in August 1941.

The high lighthouse at Formby was built in 1719, but was demolished by the War Office in 1941.

Lytham

Established	1848
Last lighthouse built	1906
Discontinued	1985
Access	No trace exists but there is a navigation light on Fairhaven United Reformed Church tower

The entry to the River Ribble has always been challenging for vessels and their crews, with shifting sandbanks covering an area of over 50 square miles, and continually changing navigable channels. To assist shipping, a lighthouse, built in 1847 but not lit until 1 February 1848, was erected on a stone stanner seaward of what is now Lightburne Avenue, Fairhaven. Locally referred to as Lytham or Stanner Point light, it was a 72ft bell-bottomed circular brick tower with gallery and lantern. A fixed white light was shown and an additional fixed red light was displayed from a small gallery a third of the way down the tower. Due to the encroachment of the sea, it was undermined and collapsed in 1863.

A temporary pile light was placed nearby and by 1864 a new 81ft octagonal wooden tower had been erected inland. First lit on 1 January 1865, it showed two lights like its predecessor, one occulting white light from the lantern on top with a fixed white tide light lower down. This second light was discontinued in 1890 when a gas-lit buoy replaced the previously unlit Nelson Buoy in the river mouth. The structure then decayed and was demolished in 1901.

In 1906 a third Lytham light was erected on a pile platform 12¼ miles from Preston Docks, on the north bank of the Gut Channel. Known as Peet's light, it was partially destroyed by fire in

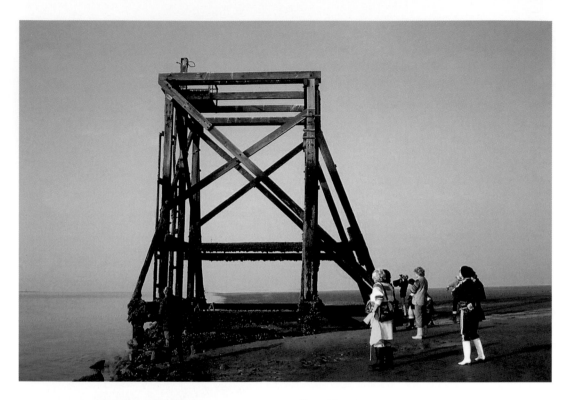

(Above) The pile structure on the training wall that held Peet's light until it was destroyed by fire in 1954. Shortly after this photograph was taken in 1985, the piles themselves were washed away. (David Forshaw)

(Left) Engraving of the stone lighthouse built at Lytham in 1848, which collapsed into the sea in January 1863. (Courtesy of Michel Forand)

1954, but a light was continued until 1985, when the piles themselves were washed away. No trace exists today and the continuing changes to the coastline in this area make it difficult to appreciate how the lights would have looked at the time.

In 1998 a Trinity-House-approved light belonging to Ribble Cruising Club was placed on the tower of Fairhaven United Reformed Church to act as a leading light for the gap from South Gut to the Gut Channel. Originally a flashing white light, it now shows an isophase white light visible for 3 miles. It is mounted 33ft below the top of the 142ft church tower.

Fleetwood

Established	1840
Current lighthouses built	1840
Operator	Port of Fleetwood
Access	Both lights are easily seen, the low light on the seafront and the high light in Pharos Road

The two lights at Fleetwood: the low light on the promenade stands in front of the grand North Euston Hotel, and ahead of the high light; the two lights should be aligned to provide vessels with a safe passage in and out of the port.

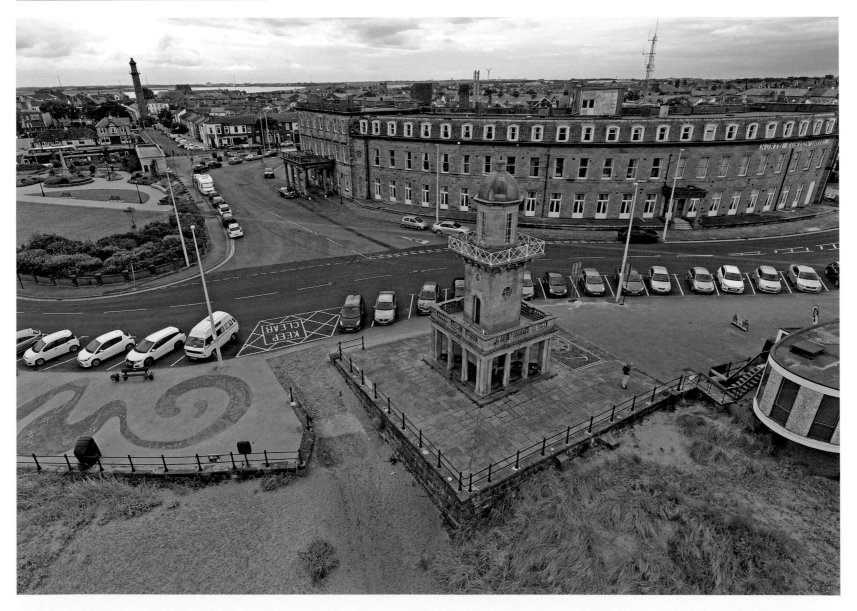

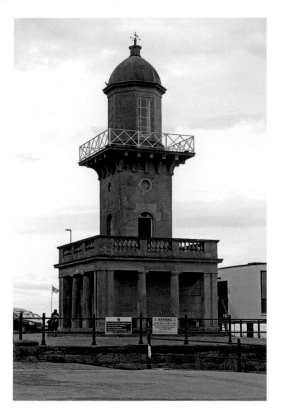

The elaborate low light at Fleetwood, designed by Decimus Burton, overlooks the entrance to the Wyre.

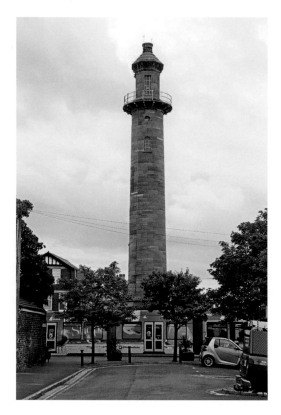

The tall high light at Fleetwood stands in the middle of the town, serving as a notable landmark.

Wyre

Established	1840
Discontinued	1948
Access	Remains are only accessible by boat

Fleetwood has been a popular resort since the 1800s and in 1840 expanded as a planned town, financed by Sir Peter Hesketh-Fleetwood, who went bankrupt before finishing it. His architect, Decimus Burton, designed the North Euston Hotel on the seafront, as well as the two lighthouses, one in the town and the other on the promenade.

The high light, known locally as the Pharos, consists of a 90ft red stone circular tower on a square stone base. Near the top is a stone gallery with metal railings and the light is shown through a narrow vertical window in a stone lantern with a domed roof. The green flashing light, visible for 12 miles, guides vessels into the correct channel. The light, situated 350 yards from the sea, was painted cream and red until it was sandblasted during the 1990s to reveal the original sandstone.

The low light consists of a square shelter with covered seating and gothic columns. The roof has an ornate stone balustrade inside which is a second tier square tower topped with a balcony. The structure is completed by a hexagonal stone lantern with a domed roof. The 43ft tower displays a green flashing light visible for 9 miles, displayed through a window. Neither of the towers are open to the public.

A third lighthouse was built to guard the entry into Fleetwood in 1840, situated just over a mile offshore to mark the North Wharf Bank at the mouth of the Wyre. First called Port Fleetwood, it was later called Wyre lighthouse and was the first screw-pile lighthouse in the world. Built by the blind Irish engineer Alexander Mitchell, it was the forerunner of screw-pile lights throughout the world and its importance is thus considerable.

It was supported on seven cast-iron legs screwed into the sand. Each was 16ft long and 3ft in diameter, and six were placed at an angle of one in five to form a hexagonal 50ft base with one vertical leg in the centre. This supported an oval platform on which stood a single-storey wood and corrugated-iron accommodation block. A hexagonal lantern room with an iron roof topped by a weather vane stood on the roof of this block. The fixed white light was visible for 10 miles and a boat was slung beneath from davits. The whole structure was 40ft tall and originally painted red. The cabin was the accommodation for the three keepers, and was made from heavy wood painted with tar and bitumen to preserve it.

The tower suffered several mishaps. In 1870 it was rammed by the schooner *Elizabeth and Jane*, of Preston, and had to be re-erected, with the colour being changed to black to make it

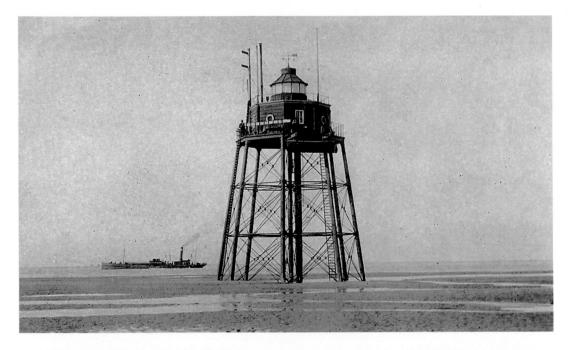

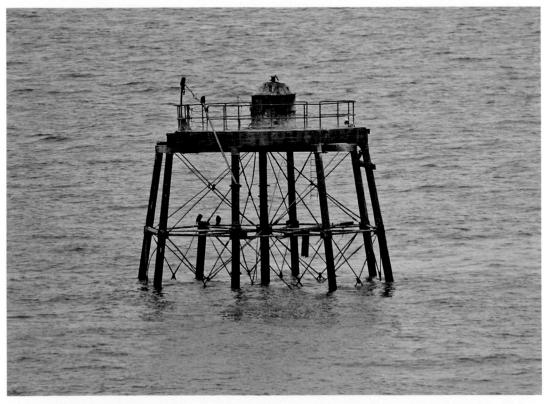

more conspicuous. In 1948 the lighthouse was destroyed by fire and, although the three keepers were rescued by the Fleetwood lifeboat, the light was not replaced and the tower gradually fell into disrepair. A navigation light was displayed from the remains of the platform until 1979, when a navigation buoy was placed nearby and the light was extinguished.

The state of the tower, a marvel of Victorian engineering, gradually worsened during the early years of the twenty-first century, and in July 2017 one of the legs, being badly corroded, gave way, causing the crumbling landmark to keel over. Fleetwood Civic Society had been planning a funding bid to carry out urgent repairs, but failed after the lighthouse's owner could not be found, and its future seems particularly precarious.

Cockersand and Plover Scar

Established	1847
Current lighthouse built	1847
Access	The wooden tower was demolished in 1954 and only the keepers' cottage remains; Plover Scar light can be seen offshore

In 1847 a pair of lighthouses was built to guide ships into the River Lune and Glasson Docks. The rear light, sometimes called Cockersand High or Upper, was also designed by Hartley and built by Charles Blades near Cockersand Abbey. Erected in 1847, it consisted of a 54ft wooden shingle-covered square wooden tower steadied by two wooden props on each corner. The square lantern above the gallery was also wooden with a pitched roof. Built within the corner stays were four keepers' quarters. A stone cottage with a slate roof was subsequently added and this still exists. The fixed white light, displayed from a window in one side of the lantern, was visible for 9 miles.

Originally fuelled by two paraffin wick lamps and parabolic reflectors with candles as back-up, the light was converted to electricity in 1947. In 1953 it was replaced by a 54ft square steel tower with a pair of 12-volt bulbs, magnifier and reflector which were switched on manually until automation in the 1950s. By 1985 the light was no longer needed and so it was demolished.

The front light, designed by John Hartley, Chief Engineer to the Mersey Docks and Harbour Board, was erected 400 yards out to sea on a reef called Plover Scar. This 58ft circular stone tower was tapered up to the lower gallery. Between the two galleries was the tower of white-painted stone; above the second gallery

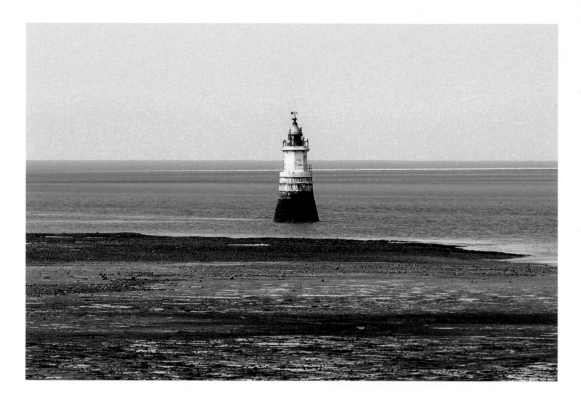

the light was displayed from a circular lantern with a domed roof with weather vane. The light, originally paraffin fuelled, was automated in 1951 and converted to solar power. The flashing white light is visible for 7 miles.

In March 2016 the tower, owned and operated by the Lancaster Port Commissioners, was hit by a cargo ship. The upper tiers of stone of the tower were dislodged and the metal retaining bands snapped in the collision. Work on restoring the tower began in September 2016, and this involved carefully dismantling it stone by stone, with the interior of the structure also having to be dismantled. Access to the lighthouse was only possible at low water, so the rebuilding work took until May 2017 when the navigation light, which had been installed on the scaffolding as a temporary measure, was reinstated in the lighthouse and service was resumed.

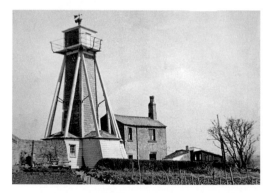

(Top) Plover Scar light is situated about a quarter of a mile offshore at the southern entrance to the River Lune.

(Above) The wooden lighthouse at Cockersand near the Abbey was demolished in 1954.

Glasson Dock

Established	1836
Current lighthouse built	1836
Access	Access to Glasson is permitted, but care needs to be taken as the light is in a working area

Glasson Dock, situated at the entrance to the River Lune, was built in 1787 as a port for the town of Lancaster. Although the port was only accessible for an hour each side of high water, it became one of the busiest in the country during the eighteenth century.

The entrance to the dock was marked in 1836 by a lantern mounted on the roof of a small watch house at the end of the dock wall. This lantern displayed a fixed white light with a range of 2 miles. The watch house was a white-painted stone building, and it is still standing. It had an apex tiled roof with the light displayed from a hexagonal lantern at one end. It became disused when new training walls and quays were built to enable a new deepwater channel to be dredged from Glasson to Lancaster.

The building is now dwarfed by a warehouse within the port complex. The docks themselves have seen a revival not only as a working port handling a variety of cargoes, but also with a marina used by pleasure craft. The area's modern navigation lights are exhibited from a series of electric lights on a trellis tower behind the old watch house.

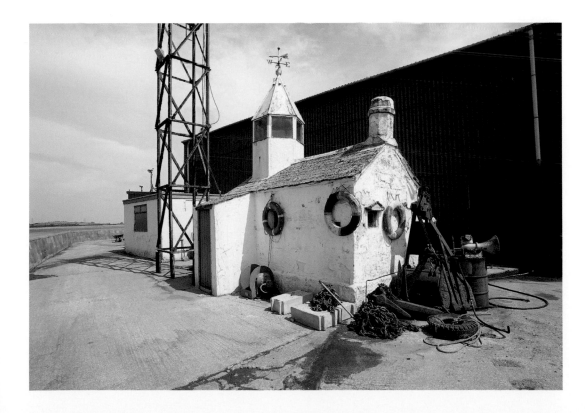

The small disused lighthouse with its steeply-pointed dome lantern at Glasson Dock.

Heysham

Established	1904
Current lighthouse	1904
Operator	Associated British Ports
Access	Both piers are accessible with good views of the lights from the ferry

Although a harbour existed at Heysham before 1904, it only became a freight and ferry port when the new docks were opened that year. Taking over from Morecambe, it became the main port for traffic to the Isle of Man and Ireland. The lighthouse on the end of the south pier was probably built in the same year. Consisting of a 20ft red-painted cast-iron tower and gallery, it shows an occulting green light, visible for 6 miles, from a white lantern with a domed roof topped by a weather vane. It is operated, along with the other port lights, by Mersey Docks and Harbour Company.

On the end of the South Breakwater is a 20ft white post which shows two fixed green lights, one above the other. Built in 1929, the post is not to be confused with the 13ft circular tower with a gallery just behind which there is what looks like a lighthouse but is in fact a fog signal.

On the North Pier are the remains of a stone tower, which was originally the North Pier front light. Only the base survives, close to the redundant stone tower which served as the North Pier rear light. This 25ft circular stone structure still has a gallery, but the top now houses a simple white aid to navigation, now redundant. It is not clear when the light became redundant but it was superseded by a simple 16ft metal lattice tower erected on the end of the pier which shows two fixed red lights.

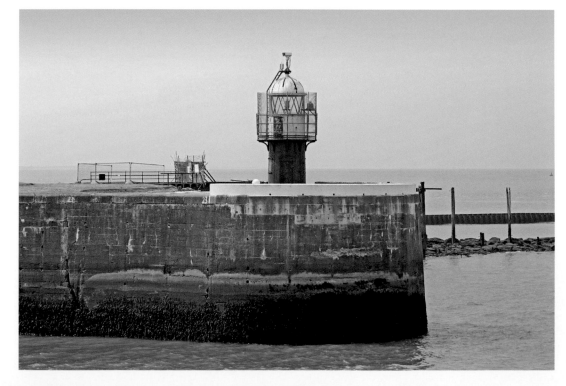

(Left) The light at the end of Heysham South Pier.

(Below) An old postcard showing the lighthouse on the end of the South Pier erected in 1904 when the docks were constructed.

Morecambe

Established	1815
Current lighthouse built	1815
Operator	Lancashire Port Authority
Access	At the end of the Stone Jetty, with the adjacent building used as a cafe

Morecambe was at one time a busy port. However, by the 1840s the size and quantity of ships had rendered Glasson Dock, the port for Lancaster, inadequate and so a harbour was built at Morecambe in the 1850s. One side of the harbour was formed by the Stone Jetty, which was completed in 1853 and reached out to the deep water channel passing Morecambe. A rail link joined it to the mainline railway and enabled Morecambe to became a major player in the export of coal to Ireland.

To guide ships towards the jetty, a 36ft octagonal stone lighthouse on a square plinth was built on the seaward side of the railway terminus building. Called Morecambe Stone Pier Head, it had a stone gallery with black railings accessed via a ladder, no longer in service, up the end wall of the railway building with a gantry onto the gallery where a small door gave entry to the lantern. The flashing white light, visible for 5 miles, is displayed from a white octagonal lantern with an ornate copper roof.

With the development of Heysham as a port, Morecambe declined as a harbour. At the end of the twentieth century, the council commenced a major redevelopment of the area and the jetty was refurbished and extended, with the lighthouse remaining a feature. It is not clear whether the light, which is operated by the Lancaster Port Authority, is still shown.

Morecambe lighthouse at the end of the Stone Pier, adjacent to the railway depot. Overlooking Morecambe Bay, it was built to guide railway ferries sailing between Morecambe and Ireland.

Walney Island

Established	1790
Current lighthouse built	1804
Operator	Lancaster Port Commission
Access	Use the nature reserve car park when open and walk to the lighthouse

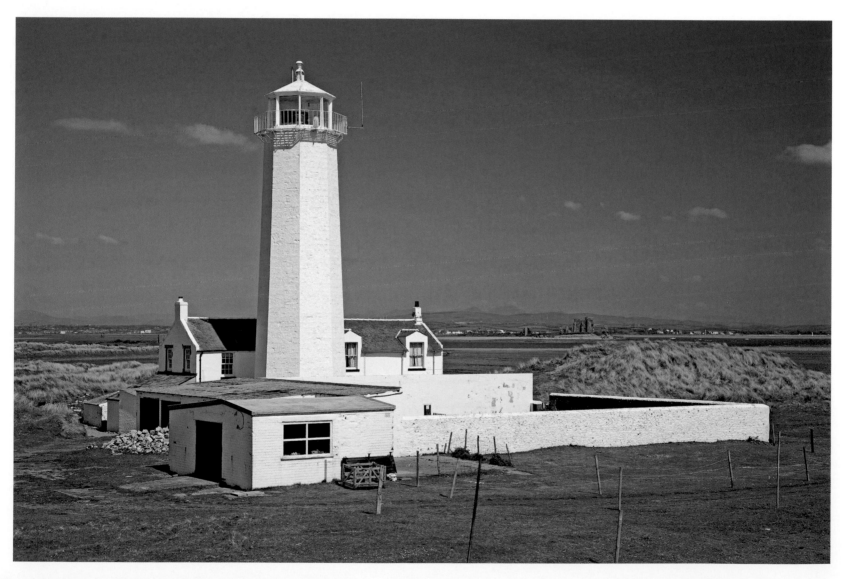

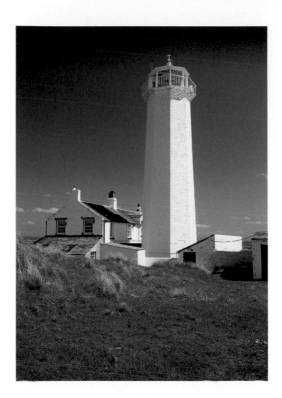

Walney Island lighthouse, built in 1790 and operated by the Port of Lancaster Commissioners, stands at the southern tip of the island.

In the 1700s the main port in the Morecambe Bay area was Glasson Dock, and Barrow was just a small fishing village. So in 1790, when a lighthouse was built at Haws Point on Walney Island, its purpose was to guide ships into the river Lune and not the Walney Channel and Barrow Docks. It was built by Lancaster Port Commissioners, who still operate it today.

The first light consisted of a wooden tower supporting an oil lamp with parabolic reflectors. To distinguish it from St Bees and the river Mersey lights, a newly invented revolving apparatus manufactured by Richard Walker was installed. The flashing light was produced by fixing three parabolic reflectors back to back on an axle driven by a weight which dropped down the tower.

In 1803 the whole structure burned to the ground, and so it was replaced the following year by the current 80ft octagonal tower. The stone for both the tower and attached keepers' dwelling was quarried in Overton in Lancashire and brought to the site by ship. The dwellings were originally one, but have since been split into two properties. The light was lit by an Argand burner until 1909 when an acetylene-powered flashing light system was installed.

In 1953 the station was converted to electrical operation with a generator and was eventually connected to mains electricity in 1969. The weight-driven motor which powered the rotating mechanism was replaced by an electrical one in 1956. The station has what is reputed to be the last catoptric apparatus in England; the reflectors from the original apparatus are on display at Lancaster Museum. The current light is visible for 18 miles.

Now automated, the light was manned for many years by Peggy Braithwaite MBE, who first went to Walney as a young girl with her father when he was appointed assistant keeper. She became well known on becoming the only female principal keeper in the country when appointed in 1975. She retired in 1994.

Walney Channel

Established	1850 to 1870
Current lighthouse built	1822
Operator	Associated British Ports
Access	The Rampside light is on the roadside at Roa Island; the plastic light can be seen by walking from the end of the road; the river lights are best approached from the sea, but can be viewed from the road to Walney lighthouse

Barrow-in-Furness, the major port between Liverpool and Glasgow, has a long shipbuilding tradition. Entry to the port is via the meandering Walney Channel which requires careful navigation. Training walls have been built in the approach to the docks but beyond them the channel passes between Roa Island, Piel Island and the tip of Walney Island.

As the main purpose of the lighthouse on Walney Island is to guide vessels into Lancaster, a series of thirteen range lights was built between 1850 and 1870 to guide vessels into Barrow. Only one survives, a 46ft narrow square brick tower with a pyramidal top situated on marshland to the side of the main road at Rampside. The bricks are red on the corners and yellowish white in the centre, giving the impression of a band on each side. The isophase white light, visible for 6 miles, is displayed from a window near the top. As a result of pressure by local inhabitants, it is now a listed structure.

The original front light has been replaced by a modern glass-reinforced plastic tower on the shingle bank leading to Foulney Island from the road to Roa Island. Also known as Foulney Island Light, it consists of a 36ft prefabricated circular tower tapered at the bottom and top with, above

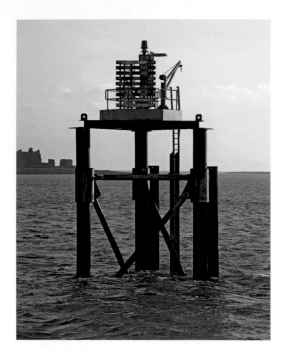

(Above) The light in the Inner channel at Hawes Point is one of a series of range lights that replaced the brick range lights built between 1850 and 1870.

(Right) The tall brick lighthouse at Rampside is the only remaining one of nine towers built between 1850 and 1870. Known as Walney Channel Middle Range Rear Light, it was only saved from demolition by a local petition

the solar panels, a simple quick-flashing white navigation light visible for 10 miles. In common with all the pile lights, these are managed by Associated British Ports.

Although the old lights have been demolished, they have been replaced by a series of range lights. One pair is situated at Biggar Sands on the west side of the channel, and another pair at the entrance to Walney Channel. They consist of pile structures with a variety of light configurations. In addition, a pair of pile lights is situated at Haws Point on the southern tip of Walney Island and a series of pile lights lines the western training wall.

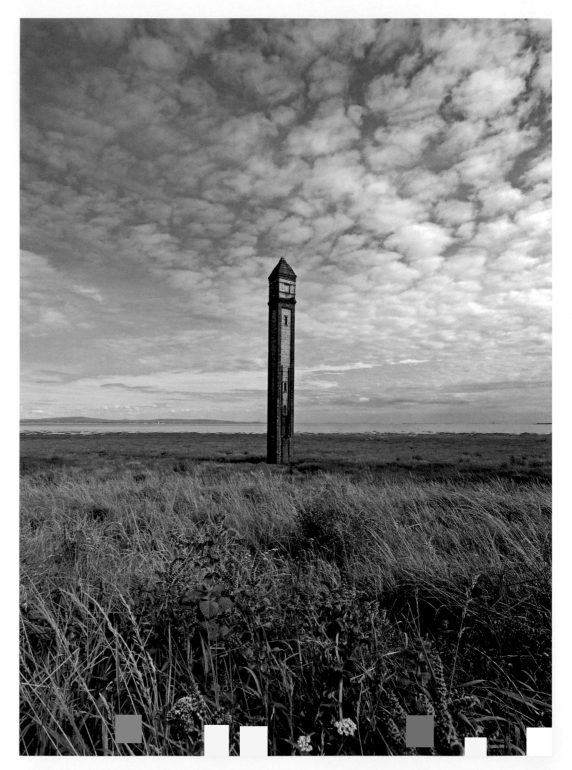

Ulverston

Established	1850 (never lit)
Current lighthouse built	1850
Access	From the car park in Ulverstone it is a 133m walk up Hoad Hill

The plastic light on Foulness Island replaced a similar structure to the one at Rampside.

The Sir John Barrow Monument in Ulverston, which looks like a lighthouse on the summit of Hoad Hill east of the town, can be seen from the A590. Its lighthouse appearance is not surprising as, when built by public subscription in 1850, Trinity House donated £100 towards the £1,250 costs on the basis that it could be used as a lighthouse if required.

Situated approximately a mile from Morecambe Bay, the 100ft monument is built from limestone quarried at Birkrigg Common. It is modelled on the famous Eddystone lighthouse, a traditional rock lighthouse, and has a profile tapering more steeply at the base. The internal spiral staircase consists of 112 narrow steps leading to a lantern chamber, which has never had a functional light.

The somewhat ornate lantern room, complete with a pepper-pot roof, was originally open on all sides, but to protect the tower it is now fully glazed. Subsequent deterioration led to it being encased in reinforced cement in 1969. It has been open to the public at various times, but since 2003 it has been closed as repairs are needed. An application for lottery funding has been made so that it can be reopened. On top of a 440ft hill, it can be reached via local footpaths.

This monument on Hoad Hill in Ulverston was never lit, but Trinity House paid for an option to light it should that be needed.

Hodbarrow Point

Established	1866
Current lighthouse built	1905
Discontinued	1949, recommissioned 2003
Operator	Local committee
Access	Drive along the sea wall from the Haverigg end; the old light can be viewed from the new light

The lighthouses at Hodbarrow Point have also been known as Haverigg, Hodbarrow Seawall or Millom Breakwater Light and date from 1866 when the Hodbarrow Mining Company built a 35ft circular stone tower lighthouse at Rock House to assist shipping approaching the company's jetties to load iron ore. Situated at what was then the extremity of the mine workings, it had a gallery with the fixed white light shown through a small circular window on the seaward side.

Between 1900 and 1905, because its workings extended under Duddon Estuary, the Mining Company built a sea wall across part of the estuary and as the lighthouse was then some distance inland it was discontinued on 15 July 1905. In the same year, a new light was erected on a 30ft two-storey cast-iron tower complete with gallery and lantern in the centre of the newly-completed sea wall. The lower cast-iron section was manufactured by Cochran & Son whilst the lantern, with domed roof and weather vane, was made in France by Barbier, Bernard & Turenne of Paris. The lamp probably used a fourth-order Fresnel lens with a revolving shutter mechanism, which gave a white occulting light.

Despite electricity coming to the mine in 1929, the light was always fuelled by paraffin and was visible for 12 miles. By 1949, the mine's output

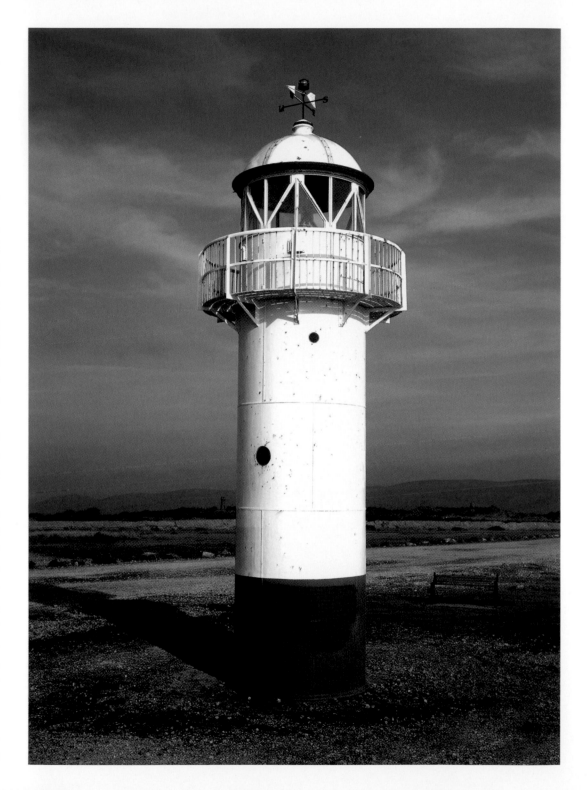

St Bees Head

Established	1718
Current lighthouse built	1822
Automated	1987
Operator	Trinity House
Access	From St Bees village via a mile walk along the cliff path, or from car park at North Head

had declined and the jetties were unsafe, and so the company closed the mine and informed Trinity House it was decommissioning the light. Both lights then deteriorated until in 2003, a local school initiative, funded by a £20,000 lottery grant and led by a local committee, restored the seawall light. Now fully restored, it is painted white with red trim.

Although efforts were made to restore the lighthouse to the original specification, internal arrangements such as the supports for the fog bell were omitted. The lantern, which originally had a small number of curved glass panes, now has flat sheets of glass held with additional supports. A new Carmanah solar-powered navigation lantern was installed to give a white flashing light visible for 2 miles which, with the approval of Trinity House, was displayed during hours of darkness with effect from 11 November 2003. The stone lighthouse was left untouched and is open to the elements. The towers are situated within an RSPB nature reserve created when the mine was flooded.

(Left) Hodbarrow Point lighthouse near Millom was restored in 2003 after £20,000 of Heritage Lottery Fund money had been granted. The project was run by the Haverigg Lighthouse Committee with the support of the local primary school.

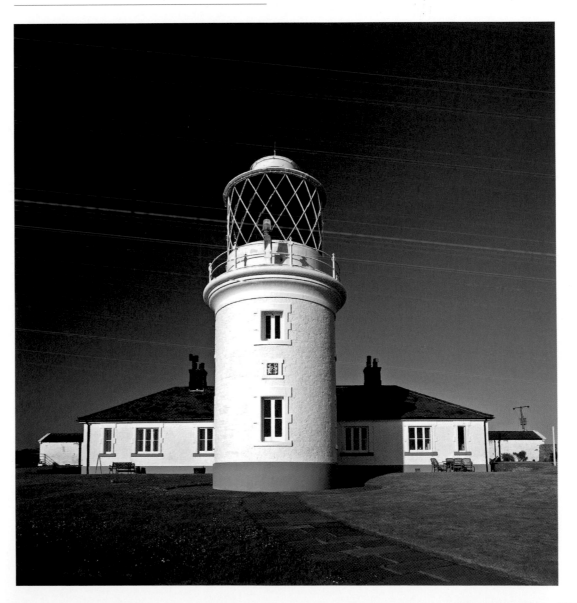

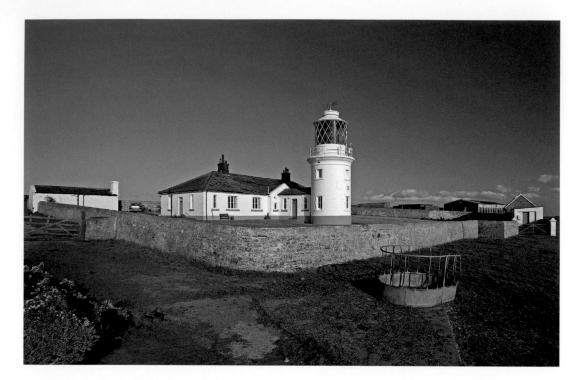

(Overleaf and above) St Bees lighthouse stands 340ft above mean sea level and is thus one of the highest lights in England and Wales.

Whitehaven

Established	1742
Current lighthouses built	1841
Operator	Whitehaven Harbour
Access	All the lights can be viewed by walking the various piers

The docks at Whitehaven were developed over a period of 300 years from the mid seventeenth century with the trade in coal superseded by iron ore and then chemicals. As a result, the port has a multitude of jetties and these have recently been restored. The earliest lighthouse, situated on the Old Outer Quay, was erected in 1742 and consisted of a 46ft three-storey circular stone tower with gallery. The light was displayed through a window. A redundant two-storey stone building with a slate roof adjacent to the tower was possibly associated with the lighthouse. Fired by oil and from 1841 by gas, the light was made redundant when the two lights in the outer harbour were built.

Another tall circular stone tower with an adjacent stone two-storey building and a pitched slate roof is located on the knuckle of the Old Quay. This quay was constructed in three stages – 1634, 1665 and 1687 – and the tower on the then terminus built sometime before 1730. Although it is thought that this tower was used solely as a watchtower, the round railings on the top may well be the remains of a fire grate. As it was built on what was at one time the outermost quay, some form of warning light would have been displayed.

This tower has been restored and the windows near the top facing seaward are a recent addition, although a window did exist before.

In north-west England, between the Welsh and Scottish borders, the only headland is that at North Head, a mile north of the small village of St Bees. As it represents a danger to shipping trading between the ports of Wales and the Solway Firth, in 1718 Trinity House gave Thomas Lutwige a licence to build a 30ft coal-fired light or beacon on the headland. This was financed from dues of three halfpence a ton levied on cargo carried by vessels calling at Whitehaven, Maryport and Workington.

The lease was granted for ninety-nine years at an annual rent of £20. Lutwige's round tower was 30ft in height and 16ft in diameter, of local sandstone, with a metal grate on top into which the keepers tipped loads of coal. The small grate led to complaints from shipowners that on windy nights the light was variable in intensity and often shrouded in smoke.

In 1822 Lutwige's tower was destroyed by fire and Trinity House replaced it the same year, with the white-painted 55ft circular brick tower, which cost £2,322, with attached dwellings. It was built to the design of Joseph Nelson and remains standing today. Because of the height of the cliffs, the station is 340ft above mean sea level. The light, initially oil fired, rotates with a white flashing light and is visible for over 20 miles. The station was automated and de-manned in 1987, and is now monitored and controlled from Trinity House's Planning Centre in Harwich.

The Old Quay was further extended in 1809. In 2000, gates were erected between the Old Quay and Old North Wall to enclose a new marina area.

In 1841, a new pier was constructed to the north of the harbour entrance, and a conical brick tower, the North Pier Light, erected on its end. This 20ft white-painted tower, castellated with a gallery halfway up, displayed a fixed red light visible for 9 miles through a window. Today, two red lights are displayed one above the other, on a mast atop the tower.

A second pier extending out from the Old New Quay, known as the West Pier, was constructed between 1824 and 1838. On its end, a 47ft tapered conical brick lighthouse complete with gallery and lantern room was erected. Its exact date of construction was probably 1841. This tower, now painted white with a red trim to the base and red gallery railings, carries a green flashing light visible for 13 miles and housed in a lantern room with an ornate domed roof. The two active lighthouses were painted in 1999 and action is being taken to restore them.

Reputedly the earliest lighthouse at Whitehaven, on the Old Outer Quay, was constructed in 1742 but subsequently made redundant by the two lights on the outer harbour.

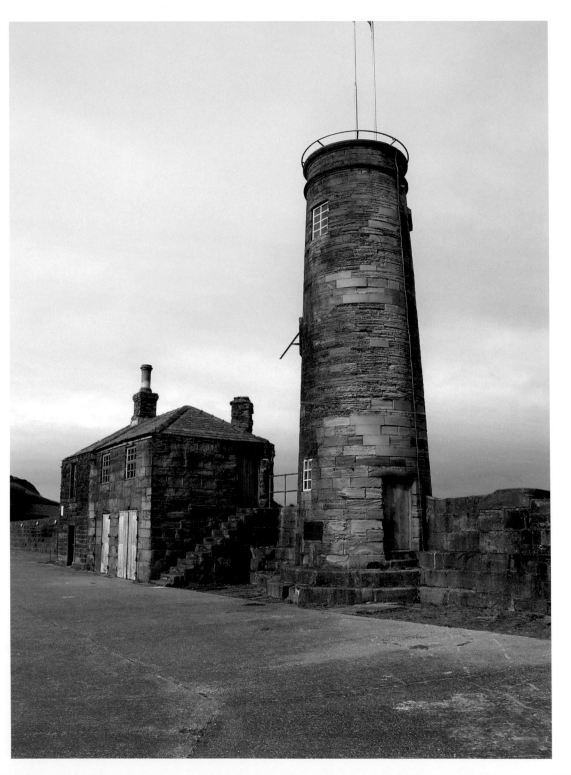

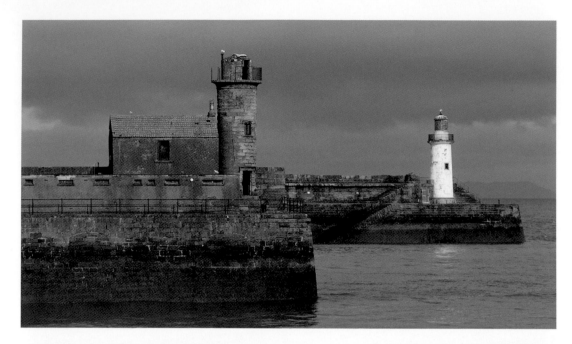

(Left) The tower on the Old Quay used as a watchtower may also have displayed a light when the pier on which it is situated was the outermost quay, with the operational light on the West Pier in the background.

(Below) The tower on Whitehaven's North Pier, which dates from 1841, displays two red lights.

(Right) The light on the West Pier of Whitehaven harbour was built in the mid nineteenth century and is the tallest of the lighthouses.

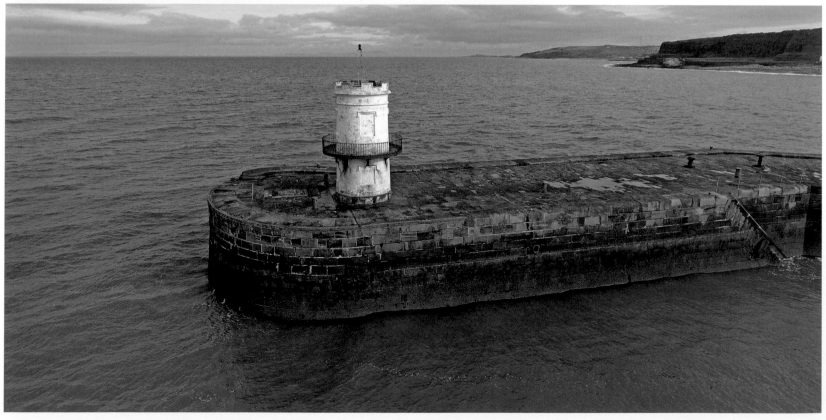

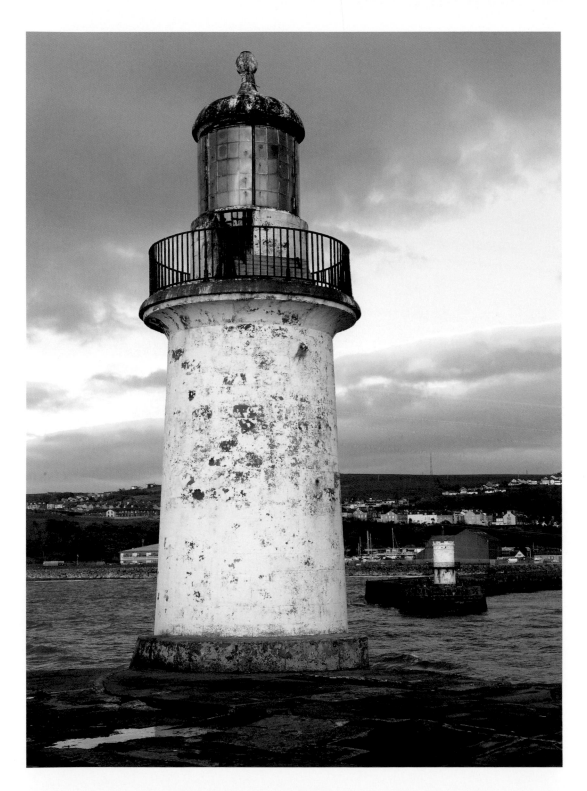

Maryport

Established	*c*. 1796
Current lighthouse built	1996
Operator	Trinity House
Access	Both lights can be viewed by walking the southern outer piers of the harbour

The first lighthouse at Maryport was probably erected on the end of the pier in about 1796. George Stephenson reported from his 1801 tour that the light was fired by oil with two reflectors. In 1846, this light was replaced by a cast-iron tower with a lantern on top, mounted on a stone polygon base. The light was visible

(Below) The old lighthouse at Maryport forms a distinctive landmark within the harbour and marina complex.

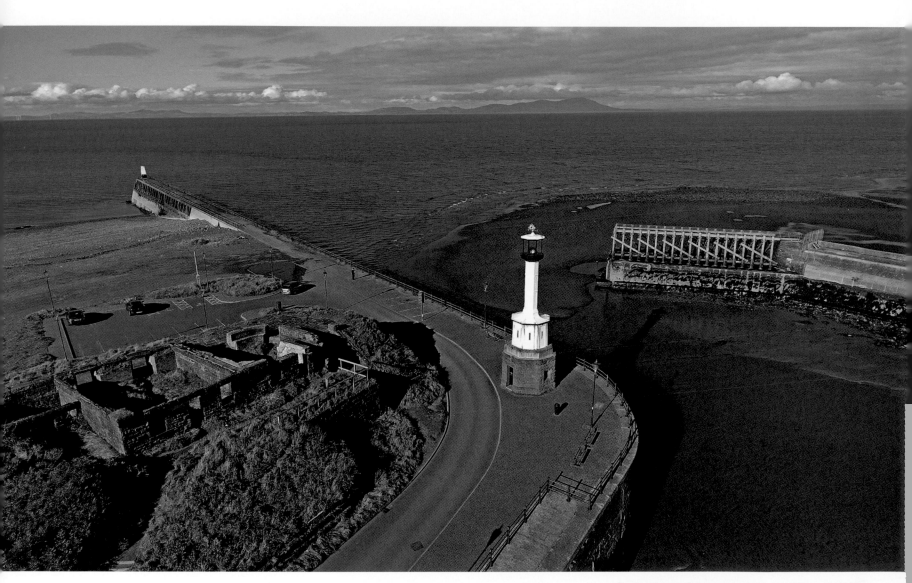

The two lights at Maryport, overlooking the Solway Firth, with the cast-iron lighthouse centre-right and the smaller light at the end of the pier.

Silloth

Established	1841
Current lighthouse built	1997
Automated	1913
Operator	Associated British Ports
Access	East Cote light is on the promenade north of the village, Lees Scar light can be seen on foot at low tide but is best visited by boat

for 12 miles. It was converted to acetylene in 1946 and, although taken over by Trinity House in 1961, was still powered by acetylene until 1996, when it was replaced by a bland aluminium triangular tower with an electrically powered navigation light on its seaward side; this has a range of 6 miles.

The exact date of its decommissioning may have been earlier, as Trinity House erected a light on a short concrete column prior to the construction of the aluminium tower. The 1846 light still stands and is probably the oldest cast-iron lighthouse in existence. It is of an unusual design, with the black-painted lantern supported by a narrow white cast-iron column on a broad base. The structure is mounted on a 6ft hexagonal base. Maryport is being developed as a tourist area and both lights are accessible.

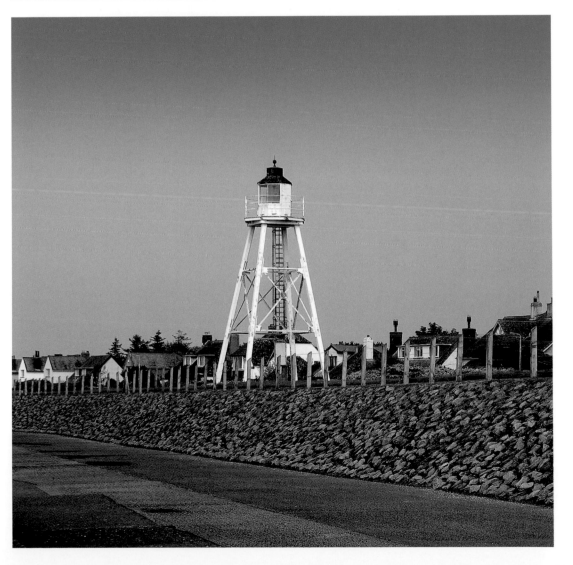

The light at East Cote, originally one of a pair of range lights, is situated north of Silloth Harbour, which itself lies on the south side of the Solway Firth.

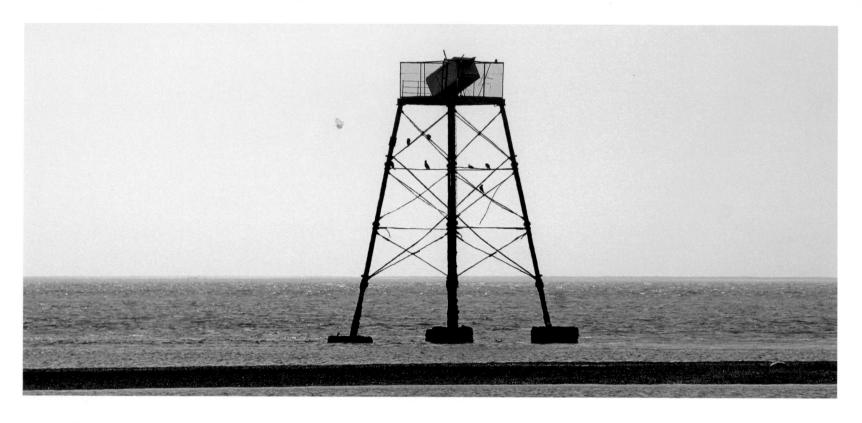

Details of lighthouses guarding the approaches to Silloth are scant, but it is believed that a wooden tower existed about 1,000 yards north of the harbour in 1841, although other records suggest 1864. Located on the foreshore adjacent to the roadway, it is sometimes called Skinburness, although its official name is East Cote Rear. It was one of a pair of leading lights with the front or Cote light mounted on a circular wooden tower on the south pier extension. The light was on a wooden pyramidal structure which in turn was mounted on a short

(Top) The pile lighthouse at Lees Scar, a submerged reef to the south-west of Silloth Harbour. (Tony Denton)

(Left) An old postcard showing the East Cote light with the keepers' dwelling beneath..

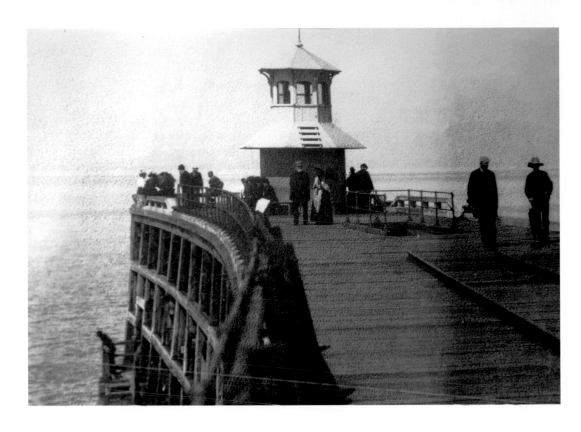

(Left) The front East Cote light at the end of the pier at Silloth; both the pier and the light were demolished in 1956. (By courtesy of Tony Denton)

rail track so that it could be moved to mark the channel into Silloth Harbour accurately.

In 1913 this wooden tower was replaced by a 39ft white square metal pyramid tower, which carried an electrically powered fixed green light, visible for 10 miles, in a white-painted corrugated-iron octagonal lantern room complete with a black-domed room. Inside the base was a single-storey keepers' dwelling. The light was electrically operated and was automated in 1930. In 1997 Associated British Ports completely rebuilt it in a similar form but fixed in position on the short railway track and dispensed with the keeper's hut. The light is still operational and can be seen on the promenade.

The front East Cote light, originally mounted on the end of the dock pier, was a short hexagonal wooden tower with a lantern room, complete with a conical roof above a circular shelter. The light and the pier were demolished in 1956, when the latter became unsafe. Today, a 14ft multi-use wooden structure on the south breakwater shows two fixed green lights.

About 800 yards south of the harbour and 700 yards out to sea was a 45ft pile lighthouse called Lees Scar, referred to locally as 'Tommy Legs'. It consisted of a cottage-style lighthouse with a circular lantern room on top of the keepers' accommodation and showed the light through a window. A small boat hung on davits was used by the keepers to reach the shore. This light, which marked a submerged reef, was demolished but the pile legs were left in place and now hold a solar-powered green flashing navigation light on a 36ft pole. The structure is unsafe and its future is in doubt.

BIBLIOGRAPHY

Boer, G. de: *A History of the Spurn Lighthouses* (East Yorkshire Local History Society, 1968)

Bowen, J. P.: *British Lighthouses* (Longmans, Green & Co Ltd, London, 1947)

Boyle, Martin: *Lighthouses: Four Countries – One Aim* (B&T Publications, Southampton, 1996)

Carpenter, Edward: *Dungeness Lighthouses* (Margaret F. Bird & Associates, 2nd edition 1998)

Hague, Douglas B.: *Lighthouses of Wales: Their Architecture and archaeology* (Royal Commission on the Ancient and Historical Monuments of Wales, 1994)

Hague, Douglas B. and Christie, Rosemary: *Lighthouses: Their Architecture, History and Archaeology* (Gomer Press, Dyfed, 1975)

Jackson, Derrick: *Lighthouses of England and Wales* (David & Charles, Newton Abbot, 1975)

Jones, Ray: *The Lighthouse Encyclopaedia: The Definitive Reference* (The Globe Pequot Press, Guildford, Connecticut, 2004)

Long, Neville: *Lights of East Anglia* (Terence Dalton, Lavenham, Suffolk, 1983)

Nicholson, Christopher: *Rock Lighthouses of Britain* (Patrick Stephens Ltd, Somerset, 1995)

Pearson, Lynn F.: *Lighthouses* (Shire Publications Ltd, Aylesbury, 1995; 2nd edition, 2003)

Sutton-Jones, Kenneth: *To Safely Guide Their Way: Lighthouses and Maritime Aids of the World* (B&T Publications, Southampton, 1998)

Tarrant, Michael: *Cornwall's Lighthouse Heritage* (Twelveheads Press, 2nd edition 2000)

Woodman, Richard and Wilson, Jane: *The Lighthouses of Trinity House* (Thomas Reed Publications, 2002)